MATERIAL

CULTURE

Rupert Chas Souaks
1986

Kenneth L. Ames

Simon J. Bronner

Peirce F. Lewis

Carroll W. Pursell, Jr.

Thomas J. Schlereth

Dell Upton

MATERIAL CULTURE

A RESEARCH GUIDE

Edited by Thomas J. Schlereth

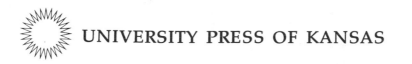 UNIVERSITY PRESS OF KANSAS

Chapters 2–6 were originally published in the *American Quarterly* (Summer 1983) and are reprinted here in edited form by exclusive arrangement, copyright 1983 Trustees of the University of Pennsylvania.

Chapter 7 was originally published in the *Journal of Social History* (June 1983) and is reprinted here in edited form by permission, copyright 1983 Peter N. Stearns.

Published by the University Press of Kansas (Lawrence, Kansas 66045), which was organized by the Kansas Board of Regents and is operated and funded by Emporia State University, Fort Hays State University, Kansas State University, Pittsburg State University, the University of Kansas, and Wichita State University

Library of Congress Cataloging in Publication Data

Main entry under title:

Material culture.

 Bibliography: p.
 Includes index.
 Contents: Material culture and cultural research / Thomas J. Schlereth—Learning from looking / Peirce F. Lewis—The power of things / Dell Upton—[etc.]
 1. Material culture—United States—Research—Addresses, essays, lectures. 2. United States—Industries—Research—Addresses, essays, lectures. 3. United States—Social life and customs—Research—Addresses, essays, lectures. 4. Vernacular architecture—United States—Research—Addresses, essays, lectures. I. Schlereth, Thomas J.
E161.M35 1985 973'.072 85-15643
ISBN 0-7006-0274-7
ISBN 0-7006-0275-5 (pbk.)

Printed in the United States of America

FOR

RONALD WEBER

Professor of American Studies

Contents

Preface ix

1 Material Culture and Cultural Research 1
 Thomas J. Schlereth

2 Learning from Looking: Geographic and Other Writing
 about the American Landscape 35
 Peirce F. Lewis

3 The Power of Things: Recent Studies
 in American Vernacular Architecture 57
 Dell Upton

4 The Stuff of Everyday Life: American Decorative
 Arts and Household Furnishings 79
 Kenneth L. Ames

5 The History of Technology and the Study of
 Material Culture 113
 Carroll W. Pursell, Jr.

6 Visible Proofs: Material Culture Study in
 American Folkloristics 127
 Simon J. Bronner

7 Social History Scholarship and
 Material Culture Research 155
 Thomas J. Schlereth

8 A Guide to General Research Resources 197
 Thomas J. Schlereth

Contributors 207

Index 211

Preface

A DECADE ago, a special issue of the *American Quarterly*, the journal of the American Studies Association, surveyed the teaching, research, and writing of American scholars for whom artifacts constituted important evidence in the documentation and interpretation of the American experience.[1] Since then much new work has been done, prompting Edith Mayo to note recently that "the use of objects as source materials for scholarship has been increasingly legitimized by the growth of American Studies programs which are now in the forefront in their work with objects."[2] In light of both the passage of time and new scholarly developments, it is now appropriate to reassess the progress, problems, and potential of the study of material culture in America.

The present collection contains essays by scholars who know the scope and significance of material culture within their respective disciplines of cultural geography, vernacular architecture, the history of technology, the decorative arts, and folklife studies. An overview of this breadth cannot fully cover the expansive domain of material culture. Two obvious limitations of this survey are, first, that such disciplines as art history, cultural anthropology, and historical archaeology—fields that have traditionally used artifacts as evidence—are not included.[3] Second, because they are covered elsewhere, innovative teaching techniques or curricular experiments using material culture are not addressed here.[4]

This collection, then, emphasizes some of the newly emergent subfields of research on material culture as assessed by Peirce Lewis, a

cultural geographer; Dell Upton, an architectural historian; Carroll Pursell, a historian of technology; Kenneth Ames, a domestic arts scholar; and Simon Bronner, a folklorist. In their essays, these scholars survey the major research of the past two decades within their own particular areas of concern and assess the present contours and promising directions of current work-in-progress. Several propose their own agenda of needs and opportunities for future study.

For example, Carroll Pursell points out the potential of computer graphics for the efficient retrieval and analytical comparison of objects located in repositories all over the country. Dell Upton has high hopes for a national inventory that would undertake a state-by-state identification, classification, and interpretation of the nation's built-environment in an architectural series to be called "Buildings of the United States." Peirce Lewis argues for a comprehensive, cross-disciplinary reference work and statistical handbook that might become a multivolume "Encyclopedia of American Things."

Despite their disciplinary diversity, the contributors to this volume share several common perspectives in assessing current American scholarship that explores the cultural ramifications of objects: a concern for methodology, interdisciplinary interests, and recognition—whether explicit or implicit—of the interrelations between the study of material culture and American Studies.[5] Many of these common perspectives are also characteristic of contemporary research on American material culture at large.

As might be expected of careful students of objects, each author has devised an appropriate typology by which to organize the scholarship he surveys. While these typologies are but heuristic devices, they acknowledge, with varying degrees of emphasis, three principal ways by which American scholars have approached the study of material culture. The first has been to concentrate primarily on the specific identification and authentication of artifacts as products. Such activity is frequently called connoisseurship. A second approach focuses on the study of the processes by which artifacts were made or used, while a third perspective seeks to understand persons and their symbiotic interaction with both products and processes. In a crude way, these three orientations to the study of objects might be said to extend from a traditional art-history approach to a social-history perspective.

Whatever the approach, now methodological problems receive greater attention in studies of material culture. Questions are raised about proper fieldwork techniques necessary to collect data, particularly in a pluralistic, increasingly urban-suburban society such as the United States. Museum collections of the past have been criticized as being

unrepresentative. It is argued that American historical museums actively collect more objects from twentieth-century material culture. Lewis, Ames, Upton, Pursell, Bronner, and Schlereth have individually been strong advocates of object studies that place artifactual contents in their appropriate cultural context.

In addition to their concern about methodology, American material culturists now share common conceptual perspectives. As is evident from these essays, structuralism commands the attention of some researchers in folklife and the decorative arts. Functionalism has its advocates in the history of technology, as well as in the history of vernacular building. Regionalism continues as a viable explanatory concept for numerous cultural geographers, decorative arts historians, and folklorists. Patterns in cultural assimilation, stages of urbanization, and modernization theory also have their champions in more than one subfield of object study.

Theories, of course, come from theorists. Contemporary scholarship on American material culture also has its roster of common intellectual heroes. Several have been influential in research within various disciplines. For example, the works of George Kubler, Fred Kniffen, Claude Lévi-Strauss, J. B. Jackson, Mircea Eliade, Carl Sauer, Henry Glassie, Don Yoder, and Brooke Hindle receive high marks in our collective assessment of the current research.

While this cross-disciplinary cadre is, with the exception of Eliade and Lévi-Strauss, native-born, one should not conclude that the study of American material culture has not been influenced by object research outside the United States. Students of American folklife and vernacular buildings have profited immensely from British and Scandinavian research extending back into the late nineteenth century.[6] Similar debts are owed to their European counterparts by those Americans working in the decorative arts and in technological history. Pursell also notes how the interaction of British and American technologies sustains a perennial interpretive question among some historians of this field—that is, is there a discoverable "American-ness" to technology of this country as opposed to that of others? And, as Lewis reminds us, geographers do not see their proper province ending at this country's national borders, but rather require the wider context of the North American continent as the necessary geographical domain for understanding American culture.

Most recent research on American material culture, however, has not focused on a continental or national scale. Instead, the majority of the new work analyzed here concentrates on micro- rather than macro-research. The emphasis is on domestic artifacts, rather than those of commercial, public, or industrial life; and the research emphasizes

artifacts that were produced in rural settings, in areas principally east of the Mississippi River prior to the twentieth century. Although the history of American technology challenges this generalization to a certain extent, and Bronner, Lewis, and Schlereth attempt to provide some instances of contemporary data used in artifact scholarship, the characterization does point up several of this country's undefined and unexplored areas of material culture research.

Questions of definition and nomenclature plague material culturists just as they have American Studies scholars for the last three decades. Each essayist accordingly proposes at least one working definition of his topic's particular scope and its relation to the wider domain of general material culture research, some offering an assortment of definitions and statements of purpose. To date, however, no one wants to escalate this quest for definitional purity to the proportions it once reached, say, in Alfred Kroeber's catalog of several hundred definitions of the culture concept.[7] Instead the majority of material culture students are anxious to extend their inquiry into other disciplines and, in turn, are usually receptive to researchers from other fields borrowing from their approaches. Most material culturists, like many American Studies practitioners, think of their scholarly workplace more as spacious commons than as a privileged estate. Moreover, as Kenneth Ames has remarked, this interdisciplinary common (or no man's) land is still much "in need of immigrants and agitators."

The metaphor of the commons might suggest another shared characteristic of contemporary research on material culture and current American Studies—the expanding fascination with all the dimensions of vernacular life. Gene Wise identified this trend in his discussion of "the rediscovery of the *particular* in American culture," and a recent (1982) bibliographic issue of the *American Quarterly,* devoted to the "Study of Everyday Life," documented this trend in American Studies.[8] Likewise, in our Emersonian fascination with what Peirce Lewis calls the study of "ordinary things close at hand," we urge the scholarly examination of tract housing, children's toys, mail-order catalogs, tombstones, hall furnishings, and mobile homes.

This contemporary orientation toward ordinary things emphasizes ordinary people, particularly how they make, consume, use, and modify such things. Several material culturists, for example, have turned to objects and how Americans interact with them to explore the bases, range, and limits of human creativity. Hence, Ames describes the research of Robert St. George on seventeenth-century New England furniture and St. George's conclusion that these objects express the "artifact dialect" of their fabricators. Upton notes Henry Glassie's quest

for the "architectural competence" of the anonymous builders of folk houses in Middle Virginia, and Pursell traces Brooke Hindle's exploration of "emulation and invention" among technological innovators. Lewis tells us of the geographer's search for "mental structures," and Bronner relates the search of American folklorists for "the mindset of the folk." Schlereth is intrigued by material history as intellectual history. All of this will sound familiar to Americanists interested in the origins of autobiography, the social and historical impetus behind creativity, and the uses of cognitive anthropology. Also familiar will be the shared emphasis in anthropological definitions of culture, the preference for pluralistic rather than monolithic interpretations of change, and an awareness of the current lack of any one single interpretation of the American experience as a whole.

In the judgment of many American Studies scholars, as well as students of American artifacts, an adequately documented and thoroughly integrated study of America as a totality remains a possibility to be achieved only at some time far in the future. Since the displacement of the myth-and-symbol school as the primary approach to American Studies, no comprehensive synthesis now dominates the field. No single interpretation commands widespread explanatory persuasiveness in the study of material culture. Lewis thinks that the last person to offer such an interpretive possibility was Walter Prescott Webb, and his was a regional, rather than a national, perspective. While others might nominate the sweeping interpretations of Alan Gowans, Roger Burlingame, or Daniel Boorstin, the fact is that, in America, material culture studies (like American Studies) remains a field where the most innovative work is currently occurring at the local or regional level. The essays that follow suggest, however, that such work will be part of the wider evidential base and broader interpretive strategy out of which a new synthesis may develop.

While much of this book's crafting has been communal and collective, its dedication is personal and singular. Ronald Weber, a founder and the first chairman of the Department of American Studies at the University of Notre Dame, has encouraged my research and writing in material culture studies in ways that few who know the public face of that work realize. Ron recruited me to his department in 1972, gave my earliest attempts at using material culture evidence in historical explanation his endorsement, and has been one of my most supportive colleagues in all of my adventures into material culture scholarship. A distinguished literary scholar and craftsman with words, he has generously encouraged me as a cultural historian increasingly intrigued with the historicity of things.

NOTES

1. *American Quarterly* 26 (Bibliography Issue, 1974).

2. Edith Mayo, "Introduction: Focus on Material Culture," *Journal of American Culture* 3 (Winter 1980): 597.

3. See, for example, works such as Bernard Karpel, ed., *The Arts in America,* 4 vols. (Washington: Smithsonian Institution, 1979); W. Eugene Kleinbauer, *Modern Perspective in Western Art History* (New York: Holt, Rinehart and Winston, 1971); Miles Richardson, *The Human Mirror: Material and Spatial Images of Man* (Baton Rouge: Louisiana State University Press, 1974); Leland Ferguson, *Historical Archaeology and the Importance of Material Things* (Columbia, S.C.: Society for Historical Archaeology, 1977); and Robert Schuyler, *Historical Archaeology: A Guide to Substantive and Theoretical Contributions* (Farmingdale, N.Y.: Baywood Press, 1978).

4. A useful digest of teaching with objects in historical archaeology, history of technology, social history, folklife, and art history can be found in Susan K. Nichols, ed., *Historians, Artifacts, and Learners: The Working Papers* (Washington: Museum Reference Center, Publications Division, Smithsonian Institution, 1982).

5. For a more detailed discussion of common characteristics of the contemporary material culture studies movement, see Thomas J. Schlereth, *Material Culture Studies in America* (Nashville, Tenn.: American Association for State and Local History, 1982), 72–75.

6. Don Yoder, "The Folklife Studies Movement," *Pennsylvania Folklife* 13 (July 1963): 43–50; Signurd Erixon, "European Ethnology in Our Time," *Ethnologra Europea* 1 (1967): 3–11.

7. A. L. Kroeber and Clyde Kluckhohn, *Culture: A Critical Review of Concepts and Definitions* (New York: Vintage Books, 1963).

8. Gene Wise, "The American Studies Movement: A Thirty-Year Retrospective," *American Quarterly* 31 (Bibliography Issue, 1979): 332–33.

1

Material Culture
and Cultural Research

Thomas J. Schlereth

MATERIAL CULTURE RESEARCH is both an old and a new scholarly
enterprise in the United States. While anthropologists and archae-
ologists have pursued its dimensions since at least the 1870s, historians
and some social scientists have only recently begun to discover its
potential in cultural analysis.

Who first fabricated the slightly awkward expression "material
culture"? When and where did someone first use the term? What was
meant by this phrase? Like many human creations—the bow saw, fresco
painting, the gerund—we cannot attribute authorship with absolute
accuracy to any one particular individual at a specific time or place.
Etymological dictionaries and conventional finding aids often neglect
the term.[1] Specialized glossaries of disciplinary terminology where one
might suspect to find it unfortunately provide descriptive rather than
historical definitions.[2]

An early scholarly use of the term "material culture" was by the
nineteenth-century anthropologist, A. Lane-Fox Pitt-Rivers. Writing
"On the Evolution of Culture" in 1875, Pitt-Rivers urged fellow re-
searchers in the emerging social sciences to consider material culture as
the "outward signs and symbols of particular ideas in the mind."[3]

Only certain American anthropologists and archaeologists pursued
Pitt-Rivers's injunction. Most were content to use the idea as a descrip-
tive tool by which to categorize the objects of native Amerindian
civilizations. For example, Clark Wissler and Otis T. Mason, archae-
ologists at the Smithsonian Institution, did pioneering research projects

surveying the material cultures of the North American Indians. Their work was followed by studies such as Robert Redfield's research on Meso-America and, still later, by Clyde Kluckhohn's magnum opus on the material world of the Navaho.[4]

At the turn of the century, an occasional American folklorist disagreed with the obsession with literary materials of many of his colleagues and toyed with the potential uses of material data for the interpretation of folk culture. These mavericks were few but, as Simon Bronner has shown, their interests, if not their actual works, prefigure some of the activities of the material folk culture revival that began in the 1960s.[5]

Anxious to be able to make more precise distinctions in their examination of human behavior, these early American anthropologists and folklorists developed a tripartite division of cultural data. The first component was ideological (evidence found usually in the form of oral or written data). The second division was sociological (evidence documented by fieldwork observation of human behavior, such as child-rearing or kinship patterns). A third resource was material (evidence found in the work of human hands, such as ceramics, tools, houses, and the like).

Folkloristic and anthropological interest in material culture atrophied in the 1930s as the evolutionary paradigm with which it was often associated fell from favor and was eclipsed by other explanatory models. With the exception of its continued use in archaeology and its token appearance in anthropology textbook surveys,[6] the term largely dropped out of scholarly discourse until its resurgence, in various fields ranging from art history to social history, in the past two decades of American scholarship.

THE DEFINITIONS OF MATERIAL CULTURE STUDIES

In both past and present scholarship, "material culture" is often considered a synonym for terms such as "artifacts," "objects," or "things." Such interchangeability is frequently evident in both professional and popular writing. However, instead of treating the terms "things," "objects," "artifacts," and "material culture" as coequals, it may be more useful to regard them as terms of increasing specificity of meaning, with "things" seen as the most general rubric and "material culture" as the most specific label when used within the confines of scholarly discourse.

For example, only in its tertiary meaning does the word "things" connote a sense of inanimate entities distinguishable from living organisms. Yet some scholars such as George Kubler prefer the general term and have attempted to study "the history of things" rather than resort to using what Kubler calls "the bristling ugliness of [the phrase] material culture."[7] The word "objects," like the term "things," is another highly abstract collective noun, whereas "artifacts" (artefacts in Britain), coming from the Latin *arte,* meaning skill, and *factum,* meaning something done, at least includes an indirect reference to a human being (an artificer) in its meaning. Objects lack this sense of implied human agency and, unlike artifacts, can be used as an expansive covering term for everything in both the natural and the man-made environment.

By contrast, the general definition of material culture specifically includes the factor of human artifice and also aptly circumscribes the scope of physical data that properly belongs within its research domain. What is useful, therefore, about the term "material culture" is that it suggests, at least among its current students, a strong interrelation between physical objects and human behavior. Despite its cumbersomeness, the phrase continually presses the researcher to consider the complex interactions that take place between creators and their culture. In other words, the assumption is that there is always a culture behind the material. Moreover, the name has one other asset: it simultaneously refers to both the subject of the study, material, and to its principal purpose, the understanding of culture.

Although scholars roughly agree on the label "material culture," they have differing ideas as to how best to define the concept. Definitions often vary by academic field. For, in addition to anthropologists and archaeologists who pioneered in material culture research, scholars in art history, history of technology, cultural geography, and folkloristics now also use the term, often understood within their specialized perspectives. A sampler of material culture definitions presently in circulation would include:

> Material culture entails the actions of manufacture and use, and the expressed theories about the production, use, and nature of material objects.[8]

> Material culture is the ideas about objects external to the mind resulting from human behavior as well as ideas about human behavior required to manufacture these objects.[9]

> Material culture is the array of artifacts and cultural landscapes that people create according to traditional, patterned, and often tacit concepts of value and utility that have been developed over time, through use and experimentation. These

3

artifacts and landscapes objectively represent a group's subjective vision of custom and order.[10]

Material culture: the totality of artifacts in a culture; the vast universe of objects used by humankind to cope with the physical world, to facilitate social intercourse, to delight our fancy, and to create symbols of meaning.[11]

The underlying premise is that objects made or modified by humans, consciously or unconsciously, directly or indirectly, reflect the belief patterns of individuals who made, commissioned, purchased, or used them, and, by extension, the belief patterns of the larger society to which they belonged.[12]

Material culture is that segment of man's physical environment which is purposely shaped by him according to culturally dictated plans.[13]

What do these contemporary definitions share in common? How do they differ in purpose, scope, and use? To state the obvious, all embrace the material, calling it variously the "physical environment," a "product," an "object," a "thing," or an "artifact." Agreement exists that man-made materials are vital to any concept of material culture.

A second axiom is the belief that a link exists between material and culture. In some definitions, this linkage is explicit; in others, the interrelation of material and culture is more guarded, as in the suggestion "material culture entails the actions of manufacture." In any event, each of the definitions recognizes the culture concept as integral to understanding material culture. The definitions also generally concur in defining culture as those socially transmitted rules for human behavior that entail ways of thinking and doing things. This economical idea of culture is expressed in phrases such as "patterns of belief," "concepts of value," "belief systems," or "culturally dictated plans."

Despite this basic definitional harmony, the term "material culture" may still strike us as one of those awkward phrases that we suspect may have been made up by a committee. Like many two-word explanations (e.g., "Yankee ingenuity"), it appears to explain everything and yet often ends up confusing everything. For example, we must admit at the outset, the phrase is something of a contradiction in terms, since material culture is not actually culture but its product. To compound this self-contradiction, the phrase labors under another liability since, in common parlance, there is a tendency to associate the word "material" with base and pragmatic things, while "culture" is a word usually connected with noble and erudite things. Moreover, if the terms are inverted, as in cultural materialism, we have a phrase of an entirely

different meaning—one that anthropologist Marvin Harris has developed into a controversial explanation of human behavior.[14]

These obstacles to lexicographic clarity can be partially mitigated by understanding the two words "material" and "culture" in a wide perspective. For example, once the culture of material culture is seen to include the objects of high culture (for instance, a J. S. Copley painting or Daniel Chester French sculpture) as well as artifacts of popular and vernacular culture (for instance, a Los Angeles freeway billboard or an Upland South barn), culture is seen to be simply culture—that is, socially transmitted rules for human behavior that entail ways of thinking and doing things. The term "material" can also be expanded. For example, James Deetz has proposed we consider cuts of meat as material culture, since there are many ways to dress an animal. In Deetz's view, the scientific breeding of livestock should also be included in any definition of material culture since the conscious modification of an animal's physical form is done according to culturally patterned behavior.[15] Kinesics (for instance, the body motions involved in performing Aaron Copland's Appalachian Spring ballet or a southern Indiana clog dance) and proxemics (for instance, the spatial uses and interactions of people in New York's Rockefeller Center or at Anaheim's Disneyland) are other culture expressions that assume, if but for a limited time, physical form and could be included within the legitimate boundaries of material culture.

Although the scope of the material in material culture continues to be expanded in various directions, this does not mean that it includes a totally unrestricted spectrum of all possible objects. Human agency is either implicit or explicit in all the definitions we have been examining. Therefore, natural objects such as trees, fossils, or skeletons are usually excluded from definitions of material culture on the grounds that they are not man-made or man-modified artifacts. However, when natural objects are encountered in a cultural pattern that suggests human activity—a stone wall in Pennsylvania or a fence row of Osage orange in an otherwise random Ozark forest, a concentration of pig bones in a midden site in Arkansas, a pile of oyster shells prepared for the making of tabby along the Florida coastline—these are examples of natural materials that have become materials of culture.

Where does all this semantic searching and definitional dancing leave us? What might be an adequate (but not elaborate) working definition of material culture that would be useful to scholars in various research fields? Here is a brief one that will be used throughout this chapter: material culture is that segment of humankind's biosocial environment that has been purposely shaped by people according to culturally dictated plans.

Some investigators use the term "material culture" not only in the sense that we have been describing it (that is, as a covering term for all man-made or man-modified artifacts) but also as a method of cultural inquiry employing physical objects as its primary data. In such usage, material culture stands for both the subject to be researched as well as the method of studying the subject. (The word "history," likewise, often stands for both the work of the discipline and also for the content of the discipline.) The possible misunderstanding that this double meaning can cause can be avoided by using the phrase "material culture studies" to describe the research, writing, teaching, exhibiting, and publishing of individuals who endeavor to interpret past and present human activity largely, but not exclusively, through extant physical evidence.

The term "material culture studies" is by no means the only nomenclature in current usage. In fact, the eclectic enterprise has often been identified by several roughly synonymous labels. They and some of their practitioners include: "artifact studies" (E. McClung Fleming), "anonymous history" (Siegfried Giedion), "material life" (Robert St. George), "pots-and-pans history" (Elizabeth Wood), "material history" (John Mannion), "above-ground archaeology" (John Cotter), "material culture history" (Brooke Hindle), "physical folklore" (Richard Dorson), "volkskunde" (Andrew Fenton), "hardware history" (Larry Lankton), and "material civilization" (Fernand Braudel).[16]

Material culture studies is deliberately plural because it comprises several disciplines, among them the triad of art, architectural, and decorative arts history; cultural geography; the history of technology; folkloristics; historical archaeology; cultural anthropology, as well as cultural and social history. To be sure, not all of these disciplines and subdisciplines use material culture to the same extent. Practically all archaeologists and most art historians share a common interest in material culture evidence, although not necessarily the same type. Artifact study is important to some, but by no means all, historical geographers and cultural anthropologists. Such data are vital to the research of a growing number of historians of technology, and to an expanding cadre of folklorists and a widening circle of social and cultural historians.

While it now possesses most of the disciplinary accouterments (for example, scholarly journals, academic conferences, and tentative plans for a national professional association), the present state of material culture studies does not constitute an academic discipline.[17] As Richard Dorson was wont to remind us, in order for an enterprise to be

considered a scholarly discipline, it must be established in both a pragmatic and philosophical way. Pragmatically, a discipline exists if it can reach an intellectual audience with scholarly works, earn a place in accepted fields of learning of its day, preserve and enlarge its area of knowledge, attract converts and young disciples, and perpetuate itself for another generation. Philosophically, the discipline exists if it can lay claim to distinctive theoretical methods or empirical data important for humankind's knowledge of self and of society.[18] At this stage of its historical development, material culture studies performs several but not all of these functions.

Material culture research can be best described at present as an expanding movement or coalition of individuals (James Deetz calls it "an emerging research community") working in museums, historical societies, and cultural agencies, as well as in academic departments in colleges and universities, who are intrigued by the idea of studying the (possibly unique) explanatory potential of material evidence as cultural meaning. Eschewing any single orthodoxy in methodology, the study of material culture seeks to develop the explanatory power of artifact knowledge in order that such knowledge might ultimately expand human understanding. The principal task of material culture studies is an epistemological one; it is an attempt to know what can be known about and from the past and present creations of humankind.

What, if anything, do the diverse practitioners of material culture research have in common? In addition to an obvious evidential concern with physical objects as cultural data, the movement works under at least four common assumptions. Most studies of material culture, as Warren Roberts has shown us, usually involve field-work research during which artifacts are collected, identified, compared, and categorized either *in situ* or in assorted museums, in private and public collections, and in historical agencies where such physical data are housed.[19] A historical perspective also characterizes most material culture studies, since (as several of their names indicate—the history of technology, art and architecture history, historical geography, for example), they seek to measure and understand change over time. In historical analysis, researchers use the culture concept in varying ways. While some see culture only with a capital C, the majority view it as an anthropological construct.[20] Finally, perhaps the hallmark of the current emphasis in American material culture studies is an increased quest for a truly interdisciplinary focus to its work, conceptually and methodologically, in order to analyze humankind's past artifactual record as a concrete manifestation of cultural history.

THE DISTINCTIVE FEATURES
OF MATERIAL CULTURE EVIDENCE

Why should we bother to investigate the material in search of the meaning of cultural? Historical and other investigators of human behavior have long argued that words, rather than things, are better resources for understanding the past and present. Can any particular claims be made for material culture as a distinctive type of empirical data? Or, to put it another way, does material culture have any special evidential characteristics in cultural inquiry?

Before answering these questions, we should emphasize that no serious student of material culture ignores any extant documentary or statistical data that is relevant to his or her investigation. Material culture invariably involves work with both words and things, and in most research the two forms of evidence are used in tandem. Of course, a great deal of material culture research (for example, this book) is communicated through words. There are, however, several evidential qualities that are more prominent in material culture evidence than in documentary evidence. These characteristics include: (a) evidential precedence; (b) temporal tenacity; (c) three-dimensionality; (d) wider representativeness; and (e) affective understanding.

Recorded human history based upon written documents goes back in time approximately six thousand years. Yet for many of these centuries, the records consist largely of artifacts. In fact, in order to tell our full human history (not merely our mislabeled "prehistory"), archaeologists are able to extend the human saga by fifty thousand additional years through their analysis of material culture evidence. Human beings were making things long before they were speaking or writing about such things. Material culture predates verbal culture by several thousand years, since toolmaking, almost universal in all cultures, preceded the invention of writing in practically all of them. Material culture possesses, therefore, evidential precedence in that it is humankind's oldest legacy of cultural expression. In fact, some scholars argue that it is the oldest manifestation of our humanness.

In western cultures, historians normally mark broad stages of this early period of human history by the kind of objects people could make: the Paleolithic, Neolithic, Bronze, and Iron ages define the times and cultures in which things were first molded out of stone and then of metal. Modern historians continue to use artifactual metaphors to explain the past of the industrial revolution, a chromo-civilization, or the atomic era. Our book titles—*Engines of Democracy, The Dynamo and the Virgin, The Republic of Technology, American Civilization in the First Machine Age*—also betray our predilection for historical periodization through artifactual symbols.[21]

Material culture is not only the most ancient of time's shapes, it is also a tangible form of a past time persisting in present time. We can no longer hear a sixteenth-century Spanish folk hymn or a seventeenth-century New England Puritan sermon as they were once sung or preached, but we can venerate a reliquary at the Mission of San Jose or meditate in the Old Ship Meetinghouse at Hingham, Massachusetts. This tenacious, although not indestructible, durability of the artifact affords the researcher a temporal range of data that enables him or her to explore human behavior over a much wider pattern of cultural change than if only written records are consulted.

The temporal tenacity of material culture evidence should not be exaggerated. All artifacts—like all humans—wear out, break down, are damaged beyond repair, destroyed, or lost. This process occurs even when the material culture is preserved in historical museums and other cultural repositories. Numerous artifacts also often go through a succession of alterations, being worn, used, or weathered over time. When a researcher encounters such objects, he must remember that their current state may be only one of their former states. Most likely such objects are not identically the same as when they were first fabricated.

Yet despite the fact that wood rots, metal corrodes, and stone crumbles, material culture enjoys an exceptional longevity among the other remains of the human past. Many interpreters also argue that such physical remains have a remarkably high degree of evidential veracity and a relatively low incidence of deliberate duplicity when compared with other historical data. Anthropologist William Rathje sees this aspect of material evidence as a data base that is usually nonreactive, quantifiable, and largely independent of the biases of traditional interpretive techniques.[22] It is claimed that physical objects are less biased records of past human activity in that they usually survive not as transcriptions or translations or condensations of events but often as events themselves.

For example, the statue of George Washington that we now see displayed in the National Museum of American History in Washington, D.C., is fundamentally the same physical artifact sculpted by Horatio Greenough from 1833 to 1841. The sculpture has, of course, had many different settings over the past century and a half—in the mall in front of the U.S. Capitol, at the East Portico of the Capitol, in storage in the Smithsonian's basement, and now on public view in the NMAH—but its basic physical form remains as Greenough executed it from a block of Italian marble. The sculpture is, therefore, a different type of historical evidence (not necessarily a better type) in that its physical composition separates it from, say, evidence such as Greenough's own writing about the sculpture as well as what has been written and said about the art work since the 1840s.

Occasionally an object, although itself destroyed, survives in another material form to instruct the historian about the past. For example, archaeologically, the terms "post construction" and "earthfast" are used to refer to buildings whose wooden structural members are set into or laid directly on the ground. Such structures are built without masonry foundations. Although the wooden members of the buildings have rotted away, they have left patterns of disconnected dots or molds in the ground. From these residues, architectural historians and archaeologists working in Maryland and Virginia have deciphered important information about the seventeenth-century vernacular buildings of which there are but extant traces. In fact, as Dell Upton points out, because of the tenacity of this material culture data more is now known about earthfast structures of the Chesapeake region than about earlier, similar buildings in England.[23]

Barring deliberate alteration or forgery or some other conscious deceit, material culture evidence directly embodies actual historical events. Such data can provide the historian with an opportunity to explore a facet of the past, first-hand as it were, not as translated by someone in the past, writing down experiences or orally describing what he encountered. The claim here is that certain human activities—particularly tasks of making and doing—can afford the researcher something like an "encounter of the third kind," providing data that may be only hinted at or totally missing in statistical or verbal commentaries on the past.[24]

Past human experience is thus given a novel degree of permanency in material culture. Past thoughts and feelings, it is argued, gain a special degree of objectivity in things such as tools and chairs that endure, across time, as historical events. Artifacts are thrust into the world and past experience is made solid. In short, artifacts have the power to stabilize experience of the past. To the historical researcher, they are here in his time; and yet they are also still there in another time—that is, in their time.

This dual personality of material culture evidence has at least two cultural ramifications. On the one hand, it helps explain the reverence and nostalgia that the antiquarian has for past artifacts, enshrining them in public and private art galleries, museums, and historical societies often designed as classical temples. (Of course, we also do this with documents—for example, the public display of the nation's sacred scriptures in a sanctuary we call the National Archives.) On the other hand, the extant historicity of material culture data (our obsession with only the "real things") will be one of the major arguments continually used against the proposals of Wilcomb Washburn and others that

historical museums should begin to collect information, not only objects.[25]

In his 1982 presidential address to his fellow historians of technology, Brooke Hindle posed two important questions: "Is there a truth inhering in the three-dimensional survivals that is missed when they become mere illustrations, even in exhibits reflecting the best possible historical understanding? If so, what is that truth?" Professor Hindle answered by suggesting what he considers to be one of the salient characteristics of material culture evidence: its three-dimensionality—a mode of knowing that entails a nonverbal comprehension of the significance of mass, scale, and amplitude in human history.[26]

Three-dimensionality is common to all material culture, including objects such as maps, photographs, and graphics; but it is, of course, more characteristic of some artifacts than of others. A Bessemer blast furnace possesses greater dimensionality than a Kodak snapshot; mass and proportion are more pronounced in the actual Brooklyn Bridge than in John Marin's watercolors of the structure.

The common trait of three-dimensionality, claims Eugene Ferguson, can be best investigated by analyzing the scale, texture, proportion, style, mass, and workmanship of an artifact. These are evidential features usually not found in any parallel way in books, diagrams, or drawings.[27] Therefore, three-dimensionality, is, to quote Brooke Hindle again, "a matter of spatial perspective, through sight, sound, and touch of the real tool or machine. The best verbal historian has no possible way of attaining this except after coming in contact with actual technological artifacts."[28]

Scholars have only begun to acknowledge the visual or tactile dimensions of history. Rhys Isaac's *Transformation of Virginia, 1740–1790* and John Stilgoe's *Common Landscapes of America, 1598–1845* are recent examples of this realization, but John Hale's indictment that "the serious historical imagination is . . . only marginally visual" and that "the element of visual recreation in a historian's work is very small" still characterizes far too much of our scholarship in American history.[29]

Surviving material culture evidence often provides us with a broader cross section of society and, therefore, extends our sources of cultural information beyond written or statistical records. For many students of material culture, this expanded representativeness of much material culture data is one of the most appealing reasons for using objects in their research. Working from the premise that only a small percentage of the world's past populations has been literate, that even a smaller percentage has left records such as diaries, correspondence, or personal papers, and that a still smaller percentage of such verbal data

adequately represents the entire socioeconomic spectrum of society, these researchers have turned to artifacts. Material culture is consequently seen as one type of historical evidence that might mitigate some of the biases of verbal data that (in the American historical experience) are largely the literary record of a small group of mostly white, mostly upper or middle class, mostly male, mostly urban, and mostly Protestant cadre of writers.[30]

Material culturists assume, therefore, that extant nonverbal data may provide a distinctive way of understanding the past cultural activities of a larger majority of nonliterate people in a society whose existence would otherwise remain inaccessible or unknown except through surviving statistical data such as census tracts, court records, and the often distorted views of their society's literary elite. In order to redress the historical inequity of ignoring a large segment of the population who produced no literary legacy, scholars have therefore turned to studying, to use Leland Ferguson's felicitous phrase, "the things they left behind." In so doing they have taken issue with some historians who have arrogantly proposed that only a "history of the inarticulate" could describe this important cultural strata of the population.[31]

Finally, some material culturists argue that physical data provides us with a certain type of knowing that art historian Jules Prown has called an affective mode of apprehension. By understanding artifacts, suggests Prown, "we can engage another culture in the first instance not with our minds, the seat of our cultural biases, but with our senses." As Prown further explains, "this affective mode of apprehension through the senses that allows us to put ourselves, figuratively speaking, inside the skins of individuals who commissioned, made, used, or enjoyed these objects, to see with their eyes and touch with their hands, to identify with them empathetically, is clearly a different way of engaging the past than abstractly through the written word. Instead of our minds making intellectual contact with minds of the past, our senses make affective contact with the senses of the past."[32]

While Prown's argument can be criticized epistemologically, its claim for a special sensory knowledge derivable from material culture data has numerous supporters. Advocates are found not only among students of the arts (where we might expect to find such devotees) but also among historians of technology, cultural geographers, and social scientists. For example, Brooke Hindle writes: "The historian of technology has to get inside the machines and processes of which he writes. He

must *feel* [emphasis added] their three-dimensionality.'' Hindle later in this essay recommends that the historian acquire ''fingertip acquaintance and fingertip knowledge'' of the material culture with which he works.[33]

The basis of this claim for a type of nonrational (not irrational) affective knowledge ascertainable largely through artifacts rests, in part, on the inherent limitations of most written or spoken language. Researchers as diverse as Prown, Henry Glassie, Clyde Kluckhohn, and John Kouwenhoven have been distressed by the delusive generality of words; that is, by the tendency for verbal evidence to take on an ''averaging-out'' quality that reduces human experience (past and present) to overly abstract formulas or symbols.[34] One result of the generality of verbal symbols such as words is that two people can be in verbal agreement without meaning the same thing. For instance, a farmer or an artist who has never been out of the American Southwest and a farmer or an artist born and bred in the Scottish Hebrides could not conceivably mean the same thing by the word ''sunlight.''

Words, therefore, are useful only to those who share a common core of experience particulars, a fact that translators, diplomats, and linguists all acknowledge. People who have not experienced similar particulars usually have difficulty in understanding, from another's words, the precise meaning that those words are intended to convey. For this reason they often resort to other methods of nonverbal communication—making drawings and diagrams, gesturing with their bodies or apparel, or manipulating nearby objects in order to demonstrate their ideas. Such experiences suggest that meaning is not an intrinsic property of words; rather, meaning is a process that words sometimes facilitate, a process in which awareness passes from one consciousness to another. As Kouwenhoven points out: ''Words do not *have* meaning; they *convey* it.''[35] Things, it can be argued, both embody meaning as well as convey that meaning.

The claim for material culture as a resource for affective understanding also receives support from researchers who see much of human creativity as primarily an aesthetic experience. Cyril Stanley Smith, a historian of metallurgy, insists that within objects—be they copper alloys, type castings, votive figures, coins, or electric generators—exists ''an instance of aesthetic curiosity.'' It is this characteristic of material culture evidence to which Prown, Smith, and others would have us turn in order to have a human history that takes into account not only past cognitive and behavioral activity, but also previous aesthetic and sensory experience.[36]

13

COMMON ERRORS IN MATERIAL CULTURE STUDIES

Despite the sometimes gradiose claims currently made for material culture evidence—folklorist Henry Glassie recently insisted it was "the deepest, broadest, and best historical source we have"[37]—it must be openly admitted that there are methodological difficulties involved in using such evidence in cultural explanation. These problems include: (a) fecklessness of data survival; (b) difficulty of access and verification; (c) exaggeration of human efficacy; (d) penchant toward progressive determinism; and (e) proclivity for synchronic interpretation.

Material culture researchers have often failed to acknowledge the fecklessness of data survival. There has not been sufficient reflection on the enormous selectivity usually operating in the formation and survival of material culture evidence. Much more research needs to be done on the inscrutable processes of selection by which some artifacts survive and others do not. For all of the great cache of objects now in our museum storehouses, we have little quantitative sense of what has been lost. We have no adequate awareness of how wide the gap is between the former reality of the physical past and its present reality as extant, material evidence in our presence. We must continually recognize that historical explanations are based only on surviving data, certainly not all that once was.

Increased methodological attention must also be given to the fact that surviving objects are not necessarily representative of their makers and users. We need to recognize, for example, that for certain historical periods many more objects created by men exist than those made by women. More artifacts survive from the upper and middle classes than from the lower classes. The recent influx of social history into material culture research may help alert us to the liabilities imposed by gender, race, ethnic origin, and socioeconomic status of the makers and users of objects.

Nonetheless, even when this information is known about objects, they often come to the researcher's purview totally wrenched from their original historical and cultural contexts. Frequently such contexts have vanished. Kits of tools have been separated from the craftsmen, from the shops where they were used, and from the products fabricated with their help. Folk work is often studied totally removed from the folk homes where it was produced. "Out of site" can mean "out of sight." Without a documented context, artifacts are little more than historical souvenirs.[38]

Although they claim special attributes for material culture evidence in comparison with documentary or statistical data, most material

culture researchers acknowledge that we must find new methods of analyzing and verifying artifacts—new methods that are analogous to those commonly used with manuscripts and printed sources. In the February 1984 issue of *Museum News,* historian Wilcomb Washburn maintained that many scholars made little use of artifacts in their research because of the difficulty of obtaining and verifying artifactual data. Unlike most documentary data, material culture evidence cannot be easily duplicated, microfilmed, published, and made widely available to other scholars for further interpretation and verification. Not only are surviving artifacts dispersed in institutional and private hands; even within museums they are often inadequately catalogued, stored off site, and hard to locate for systematic study. Washburn proposed to solve this major limitation of material culture data by reducing artifacts to photographs, drawings, and other more portable, quantitative, and storable forms of data. Such extracted data would then permit the disposal of many, although not all, preserved objects.[39]

Brooke Hindle has suggested that researchers now have a new tool, the computer, that could greatly assist in the extraction of data from material culture evidence in order to duplicate and manipulate such evidence. Researchers may also use computer graphics, scale-modeling, video-disk technology, and holography. Hindle is optimistic about the potential of using such modern artifacts in analyzing material culture data of earlier historical periods. In his judgment, the computer has enormous capacities for "working with multidimensional constructs, particularly two-dimensional representations of three-dimensional devices. For the first time, the basic verbal and mathematical records can be collected in the same context with three-dimensional records and can be accessed and analyzed by the historian in developing his syntheses."[40]

Collecting and analyzing information from objects, via the computer, may help mitigate another methodological fallacy to which material culture research is susceptible. This problem might be called the exaggeration of human efficacy. The very physicalness of a thing, perhaps a metal object, especially one so old it possesses an alluring patina, sometimes can be so emotionally compelling, so powerfully evocative in size and scale that the researcher cannot help but center his or her attention on what cultural anthropologists sometimes call "the culture of agency." The existence of things still tangibly present centuries after their actual making can often oblige the researcher to overemphasize the self-defining or self-assertive activities of their original makers. The history that is written from such data might, therefore, champion only the activities of the doers and achievers, makers and

15

molders, movers and shakers of the past. Perhaps more triumphs than tragedies survive in the extant physical record.

Exhibition of artifacts in museums often promotes a view of history as a story of success and achievement. Such exhibits usually neglect the downside of human life, common to us all but not commonly depicted. For example, in many living-history farms in America there is little material culture that helps a visitor experience something of the isolation, monotony, or high mortality rate of a frontier prairie existence. Usually we do not see objects that would convey to a visitor the dread of drought, fluctuating crop prices, or mortgage foreclosure. Where are the artifacts of the anxiety over frequent childbirth, personal depression, or chronic loneliness? Where are the instances of insanity, brutality, and suicide that also characterize nineteenth-century American rural life?[41]

In these contexts, the documentary and statistical records (rather than the artifactual) may prove more helpful to the researcher since people could and did write about the dark and unpleasant side of their existence; that is, the uncertainties, the false starts, the half-way measures, the intentions that failed. Nonetheless, in object study we also need analyses of material culture pathology so that we might know more about what things, in various historical periods, did not work, that consistently broke down or were quickly junked in favor of other products. Inasmuch as most of the American material culture history studied to date has been, like so much of American written history, the history of winners, a greater appreciation of the losers (people and products) might be a valuable corrective.

John Demos, in a review of *New England Begins: The Seventeenth Century,* an exhibition and catalog produced by the Department of American Decorative Arts and Sculpture of the Boston Museum of Fine Arts (BMFA), suggests as much in his recognition of exaggerated human efficacy in these two historical publications.[42] Demos notes that both the material culture exhibit and its impressive three-volume catalog depict New England settlers as uncommonly active, effective, and forceful in coping with the circumstances of their lives. This viewpoint on their experiences presents a sharp contrast to a generation of scholarly opinion on seventeenth-century New England life. One thinks, for example, of Bernard Bailyn's *Education in the Forming of American Society* and Oscar Handlin's essay ''The Significance of the Seventeenth Century,'' both written in the 1950s and both highly influential on historical writing ever since. The emphasis in the Bailyn and Handlin explanations falls on the element of the unanticipated and the unwelcomed effects of seventeenth-century life in a new environment. Americans arrived with plans, expectations, and assumptions as to what

they were about, but environmental circumstances transformed most of these.[43] The artifacts analyzed by the BMFA research team of archaeologists, decorative arts specialists, and social historians lead to quite another conclusion. New Englanders were in control of their lives and their actions, artifice, and artifacts show them so.

A belief in progress has been enormously influential in both American history and material culture research. The latter often sees the American past as one material success after another in an ever-upward ascent of increased goods and services for all the nation's citizens. George Basalla and others have traced this tendency in the history of technology and in technical museums. Such museums, notes Basalla, are often dominated by a "technological cornucopia" mentality in their celebration of American progress. Michael Ettema sees the same problem in the American decorative arts as does Dell Upton in American vernacular architecture.[44]

Progressive determinism has sometimes pervaded another aspect of material culture research that might be called "the national character focus," a historiographic tradition so labeled because of its relation to a similarly named and oriented trend in American Studies and, in part, because its advocates have sought nothing less than a total explanation of the American national experience.[45]

Beginning with Roger Burlingame's two-volume survey of technology's impact on American life, through the work of J. C. Furnas, John Kouwenhoven, Elting Morison, Alan Gowans, and Daniel Boorstin, there has been a conscious attempt to extrapolate the ideological configurations of American history from American artifacts. At present, such metahistory is no longer in vogue among most contemporary students of material culture. The most innovative work is currently occurring at the local or regional level. There have been some macrolevel hypotheses proposed by material culturists (discussed below in reviewing current explanatory theory), but the majority of researchers—influenced as they increasingly are by the social sciences—are wary of making grandiose claims as to what might be most singularly "*American* about American artifacts."[46]

Opposite the tendency to progressive determinism is a proclivity toward synchronic method in material culture research. Some culture anthropologists, literary critics, folkloristic scholars, and art historians, for example, have been prone to this approach to the artifact. Synchronic analysis I take to mean simply a descriptive study of objects without reference to time duration or cultural change. Its antonym, diachronic analysis, is a comparative study of objects as historical data—that is, as resources that can be considered as being both effects and causes in history.[47]

Synchronic analysis has been seen by some as the only sufficient and proper task of material culture analysis. Others, while acknowledging the value of such an approach in solving interpretive problems of form or design, insist that material culture research must also include a diachronic element if it is to result in a cultural interpretation useful to other scholars for whom the historical is a useful mode of knowing.[48] Two forms of the synchronic perspective, one conceptual, the other methodological, might be noted here. The first could be called material culture neo-criticism. Here the claim is made that objects can possess, as literary critic Northrop Frye argues, ''an imaginative element . . . that lifts them clean of the bondage of history.''[49] The artifact, therefore, exists *sui generis,* possessing a life of its own, not shackled to time or place. Material culturists influenced by Claude Lévi-Strauss and Michel Foucault have been especially attracted to this nonhistorical stance. Richard Poulsen, for example, in *The Pure Experience of Order*, argues that ''it seems quite clear that psychic needs evident in material artifacts cannot be explained through chronology.'' Paulsen sees his approach to material folk culture as one that ''describes movements or conditions that are ahistorical—not explicable by history and actually in opposition to it.''[50]

The synchronic syndrome also expresses itself in a perennial quest for aesthetic uniqueness, special artistic achievement, and Procrustean stylistic periodizations. These tendencies manifest themselves in many temporary and permanent museum exhibitions as well as in catalogs and monographs. Despite their name's injunction, art historians can be extremely nonhistorical in this respect. Material culture research in American art, architecture, and decorative arts history still often resorts to a flat, overly generalized, style nomenclature (e.g., Romanic, Neo-Grec, Colonial Revival) in its historical periodizations. Such labels are conclusions about material culture, not explanations of the data. Of course, such approaches may increase our knowledge of a style's components (that is, provide us with something of the what of the style) but they are invariably deficient in explaining how a style came to be or why it may have changed.

EXPLANATIONS IN MATERIAL CULTURE RESEARCH

What can material culture research explain about the past? How valuable might it be to scholars such as historians, many of whom traditionally have been either hostile or indifferent to it?[51] What are the levels of its veracity and persuasiveness in cultural inquiry?

Few would argue with the claim that material culture evidence of the past should obviously be used in historical research when it is the only evidence available. Such historical explanations can be labeled explanations of singularity. Much of the Native American history of this continent (for example, that being uncovered at the Koster site in Illinois) has been written by archaeologists and anthropologists in this explanatory mode.[52] Studies of Inca copper objects have also yielded precise information about complex gilding processes while the examination of the microstructure of other metals has taught us much about various heating, forging, and quenching processes that we would know in no other way. Social history information on such diverse subjects as the rate of consumption of alcohol in the urban workplace and living conditions of Chinese immigrants in the American West has also been generated from artifacts used as the primary data.[53]

Here the research on earthfast construction in the colonial Tidewater might be cited again. Not only did the careful scrutiny of that material culture provide documentation for a chronological and geographical distribution of these frontier houses, it also enabled the researchers to understand the colonial economic context and how such structures reflected a value system nurtured by single-crop, labor-intensive tobacco farming.

No documentary, statistical, or oral data survives yielding sufficient information on the history of a distinctive type of Dutch barn in America. In order to understand both how such barns were built and who built them, architectural historian John Fitchen had to rely almost exclusively on the extant structures. His book *The New World Dutch Barn: A Study of Its Characteristics, Its Structural System, and Its Probable Erectional Procedures* (Syracuse: Syracuse University Press, 1968) has rightly become a classic in material culture research. Henry Glassie would later apply a structuralist interpretation to 156 Middle Virginia houses in a similar attempt to ascertain the architectural competence, community values, and mentality of their makers.[54]

In the history of numerous manufacturing processes and technological activities, there are often no documentary resources for us to explain how such processes were employed or how various manufacturing techniques were developed. A methodology of material culture studies known as experimental archaeology is helping to explain the work force, the work place, and the work routine of the American worker who created such processes. As folklife scholar Jay Anderson explains, ''experimental archaeology was developed as a means of 1) practically testing theories of past cultural behavior, especially technological processes involving the use of tools and 2) obtaining data not read-

19

ily available from more traditional artifact analysis and historical sources."[55] Major centers for this type of historical research have been the country's outdoor living-history museums such as Old Sturbridge Village, Colonial Williamsburg, and Plimoth Plantation, where experimental archaeology has been applied to expand the historian's understanding of agricultural practices, metal working, and dietary habits.

While their interpretations to date have been mostly microexplanations, researchers who have produced explanations of singularity from material culture data have often been the very first to establish any type of explanation whatsoever in their area of historical interest. We are in their debt for the incremental knowledge they are slowly adding to our portrait of the past.

Artifacts can be used as supporting or supplementary evidence in research when the available documentary and statistical data for a topic are limited, seriously flawed, or problematic in some fashion. We might refer to these interpretations as explanations of support. Such explanations involve both visual and verbal, artifactual and documentary evidence.

Scholars use this explanatory mode in two ways. For example, if the historian has formulated his hypothesis initially on the basis of material culture evidence, he may wish to substantiate or further document his argument by careful examination of parallel documentary data. Or, in reverse, a historian who has developed his hypothesis primarily from statistical and documentary data may wish to scrutinize the material culture record that parallels (in time and place) the verbal record he has already mastered.

Harvey Green and Rhys Isaac have done recent studies integrating both material culture data and documentary materials to explain issues such as nineteenth-century Victorians and eighteenth-century Virginians.[56] On certain other topics of interest to contemporary scholars, material culture research may prove especially supportive in its contributions to explanatory theory. For example, if economic historians such as Neil McKendrick and Mario Szabo are correct in their claim that "the way that people spend their money in the consumption of goods, can be said to be the way that they order their lives," then consumerism may be a historical issue on which we will see increased cooperative research based upon documentary data and material culture evidence.[57] So, too, on the roles of diet, advertising, childhood, recreation, domesticity, and creativity in the American past. On the last topic, the historical origins, dimensions, and ramifications of innovation and invention, we are already seeing research combining traditional documentation and material culture evidence.[58]

Such collaboration increasingly characterizes material culture research strategies presently being employed in the exploration of several broad explanatory concepts such as modernization, mechanization, urbanization, and consumerism. Modernization theory, for instance, guided some of the research of the BMFA investigation of seventeenth-century New England and presently informs part of the interpretative program of the Henry Ford Museum's analysis of nineteenth-century America. The implications of the "consumer revolution" thesis argued in France by Fernand Braudel and in England by McKendrick is partially now being explored against the material culture evidence amassed in places like Colonial Williamsburg and the Strong Museum.[59]

Material culture research, argues social historian Cary Carson, performs a final supportive role in historical explanation when it assists in communicating that explanation in a format understandable to an audience broader than that of the professional history fraternity. Carson maintains that historians have only begun to explore the enormous heuristic potential of artifacts, sites, settings, reenactments, and ethnographic dramas in the communication of their knowledge of the past.[60] If he is right, material culture may both significantly widen the evidential basis on which American history is explained and play a major role in explaining it to a wider audience of the American people.

Finally, the third major research strategy in which material culture evidence can be deployed is to subject established interpretations usually based strictly on documentary and statistical data to a careful critique. Here the objective is to revise or overturn an interpretation if there appears to be some discrepancy in the material culture evidence surrounding the topic. This revisionist perspective subjects long-accepted historical generalizations—such as the interchangeability of parts in early American manufacturing, the importance of the fall line in American historical geography, the introduction of log building by the Swedes, or the superiority of nineteenth-century American agricultural machinery—to close scrutiny from another angle and with the aid of different evidence. We might call these explanations of superiority simply because they prove material culture evidence to be the superior data base in explaining a part of the past heretofore interpreted largely (and mistakenly) through documentary data.

Typical revisions of our understanding of the American past that have been made by comparing material evidence with previously established documentary and statistical data explanations would include Allan Ludwig's reinterpretation of the Puritans based upon his analysis of their funerary art rather than their sermons.[61] James Deetz has suggested a format for the rewriting of the cultural history of seven-

21

teenth- and eighteenth-century New England (and by inference much of colonial America) based upon ceramics, architecture, foodways, decorative arts, and household furnishings.[62] Ivor Noel Hume, in *Martin's Hundred*, has recreated a nearly forgotten British settlement at Wolstenholme that was wiped out by an Indian massacre in 1622. He learned from the material culture data "more about the struggles to maintain European standards on the frontier of civilization" than he could have from all the written records of the time.[63]

In the history of technology, Robert Howard, Merritt Roe Smith, and other American scholars have suggested that one standard explanation for early nineteenth-century American technological creativity—the idea of the interchangeability of parts—simply does not square with the historical reality of the extant museum specimens. For example, the fact that Eli Whitney did not achieve true interchangeability, despite his voiced enthusiasms, was not clear until the parts of his muskets were actually examined. Generations of historical writing about the "interchangeability" of the parts in Whitney's muskets was finally confronted and revised with the empirical fact that, once taken apart, the extant specimens proved not to be interchangeable at all.[64] Such comparative analysis can prompt the historian to seek another explanation for his data. "Seeing devices" only through the written word, suggests Carroll Pursell, puts one in danger of "reproducing old errors of perception, of mistaking rhetoric for reality," and often of completely misunderstanding complex interconnections of acts, artifacts, and authors in the past.[65]

Most material culturists have thus far been content to practice a type of incremental revisionism, re-evaluating historical explanations within the boundaries of their disciplinary or subdisciplinary precincts. Kenneth Ames's critique of American folk art is an instance of this practice; Ruth Schwartz Cowan's perceptive study of the ironies of household technology is another example. Some have taken on the reinterpretation of a particular historical era such as the seventeenth century, which Alan Gowans two decades ago labeled as medieval and now Robert St. George and Robert Trent explain as mannerist.[66]

James Deetz's tripartite explanation for interpreting cultural change in colonial American society currently looms as one material culture paradigm that seeks to challenge traditional historical explanation on a macrolevel. Deetz initially argued his theory and method in a working paper ("A Cognitive Historical Model for American Material Culture") that he subsequently elaborated in a small volume called *In Small Things Forgotten: The Archaeology of North American History* (1980).

Documentary and material culture evidence suggested to Deetz that New England culture evolved through three phases: a Stuart yeoman

phase (1620–1660), a localized Anglo-American era (1660–1760), and a Georgian period (1760–1830). Although Deetz used all the evidence available, including census records, cartography, probate inventories, and other assorted documentary data, he made a special attempt to employ "aspects of the material culture record which represented universals in the lives of people of early Anglo-America: ceramics, since everyone ate; housing, since everyone lived in some kind of a building; gravestones, since everyone died, although not all were commemorated by a memorial."[67] To a lesser extent, Deetz also used musical forms, trash disposal, and foodways in his analysis. His conclusions challenged the traditional political and diplomatic history interpretation of the American independence movement as the major cultural watershed— the major cultural change, if you will—of American colonial history. The documentary and material data that Deetz assembled and integrated suggested that the political revolution actually had little impact on American cultural history; in fact, the general American cultural pattern before and after the war was closer to British material culture than had previously been believed.

In summary, the formulating of explanations, the testing of explanations, and the revising of explanations that we have examined afford us a typology of how material culture research has been used in cultural interpretation. Two caveats, however, are worth noting before reflecting on the future of material culture studies.

First, it would be hubris indeed to assume that we can acquire complete access to a culture's behavioral and belief systems simply because ample objects have survived. Like explanations written with verbal data, our understanding of material culture will always be a mere approximation, a conjecture based at best on fragmentary evidence. Moreover, objects may prove appropriate only to decipher certain kinds of human intentions; it may be that only certain specific patterns of thought can be teased from them. In the study of objects, there may be a spectrum of explanatory potential that extends from one end of a scale in which material culture is highly revelatory of culture (architecture, furniture) to the other end where objects have little cultural content for human activities.

Second, we must always remember that it is the culture, rather than the material, that should interest the material culture researchers. As Brooke Hindle reminds his fellow historians: "It is the spatial and analytical understanding offered by artifacts, not the things themselves, that is the historian's goal. He has to see through the objects to the historical meaning to which they relate."[68]

FUTURE DIRECTIONS IN MATERIAL CULTURE STUDIES

Most scholarship on material culture in America in the immediate future will most probably be concentrated on a micro- rather than a macrolevel. The monograph, the field report, and the specialized exhibit catalog will dominate the field as researchers nibble away at previously unexplored topics, artifact genres, time periods, and geographical regions. Case studies and tightly focused research will be the norm. Eventually, of course, some audacious soul will initiate a new synthesis of all this piecemeal research, and we will see a new array of broad interpretations of American culture (past and present) in which physical evidence will play its relevant and necessary part. Such a new synthesis may be wound around any one (or a combination thereof) of several cultural theory models (for example, structuralism or modernization) presently contending for our attention. Or we may also see a new explanatory principle (perhaps one empirically derived from material culture data itself) enumerated, documented, and defended.

In the age of particularism, we may see more polemics. Heretofore, intellectual discourse in material culture research has been a rather genteel endeavor. This may change as scholars come to feel more strongly about their methodological turf. Attacks on and defenses of research technique and evidential usage may become more spirited and vigorous, serving, as a result, as important catalysts in promoting more rigorous scholarship. Perhaps even an occasional methodological "slaying of the father" will take place as some young scholars in the field (many of whom are the first to be trained specifically as material culturists) take on their graduate-school mentors and challenge older research techniques and interpretive positions. It could be a heady time.[69]

If the number of conferences, symposia, museum exhibitions, and publications that have appeared recently on the collecting of contemporary material culture is any bellwether, then we can anticipate seeing more research based upon the physical remains of the twentieth century.[70] In short, we are seeing a major redefinition of what constitutes a historical artifact and what artifacts are suitable for cultural study. This redefinition is concerned with, first, the acceptable antiquity of artifacts for study, and, second, their provenance.

The old prescript coined by dealers, collectors, and the U.S. Customs Office, "one hundred years doth an antique make," no longer holds among those who now work with American artifacts. Instead there has been a drift away from the fascination with the colonial material culture of the seventeenth and eighteenth centuries, particu-

larly of revolutionary America, to artifacts of the recent past. In addition to expanding research on the post–Civil War era, there is interest developing in art deco and art moderne decorative arts and architecture, in documentary photography since 1900, and in the material culture of roadside America. Now, for example, a Society for Commercial Archaeology studies artifacts of the highway strip.[71] All of this professional collecting of the contemporary is paralleled on the amateur level by the growth of flea markets and innumerable house, lawn, and garage sales where objects of every kind are offered, traded, and bought by an ever-widening public. Nearly everything is fair game today.

Along with the collapse of the definition of what constitutes a "historical" artifact has come an absorbing interest in the material culture of the American Everyman. As Fred Kniffen put it, "There must be, for example, less concern for a house because some famous character lived in it and more concern that it is or that it is not typical of the houses of its time and place. The study of the unique normally adds little to the sum of understanding of human behavior. The study of the kinds of things used by people during a given historical period reveals a great deal about them."[72] This emphasis helps explain the vogue of the social history approach among material culturist as well as why there has been a slight shift in research interest from the public sector to what Carroll Smith-Rosenberg has called "private places"—that is, to the household, the bedroom, and the nursery.[73]

The new populist emphasis on artifact studies that focus on vernacular, commonplace, and mass-style objects, as opposed to that which is unique, elite, or high-style, has had analogs in other dimensions of the American material culture movement. The historical preservation cause in the United States now seeks more aggressively to save whole "historical districts" (even industrial or commercial ones) instead of simply the home of the town founder. American museums now mount more exhibitions devoted to the material culture of varied ethnic groups, of workers, of dissidents, and even of people who were the counter-culturists of yesteryear.[74] The popular culture movement has also added to the democratization of American objects studied, arguing that mass-produced lawn ornaments and suburban garden plots are as crucial as indices to the American experience as are Tiffany lamps or Duncan Phyfe chairs.[75]

Although the historical profession as represented by the American Historical Association has been laggard in recognizing material culture scholarship in its journals and at its professional conclaves, there are a few signs that more collaboration is ongoing between those whom E. M. Fleming once defined as "university historians and museum histo-

rians."[76] In 1984 the Organization of American Historians highlighted material culture scholarship in a special session ("Interdisciplinary Perspectives: Material Culture and History") devoted to new approaches to material culture research of special interest to academic historians. A year-long symposium on historical methodology, sponsored by Indiana University at Indianapolis, makes similar recognition of the growing awareness by historians of material culture's potential.[77]

If material culture research is to make a difference in historical studies, it will probably do so because of the discipline's current fascination with social history. If social history's influence continues to expand within the academic history profession, so too will material culture's role. Already common allies, they may be expected to share common causes in the future—common causes such as a mutual concern for explanations of human behavior over time and place; a willingness to challenge an older view of history as only past politics; a wish to demonstrate the great pluralism of the American people and their lifestyles; and a desire to expand the traditional boundaries of American historical scholarship, thereby actually redefining what constitutes the American historical experience.[78]

At the same time that the discipline of history may be turning up as the newest kid on the material culture block, we may also be seeing the return of anthropology, the field's parent returning to some of its old haunts. Nothing could be more fortuitous: the study of material culture was, as Jane Dwyer has argued, "one of the foundations of early anthropology." At the turn of the century, the customary ethnographic report was filled with lengthy descriptive accounts of "tools," "house types," or "body ornamentation." Such data became outmoded as ethnologists concerned themselves more with social organization; and, by the early 1930s, material culture studies in anthropology waned.

Now, a half century later, different theoretical and methodological orientations in anthropology have renewed interest in material data. As Dwyer suggests, anthropologists are now recognizing "that the range of objects which a society creates is the product and residue of the thoughts and behavior of its members."[79]

The re-emergence of anthropology as promoter of and perhaps major policymaker in material culture studies should give future scholarship in the field a stronger social-scientific perspective—an orientation it has not had in the recent past. Examples of the flavor of this perspective can be found in Miles Richardson's *The Human Mirror*, as well as in the recent material culture sessions of the International Congress of Ethnological and Anthropological Sciences. At those meetings, organized by anthropologists Barrie Reynolds and Margaret Stoff

in Canada, twelve anthropologists participated in detailed discussions of material culture in contemporary anthropology. By no means is this renewed disciplinary interest in material culture among anthropologists confined to aboriginal or exotic physical data. The work of Mark Leone on structures, Grant McCracken on clothing, and Michael Schiffer on refuse indicates that there is a growing fascination with contemporary North American data.[80]

The renewed interest of anthropologists and the new interest of historians ought to make for a more boisterous and bountiful house of material culture students in the next decade. There will probably be some attempts to organize, maybe even domesticate, the inhabitants. In recent years, there has been talk of a need for a national scholarly association, but this still awaits its impresario and its institutional home. James Deetz thinks we will eventually see interdisciplinary departments of material culture in the country's colleges and universities.[81] Before this happens on a large scale, it is more likely that we will see a number of American museums vying to become, in concert with neighboring universities, major research centers in material culture. At such centers, the continual research agenda will be simply what can we learn about human behavior from the objects that human beings have made or modified.

Whether or not we see a revival and an expansion of museum-university collaboration such as that which took place in the 1950s with the birth of the Cooperstown and Winterthur programs, the material culture field is ready for another step forward. As Brooke Hindle recently told the Early American Emeriti Conference, "material culture is at an early stage of professional development."[82] The struggle for recognition will, of course, continue, but that battle is going well. More important issues, however, now demand attention. Questions of definition, methodology, verification and documentation of data, and interpretation strategies need to be addressed in the next decade of scholarship. If this is done with the enthusiasm we see demonstrated in this book, the state of material culture research in future years should continue to be, as Ken Ames recently characterized it, "a new frontier for scholarship," one worthy of our time and talent.[83]

NOTES

The author extends special thanks to Brooke Hindle, David Kyvig, and Ian Quimby for their valuable critique and useful suggestions on earlier drafts of this chapter.

1. An exception to this claim, however, would be George I. Quimby, "Material Culture," *Encyclopedia Britannica*, vol. 14 (1968): 1054–1055.

2. For a recent example of this descriptive focus see the entry "Material Culture" in *Encyclopedia of Anthropology*, ed. David E. Hunter and Philip Whitter (New York: Harper and Row, 1976), 260. Here material culture is described as "the tangible expression of changes produced by humans in adapting to, and exercising control over, their biosocial environment. If human existence were merely a matter of survival and satisfying basic biological needs, then material culture would consist simply of the tools and equipment of general subsistence and the weapons of warfare and defense against aggression. But human needs are varied and complex, and the material culture of even the simplest human society reflects other interests and emphases. A representative sample of the material manifestations of culture would have to include works of art, ornaments, musical instruments, ritual paraphernalia, and exchange currencies, as well as shelter, clothing, and the means of procuring or producing food and transporting people and goods."

3. A. Lane-Fox Pitt-Rivers, "On the Evolution of Culture," in *The Evolution of Culture and Other Essays*, ed. J. L. Myers (Oxford: Clarendon Press, 1906), p. 23.

4. Clark Wissler, "Material Cultures of North American Indians," *American Anthropologist* 16:3 (July–September 1914): 447–505; Otis F. Mason, *The Origins of Invention* (London: W. Scott, 1895); Robert Redfield, "The Material Culture of Spanish-Indian Mexico," *American Anthropologist* 31:4 (October–December 1929): 602–19. Clyde Kluckhohn, W. W. Hill, Lucy Wales Kluckhohn, *Navaho Material Culture* (Cambridge: Harvard University Press, 1971).

5. Simon Bronner, "The Hidden Past of Material Culture Studies in American Folkloristics," *New York Folklore* 8 (Summer 1982): 1–10. An early discussion of material culture research in folklore theory can be found in Pliny Earle Goddard, "The Relation of Folk-Lore to Anthropology," *Journal of American Folklore* 28 (1915): 22.

6. The persistence of the idea in the theoretical literature can be traced from Clellan S. Ford, "A Sample Comparative Analysis of Material Culture," in *Studies in the Science of Society*, ed. G. P. Murdock (New Haven: Yale University Press, 1937), 225–46; to Alfred L. Kroeber, *Anthropology* (New York: Harcourt, Brace; 1948), 296; to Harry L. Shapiro, *Man, Culture, and Society* (New York: Oxford University Press, 1956), 176.

7. George Kubler, *The Shape of Time: Remarks on the History of Things* (New Haven: Yale University Press).

8. Ford, "A Sample Comparative Analysis of Material Culture," 225–46.

9. Cornelius Osgood, *Ingalik Material Culture* (New Haven: Yale University Press, 1940), 26.

10. Howard W. Marshall, *Folk Architecture in Little Dixie: A Regional Culture in Missouri* (Columbia: University of Missouri Press, 1981), 17.

11. Melville Herskovits, *Cultural Anthropology* (New York: Knopf, 1963), 119.

12. Jules Prown, "Mind in Matter: An Introduction to Material Culture Theory and Method," *Winterthur Portfolio* (hereafter cited as *WP*) 17:1 (Spring 1982): 1–2.

13. James Deetz, "Material Culture and Archaeology—What's the Difference?" in *Historical Archaeology and the Importance of Material Things*, 10.

14. Marvin Harris, *Cultural Materialism: The Struggle for a Science of Culture* (New York: Random House, 1979).

15. James Deetz, *In Small Things Forgotten: The Archaeology of North American Life* (Garden City, N.Y.: Anchor Press, 1977), 24–25.

16. E. McClung Fleming, "History 803: The Artifact in American History," unpublished course outline, Winterthur Program in Early American Culture, 1969; Elizabeth B. Wood, "Pots and Pans History: Relating Manuscripts and Printed Sources to the Study of Domestic Art Objects," *The American Archivist* 30 (July 1967): 431–42; David Goldfield, "The Physical City as Artifact and Teaching Tool," *The History Teacher* 8 (August 1975): 535–56; Charles F. Montgomery, "Classics and Collectibles: American Antiques as History and Art," *Art News* (November 1977): 126–36; Kenneth L. Ames, "Meaning in Artifacts: Hall Furnishings in Victorian America," *Journal of Interdisciplinary History* 9 (Summer 1978): 19–46; John Cotter, *Above-Ground Archaeology* (Washington: Government Printing Office, 1977); Ivor Noel Hume, *Historical Archaeology* (New York: Knopf, 1968), 21; American Association of Museums, *Museum Studies: A Curriculum Guide for Universities and Museums* (Washington: American Association of Museums, 1973); Alexander Fenton, "Scope of Regional Ethnology," *Folklife* (1973): 6; Richard Dorson, *Introduction to Folklore and Folklife* (Chicago: University of Chicago Press, 1972), 2–3; Siegfried Giedion, *Mechanization Takes Command: A Contribution to Anonymous History* (New York: W. W. Norton, 1948), 2–4.

17. Two American scholarly journals now carry the term "material culture" on their mastheads. In 1978, *Pioneer America,* a quarterly that publishes the research of scholars and amateurs alike, assumed the subtitled *Journal of Historic American Material Culture.* Five years later the organization changed the name of its journal to *Material Culture: The Journal of Pioneer American Society.* In 1979 *WP* (begun in 1961 as a clothbound annual devoted primarily to the specialized research of professionals in the American decorative arts) became a quarterly emphasizing the research of several disciplines that seek "to integrate artifacts into their cultural contexts." Significantly, *WP* has also acquired a subtitle, *A Journal of American Material Culture.*

18. Richard Dorson, "The Fields of Folklore and Folklife Studies," in *Introduction to Folklore and Folklife* (Chicago: University of Chicago Press, 1972), 2–3.

19. Warren Roberts, "Fieldwork: Recording Material Culture," in *Folklore and Folklife, An Introduction,* ed. Richard Dorson (Chicago: University of Chicago Press, 1972), 431–44.

20. One statement of the position is suggested by James Deetz: "The central paradigm with which we as archaeologists are dealing is culture. It's not behavior. It's not commodity flow. So the best thing we can do is use archaeological methods to block out and define, from a material perspective, the form of American Culture at different times at different places." As quoted in Robert Friedman, "Digging Up the U.S.," *American Heritage* 34:5 (August 1983): 45.

21. Roger Burlingame, *Engines of Democracy* (New York: C. Scribners, 1940); Lynn White, *The Dynamo and the Virgin Reconsidered* (Cambridge: MIT Press, 1970); Daniel Boorstin, *The Republic of Technology* (New York: Harper and Row, 1978); Gilman M. Ostrander, *American Civilization in the First Machine Age* (New York: Harper and Row, 1970).

22. William Rathje, "Archaeological Ethnography . . . Because Sometimes It Is Better to Give Than to Receive," in *Explorations in Ethnoarchaeology,* ed. R. A. Gould (Albuquerque: University of New Mexico Press, 1978), 51–52.

23. Dell Upton, "Traditional Timber Framing," in *Material Culture of the Wooden Age* (Tarrytown, N.Y.: Sleepy Hollow Press, 1981), 52; also see Cary Carson, Norman F. Barka, William M. Kelso, Garry Wheeler Stone, and Dell Upton, "Impermanent Architecture in the Southern American Colonies," *WP* 16:2/3 (Summer–Autumn 1981): 135–96.

24. Prown, "Mind in Matter," 9. Also see Yi-Fu Tuan, "The Significance of the Artifact," *Geographical Review* 70:4 (October 1980): 463.

25. Wilcomb E. Washburn, "Are Museums Necessary?" *Museum News* 47 (October 1968): 9–10. Also see note 45 below.

26. Brooke Hindle, "Technology through the 3-D Time Warp," *Technology and Culture* 24:3 (July 1983): 455.

27. Eugene Ferguson, "Technical Museums and International Exhibitions," *Technology and Culture* 6 (1965): 45; also see Ferguson's "The Mind's Eye: Nonverbal Thought in Technology," *Science* 197 (1977): 826–27.

28. Hindle, "Technology through the 3-D Time Warp," 456. For Hindle's extended discussion of "spatial thinking," see pp. 456–57.

29. John Hale, "Museums and the Teaching of History," *Museum* (UNESCO) 21 (1968): 67–27.

30. Henry Glassie, "Folkloristic Study of the American Artifact: Objects and Objectives," in *Handbook of American Folklore* (Bloomington: Indiana University, 1983), 377.

31. Rhys Isaac, in his *The Transformation of Virginia, 1740–1790* (Chapel Hill: University of North Carolina Press, 1982), summarizes this arrogance in this footnote manifesto: "Historical understanding has too long been enthralled by the assumptions, preferences, and definitions of intellectuals—a high priesthood of which historians themselves form a part. In highly literate milieus the assumption is unquestioned that significant communication is conveyed by words, especially by written words, and above all by printed words. Yet one may ask: How many people in our own society—among the elite even—arrive at articulate verbal statements of the meaning of their own lives? For all persons such statements are most often implied in patterns of behavior. In face-to-face oral cultures like that of 18th-century Virginia, action in a social context assumes an even more important place in the total process of communication. Scholars' predilections have long placed undue emphasis in early American history on New England, with its great output of printed sermon commentary about society and the nature of things. In Virginia it was not in words but in vivid dance forms that the meaning of life was most fully expressed. Historians must seek to 'read' these kinds of statements."

32. Prown, "Style As Evidence," *WP* 15:3 (Autumn 1980): 208.

33. Hindle, "Technology through the 3-D Time Warp," 456, 458.

34. See, for example, John Kouwenhoven, "American Studies, Words or Things?" in *Material Culture Studes in America,* ed. Thomas J. Schlereth (Nashville, Tenn.: American Association for State and Local History [hereafter cited as AASLH], 1982), 80–92; Clyde Kluckhohn as quoted in Richard B. Woodbury, "Purposes and Concepts," in *The Teaching of Anthropology,* Memoir 94, ed. David B. Menolbaum et al. (Washington: American Anthropology Association: 1963), 228.

35. Kouwenhoven, "American Studies: Words or Things?" 85–86.

36. Cyril Stanley Smith, "Metallurgy Footnotes to the History of Art," in *American Philosophical Society Proceedings* 116 (1972): 128; also see Robert R. Armstrong, *The Affecting Presence: An Essay in Humanistic Anthropology* (Urbana: University of Illinois Press, 1971); Prown, "Mind in Matter," 9–10.

37. Glassie, "Folkloristic Study of the American Artifact," 377.

38. James Deetz, "The Artifact and Its Context," *Museum News* 62:1 (October 1983): 26; Hindle, "Technology through the 3-D Time Warp," 453; A. E. Parr, "History and the History Museum," *Curator* 15 (1972): 54.

39. Wilcomb E. Washburn, "Collecting Information, Not Objects," *Museum News* 62:3 (February 1984): 5–15; also see Washburn's earlier statement of his position in "Are Museums Necessary?" *Museum News* 47:2 (October 1968): 9–19.

40. Hindle cites Wolfgang K. Giloi, *Interactive Computer Graphics: Data Structures, Algorithms, Languages* (Englewood Cliffs: Prentice-Hall, 1978), in reference to his argument in "Technology through the 3-D Time Warp," 461.

41. Thomas J. Schlereth, "It Wasn't That Simple," *Museum News* 56:3 (January–February 1978): 36–44; a parallel argument is found in "Causing Conflict/Doing Violence," *Museum News* 63:1 (October 1984): 45–52.

42. John Demos, "Words and Things: A Review and Discussion of 'New England Begins,'" *William and Mary Quarterly* 40:4 (October 1983): 584–97.

43. Bernard Bailyn, *Education in the Forming of American Society: Needs and Opportunities for Study* (Chapel Hill: University of North Carolina Press, 1960); Oscar Handlin, "The Significance of the Seventeenth-Century," in *Seventeenth-Century America: Essays in Colonial History,* ed. James Morton Smith (Chapel Hill: University of North Carolina Press, 1959), 3–12.

44. George Basalla, "Museums and Technological Utopianism," in *Technological Innovation and the Decorative Arts,* ed. Ian M. G. Quimby and Polly Anne Earl (Charlottesville: University of Virginia, 1974), 360, Michael J. Ettema, "History, Nostalgia, and American Furniture," *WP* 17:2/3 (Summer–Autumn 1982): 135–44. See Upton's "The Power of Things," chapter three of this book.

45. Thomas J. Schlereth, "Material Culture Studies in America, 1876–1976," in *Material Culture Studies in America,* 63–68.

46. Thomas J. Schlereth, "American Studies and Students of American Things," *American Quarterly* 35:3 (Summer 1983): 236–41.

47. For a review of the merits of synchronic versus diachronic analysis, see Jeffrey L. Eighmy, "The Use of Material Culture in Diachronic Anthropology," in *Modern Material Culture: The Archaeology of Us,* ed. Richard A. Gould and Michael B. Schifler (New York: Academic Press, 1981), 31–50, and Henry Glassie, *Folk Housing in Middle Virginia: A Structural Analysis of Historic Artifacts* (Knoxville: University of Tennessee Press, 1975), vii–viii, 8–9, 11–12, 17, 20, 36–37.

48. Henry Glassie, "The Nature of the New World Artifact, The Instance of the Dugout Canoe," in *Festschrift fur Robert Wildhaber,* ed. Theodore Gartner and Walter Escher (Basel: Schweizerische Gesellschaft für Volkskunde, 1973), 168.

49. Northrop Frye, *Anatomy of Criticism, Four Essays* (Princeton: Princeton University Press, 1957), 347.

50. Richard Poulsen, *The Pure Experience of Order: Essays on the Symbolic in the Folk Material Culture of Western America* (Albuquerque: University of New Mexico Press, 1982), 29; also see pp. 15–16 for an even stronger critique of historical knowing.

51. William B. Hesseltine, "The Challenge of the Artifact," in *The Present World of History* (Madison: AASLH, 1959), 64–70; Brooke Hindle, "A Retrospective View of Science, Technology, and Material Culture in Early American History," *William and Mary Quarterly*, 3rd ser., 41 (July 1984): 432.

52. Stewart Struever, *Koster: Americans in Search of Their Prehistoric Past* (New York: Anchor Press / Doubleday, 1979).

53. Heather Lechtman and Robert Merrill, *Material Culture: Styles, Organization, and Dynamics of Technology* (Proceedings of American Ethnological Society, 1975); Cyril S. Smith, *A Search for Structure: Selected Essays on Science, Art, and History* (Cambridge: MIT Press, 1981), especially chapters 5, 8, and 11; Robert L. Schuyeler, ed., *Archaeological Perspectives on Ethnicity in America* (Farmingdale, N.Y.: Baywood Publishing Company, 1980).

54. Henry Glassie, *Folk Housing in Middle Virginia: A Structural Analysis of Historic Artifacts* (Knoxville: University of Tennessee Press, 1975).

55. Jay Anderson, "Immaterial Material Culture: The Implications of Experimental Research for Folklife Museums," *Keystone Folklore* 21 (1976–1977): 1–13; a survey of experimental archaeology in the United States can be found in Anderson, *Time Machines: Living History Museums* (Nashville: AASLH, 1984), 85–136.

56. Harvey Green, *The Light of the Home: An Intimate View of the Lives of Women in Victorian America* (New York: Pantheon, 1983); Rhys Isaac, *The Transformation of Virginia*; also see David Hackett Fischer, *Growing Old In America* (New York: Oxford University Press, 1978), and Daniel Calhoun, *The Intelligence of a People* (Princeton: Princeton University Press, 1973).

57. Neil McKendrick, John Brewer, and J. H. Plumb, *The Birth of a Consumer Society: The Commercialization of Eighteenth Century England* (Bloomington: Indiana University Press, 1982); Matyas Szabo, "The Use and Consumption of Things," *Ethnologia Scandinavia: A Journal for Nordic Ethnology* (1978): 107–118.

58. On material culture resources for the study of creativity, see Eugene Ferguson, "The Mind's Eye: Nonverbal Thought in Technology," *Science* 197 (1977): 827–36; Roger N. Shepard, "The Mental Image," *American Psychologist* 33 (February 1978): 125–37; Brooke Hindle, *Emulation and Invention* (New York: New York University Press, 1981).

59. The Braudel thesis can be found in the three-volume series *Civilization and Capitalism, 15th–18th Century:* vol. 1 *(The Structures of Everyday Life)*; vol. 2 *(The Wheels of Commerce)*, vol. 3 *(The World of Wealth)* (New York: Harper and Row, 1981, 1982, 1984).

60. Cary Carson and Barbara C. Carson, "Things Unspoken: Learning Social History from Artifacts," in *Ordinary People and Everyday Life*, ed. James B. Gardner and George Rollie Adams (Nashville: AASLH, 1983), 200.

61. Alan Ludwig, *Graven Images: New England Stonecarving and Its Symbols* (Middletown, Conn.: Wesleyan University Press, 1966).

62. James Deetz, *In Small Things Forgotten: The Archaeology of Early American Life* (Garden City, N.Y.: Anchor Press / Doubleday, 1977).

63. Ivor Noel Hume, *Martin's Hundred: The Discovery of a Lost Colonial Virginia Settlement* (New York: Dell, 1982).

64. Merritt Roe Smith, *Harper's Ferry Armory and the New Technology: The Challenge of Change* (Ithaca: Cornell University Press, 1977).

65. See Carroll W. Pursell, Jr., "The History of Technology and the Study of Material Culture," chapter 5 of this book.

66. Kenneth L. Ames, *Beyond Necessity: Art in the Folk Tradition* (New York: W. W. Norton, 1977); Ruth Schwartz Cowan, *More Work for Mother: The Ironies of Household Technology From Open Hearth to The Microwave* (New York: Basic Books, 1983); Alan Gowans, *Images of American Living: Four Centuries of Architecture and Furniture As Cultural Expression* (Philadelphia: J. P. Lippincott, 1964); Robert F. Trent, "Style," vol. 3 of *New England Begins: The Seventeenth Century* (Boston: Museum of Fine Arts, 1982).

67. James Deetz, "Scientific Humanism and Humanistic Science: A Plan for Paradigmatic Pluralism in Historical Archaeology," unpublished paper, 1981, p. 10.

68. Hindle, "Technology through the 3-D Time Warp," 464.

69. Controversies among folk material culturists stirred up by Michael Owen Jones and Ken Ames in what some have called "the moldy fig wars" may, for example, occur more often in the future. See Scott T. Swank's Introduction in *Perspectives on American Folk Art*, ed. Ian M. G. Quimby and Scott T. Swank (New York: W. W. Norton, 1980), 1–4, and Michael Owen Jones, "Pink Plastic Flamingos and Moldy Figs: American Folk Art Study in Controversy," unpublished paper presented at the UCLA Symposium, "Folklore, the Arts, the Humanities, and the Social Sciences," 9–10 May 1980.

70. For a listing of such events, see Thomas J. Schlereth, "Contemporary Collecting for Future Recollecting," *Museum Studies Journal* 113 (Spring 1984): 23.

71. Chester H. Liebs, "Remember Our Not-So-Distant Past?" *Historic Preservation* 30 (January–March 1978): 30–35; Bruce A. Lohof, "The Service Station in America: The Evolution of a Vernacular Form," *Industrial Archaeology* (Spring 1974): 1–13; Robert Heide and John Gilman, *Dime-Store Dream Parade, Popular Culture, 1925–1955* (New York: Dutton, 1979); Warren J. Belasco, "The Origins of the Roadside Strip, 1900–1940," paper presented at the annual meeting of the Organization of American Historians, New Orleans, La., 13 April 1979.

72. Fred Kniffen, "On Corner-Timbering," *Pioneer America* 1 (January 1969): 1.

73. See Carroll Smith-Rosenberg, "The New Woman and the New History," *Feminist Studies* 3 (1975): 185–98. Gene Wise has parallel remarks on pluralism in both the American studies movement and the material culture movement; see Wise, "Paradigm Dramas in American Studies," *American Quarterly* 31:3 (Bibliography Issue, 1979): 332–33.

74. Representative museum exhibitions in this category include "Plain and Elegant, Rich and Common, Documented Country Furniture," New Hampshire Historical Society, Concord, N.H., 1978; "American Folk Art from the Traditional to the Naive," Cleveland Museum of Art, 1978; "Bo' Jou, Neejee! Profiles of Canadian Art," Renwick Gallery, Washington, 1979; "At Home: Domestic Life in the Post-Centennial Era, 1876–1920," State Historical Society of Wisconsin, Madison, 1976; and "The Afro-American Decorative Arts," Cleveland Museum of Art, 1978.

75. Fred E. Schroeder, "The Democratic Yard and Garden," in *Outlaw Aesthetics: Arts and the Public Mind* (Bowling Green, Ohio: Popular Press, 1977), 94–122; and Thomas J. Schlereth, "Plants Past: A Historian's Use of Vegetation as Material Culture Evidence," *Environmental Review* 4 (Fall 1980): 20–38.

76. On the continual neglect by historians of material culture evidence, see Charles T. Lyle, "The Historian's Attitude Toward the Artifact" (M.A. thesis,

Hagley Museum–University of Delaware, 1972); on Fleming's call for a new profession of material culturists, see E. M. Fleming, "The University and the Museum: Needs and Opportunities for Cooperation," *Museologist* 111 (June 1969): 10–18.

77. *Organization of American Historians National Meeting 1984 Program*, Los Angeles, Calif., p. 36.

78. On this realignment, see Carl N. Degler, "Remaking American History," *The Journal of American History* 67:1 (June 1980): 7, 16–17, and Cary Carson, "Doing History With Material Culture," in *Material Culture and the Study of American Life*, 41–49.

79. Jane Powell Dwyer, ed., *Studies in Anthropology and Material Culture*, vol. 1 of the Haffenreffer Museum Studies in Anthropology and Material Culture (Providence: Brown University, 1975), 5.

80. Miles Richardson, *The Human Mirror* (Baton Rouge: Louisiana State University Press, 1974); Mark Leone, "The New Mormon Temple in Washington, D.C.," in *Historical Archaeology and the Importance of Material Things*, ed. L. Ferguson (Columbia, S.C.: Society for Historical Archaeology, 1977); Grant McCracken "Clothing As Language: An Object Lesson in the Study of the Expressive Properties of Material Culture," in *Proceedings of the XIth International Congress of Anthropology and Ethnological Sciences* (1984), in press; Michael B. Schiffer and Richard A. Gould, eds., *Modern Material Culture: The Archaeology of Us* (New York: Academic Press, 1981).

81. Deetz, "Material Culture and Archaeology—What's the Difference?" 11, 66.

82. Hindle, "A Retrospective View," 433.

83. Ames, "Meaning in Artifacts," 20.

2

Learning from Looking: Geographic and Other Writing about the American Landscape

Peirce F. Lewis

> [T]here is really no such thing as a dull landscape. . . . Wherever we go, whatever the nature of our work, we adorn the face of the earth with a living design which changes and is eventually replaced by that of a future generation. How can one tire of looking at this variety, or of marveling at the forces within man and nature that brought it about?[1]

FOR AS LONG AS HISTORY records, people have wondered about man-made patterns on the surface of the earth—the patterns which together compose the human landscape. Some of those people have called themselves geographers, trying to describe those patterns in words or maps, trying to explain how those patterns came to be, and trying to unravel their cultural meaning. Those geographers who share a common passion to understand cultural landscapes habitually devour the literature of any academic field that concerns itself—however marginally—with describing and interpreting material culture. And, quite naturally, the literature of academic geography contains an alluring array of writing and maps about material artifacts. This essay reviews a body of recent literature about the American cultural landscape, a literature that has deep intellectual roots, and that has flowered luxuriantly in the last twenty or so years. Given the fact that many of the most imaginative and energetic students of American cultural landscapes are just now entering their most productive years, it is safe to predict that the growth may become yet more fruitful.

FOUR LEADING INTERPRETERS
OF AMERICAN CULTURAL LANDSCAPES

Although the study of American cultural landscape goes back well into the nineteenth century, and although the term "landscape" has been employed in various ways,[2] contemporary students of the subject share a common debt to four major scholars of recent time: Carl O. Sauer, Fred B. Kniffen, John K. Wright, and J. B. Jackson. In describing these men, I do not use the word "major" lightly. Each left the scholarly world a different and richer place than when he found it.

Carl Ortwin Sauer (1889–1975) was invited in 1923 to become head of the geography department at the University of California, Berkeley, and he dominated the intellectual life of the department and its students for over fifty years. At its peak, many believed the Berkeley geography department to be the best in America; it was certainly one of the best in the world.

Sauer was a prolific writer, and John Leighly, his student and later a colleague at Berkeley, has collected a representative selection of Sauer's works in *Land and Life: A Selection from the Writings of Carl Ortwin Sauer*,[3] a volume that contains Sauer's biographic data and a list of his published works. His most famous work about cultural landscape is "The Morphology of Landscape" (1925), an essay that has been relentlessly cited ever since, but a maturer statement is Sauer's presidential address to the Association of American Geographers in 1956, "The Education of a Geographer."[4] "Geography," he urged, "is the science of observation. . . . The geographic bent rests on seeing and thinking about what is in the landscape. . . . By this we do not limit ourselves to what is visually conspicuous, but we do try to register both detail and composition of the scene, finding in it questions, confirmations, items or elements that are new and such as are missing." To Sauer the interpretation of cultural landscape demanded both attention to detail, and a "sense of significant form. . . . [S]ome develop it (and in them I take it to have been latent), and some never get it. There are those who are quickly alerted when something new enters the field of observation or fades out of it. One of the rewards of being in the field with students is in discovering those who are quick and sharp at seeing. And then there are those who never see anything unless it is pointed out to them."[5] Students like that rarely lasted very long at Berkeley.

Sauer was a demanding and memorable teacher, but unlike many charismatic scholars, he never tried to make students into clones of himself.[6] Rather, he sought to inculcate habits of mind—open-mindedness to new questions, resistance to creating neat formulae to explain

the world, flexibility of mind that takes the world on its own terms, intolerance of intellectual shoddiness, and a fairly catholic interest in the tangible world. James Parsons, Sauer's student and later himself chairman of the Berkeley department, summed it up: "Throughout the country there was a distinct group of Berkeley doctorates, and geographers from other schools . . . could spot them a mile away."[7] Given Sauerian training and its fierce insistence on paying attention to the tangible fabric of physical and human landscape, it is no wonder that those Berkeley doctorates came to include some of the most perceptive students of material culture in contemporary America.

A second stream of landscape study stems from the work of Fred B. Kniffen (1900–). Kniffen received a Berkeley doctorate in 1930, then went to Louisiana State University where he ultimately rose to become Boyd Professor in the department of geography and anthropology. When Kniffen went to Baton Rouge, one might have been forgiven for thinking he had been banished to limbo—at that time LSU was a small parochial technical college on the boundary between the piney woods and the swamps of the Mississippi Delta in one of the poorest and most backward states of the American union. In the best Berkeley tradition, Kniffen ignored conventional opinion and set about enthusiastically to learn as much as he could about the countryside that lay beyond the bounds of Baton Rouge, and then to describe and classify the material objects that rural inhabitants of Louisiana had placed upon their land. Like Sauer, Kniffen had strong training in geomorphology, and was ingrained with the "sense of significant form" that comes as second nature to any student of landforms. (To one accustomed to noticing subtleties of changing slope on an alluvial fan or terminal moraine, it comes naturally to pay similar attention to the slope of a barn roof, or the floor plan of a log house). By 1936, Kniffen was ready to publish his first major work on material culture in an essay called simply "Louisiana House Types."[8]

The paper presaged much of Kniffen's later work and that of his students.[9] It dealt with houses, which Kniffen saw as the single most important artifacts in the day-to-day life of a people. And it dealt with the common houses of a folk culture—not houses designed as described for the elite by architects, but those whose form was perpetuated through the oral and visual tradition of unlettered people and thus reflected long-standing and often unspoken tribal ideas. Kniffen's work was based on three premises: that the commonest material objects possess the strongest cultural meaning, that material objects inevitably display meaningful geographical patterns that can best be revealed by mapping them, and that one was unlikely to discover either meaning or

pattern without meticulous field observation of innumerable individual objects. Kniffen rarely found it necessary to seek intellectual stimulation in the landscapes of far-off or exotic places. Like the distinguished British students of cultural landscapes William Hoskins and E. Estyn Evans,[10] Kniffen was content to pay attention to ordinary things close at hand, whose very familiarity perhaps explains why most scholars had overlooked them so long.

Kniffen spent thirty immensely productive years recording what he saw, first in the traditional rural landscapes of Louisiana, eventually throughout the whole eastern United States. It was not until 1965 in an epochal presidential address to the Association of American Geographers that Kniffen ventured to argue that one could trace *streams* of house-types across the eastern United States, and view them as surrogates for grand movements of cultural ideas: in Kniffen's words, folk houses are "the key to diffusion,"[11] or, as I put it later, common houses are "cultural spoor."[12]

It would overstate the case to suggest that Kniffen founded a "school" of academic geography or the study of material culture, but his influence was profound. Henry Glassie, in his brilliant and moving *Passing the Time in Ballymenone: Culture and History of an Ulster Community*, acknowledges Kniffen as "my first and best guide [who] has, more than anyone, molded my intellectual life."[13] The strong seed that Kniffen planted also emerges in the landscape studies of Milton B. Newton, Jr., Kniffen's student who later became chairman of the department that Kniffen helped shape. Like their mentor, both Glassie and Newton work in traditional rural areas and pay scrupulous attention to the myriad details of material landscape, but both have also applied formidable intelligence to the task of deciphering the mental structures which lie beneath tangible patterns in the landscape. Fine samples of these efforts are Glassie's *Folk Housing in Middle Virginia: A Structural Analysis of Historic Artifacts*,[14] and Newton's "Settlement Patterns as Artifacts of Social Structure."[15]

A third major figure in the genealogy of American landscape studies was John Kirkland Wright (1891–1969), who served the American Geographical Society of New York from 1920 to 1956 as its librarian, research editor, and ultimately director. Although Wright spent very little time in formal teaching, his impact was far-reaching, the result of a lively intelligence, a perceptive eye, and a literate style.[16] Wright's ideas concern us in the present context because he urged students of the environment to look beyond landscape as a collection of tangible objects, or even as cultural evidence, and to ask how the human mind contends with landscape's stimuli—to turn from the perceived object to

38

the mind of the perceiver. Wright's seminal statement on the subject is *"Terrae Incognitae:* The Place of Imagination in Geography," his 1947 presidential address to the Association of American Geographers.[17] Since that time, there has been an explosion of interest in "environmental perception," partly stimulated by the writings of Wright's long-time colleague, David Lowenthal, whose "Geography, Experience, and Imagination: Toward a Geographical Epistemology" was an early call for scholars to turn their attention inward to the landscapes of the mind.[18] A sampling of Wright's writings has been assembled under the title *Human Nature in Geography.*[19]

In their concern with the way the mind behaves, some of Wright's intellectual descendants have moved into some fairly arcane realms of philosophy and psychology. That literature may not prove very alluring to a student of material culture who wants to get his hands on the things he is studying. But even if we sidestep the more abstruse excursions into phenomenology, students of material culture must eventually confront the fact that landscape is landscape only if we see it; and our sight is filtered through our mind, which often does odd things to external stimuli. And, of course, what we think about landscape very materially determines what we are likely to do to it. Those who want to pursue such matters will find their tasks considerably eased by consulting Thomas Saarinen and James L. Sell's excellent bibliographic essay, "Environmental Perception."[20] Yi-Fu Tuan's *Topophilia: A Study of Environmental Perception, Attitudes, and Values* is a deliberate and comprehensive statement.[21]

John Brinckerhoff Jackson (1909–) is the fourth towering figure in the evolution of thinking about American cultural landscapes and what they mean. There is no need to recount Jackson's enormously productive and fascinating career; Donald Meinig has written an eloquent appreciation of Jackson and William Hoskins, which does the job superbly.[22] A recent informal sketch by Helaine Kaplan Prentice helps explain why so many contemporary students of American landscape view Jackson not only with respect but also with warm affection.[23]

The basic facts are simple enough. Jackson founded *Landscape* magazine in 1951 and, until he passed the journal into other hands in 1969, it remained his personal testament. From 1967 to 1978 Jackson taught celebrated courses on the history of American cultural landscape, once a year at Berkeley and once at Harvard. During his year as editor and as teacher, Jackson wrote and lectured extensively about cultural landscapes. The writing and lecturing did not abate when he ostensibly retired from academic life. Probably no other writer about ordinary American landscape has been so widely read, heard, discussed, and admired.

Jackson's contribution has taken two forms: what he said himself about cultural landscape, and what he encouraged others to say. Jackson's own writings are spread over almost thirty years; some of the most important take the form of short essays and unsigned "notes and comments" in *Landscape,* sometimes published under the *nom de plume* "Ajax." Although Jackson has written one book, and three collections of essays have been assembled in book form, perhaps the best way to grasp Jackson's thinking is to sit down in a library carrel and read his writings in *Landscape* from Volume 1 through Volume 19.[24]

In various contexts, in clear unpretentious prose, Jackson repeats the same message: look at everything. Give no preference to rural or to urban landscapes, modern or old, elite or ordinary, designed or undesigned. Human landscape is a document wherein cultures unwittingly reveal their present and their past in a kaleidoscopic array of things, patterns, and symbols. Before rushing to judge a landscape ugly or beautiful, one should pause and try to understand how it came to be, and what it says about the people who created it. Look. Listen. Read. Then look again. There is intellectual stimulation everywhere for one who keeps eyes and mind open. More than incidentally, there is beauty too.

In the late 1950s and 1960s, when some prominent geographers were trying to convert their discipline into a rigid abstract science where students of material culture were banished to outer darkness, Jackson's message came as a draught of life-giving air. And Jackson was not alone, for *Landscape* had become a continuing forum for some of the best minds in America. As Wilbur Zelinsky remarked to me recently, "*Landscape* was an asylum for the sane." Helaine Kaplan Prentice has said much the same thing: "He freed us from the guilt of enjoying what we saw."[25]

CONTEMPORARY APPROACHES TO THE STUDY OF AMERICAN LANDSCAPE

The writings of Sauer, Kniffen, Wright, and Jackson all exhibit a strong and vital sense of the past, as does the work of any serious student of cultural landscape. It is not antiquarianism—as some have wrongly believed—but a clear-eyed understanding that all landscapes were made in the past, often under conditions that are incomprehensible in contemporary terms.

Much of the recent literature about cultural landscape, in fact, can be seen as a response to this historic imperative. If we list the tangible things

and the intangible forces that go to create any cultural landscape, a logical historical sequence reveals itself. Consider the ingredients:

There is, to begin with:

1. Physical environment, the raw material. All cultures must work with it, and it is rarely the same in two places. People bring to that environment . . .

2. Knowledge and perception of what the environment is like. In all cultures, knowledge is flawed and perceptions warped. These defects vary from culture to culture. To that defective vision, cultures bring . . .

3. Ambitions about how environments should be ordered and improved. Some ambitions are economic, concerned with improving man's material lot. Some are religious or artistic, aimed to stabilize or uplift the moral or aesthetic condition of society. But all ambitions are curbed by . . .

4. Cultural strictures. These can be expressed as canons of good taste or proper behavior, as religious doctrine, or as political codes—but they combine to describe the limits (sometimes geographical) within which a culture permits itself to operate. Only within the context of these ambitions and strictures, can we understand the impact of . . .

5. Tools that humans use to shape their tangible landscape. Particular tools leave particular marks, but the effects of any tool depends on the level of technological sophistication, and also on a society's ability to pay for it. The final product is . . .

6. The cultural landscape, which can be viewed as:
 a. A collection of individual artifacts—houses, fences, roads, skyscrapers, and the like—or as . . .
 b. Types of landscapes—urban, rural, industrial, recreational, and the like—or as . . .
 c. Landscapes taken as a whole.

Such a list helps to identify some major strengths and some considerable gaps in the recent literature about cultural landscapes.

1. Physical environment. Most disappointing, perhaps, is the failure by most recent students of American human landscape to take adequate account of physical environment. In many of America's main centers of geographic study, physical geography receives lamentably small attention—and regional physical geography almost none at all. The literature reflects that fact. The best book about the landforms of the United States, William Thornbury's *Regional Geomorphology of the United States*, has been allowed to go out of print by a negligent publisher.[27] Fortunately, the best and most dramatic map of American topography, Erwin Raisz's superb *Map of the Landforms of the United States,* is still very much in print.[28] The U.S. Department of Commerce has been left with

the task of publishing the best summary of American regional climatology, the *Climatic Atlas of the United States* (1968). H. A. Gleason and Arthur Cronquist's final section of *The Natural Geography of Plants* contains a good regional summary of North America's natural vegetation.[29]

Things may be improving. In 1979–80, Michael Conzen edited a fine, sprawling, twelve-issue series of essays in *The Geographical Magazine* (London), written by American and Canadian geographers, entitled "Fashioning the American Landscape." It is a tribute to Conzen's good sense that he asked the geomorphologist G. H. Dury to write the first essay in the series, a broad and vivid canvas of America's physcial environment.[30] A similar sketch appears in the *Encyclopaedia Britannica* and contains a brief annotated bibliography on American natural landscapes.[31]

2. Perception of landscape. As we have seen, the literature of environmental perception is enormous, especially since the work of John K. Wright. Not all of it is germane to the study of cultural landscape. The basic importance of the idea, however, is set forth in Donald Meinig's essay, "The Beholding Eye: Ten Versions of the Same Scene"—there are wildly different ways to see things, depending on ideas that viewers bring to the scene, and what people do to landscape depends on how they think about it.[32] The same idea is elaborated by several of John K. Wright's intellectual offspring in Lowenthal's *Festschrift* collection for Wright, *Geographies of the Mind* (cited in note 16). Most of the papers contain extensive and useful biographies.

3. Cultural ambitions as shapers of human landscape. This subject has lately begun to receive the attention it deserves, even to the point of infiltrating standard college textbooks—those last bastions against fresh ideas. For a long time, many texts in human geography tended to talk as if human landscape were made by the invisible hand of Economic Man, who single-mindedly sought monetary gain as he arranged cities, farms, and people across the face of the land. But there have recently appeared some happy antidotes to that arid view.[33] One of the most comprehensive statements is Wilbur Zelinsky's *The Cultural Geography of the United States*, a felicitous book that subversively looks unlike a textbook and contains a sweeping discussion of American attitudes toward themselves and their land, as well as a good annotated bibliography.[34] Another landmark is David Lowenthal's seminal essay "The American Scene," which holds up America's material landscape as a mirror of deep-seated cultural values.[35] Roderick Nash's *Wilderness and the American Mind* is of the same genre, treating American's longstanding moral, aesthetic, and economic ambivalence about how they should comport

themselves in the presence of wild landscapes; Nash's book is a classic study of environmental perception.[36] A thoughtful review of recent changes in American cultural landscape and what they reveal about our changing culture is Robert Riley's "Speculations on the New American Landscape."[37]

4. Aesthetic and moral strictures. All cultures, of course, approach their environment with a set of aesthetic values called "taste," an irrational (and therefore strong) collection of opinions that determine what they do to make their landscapes "look nice." Tastes in landscape vary systematically from place to place and from people to people, and that is one reason why travel is interesting. The properties and persistence of American landscape tastes has been treated perceptively by David Lowenthal and Yi-Fu Tuan.[38] Landscape tastes also change systematically through time, and May Thielgaard Watts shows us how those changing tastes can alter the morphology of a single domestic garden over a century of American history.[39] And, despite insistent claims that America is a classless society, cultural landscape proves it is not so, as Russell Lynes documents in his classic essay "Upperbrow, Middlebrow, and Lowbrow,"[40] James Duncan makes a similar point in his "Landscape Taste as a Symbol of Group Identity [in] a Westchester County Village," and Melvin Hecht has drawn attention to a change from green lawns to "desert lawns" in residential areas of Tucson, Arizona, a change which may signal important shifts in cultural attitudes toward environment.[41]

Many scholars have viewed basic geographic patterns of cultural landscape as the outcome of deep-seated religious values. Both J. B. Jackson and Yi-Fu Tuan have written perceptively on the subject, and both acknowledge their debt to Mircea Eliade's discussion of sacred and profane space.[42] Despite ample evidence to the contrary, many Americans still view their nation as basically secular, and religious values are often concealed under the cloak of patriotism, as Zelinsky demonstrates in his study of nationalism in the American landscape, and Reuben Rainey in a study of the preservation of historic battlefields.[43] Most students of America's religious landscapes, however, have focused their attention on places where the impact of religion is immediate and obvious, and that occurs mainly in unusual places: the Mormon oases of Utah, the archaic landscapes of the Pennsylvania Amish, and the icon-laden yards of the Cuban emigre community of Miami.[44] There is a modest literature about the landscape of cemeteries, of which Terry Jordan's *Texas Graveyards, A Cultural Legacy* is overwhelmingly the most important.[45]

There remains plenty of work to be done on the basic tissue of America's religious landscape, and the ambitious student might begin by examining the highly systematic patterns in the design of the nation's vernacular churches. We know almost nothing about them, despite their prominence in every American town, their powerful symbolism, and the strong family resemblances between them, which suggest cultural linkages that I have never seen described anywhere.[46] (Why, to take but one of innumerable examples, do most Methodist, Baptist, and Presbyterian churches, built by the white elite in Southern towns between 1900 and 1930, all look as if they came from the same architect's drawing board? There must be thousands of them, and it is impossible to believe that the resemblance is coincidental.)[47]

Just as patriotism is a kind of secular religion in America, artifacts and landscapes that are thought of as "historic" commonly are viewed with a semireligious reverence, and their preservation is encouraged with evangelical zeal. Until recently, historic preservation in the United States has popularly been viewed as the private preserve of an effete elite. Within the last few years, preservation has become a growth industry, and preservationists have begun manipulating landscape on a large scale, with tangible results that differ drastically, depending on what motivates the act of preservation.[48] In 1966, David Lowenthal described what he called "The American Way of History," a national penchant to treat history as a disembodied artifact, and he has elaborated on the idea in "Past Time, Present Place."[49] And, while scholars may deplore Main Street in Disneyland as expensive historic hokum, Richard Francaviglia has shown that many American small towns are consciously and tangibly remodeling their genuine historic main streets into a historic dream conjured up by Walt Disney and Norman Rockwell.[50] Datel and Dingemans' "Historic Preservation and Urban Change" is a nice summary of the larger subject, and Larry Ford has written a useful bibliographic survey, "Urban Preservation and the Geography of the City in the USA." John Jakle's is the definitive bibliography on the subject, with extensive reference to geographic literature on material culture.[51]

Like religion, political ideas and political codes profoundly affect the morphology of cultural landscape, as Derwent Whittlesey remarked in his seminal essay of 1935, "The Impress of Effective Central Authority upon the Landscape."[52] Since politics is often nothing more (nor less) than the codification of deeply held cultural beliefs, human landscapes often look very different on opposite sides of international borders. One of J. B. Jackson's early essays surveys both sides of the U.S.–Mexican border and describes the cultural landscape of northern Mexico in

"Chihuahua, as We Might Have Been."[53] More recently, Victor Konrad assembled a symposium, "The Transfer of Culture on the Land between Canada and the United States," where a group of geographers discussed the effect of international borders on the morphology of barns, fences, and various kinds of architecture.[54] There is also a small but useful literature concerning the landscape of capitols, courthouses, and courthouse squares,[55] but I know of no definitive study of that ubiquitous American phenomenon, the state capital city.

Just as the subdivision of space is a religious matter, it is inevitably political also, and most cultures have strong and unyielding views about how land should be surveyed and divided. Hildegard Binder Johnson's *Order Upon the Land* is the most complete discussion of the origin, consequences, and potent symbolism of the U.S. rectangular survey system.[56] Sam B. Hilliard's "An Introduction to Land Survey Systems in the Southeast" describes the various ways that land has been subdivided in Georgia, a state which contains somewhere within its borders almost every kind of survey system found in the United States.[57] Within survey systems, of course, land is further subdivided according to individual decisions. John Fraser Hart has analyzed some of those patterns in "Field Patterns in Indiana," and Paul Groth discusses the urban counterpart of the same matter in "Street Grids as Frameworks for Urban Variety."[58]

Political landscapes are often secret landscapes, at least to untutored bystanders. Robert Caro's monumental biography of Robert Moses reveals that something like one-sixth of the total area of Greater New York was literally shaped by the power of the Port of New York Authority under Moses' direct command.[59] While we are all familiar with the wedding-cake skyscrapers of New York as obvious responses to the city's zoning law, even a nodding acquaintance with tax laws compels one to believe that modern American landscape—urban and rural alike—is quite visibly molded by invisible regulations in ways to which most American scholars are oblivious. John Fraser Hart's description of how federal price-support programs affect rural landscape is a useful remedy to our ignorance.[60] Broad discussions of environmental law and its very tangible effect on landscape can be found in both Walter Prescott Webb's *The Great Plains* and Roderick Nash's *Wilderness and the American Mind.*[61]

If politics and religion mold landscape, so does the innate human urge for physical diversion. Despite that, the growing geographic literature of sport and recreation gives scant attention to the tangible landscape which sports produce.[62] We need to know much more about the way Americans have subdivided and allocated geographic space for

recreation and games, and what those geographic patterns—as they have changed through time—have to tell us about basic rituals of American culture.

Travel and tourism constitute an important and expensive form of American recreation, and there is a large literature on the subject. But a review of Alvar Carlson's recent bibliography on the geography of tourism reveals the overwhelming attention to the subject of tourist flows, and economic impacts, rather than what a multibillion-dollar industry has done to the appearance and morphology of American landscapes. Refreshing exceptions, however, are Warren James Belasco's *Americans on the Road* and Charles Funnell's *By the Beautiful Sea: The Rise and High Times of That Great American Resort, Atlantic City.*[63]

One need not be a close student of landscape to know that much human behavior operates outside the law. Nevertheless, it is hardly surprising that scholars have generally avoided the subject of illegal or illicit landscapes; if one can believe the popular press, investigating the landscape of the Mafia would be both difficult and risky. There is, however, a small literature in what might be called the "landscape of unaccepted behavior": Loyal Durand's "Mountain Moonshining in East Tennessee," Denis Wood's brilliant discussion of "shadowed spaces" where anonymous people go to perform unmentionable acts, David Ley and Roman Cybriwsky's "Urban Graffiti as Territorial Markers," and Barbara Weightman's "Gay Bars as Private Places."[64]

5. Technology and landscape. Nobody has ever explained the complex interplay between technology and material environment better than Walter Prescott Webb in his discussion of six-shooters and barbed-wire fences on the Great Plains—tools that drastically altered the landscape and culture of the Plains but were also changed *by* them in a circular, symbiotic relationship. John Fraser Hart has consistently shown a similar keen appreciation for the way that tools shape agricultural landscapes, as does Tom McKnight in his treatment of center-pivot irrigation systems on the Great Plains—the things that make the Plains look from the air like checker-boards with checkers on them. And, shades of Eli Whitney and the cotton gin, Hart and Ennis Chestang have shown how a simple device like a new kind of tobacco-dryer can produce a "Rural Revolution in East Carolina," not only in the look of the land, but in the functioning of a whole culture.[65] By and large, students of folk and rural cultures like Hart and Kniffen and Glassie have shown greater sensitivity to the impact of technology on landscape than have students of the urban scene. Some of the exceptions, however, are brilliant: David Plowden's definitive and beautiful book about American bridges, David McCullough's sweeping history of

the building of the Brooklyn Bridge, and John Stilgoe's remarkable book about railroads and how they turned the American landscape inside out.[66]

What we still lack, however, is systematic accessible information about the history of the tools and building materials that literally *made* the ordinary American landscape. I do not mean that we need another work like Singer's massive seven-volume *History of Technology*, that great compendium of inventions.[67] Rather, we need an encyclopedia that not only describes when things were invented and how they work but also when they became cheap enough and in sufficient demand for widespread diffusion, adoption, and use, and what they did to ordinary American landscapes. For example, the principles of McCormick's reaper were known long before that portentous machine changed the face of the Midwest, and Mr. Otis's invention preceded by twenty years the widespread adoption of high-speed, safe elevators in burgeoning skyscrapers. There are innumerable other bits of technological information about various kinds of ordinary bricks and building blocks and fire hydrants and municipal water towers that badly need to be assembled under one cover for the benefit of those who want to make sense of cultural landscapes.[68]

6a. Cultural landscape as collection of artifacts. Many scholars have chosen to see the cultural landscape as a collection of isolated items, extracted from their geographic context. Although the list of items in any landscape is almost endless, of course, the list of things studied is not. Overwhelmingly, students of material culture in America have preferred to study rural things over urban things, and domestic things over commercial or industrial things—a bias which resembles that of Sauer and Kniffen. The literature is much too large to enumerate here, but several major bibliographic sources reveal the same bias: Douglas McManis's dated but still useful *Historical Geography of the United States: A Bibliography*, the index and bibliography of Henry Glassie's *Pattern in the Material Folk Culture of the Eastern United States*, Gary Dunbar's "Illustrations of the American Earth: A Bibliographic Essay on the Cultural Geography of the United States," Thomas Schlereth's "History Outside the History Museum: The Past on the American Landscape," and John Jakle's *Past Landscapes: A Bibliography for Historic Preservation* (revised ed.). Since the publication of Kniffen's seminal work, the literature on vernacular houses is so considerable that Jakle and others have assembled a large bibliography on that subject alone.[69]

This is not to say that traditional rural things are unimportant, but only to note the lack of attention to the ordinary material objects that constitute most commercial and industrial landscapes. For every essay

on skyscrapers[70] there are dozens about barns and rural cemeteries, and some subjects (like the design of warehouses and factory buildings) are so badly neglected that they represent a kind of *terra incognita* in the study of cultural landscape.

6b. Types of landscapes. The balance is better in the literature about urban and rural landscapes—in contrast with writing about the items that constitute them. As might be expected, there is a considerable volume of first-rate writing about rural landscapes and how they came to be. It is impossible to cite them all, but landmarks are Glenn Trewartha's work on American farmsteads, Terry Jordan's work on cultural boundaries in rural Texas, Merle Prunty and Charles Aiken's on the demise of the southern cotton belt and Milton Newton and Linda Pulliam's "Log Houses as Public Occasions: A Historical Theory." Overwhelmingly the best comprehensive work on America's rural landscape is *The Look of the Land* by John Fraser Hart, the acknowledged dean of American rural landscape study.[71]

There exists a considerable literature that treats the appearance of American urban landscapes—although only lately by people who call themselves geographers. As Michael Conzen has noted in a recent thoughtful review, European geographers never completely abandoned the study of urban morphology, and Americans may now be seeing a resurgence of interest in the subject, perhaps a delayed reaction to the textbook view of cities as exsanguine collections of ahistoric statistics and dollar signs.[72] A major landmark is James Vance's sprawling *This Scene of Man: The Role and Structure of the City in the Geography of Western Civilization*, a book that places heavy emphasis on "urban morphogenesis," that is, the making of urban landscapes. John Jakle's recent book *The American Small Town* is a useful summary, and it contains a large bibliography.[73]

Despite its age, Tunnard and Reed's *American Skyline* remains one of the best existing histories of American urban landscapes, what they look like and how they evolved. In my opinion, the most imaginative treatment of America's contemporary urban morphology is Grady Clay's sparkling *Close-up: How to Read the American City*.[74] More than incidentally, Clay's book is the single best work I know for introducing a neophyte to the techniques of reading American landscapes. Recently, as American cities continue to change under the impact of automobile technology, geographers and others have turned their attention to the explosion of urban tissue into heretofore suburban and rural areas— what Thomas Baerwald calls "The Emergence of a New Downtown" around Minnesota freeway interchanges, and what I have termed "the galactic city."[75]

A serious deficiency in the urban literature is the absence of intelligent guidebooks to America's major cities, although there are books on several American cities—Baltimore, Chicago, Los Angeles, New Orleans, Philadelphia, and San Diego—that pay considerable attention to urban landscapes.[76] The ordinary visitor to the ordinary city almost anywhere in Britain or in western Europe can buy a guidebook that tells him how the city is laid out functionally and why its landscape looks the way it does. But this is not true in the United States. Americans remain embarrassingly deprived in their geographic education.

6c. Landscapes taken as a whole. But the greatest glories of the geographic literature remain those that treat landscapes as a whole. As John Fraser Hart has correctly said, in his recent presidential address to the Association of American Geographers, regional writing is the highest form of the geographer's art.[77] Writing about total landscapes, however, may be even more demanding.[78] It is not surprising that scholars rarely try to treat synthetically the full range of tangible things and intangible ideas that weave together to produce any given human landscape. But when it happens, the results can be stunning. I think of Walter Prescott Webb's *The Great Plains,* perhaps the finest analysis of a complete landscape by any American author. There is David McCullough's *The Great Bridge,* not merely a history of the building of the Brooklyn Bridge but a sweeping account of how people, things, and ideas came together to produce America's most potent symbolic monument. J. B. Jackson's *American Space: The Centennial Years, 1865–1876,* possesses the same kind of depth and breadth, as do some of John McPhee's writings,[79] and several vivid regional vignettes by Bret Wallach (Wallach needs somebody to anthologize him).[80]

Some of the best writing about American cultural landscapes comes from the pen of travelers—people who look at landscape with the eyes of a naïve child, but think about what they see with the brains and experience of an adult. Some of the most eloquent writing about cultural landscape comes from the itineraries and journals of such folk. Peter Kalm's *Travels in North America,* Dickens's *American Notes,* Charles Lyell's journals, and Mrs. Trollope's acerbic *Domestic Manners of the Americans* spring immediately to mind. My own nomination to that pantheon is George Stewart, whose masterpiece, *U.S. 40,* is accurately subtitled *A Cross-Section of the United States of America.*[81] Stewart was a professor of English at Berkeley, a friend of Carl Sauer's, who got into his car in the early 1950s and drove from Atlantic City to San Francisco along the road that was then America's main transcontinental highway. From time to time, he stopped and took pictures of what he saw, and

then he reflected and wrote about what the pictures showed. The result—flat grey photographs, flat unexcited prose—combine to create one of the clearest and most perceptive portraits of the United States that I have ever seen or read.

We need more writing like that—literate description and clear thinking about the American landscape. Occasionally we find it in fugitive field-trip guides prepared by and for professional geographers.[82] More often we find it in writings by folklorists and cultural historians and landscape architects and by scholars and laymen of any calling, who share a love of the American land and what it has to tell us about ourselves and our forebears. We find it more and more these days, and I suspect that it will become commoner yet as time goes by.

Not long ago, I obtained a copy of a new atlas, edited by three cultural geographers, John Rooney, Wilbur Zelinsky, and Dean Louder. *This Remarkable Continent: An Atlas of United States and Canadian Societies and Culture,*[83] is itself a remarkable book, an eclectic collection of maps and text, depicting and analyzing the location and spread of the innumerable material objects and nonmaterial ideas and institutions that contribute to creating the American cultural landscape. (The directory of map sources constitutes a fine bibliography in itself.) It comforts me to note that most of the 387 maps were extracted from scholarly writing of the last twenty years. If the next twenty years brings an equivalent volume of scholarly achievement, there is no need for concern about the future intellectual health of American cultural geography—or any of its fellow disciplines.

NOTES

I am indebted to Brian Banks of the Pennsylvania State University geography department for his bibliographic assistance. Wilbur Zelinsky was also a major source of aid and comfort, as were Michael Conzen, Larry Ford, Paul Groth, Sam Bowers Hilliard, John Jakle, and Donald Meinig.

1. J. B. Jackson, "The Need for Being Versed in Country Things," *Landscape* 1:1 (1951): 4–5.
2. To savor the variety of definitions, see Marvin Mikesell, "Landscape," *International Encyclopedia of the Social Sciences* 8 (New York: Crowell-Collier and Macmillan, 1958), 575–580. See also Mark D. Billinge, "Cultural Landscape," *The Dictionary of Human Geography,* ed. R. J. Johnston (Oxford: Basil Blackwell, 1981), 67–68. For practical purposes, Christopher Salter's definition is as good as any: landscape is "that segment of earth space which lies between the viewer's eye and his or her horizon." See also "Signatures and Settings: One Approach to Landscape in Literature," in *Dimensions of Human Geography: Essays on Some*

Familiar and Neglected Themes, ed. Karl Butzer, Research Paper 186 (Chicago: University of Chicago Department of Geography, 1978), 71. J. B. Jackson simply approves the dictionary definition: "A portion of the earth's surface that can be comprehended at a glance." *Discovering the Vernacular Landscape* (New Haven: Yale University Press, 1984), 8.

3. Berkeley, University of California Press, 1963.

4. Both republished in Leighly, ed., *Land and Life,* 315–50 ("The Morphology of Landscape"), 389–404 ("The Education of a Geographer").

5. "The Education of a Geographer," 400, 392, 393.

6. An excellent appreciation of Sauer as teacher is his obituary by Dan Stanislawski, "Carl Ortwin Sauer, 1889–1975," *Journal of Geography* 74 (1975): 548–54.

7. James J. Parsons, "The Later Sauer Years," *Annals, Association of American Geographers* (hereafter cited as *AAAG*) 69 (1979): 15.

8. *AAAG* 26 (1936): 173–93. Kniffen's classic paper has been reprinted in Philip Wagner and Marvin Mikesell's *Readings in Cultural Geography* (Chicago: University of Chicago Press, 1962), 157–69.

9. H. J. Walker and W. G. Haag have assembled a *festschrift* for Kniffen: "Man and Cultural Heritage: Papers in Honor of Fred B. Kniffen," *Geoscience and Man,* vol. 5 (Baton Rouge: School of Geoscience, Louisiana State University, 1974), which contains a summary of Kniffen's geographic philosophy (pp. 1–6) and a listing of Kniffen's *ouvre.*

10. Both Hoskins and Evans are wonderfully prolific. Samples of their best work are Hoskins's *The Making of the English Landscape* (London: Hodder and Stoughton, 1955) and Evans's *The Personality of Ireland: Habitat, Heritage and History* (Cambridge: Cambridge University Press, 1973). Most reviews of Sauer's thinking portray him as a monumental figure at the apogee of his intellectual powers. Like any complex figure, however, Sauer's ideas evolved over a long and fruitful life, and many of those ideas contradicted each other. An excellent sketch of Sauer's intellectual evolution is Michael Williams's " 'The Apple of My Eye': Carl Sauer and Historical Geography," *Journal of Historical Geography* 9 (1983): 1–28.

11. Fred Kniffen, "Folk Housing: Key to Diffusion," *AAAG* 55 (1965): 549–77. See also Henry Glassie's map, "The Movement of Ideas," in his *Pattern in the Material Folk Culture of the Eastern United States* (Philadelphia: University of Pennsylvania Press, 1968), 38.

12. Peirce Lewis, "Common Houses, Cultural Spoor," *Landscape* 19:2 (1975): 1–22.

13. Philadelphia: University of Pennsylvania Press, 1982, xvi.

14. Knoxville: University of Tennessee Press, 1975.

15. Chapter 14 in Miles Richardson, ed., *The Human Mirror: Material and Spatial Images of Man* (Baton Rouge: Louisiana State University Press, 1974). Thomas C. Hubka seeks similar structures in "Maine's Connected Farm Buildings" (Parts 1 and 2), *Maine Historical Society Quarterly* 18:3/4 (1978, 1979): 139–70, 217–45.

16. See Wright's obituary by David Lowenthal, "John Kirkland Wright: 1891–1969," *The Geographical Review* (hereafter *GR*) 59 (1969): 598–604. Wright's *ouvre* is listed in his *Festschrift, Geographies of the Mind: Essays in Historical Geosophy in Honor of John Kirkland Wright,* ed. D. Lowenthal and Martyn J. Bowden (New York: Oxford University Press, 1976).

17. *AAAG* 37 (1947): 1–15.

18. *AAAG* 51 (1961): 241–60.

19. Cambridge: Harvard University Press, 1966.

20. *Progress in Human Geography* 4 (1980): 525–48.

21. Englewood Cliffs, N.J.: Prentice-Hall, 1974.

22. "Reading the Landscape: An Appreciation of W. G. Hoskins and J. B. Jackson," in Meinig, ed., *Interpretation of Ordinary Landscapes*, 195–244.

23. "John Brinckerhoff Jackson," *Landscape Architecture* 71 (1981): 740–45.

24. The book is *American Space: The Centennial Years 1865–1876* (New York: W. W. Norton, 1972); the collections are *Landscapes: Selected Writings of J. B. Jackson*, ed. Ervin H. Zube, and J. B. Jackson's *The Necessity for Ruins, and Other Topics* (Amherst: University of Massachusetts Press, 1970 and 1980); and J. B. Jackson, *Discovering the Vernacular Landscape* (New Haven: Yale University Press, 1984).

25. Meinig, "Reading the Landscape," *Interpretation of Ordinary Landscapes*, 212–32.

26. This historic theme is the basis of John Stilgoe's *Common Landscape of America: 1580 to 1845* (New Haven: Yale University Press, 1982), the first volume in a detailed scholarly history of American vernacular landscape, the first such book to be published in this country. Stilgoe was Jackson's graduate advisee at Harvard, and subsequently he took over the teaching of Jackson's "landscape course" when he retired. In content and in tone, the book bears the strong imprint of Stilgoe's mentor.

27. New York: John Wiley, 1967.

28. Although Raisz's map is one of the best maps of the United States ever made, it is sometimes hard to find. It is published by the author at 130 Charles Street, Boston, MA 02114.

29. New York: Columbia University Press, 1964, chapter 22, 275–414.

30. The Conzen series appeared *seriatim* in the twelve numbers of *The Geographical Magazine* 52 (1979–80), as follows: (1) G. H. Dury's "Vast Continent with a Simple Layout," 37–46; (2) Karl W. Butzer's "This Is Indian Country," 140–48; (3) Richard L. Nostrand's "Spanish Roots in the Borderlands," 208–9; (4) Cole Harris's "Brief Interlude with New France," 274–80; (5) Peirce Lewis's "When America Was English," 342–48; (6) Sam Hilliard's "Plantations Created the South," 409–16; (7) Michael Conzen's "The Woodland Clearances," 483–91; (8) James E. Vance's "Utopia on the American Earth," 555–60; (9) David Meyer's "Industrious Entrepreneurs Make Their Mark," 647–54; (10) Martyn Bowden's "Creating Cowboy Country," 693–701; (11) Edward K. Muller's "Distinctive Downtown," 747–55; and (12) Wilbur Zelinsky's "Lasting Impact of the Prestigious Gentry," 817–24.

31. Peirce Lewis, "The United States: The Natural Landscape," in *Encyclopaedia Britannica*, 15th ed., vol. 18 (Chicago: Encyclopaedia Britannica, 1974): 905–18, 945.

32. In Meinig, ed., *Interpretation of Ordinary Landscapes*, 33–48. For an intelligent discussion of perception and pictorial depiction of landscape, together with a fine bibliography, see Hildegard Binder Johnson and Gerald R. Pitzl, "Viewing and Perceiving the Rural Scene: Visualization in Human Geography," *Progress in Human Geography* 5 (1981): 211–33.

33. For that rare thing, a literate, well-documented, thoughtful textbook, see Terry G. Jordan and Lester Rowntree's *The Human Mosaic: A Thematic*

Introduction to Cultural Geography (New York: Harper and Row, 1982), now in its third highly successful·edition.

34. Englewood Cliffs, N.J.: Prentice-Hall, 1973.

35. *GR* 58 (1968), 61–88.

36. New Haven: Yale University Press, 1973.

37. *Landscape* 24:3 (1980): 1–9.

38. For example, two essays by Lowenthal, "Not Every Prospect Pleases," *Landscape* 12:2 (1962): 19–26, and "The Offended Eye: Toward an Excrescential Geography," in Peirce Lewis, ed., *Visual Blight in America*, Association of American Geographers Resource Paper No. 23 (Washington: Association of American Geographers, 1973), 29–44. Also Yi-Fu Tuan, "Visual Blight Exercises in Interpretation," 23–28 in the same volume.

39. "The Stylish House, or Fashions as an Ecological Factor," chapter 13 in *Reading the Landscape of America* (New York: Macmillan, 1975), 320–46. See also Daniel D. Arreola, "Fences as Landscape Taste: Tucson's Barrios," *Journal of Cultural Geography* 2:1 (1981): 96–105.

40. Chapter 17 in *The Tastemakers* (New York: Grossett and Dunlap, 1949), 310–33.

41. *GR* 63 (1973): 334–55; *Landscape* 19:3 (1975): 3–10.

42. See Jackson, "The Sacred Grove in America," in *Necessity for Ruins*, 77–88; Tuan, "Sacred Space: Explorations of an Idea," in Butzer, *Dimensions of Human Geography*, 84–99; and Eliade, *The Sacred and the Profane: The Nature of Religion: The Significance of Religious Myth, Symbolism, and Ritual within Life and Culture*, trans. Willard R. Trask (New York: Harcourt Brace Jovanovich, 1959).

43. Zelinsky, "O Say, Can You See: Nationalistic Emblems in the American Landscape," *WP* 19:4 (1985), in press. Rainey, "The Memory of War: Reflections on Battlefield Preservation," *The Year Book of Landscape Architecture*, vol. 1 (New York: Van Nostrand Reinhold, 1983).

44. Richard Francaviglia, *The Mormon Landscape* (New York: AMS Press, 1978), and "The Passing Mormon Village," *Landscape* 22:2 (1978): 40–47; John A. Hostetler, *Amish Society*, 3rd ed. (Baltimore: Johns Hopkins Press, 1980); Joseph Glass, "Be Ye Separate, Saith the Lord," in *The Philadelphia Region: Selected Essays and Field Trip Itineraries*, ed. Roman A. Cybriwsky (Washington: Association of American Geographers, 1979), 51–73; James R. Curtis, "Miami's Little Havana: Yard Shrines, Cult Religion and Landscape," *Journal of Cultural Geography* 1 (1980): 1–15.

45. See the bibliography in Wilbur Zelinsky's "Unearthly Delights: Cemetery Names and the Map of the Changing American Afterworld," in Lowenthal and Bowden, *Geographies of the Mind*, 171–95. Jordan's *Texas Graveyards* was published by the University of Texas Press (Austin: 1982).

46. Terry Jordan comes closer than anyone I know. "Forest Folk, Prairie Folk: Rural Religious Cultures in North Texas," *Southwestern Historical Quarterly* 80 (1976): 135–62.

47. For illustrations of twelve distinctive American churches, see Peter Spier's brilliant panel of watercolor miniatures in *The Star Spangled Banner* (Garden City, N.Y.: Doubleday, 1973).

48. Peirce Lewis, "The Future of the Past: Our Clouded Vision of Historic Preservation," *Pioneer America* 7:2 (1975): 1–20.

49. *Columbia University Forum*, 9:3 (1966): 27–32, and *GR* 65 (1975): 1–36.

50. "Main Street U.S.A.: A Comparison/Contrast of Streetscapes in Disneyland and Walt Disney World," *Journal of Popular Culture* 15:1 (1981): 141–56.

51. Robin E. Datel and Dennis J. Dingemans, "Historic Preservation and Urban Change," *Urban Geography* 1:3 (1980): 229–53; Ford in *Progress in Human Geography* 3:2 (1979): 211–38; Jakle, *Past Landscapes: A Bibliography for Historic Preservation*, rev. ed., Architecture Series A-314 (Monticello, Ill.: Vance Bibliographies, August 1980).

52. *AAAG* 25 (1935): 85–87.

53. *Landscape* 1:1 (1951): 16–24.

54. *American Review of Canadian Studies* 12:2 (1982): 1–86.

55. Henry-Russell Hitchcock and William Seale, *Temples of Democracy: The State Capitols of the U.S.A.* (New York: Harcourt Brace Jovanovich, 1976); Richard Pare, ed., *Court House: A Photographic Document* (New York: Horizon Press, 1978); and Edward T. Price, "The Central Courthouse Square in the American County Seat," *GR* 58 (1968): 29–60.

56. New York: Oxford University Press, 1976.

57. In "Geographic Perspectives on Southern Development," *West Georgia College Studies in the Social Sciences*, vol. 12 (Carrollton, Ga.: West Georgia College, 1973): 1–15; see also "Headright Grants and Surveying in Northeastern Georgia," *GR* 72 (1982): 416–29.

58. Hart, *GR* 58 (1968): 450–71; Groth, *Harvard Architectural Review* 2 (1981): 68–75.

59. *The Power Broker: Robert Moses and the Fall of New York* (New York: Knopf, 1974).

60. *The Look of the Land* (Englewood Cliffs, N.J.: Prentice-Hall, 1973), 110–13.

61. Webb (Boston: Ginn and Co., 1931), chapter 9, "New Laws for Land and Water." Nash, *Wilderness and the American Mind, passim*.

62. See, e.g., John F. Rooney, Jr., *A Geography of American Sport* (Reading, Mass.: Addison-Wesley, 1974).

63. Carlson, "A Bibliography of Geographic Research on Tourism," *Journal of Cultural Geography* 1 (1980): 161–84. Belasco (Cambridge: MIT Press, 1979); Funnell (New York: Knopf, 1975).

64. Durand, in *GR* 46 (1956): 168–81; Wood, "In Defense of Indefensible Space," in *Urban Crime and Environmental Criminology*, ed. Paul and Patricia Brantingham (Beverly Hills, Calif.: Sage Publications, 1981); Ley and Cybriwsky, in *AAAG* 64 (1974): 491–505; and Weightman, *Landscape* 24:1 (1980): 9–16. See also Richard Symanski's rather self-conscious "Prostitution in Nevada," *AAAG* 64 (1974): 357–77.

65. Webb, *The Great Plains*; Hart, *Look of the Land*; McKnight, "Great Circles on the Great Plains: The Changing Geometry of American Agriculture," *Erdkunde* 33 (1979): 71; Hart and Chestang in *GR* 68 (1978): 435–58.

66. Plowden, *Bridges, The Spans of North America* (New York: Viking, 1974); McCullough, *The Great Bridge: The Epic Story of the Building of the Brooklyn Bridge* (New York: Simon and Schuster, 1972); Stilgoe, *Metropolitan Corridor Railroads and the American Scene* (New Haven: Yale University Press, 1983).

67. Charles J. Singer et al., eds., *A History of Technology*, vols. 1–5 ("From Early Time . . . c. 1900") (Oxford: Clarendon Press, 1954–58), and Trevor I. Williams, ed., vols. 6 and 7 ("The Twentieth Century . . .") (1978).

68. The history of technology and the interaction between technology and culture is the subject of a large literature and an important journal, *Technology and Culture: The International Quarterly of the Society for the History of Technology* (Chicago: University of Chicago Press). For all its riches, that literature pays scant attention to the way technology shapes vernacular American landscapes.

69. McManis (Ypsilanti: Eastern Michigan University, 1965); Glassie (Philadelphia: University of Pennsylvania Press, 1967); Dunbar, in *American Studies* 12:1 (1973): 3–15; Schlereth, in Fred E. H. Schroeder, ed., *Twentieth-Century Popular Culture in Museums and Libraries* (Bowling Green, Ohio: Popular Press, 1981), 87–103; Jakle on historic preservation (Monticello, Ill.: Vance Bibliographies, 1980), and Jakle et al., *American Common Houses: A Selected Bibliography of Vernacular Architecture*, Bibliography A-574 (Monticello, Ill.: Vance Bibliographies, 1981).

70. Jean Gottman, "Why the Skyscraper?" *GR* 56 (1966): 190–212, and Larry Ford, "The Diffusion of the Skyscraper as an Urban Symbol," *Yearbook of the Association of Pacific Coast Geographers*, vol. 35 (1973): 49–60.

71. Trewartha, "Some Regional Characteristics of American Farmsteads," *AAAG* 38 (1948): 169–225; Jordan, "The Imprint of the Upper and Lower South on Mid-Nineteenth-Century Texas," *AAAG* 57 (1967): 667–90; Prunty and Aiken, "The Demise of the Piedmont Cotton Region," *AAAG* 62 (1972): 283–306; Newton and Pulliam, *AAAG* 67 (1977): 360–83; Hart (Englewood Cliffs, Prentice-Hall, 1975).

72. Conzen, "Analytical Approaches to the Urban Landscape," 128–65.

73. Vance (New York: Harper's College Press, 1977); Jakle (Hamden, Conn.: Shoestring Press, 1982). See also Wilbur Zelinsky's exemplary study of small-town morphology, "The Pennsylvania Town: An Overdue Geographical Account," *GR* 67 (1977): 127–47. The best accounts of how American cities were planned and platted are John Reps's gorgeously illustrated *The Making of Urban America: A History of City Planning* and *Cities of the Urban West: A History of Frontier Urban Planning* (Princeton: Princeton University Press, 1969 and 1979).

74. Christopher Tunnard and H. H. Reed, *American Skyline* (New York: Houghton Mifflin, 1953); Clay (New York: Praeger, 1978; Chicago: University of Chicago Press, 1980). Apropos landscape reading, see also Peirce Lewis, "Axioms for Reading the Landscape," in Meinig, *Interpretation of Ordinary Landscapes*, 11–32.

75. Baerwald, *GR* 68 (1978): 308–18; Lewis, "The Galactic Metropolis," in *Beyond the Urban Fringe: Land Use Issues of Non-Metropolitan America*, ed. Rutherford H. Platt and George Macinko (Minneapolis: University of Minnesota Press, 1983), 23–49.

76. Sherry H. Olson, *Baltimore: The Building of an American City* (Baltimore: Johns Hopkins University Press, 1980); Harold Mayer and Richard Wade, *Chicago: Growth of a Metropolis* (Chicago: University of Chicago Press, 1969); Reyner Banham, *Los Angeles: The Architecture of Four Ecologies* (New York: Harper and Row, 1971): Peirce Lewis, *New Orleans: The Making of an Urban Landscape* (Cambridge, Mass.: Ballinger, 1976); Richard Saul Wurman and John Gallery, *Man-Made Philadelphia: A Guide to Its Physical and Cultural Environment* (Cambridge, Mass.: MIT Press, 1972); Philip R. Pryde, ed., *San Diego: An Introduction to the Region* (Dubuque, Iowa: Kendall/Hunt, 1976).

77. "The Highest Form of the Geographer's Art," *AAAG* 72 (1982): 1–29.

78. A lucid exposition of the idea is Donald Meinig's "Environmental Appreciation: Localities as a Humane Art," *Western Humanities Review* 25 (1971): 1–11.

79. See McPhee's *The Pine Barrens*, about southern New Jersey, and *Coming into the Country*, about Alaska (New York: Farrar, Straus and Giroux, 1968 and 1977).

80. Wallach, "The Potato Landscape: Aroostook County, Maine," *Landscape* 23:1 (1979): 15–22; "Logging in Maine's Empty Quarter," *AAAG* 70 (1980): 542–52; "The West Side Oil Fields of California," *GR* 70 (1980): 50–59; "Sheep Ranching in the Dry Corner of Wyoming," *GR* 71 (1981): 51–63.

81. Boston: Riverside Press, 1953; reprint Westport, Conn.: Greenwood, 1973.

82. The best of that genre is Harry Swain and Cotton Mather's guide to the fringes of Minneapolis exurbia, *St. Croix Border Country* (Prescott, Wis.: Trimbelle Press, 1968). See also, e.g., Cybriwsky, *The Philadelphia Region.*

83. College Station, Texas: Texas A & M University Press, 1982.

3

The Power of Things:
Recent Studies in American
Vernacular Architecture

Dell Upton

THE STUDY of vernacular architecture differs from other aspects of
material culture studies treated in this book in two ways. First, the name
itself is inadequate, since an increasingly large number of apparently
disparate kinds of buildings have been included under its rubric. While
the term "vernacular architecture" will be novel and puzzling to many
readers, it was first used in the nineteenth century by architectural
theorists to refer to traditional rural buildings of the preindustrial era,
buildings that were apparently the houses of yeoman farmers and that
seemed not to have been "consciously" designed or affected by the
intellectual and artistic currents of the Renaissance.[1] They were thought
to be in some sense Gothic or medieval buildings, even though many of
the examples cited were built long after the Reformation. Buildings of
this sort or their functional equivalents in America—the log houses of
the southern mountains and other folk buildings, for example—have
continued to be the principal interest of many students of vernacular
architecture. In recent years, however, the term has been extended to
include less pretentious examples of any currently fashionable form of
mass-produced, middle-class housing such as one might find in many
nineteenth- and twentieth-century speculative developments, in indus-
trial buildings, and in the architecture of the buildings housing fast-food
and other commercial franchised businesses—virtually anything not
obviously the product of an upper-class, avant-garde aesthetic move-
ment.[2]

As a single unexceptional example of the variety of interests found in recent vernacular architecture studies, one might cite *Carolina Dwelling*, a collection of essays on the North Carolina "vernacular landscape." In addition to articles on rural houses of the eighteenth through the twentieth centuries that one might expect in a book about a culturally conservative agricultural state, the volume includes essays on a group of large mansions built in a local version of the then-current neoclassical high style, and on beach houses, porches, tobacco barns, town planning, courthouse squares, churches, mill houses built from published designs, and the representation of the landscape in postcards.[3]

The profusion of built forms drawn into recent studies of vernacular architecture points toward the second characteristic that separates vernacular architecture from the other kinds of material culture included here. Often "vernacular architecture" has been a catch-all term for the study of kinds of buildings that were thought to have been neglected by traditional architectural history. Furthermore, the study of vernacular architecture has been, mainly by default, an interdisciplinary or, more correctly, a multidisciplinary enterprise. Where the study of decorative arts, for instance, has been pursued largely within the bounds of art history, vernacular architecture has been examined from the perspectives of art and architectural history, social history, folklore, anthropology, historical and cultural geography, archaeology, architectural theory, and sociology, to name only those disciplines that come immediately to mind. This variety of approaches and interests has aggravated that fragmentation of focus fostered by the negative definition of vernacular architecture as not-high-style architecture.

For this reason, I have always avoided defining the term. When pressed, my preference is to define vernacular architecture not as a category into which some buildings may be fit and others not but as an approach to architectural studies that complements more traditional architectural historical inquiries. Increasingly, it seems to me, the best studies of vernacular architecture are characterized not by the kinds of buildings that they treat but by how they go about it. Vernacular architecture studies will have reached maturity when we have defined an inclusive approach to the study of all architecture that will eliminate the need for such an exclusive label as vernacular architecture.

In this essay I want to identify four avenues of inquiry that I think have been pursued in the best recent vernacular architecture studies. Others have summarized the field by dividing it along disciplinary lines, or by examining certain subsets of vernacular architecture.[4] My four approaches are interdisciplinary with respect both to the individuals

who practice them and to the methods that they use. In no way do they include all of the kinds of buildings or all of the methods and theoretical assumptions to be encountered in current vernacular architecture publications, but I do believe that they represent the best work recently done, and the most likely lines along with vernacular architecture studies will continue to develop.[5]

OBJECT-ORIENTED STUDIES

By far the longest-lived strain of vernacular architecture studies has been concerned with the buildings themselves. How old are they? How were they made? How have they been changed over time? I have chosen the neutral term "object-oriented studies" for this approach, but in many respects it is the counterpart of the "scientific antiquarianism" practiced by some leading decorative-arts scholars.[6] Indeed, the two have their roots in the turn of the century in the work of the same men.

The earliest students of vernacular architecture were the heirs of two related traditions in eighteenth- and nineteenth-century artistic thought. One valued the romantic and historical associations and the picturesque visual effects created by the actions of time and human alterations on the oldest buildings of a given area. The second encouraged the study of architectural history through field examination and the precise recording of buildings in measured drawings. The first American scholars—men like Norman Morrison Isham, Irving W. Lyon, and Henry Chapman Mercer—were attracted to the oldest and most picturesque specimens of indigenous American architecture. They valued these buildings for their visual appeal and as relics of the lives and ideals of the first Euro-Americans. Those who were architects used vernacular buildings as artistic source materials, but they felt no need to be bound literally by precedent in their own designs. Nevertheless, they had a growing sense that a true understanding of their sources depended upon precise antiquarian knowledge.

The first scholarly studies of vernacular architecture appeared in the 1890s. Two Providence architects, Norman Morrison Isham and Albert F. Brown, published a study of Rhode Island's seventeenth- and eighteenth-century houses in 1895. It was intended "to promote the collection of scientific data about the oldest houses in the original New England colonies, so that the vague descriptions of too many of our town histories may be supplemented by accurate measured drawings." Isham and Brown "personally examined, sometimes from garret to cellar, every house described in the text . . . [and] every plan, elevation,

and section is based upon measurements of the house it illustrates." This emphasis on the recording of individual buildings in measured drawings was directly derived from the practice of European antiquarians. It was stimulated as well by Isham and Brown's admiration of hand craftsmanship and the products of arts and crafts. Though drawing on a century-old tradition in the field study of antiquities, it was a method that was nevertheless novel in America, and it bore the mark of late nineteenth-century America's fascination with "science" in all things. Before Isham and Brown, some architects had made measured drawings of details, but no one had included plans, framing diagrams, and structural details, nor had anyone analyzed individual examples so meticulously. Isham and Brown followed their Rhode Island book with a parallel work on Connecticut, published in 1900. In both volumes, they supplemented their artifactual data with other information obtained from documentary sources, especially probate inventories. Using both the written and the material evidence, they constructed an evolutionary sequence of house plans and external forms that is still frequently cited. Indeed, neither their methods nor many of their conclusions have been superseded in much of the object-oriented study of vernacular architecture.[7]

The formal and structural data that Isham and Brown provided were complemented by other early antiquarians who investigated the more minute details of American vernacular building. Had he lived longer, the Hartford physician Irving Whitall Lyon would have published a vernacular architectural study soon after Isham and Brown's Rhode Island volume appeared. Lyon had a keen sense of competition with Isham, but his methods were those developed in his earlier, pioneering study of New England furniture. Like Isham and Brown, Lyon also consulted probate inventories, but he used them to correlate surviving artifacts with the names applied to them by their original owners. He was interested in the visual qualities of houses, and in the materials used to build them. Though Lyon died before his book could be completed, his details-and-materials orientation, rather than Isham and Brown's formal and technological approach, dominated vernacular architecture studies until the 1960s.[8]

It has been worth investigating the roots of object-oriented studies at such length because it is a lively, continuing tradition. Since Isham and Brown's first publication, object-oriented treatments, mostly of New England subjects, have continually appeared. The first generation also established the tradition of dealing almost entirely with domestic architecture, a tradition not frequently violated except in studies of modern buildings. With the exception of J. Frederick Kelly, who worked

in Connecticut from the second decade of the century until his death in 1943, no subsequent scholar until recently has matched the quality and the originality of the founders' work.[9]

The greatest and one of the most recent contributions to object-oriented studies is Abbott Lowell Cummings's *The Framed Houses of Massachusetts Bay, 1625–1725*.[10] This work, like others in the tradition, roughly parallels what decorative-arts scholars call connoisseurship, that is, the identification and authentication of objects. Like his predecessors, Cummings is interested in the relationship between English and American building traditions, and by implication in the long-standing question of the transit of civilization. Much of his attention is focused on identifying the English regional origins of craftsmen and particular architectural traits. The underlying assumption is that the character of American architecture, at least in the first part of the seventeenth century, can be understood as the sum of the regional origins of its builders. The identification process thus consists of an effort to match American buildings with English sources.

In addition to this concern for origins, Cummings shares with the vernacular-architecture pioneers a holistic view of objects that has been lost in most recent studies. He treats plans, framing, the assembly process, interior architecture, painting and other decorative schemes, as well as building materials, in his text. But while his debt to his intellectual ancestors is obvious, he surpasses them in his understanding of the details of historical change in building traditions, in his interest in understanding the interrelations among building elements, and in his superior skill in analyzing and dating buildings. To all of this he adds an interest in aesthetic ideas that is derived from his training as an art historian.[11]

While modern object-oriented study has moved far beyond antiquarianism, scientific or otherwise, it still tends to rely too often on intuitive, rather than explicit, concepts of change. Even the most narrow antiquarianism involves assumptions about the people who made and used the objects, since artifacts are human products. Rather than specifying these assumptions, however, object-oriented researchers typically rely on a kind of common-sense functionalism and on aesthetic trickle-down theories to account for architectural choices. Other recent scholars have made use of architecture to understand its makers and users, rather than making assumptions about people in order to understand their artifacts. The single most important development in the vernacular architecture studies of the last twenty years has been to effect this reversal, to use objects as evidence about past and present human behavior. The change has come from several directions. Archae-

ologically and historically oriented studies of English vernacular architecture introduced it to many people who were trained in object-oriented studies of colonial American buildings. Cultural geographers represent a second important strain of interest in the social aspects of vernacular architecture. In recent years, anthropologists and folklorists have added important theoretical concepts to the largely intuitive and descriptive efforts of the geographers.

SOCIALLY ORIENTED STUDIES

As the "new" history probes deeper into daily life in the past, buildings are being drawn in both as a part of everyday existence and, more recently, as evidence for aspects of the past that can be known imperfectly or not at all from other kinds of evidence. The historical outlook on vernacular buildings was initially adopted by English scholars who asked, first of all, what did people have in the past?[12] This elementary question has inspired similar efforts to reassess the quality of the material culture of a variety of Americans. Because the earliest surviving Anglo-American houses do not resemble the large country houses of Europe, for example, architectural historians have tended to think of surviving seventeenth- and eighteenth-century American houses as representative of the dwellings of middling colonials. Intense study in Maryland and Virginia over the past decade and a half has altered this picture drastically. In a long article in the *Winterthur Portfolio*, five historians and archaeologists examined the evidence for seventeenth-century housing in the Chesapeake region and found that for most residents home was a flimsy wooden house that required frequent repair and early replacement. Their conclusions reinforced the portrait of a precarious existence in an unstable society that has been drawn by recent social historians of the early Chesapeake. But they suggested that the possibilities for a contribution to the history of the area went beyond the mere seconding of documentary evidence. When and why did these impermanent structures cease to be the dominant architectural mode? In those parts of the region where detailed economic studies have been made, the change correlates with the transition from a purely tobacco-based economy to a more balanced or at least a less labor-intensive one. The field examination of buildings thus presents a way of investigating more quickly and in greater detail the point of transition, which varied from county to county. Vernacular architecture suggests that "the Chesapeake" was not as monolithic a place as it often appears to have been from documentary studies.[13]

Beyond the level of pure quality, other historians have begun to ask about the size of houses, and about the social use of the spaces they contained. If the surviving houses are, as the Chesapeake work indicates, much more substantial than those most early Americans lived in, they are also much larger. For all but the wealthiest people, houses of one or two rooms seem to have been the norm in the South and the Middle Colonies until the early nineteenth century at least, with slightly larger houses characteristic of the North.[14]

When houses became larger than that norm, vernacular architectural historians have begun to ask how possessions and daily activities were distributed within them. How did this distribution reflect changing social structures? Two modes of inquiry have been pursued here, one through the examination of spaces in standing buildings (or the spaces revealed archaeologically) and the other through the study of room names and contents as recorded in probate inventories. Where it was once common to assign fixed names and uses to rooms, more recently scholars have begun to observe that traditions of naming and use were flexible over time and social class, and that the disposition of objects and social activities was constantly reshaped by the developing structure of American society. For example, traditional room names and definitions altered drastically in the late seventeenth century. In the South, the hardening social distinction between masters and their white servants prompted the separation of masters' and servants' spaces in the second half of the century. This created the familiar plantation house with surrounding outbuildings that characterized the region throughout the antebellum period. A similar restructuring for other, as yet unexamined, reasons took place in other colonies.[15]

The study of living standards and of the social relations of farm labor within the household imply a connection with other farm buildings and with broader issues of economic history. Few American scholars have chosen to follow these lines of inquiry, however. Henry Glassie published a description of the buildings on an upstate New York farmstead, and there are studies of individual farm building types, notably of the barn. Jack Michel has taken landholding and economic activities into consideration in his study of Pennsylvania houses. To date, though, the only extended attempt to treat the farmhouse and its associated buildings and yards as an economic, social, and functional unit is Thomas Hubka's study of the connected farms of northern New England.[16]

The possibilities for studying social change using architectural evidence are extensive, yet this aspect of vernacular architectural history has been underutilized. It has clear promise of the analysis of more

63

recent domestic architecture, for example. Studies of nineteenth- and twentieth-century domestic life have tended to rely on prescriptive literature such as etiquette books, advertisements and trade catalogs. Research along the lines of that undertaken for colonial American houses, incorporating the systematic inspection of standing buildings along with supporting evidence such as historic photographs, could supplement or circumvent the prescriptive literature. Historians might ask not only whether the literature was used, but to what extent, and could investigate the alternate domestic arrangements that nineteenth- and twentieth-century Americans adopted in addition to or instead of the middle-class norms promulgated in the published advice.[17]

CULTURALLY ORIENTED STUDIES

The social historical approach presumes that architectural forms varied with the social and economic structures of American society. Other students of vernacular architecture have asked about the more pervasive, less easily defined aspects of human activity that are sometimes grouped under the anthropological heading "culture." Culture can be defined for our purposes as learned behavior that embodies the enduring values and deepest cognitive structures of a social group.

Among the earliest investigators of vernacular architecture in this mode were the cultural geographers. Starting with the assumption that built forms are enduring aspects of any migrating group's culture, the geographers traced the distribution of major building types like the I-house, a two-story, two-room-long, one-room-deep dwelling built in many parts of the United States into the twentieth century. The intention was to understand the patterns of cultural movement and integration created during the great migratory years of the nineteenth century.[18]

Henry Glassie's *Pattern in the Material Folk Culture of the Eastern United States* is a large-scale application of the methods of cultural geography to a variety of artifacts including buildings.[19] It marks the entry of American folklorists into vernacular architecture studies in an enduring way. Employing the geographer's concept of cultural hearths, Glassie identified four areas of the East Coast from which the material folk culture of the eastern United States emanated and demonstrated the contribution of each to the distinctive artifactual landscapes of later-settled parts of the east. In the process, Glassie delineated the character of folk culture and its patterns of change. This book has been enormously influential not only for its theoretical base but as a virtual catalog

of traditional artifacts against which subsequent field workers have measured their finds.

Cultural students of vernacular architecture have in the last decade moved away from the mapping and cataloging of forms to study their intermixture and their generation. Some have asked about the relationship of vernacular architecture to academic or avant-garde architecture. This issue touches on the very definition of vernacular architecture, since a specification of the relationship has often been built into that definition. Some people have conceived of vernacular architecture as imitative, in an inferior, old-fashioned, or provincial way, of elite forms. Others have seen it as competitive with, and ultimately the victim of, high-style architecture. Still others have depicted vernacular architecture as a kind of spontaneous or natural architecture that has no relationship to academic styles. Again, Henry Glassie has been the leader in rethinking this problem. In a series of essays he points out that there was a change in the very structure of Euro-American cognition in the eighteenth century in America, one that he calls, for convenience, Georgianization. This change was marked by a transition from a preference for symmetrical, organic forms, to forms that were rigidly symmetrical and tightly controlled. Both traditional and high-style building were transformed by this deep alteration in mindset, which is related in complex and not yet clearly understood ways to the great transformation in other aspects of western life that historians have puzzled over for so long. Glassie goes on to suggest that vernacular builders have a distinctive way of seeing that allows them to rethink high-style elements and to incorporate them into their buildings in their own manner, within the cognitive framework provided by the Georgian mindset. Glassie's elegant formulation of the concept of Georgianization has been accepted in recent years as a basic tool in most culturally oriented studies of vernacular architecture.[20]

Other culturally oriented students have been attracted to questions of ethnicity, interethnic influence, and acculturation. For example, questions about the nature of the Afro-American experience that have engaged scholars of black history in general have also affected studies of vernacular architecture. While some writers have spent time chasing after a few buildings in the New World that are questionably African, others have taken a broader view. Following the lead of Robert Faris Thompson, who argued that many Euro-American and Native-American forms have been reinterpreted in characteristically Afro-American ways, folklorist John Michael Vlach painstakingly traced the history of the shotgun house, an unprepossessing domestic form built in large numbers into the twentieth century, particularly along the Mississippi

River and its tributaries. Vlach was able to show that the shotgun, now used by both blacks and whites, was formed in the West Indies from the conjunction of a Caribbean Indian and an African house type with a French structural system, all unified by African-derived proxemic or spatial values. The shotgun house is a truly Afro-American form, a new entity created from elements of several ethnic traditions.[21]

Over the last thirty years archaeologists have questioned the character and utility of their system of classification of artifacts, as part of a reassessment of the concept of culture itself, and of the ways that artifacts embody culture.[22] Most of the cultural expositions of formal change cited so far depend on the concept of building typology. They tend to accept the existence of I-houses, shotgun houses, and other familiar types without question and to assume in turn that they are useful cultural signs. The most recent developments in the cultural analysis of vernacular architecture, however, have taken a clue from the archaeologists and questioned the very concept of the type as a relatively fixed entity readily identifiable in the field, or they at the least inquired about how types are formed and how they reflect the built world.

As an example, let us look at the familiar I-house. Its appearance in such large numbers and relatively standard forms suggests that though the name might be a modern one, the concept of a two-room house, two stories high, with a central hall or passage must presumably have been learned in relatively complete form as a kind of mental template by many nineteenth-century Americans.[23] They would learn at the same time to vary the template according to the preferred placement of chimneys, the number and location of windows, and the presence or absence of fashionable trim. Yet surviving contracts for I-houses take for granted no such basic concept. The many details of these contracts suggest that there was no common reference point to which builder and client could conveniently look. Furthermore, the variations of standing structures suggest that any common concept must be a very general one, to allow for the differences among buildings that we group under the heading of a given type. While in any locality the traditional types are usually predominant, there are always a substantial number of buildings that do not fit easily into any category. Where are their templates?

The same problems that arise in applying the theory to artifacts were encountered in the study of language. Structural linguists, who also relied on a typological system, could not account satisfactorily for what the linguist Noam Chomsky called "creativity"—the ability of an individual to produce an infinite number of sentences and sentence

types after a limited exposure to the language.[24] In buildings, we might express the problem of creativity as follows: vernacular buildings are infinitely variable; no two are alike in every respect. Yet the vernacular architecture of any area falls within a relatively narrow range of variations, thus allowing us to identify key types, at least as a heuristic device. How can we account for both the variation and the patterning?

Chomsky proposed to use for language what he called a generative or transformational grammar that was based not on the surface analysis of observable behavior—the spoken sentence—and the postulation of a learned model or template, but on an attempt to use the behavior to understand the mental processes that produced it. He claimed that one learned rules from which any sentence type could be generated anew by applying the rules to a basic concept, or kernel sentence. Thus, while the example of one's peers might lead one to repeat certain sentence types more than others, one could in fact generate an infinite variety of sentences at will.

Drawing on Chomsky's work, Henry Glassie applied generative linguistics to architecture in his landmark book *Folk Housing in Middle Virginia.* The first part of the work consists of a lengthy grammar of the traditional architecture of a small section of Piedmont Virginia, a set of rules from which, starting with a basic geometrical concept—the square—one could see the derivation of the houses of the region. Ultimately, Glassie turns back to the concept of the type, but the traditional types of Middle Virginia can now be recognized simply as the most popular among all the variations created within the local context. Their relationship to the unusual examples is clearly specified in the grammar. Having constructed his grammar, or architectural competence—a distilled statement of the architectural knowledge of all eighteenth- and nineteenth-century Middle Virginians—Glassie was able to show how new ideas were understood, reworked, and incorporated into the local tradition. In the second part of the book, he moved from the competence to the performance—to what was actually done by his builders, as opposed to what they knew how to do. Here he set aside generative grammar in favor of an investigation of cognition based on the anthropological research of Claude Lévi-Strauss and Robert Plant Armstrong. Glassie concluded that within the bounds of a mental outlook structured around binary oppositions, the Virginians built houses that were increasingly private, artificial, intensive, practical, symmetrical, repetitious, closed. Tradition is revealed not as dull mimicry of previous examples but as a shared body of knowledge in which choices arise out of the tension between individual inclinations and social context.[25]

Rather than correlating ethnicity with house types or population migration with house types, Glassie attempted in *Folk Housing* to use artifacts to probe mental structures. His work thus stands in direct opposition to that of members of the object-oriented school, who assume behavior to understand artifacts. His book pushes the issue of architectural form and its relation to cultural values much farther than has ever been done, and it remains for others to catch up. If few would need to work out as elaborate a grammar as Glassie has, careful investigations of the mental principles of house design such as he has provided would nevertheless go a long way toward correcting the fuzziness with which formal change and cultural significance are now treated. To date, while many people have imitated the sweeping cultural statements that characterize Glassie's work, few have based their pronouncements on the rigorous analyses and the command of linguistic and anthropological theory that underlie *Folk Housing in Middle Virginia.*[26]

SYMBOLICALLY ORIENTED STUDIES

The second half of *Folk Housing*, which discusses the performance aspects of Piedmont vernacular architecture, treats the deep cognitive structures that shaped the general change in formal qualities of the houses. Although it is concerned less directly with the reasons for the choice of particular forms, and especially with decorative and aesthetic elements, it deals by implication with the symbolic character of the architecture. This is an issue that has been of greatest interest and has been treated most explicitly by students of more recent kinds of vernacular buildings, although it cannot be said that anyone has yet hit upon the ideal methodology.

Symbolism is a form of social interaction that has been of considerable interest to recent anthropologists and linguists, and much of the symbolically oriented study of architecture, vernacular or otherwise, draws upon those disciplines in its search for the meaning of buildings.[27]

Linguistic models have been used to understand the structures through which architectural symbolism acts in society. For instance, students of older traditional or folk buildings have assumed, not always correctly, that the owners and users of them had a close involvement with their design, and that the structures therefore embodied the desires of the client in a direct manner. In an analysis of some eighteenth-century Virginia houses, I used sociolinguistic theory to suggest that

vernacular builders chose a limited vocabulary of architectural forms from a range of possibilities available to all members of the society, and that these acted as codes that depended on and at the same time reinforced the connections among small groups of people. The focus was on the social effects of the choice, and it remained a descriptive effort that did not demonstrate why specific forms were chosen.[28]

Even these user-limited choices have rarely been available in the vernacular buildings of the last hundred years, during which time most buildings have been erected to standardized designs on speculation. The client's selection has not been from among all or a limited range of possibilities, but from existing offerings. Discussion of newer buildings has therefore concentrated on the use of standardized formal elements as commercial bait and on their adaptation by consumers. How do builders of commercial housing or owners of hamburger stands attract buyers? To put it another way, what induces a client to choose one house or one chain store over another? What do users typically do to alter undistinguished, commercially built structures? In an article entitled "L.A. Add-ons and Re-dos," Michael Owen Jones investigated owner alterations to existing buildings, focusing on a functional consideration of the social interactions that remodeling facilitated but giving little attention to the symbolic character of forms or to the reasons that they attracted the remodelers. The latter was given more consideration by Elizabeth Collins Cromley, who inquired into the connotative qualities of building materials in her brief examination of home remodeling in East Coast cities.[29]

To date the most successful essays in symbolic architecture have utilized the semiotic theories fashionable among modern architectural critics in the late 1960s and the 1970s. Semiotics, derived from linguistics, is the study of signs. Semioticians presume that all communicative systems are structurally analogous to spoken languages. In the study of architecture, semiotics proposes that buildings and their formal elements are systems of signs that communicate identification with or rejection of a given social group, specific social values, status, or merely assertions of existence in a social or commercial sense.[30]

Within vernacular architecture studies, semiotics has appealed most to those reassessing the commercial strip and its domestic equivalent, the tract house. The strip has been condemned by academic aestheticians as chaotic, manipulative, and destructive of community values. Barbara Rubin traced the origins of this view, and of the strip architecture which inspired it, to the Midway Plaisance, the amusement sector of the World's Columbian Exposition of 1893. She linked unattractive commercial buildings with small entrepreneurs who sought to be

noticed and to survive in an economic environment controlled by monopolistic corporate giants. At the same time that the corporations were squeezing entrepreneurs economically, aesthetic allies were denouncing garish commercial buildings erected by entrepreneurs. The strip can thus be seen as part of a populist challenge to the ruling order, and specifically as one front in a war for the control of valuable urban space.[31]

Rubin's essay is a sensitive one, and she has taken into account the social and aesthetic problems that her view raises. Other devotees of the strip and of tract housing have been less ambivalent. They have chosen to celebrate these forms rather than to examine them critically. The most influential of these proponents are a group of Philadelphia architects, Robert Venturi, Denise Scott Brown, Steven Izenour, and Paul Hirshorn, whose works have treated tract housing, Las Vegas casinos, and hamburger stands.[32] Their explication of the symbolism of popular architecture is more explicitly semiotic than Rubin's. These forms are designed to make a qualitative and existential statement quickly, strikingly, and simply. The strident message is well-suited to the speed and landscape scale of automotive travel. The work of Venturi and his colleagues has often been marked by facility and intellectual one-upmanship, and—like those who, under the title commercial archaeologists, study the strip academically—they have tended not to distinguish the products of individual entrepreneurs (such as Rubin discusses) from those of the design departments of giant corporations. Strips and tract houses are presumed to exist because The People want them. This eliminates consideration of power and class from the discussion of development strategies and substitutes the dictum that whatever is, is (almost all) right. Nevertheless, embedded in their cuteness is a theory of architectural design and symbolism that distinguishes an academic process of composition in integrated wholes from a popular process—that evident in Las Vegas and Levittown—in which composition proceeds by the additive compilation of discrete symbols, with the effect created not by integration but by cumulation.[33] A more rigorous exploration of this idea might prove to be the most lasting contribution of the group to vernacular architecture and to architectural theory generally.

CONCLUDING REFLECTIONS

Each of the four avenues of inquiry that I have mapped is important for the future of vernacular architecture studies. Object-oriented research will always be necessary, for there is much data to be gathered,

much remaining to be understood about the physical history of buildings. This understanding forms the basis of all other vernacular architecture research. All of the best publications in any of the four categories that I have treated are grounded in an intimate first-hand knowledge of the artifacts, and poor ones inevitably betray their authors' inadequate grasp of the physical evidence.

The next step for all students of vernacular buildings is to recover the insight that the object-oriented pioneers of the late nineteenth century shared—that architecture cannot be adequately understood apart from its contents and its context. We need histories of vernacular architecture that integrate furniture, yards, farmsteads, and ultimately settlement patterns into the whole. Some attempt has been made in this direction within each of the four branches of the field. Abbott Lowell Cummings has written about probate inventories and household furnishings.[34] The historians and archaeologists of the St. Mary's City Commission have combined, in their inventory analyses, the study of houses and their contents from the social historian's perspective, as has George McDaniel in his study of postbellum black life in the same region.[35] Investigators of modern tract houses have sometimes looked at their contents as well.[36] Henry Glassie has again set a standard to be striven for in his latest work, *Passing the Time in Ballymenone: Culture and History of an Ulster Community*. This study of a small Ulster town integrates the architecture and furnishings of the townspeople with their oral literature in a way that is both daunting and exciting, and it fuses all four of the models of thought that I have outlined into a single powerful entity.[37]

Of these four approaches, the fourth may be the most promising for future development. The study of objects as signs and symbols may provide underlying connections and a key to the artifactual landscape as a system in a way that helps us to understand the choices that people make in adopting and adapting building forms and all other objects, and to see material culture as primary rather than as supporting or reflective evidence for larger inquiries. If that is to happen, we must move away from the semiotic conception of architectural symbols as keys to corresponding, simpler values.[38]

Publications on vernacular architecture often include a rather egregious appeal to a higher, or deeper, reality, to a set of embedded communal values that make this material more valuable than other kinds of architecture for understanding most people. The study of architectural symbolism, to be useful, can and must move beyond such consensus-oriented claims to the study of architecture as ideology. How do buildings—vernacular buildings and high-style buildings—embody and convey the competing values of groups in their material surround-

ings? The study of contemporary tract housing and of commercial architecture, stripped of the cheerleading that too frequently characterizes it now, holds great promise for developing this kind of inquiry. As with documentary history, the study of past landscapes is more than we realize an exploration of the material culture of the winners. This is true in the sense that the best and most substantial buildings have survived, and that these are usually the houses of the better-off segments of the population, but it is true in a broader sense as well. The buildings that have survived in numbers are those that have been best adapted to the lives of subsequent generations. They do not necessarily represent the dominant or preferred modes of the past. The complementary use of documents can correct some of this skew, but, more than we would like to admit, the study of past material culture will always be a kind of Whig history. The investigation of contemporary artifactual landscapes is less subject to this stricture, and it has the advantage that another kind of source—the testimony of makers and users—is available to enrich the analysis of the physical world. Thus, while vernacular architecture studies have for most of the past century concentrated on the rural domestic architecture of preindustrial America, and while there is much remaining to be done there, the buildings being constructed and used right now may offer the greatest potential for theoretical and substantive contributions in the foreseeable future.

Artifacts are inherently more powerful than words. To see an aesthetic or a social vision realized in the material world is to be captured by it, to lose one's grip on alternative possibilities. Unfortunately for scholarship concerned with vernacular architecture and other material culture, this spellbinding quality of objects has too often resulted in essays that have been purely descriptive. We have been overpowered by our subject matter. We have not been able to find verbal concepts equal to the things themselves. Few material culture studies have progressed much in quality, methodology, or analytical depth beyond those of the founding fathers and mothers of the late nineteenth century. At the same time, the inherent power of the physical world suggests that for those who can break the spell—and I think that the scholars discussed in this essay have made the most significant steps toward creating a mature, analytical study of vernacular architecture—an immensely revealing and exciting vein in the study of American life will be opened.

NOTES

I wish to thank John Vlach, Edward Chappell, and the book editor, Thomas Schlereth, for comments on an earlier draft of this article.

1. Richard Guy Wilson, "The Early Work of Charles F. McKim: The Country House Commissions," *Winterthur Portfolio* (hereafter cited as *WP*) 14 (Autumn 1979), 241 n. 20. For early interest in vernacular buildings, and to illuminate the intellectual roots of modern vernacular architecture studies, see Peter Collins, *Changing Ideals in Modern Architecture, 1750–1950* (Montreal: McGill University Press, 1967), especially chapters 2–13.

2. For examples of the diverse kinds of buildings included in the best vernacular architecture studies of recent years, see Elizabeth Collins Cromley, "Modernizing—or, 'you never see a screen door on affluent homes,'" *Journal of American Culture* (hereafter cited as *JAC*) 5 (Summer 1982): 71–79; Gary Kulik, "A Factory System of Wood: Cultural and Technological Change in the Building of the First Cotton Mills," in *Material Culture of the Wooden Age*, ed. Brooke Hindle (Tarrytown, N.Y.: Sleepy Hollow Press, 1981), 300–35; Paul Hirshorn and Steven Izenour, "Learning from Hamburgers: Architecture of 'White Tower' Lunch Counters," *Architecture Plus* (June 1973): 46–55; and the essays collected in Camille Wells, ed., *Perspectives in Vernacular Architecture* (Annapolis: Vernacular Architecture Forum, 1982).

3. Doug Swaim, ed., *Carolina Dwelling: Towards Preservation of Place; In Celebration of the North Carolina Vernacular Landscape*, The Student Publication of the School of Design, vol. 26 (Raleigh: North Carolina State University, 1978).

4. For good examples of alternate approaches, see Thomas J. Schlereth, "Historic Houses as Learning Laboratories: Seven Teaching Strategies," *History News* 33 (April 1978): 87–98 (also available as *History News Technical Leaflet 105* and in Thomas J. Schlereth, *Artifacts and the American Past* [Nashville: American Association for State and Local History, 1980], 91–119); and Howard Wight Marshall, *American Folk Architecture: A Selected Bibliography*, Publications of the American Folklife Center, no. 8 (Washington: American Folklife Center, Library of Congress, 1981).

5. For a more comprehensive list of titles in all areas of vernacular architecture studies, see Dell Upton, "Ordinary Buildings: A Bibliographical Essay on American Vernacular Architecture," *American Studies International* 19 (Winter 1981): 57–75.

6. Michael J. Ettema, "History, Nostalgia, and American Furniture," *WP* 17 (Summer–Autumn 1982): 137–38.

7. Norman M. Isham and Albert F. Brown, *Early Rhode Island Houses: An Historical and Architectural Study* (Providence: Preston and Rounds, 1895), 5–6; Norman M. Isham and Albert F. Brown, *Early Connecticut Houses: An Historical and Architectural Study* (1900; reprint New York: Dover, 1965). As good arts-and-crafts men, Isham and Brown dedicated their books to the craftsmen of the two colonies, respectively. In 1863 John Hubbard Sturgis did make measured drawings of the soon-to-be-demolished Hancock House, Boston, but this was an isolated instance and not connected to a sustained scholarly project. (Margaret Henderson Floyd, "Measured Drawings of the Hancock House by John Hubbard Sturgis: A Legacy of the Colonial Revival," in *Architecture in Colonial Massachusetts*, ed. Abbott Lowell Cummings [Charlottesville: University Press of Virginia, 1979], 87–111).

8. Irving W. Lyon, *The Colonial Furniture of New England* (1891; reprint New York: Dutton, 1977). Lyon's approach was similar to that followed by the antiquarians Henry Chapman Mercer of Pennsylvania and Wallace Nutting of Rhode Island, who also combined the study of traditional buildings and building

materials with the study of furniture. For Mercer, see Joseph E. Sandford, *Henry Chapman Mercer: A Study* (Doylestown, Pa.: Bucks County Historical Society, 1956), and Claire Gilbride Fox, "Henry Chapman Mercer (1856–1930): Tilemaker, Collector, and Builder Extraordinaire," *Antiques* 104 (October 1973): 678–85; for Nutting, see William L. Dulaney, "Wallace Nutting: Collector and Entrepreneur," *WP* 13 (1979): 47–60.

9. J. Frederick Kelly, *Early Domestic Architecture of Connecticut* (1924; reprint New York: Dover, 1966).

10. Cambridge: Harvard University Press, 1979. A valuable companion to Cummings's book is his article "Massachusetts and Its First Period Houses: A Statistical Survey," in *Architecture in Colonial Massachusetts*, ed. Cummings, 113–221.

11. Other studies in this tradition include Ernest A. Connally, "The Cape Cod House: An Introductory Study," *Journal of the Society of Architectural Historians* 19 (May 1960): 47–56; Richard M. Candee, "A Documentary History of Plymouth Colony Architecture, 1620–1770," *Old-Time New England* 59 (Winter 1969): 59–71; 59 (Spring 1969): 105–11; 60 (Fall 1969): 37–53; Paul E. Buchanan, "The Eighteenth-Century Frame Houses of Tidewater Virginia," in *Building Early America: Contributions toward the History of a Great Industry*, ed. Charles E. Peterson (Radnor, Pa.: Chilton, 1976), 54–73; and Dell Upton, "Traditional Timber Framing," in *Material Culture of the Wooden Age*, ed. Brooke Hindle (Tarrytown, N.Y.: Sleepy Hollow Press, 1981), 35–93. Most of these reflect the strong interest in building technology that characterizes object-oriented studies so much more than any of the other strains of vernacular architecture scholarship. The recent exhibition at the Boston Museum of Fine Arts, "New England Begins," was built on a solid foundation of New England object-orientation, although several of the essays in the catalog went beyond that tradition to apply recent research in art history, anthropology, geography, and social history to the material. *New England Begins: The Seventeenth Century*, ed. Jonathan L. Fairbanks and Robert F. Trent (Boston: Museum of Fine Arts, 1982).

12. The essential works are M. W. Barley, *The English Farmhouse and Cottage* (London: Routledge and Kegan Paul, 1961); J. T. Smith, "The Evolution of the English Peasant House to the Late 17th Century: The Evidence of Buildings," *Journal of the British Archaeological Association*, n.s., 33 (1970): 122–47; and Eric Mercer, *English Vernacular Houses: A Study of Traditional Farmhouses and Cottages* (London: Her Majesty's Stationery Office, 1975).

13. Cary Carson, Norman F. Barka, William M. Kelso, Garry Wheeler Stone, and Dell Upton, "Impermanent Architecture in the Southern American Colonies," *WP* 16 (Summer–Autumn 1981): 135–96. Parallel studies of Southern domestic objects, as yet unpublished, are being conducted by Barbara Carson, Cary Carson, Lois Green Carr, and Lorena S. Walsh.

14. Dell Upton, "Toward a Performance Theory of Vernacular Architecture in Tidewater Virginia," *Folklore Forum* 12 (1979): 180–84; Jack Michel, " 'In a Manner and Fashion Suitable to Their Degree': A Preliminary Investigation of the Material Culture of Early Rural Pennsylvania," *Working Papers from the Regional Economic History Research Center*, 5 (1981): 1–83; Robert Blair St. George, " 'Set Thine House in Order': The Domestication of the Yeomanry in Seventeenth-Century New England" in *New England Begins*, ed. Fairbanks and Trent, 165–72; Cummings, *Framed Houses*, 212–15.

15. Abbott Lowell Cummings, ed., *Rural Household Inventories: Establishing the Names, Uses and Furnishings of Rooms in the Colonial New England Home, 1675-1775* (Boston: Society for the Preservation of New England Antiquities, 1964), xii–xl; Cummings, *Framed Houses,* 216–32; St. George, " 'Set Thine House in Order,' " 165–72; Cary Carson, "Doing History with Material Culture," in *Material Culture and the Study of American Life,* ed. Ian M. G. Quimby (New York: Norton, 1978), 52–55; Fraser D. Neiman, "Domestic Architecture at the Clifts Plantation: The Social Context of Early Virginia Building," *Northern Neck Historical Magazine* 28 (December 1978): 3096–3128; Dell Upton, "The Origins of Chesapeake Architecture," in *Three Centuries of Maryland Architecture* (Annapolis: Maryland Historical Trust, 1982), 44–57. Cary Carson's article on English houses, "Segregation in Vernacular Building," *Vernacular Architecture* 7 (1976): 24–29, is in fact an important contribution to the American research. Studies of the social uses of space in later periods and in larger buildings are scarce despite the popularity of Mark Girouard's *Life in the English Country House* (New Haven: Yale University Press, 1977), but see Edward S. Cooke, Jr., "Domestic Space in the Federal-Period Inventories of Salem Merchants," *Essex Institute Historical Collections* 116 (1980): 248–64; and Dell Upton, "Vernacular Domestic Architecture in Eighteenth-Century Virginia," *WP* 17 (Summer–Autumn 1982): 95–119.

16. Henry Glassie, "The Wedderspoon Farm," *New York Folklore Quarterly* 22 (September 1966): 165–87; Michel, " 'In a Manner and Fashion Suitable to Their Degree' "; Thomas C. Hubka, *Big House, Little House, Back House, Barn: The Connected Farm Buildings of New England* (Hanover, N.H.: University Press of New England, 1984). Two notable studies of individual farm buildings are Henry Glassie, "The Variation of Concepts Within Tradition: Barn Building in Otsego County, New York," in *Man and Cultural Heritage: Papers in Honor of Fred B. Kniffen,* ed. H. J. Walker and W. G. Haag, Geoscience and Man, vol. 5 (Baton Rouge: Louisiana State University School of Geoscience, 1974), and Amos Long, Jr., *The Pennsylvania German Family Farm: A Regional Architectural and Folk Cultural Study of an American Agricultural Community,* Publications of the Pennsylvania German Society, vol. 6 (Breinigsville, Pa.: Pennsylvania German Society, 1972). Two useful short works aimed at a general audience are Amos Long, Jr., *Farmsteads and Their Buildings* (Lebanon, Pa.: Applied Arts Publishers, 1972) and Britta Bloomberg, Robert Frame, Dennis Gimmestad, Ellen Green et al., *Minnesota Farmscape: Looking at Change* (St. Paul: Minnesota Historical Society, 1980).

17. Three excellent studies that use the prescriptive literature are Kenneth L. Ames, "Meaning in Artifacts: Hall Furnishings in Victorian America," *Journal of Interdisciplinary History* (hereafter cited as *JIH*) 9 (Summer 1978): 19–46; Clifford E. Clark, Jr., "Domestic Architecture as an Index to Social History: The Romantic Revival and the Cult of Domesticity in America, 1840–1870," *JIH* 7 (Summer 1976): 33–56; and Gwendolyn Wright, *Moralism and the Model Home: Domestic Architecture and Cultural Conflict in Chicago, 1873–1913* (Chicago: University of Chicago Press, 1980). Fred W. Peterson compares standing vernacular buildings with the literature in "Vernacular Building and Victorian Architecture: Midwestern American Farm Homes," *JIH* 12 (Sring 1982): 409–27. For photographs as a source for architectural study, see James Borchert, "Analysis of Historical Photographs: A Method and a Case Study," *Studies in Visual Communication* 7 (Fall 1981): 30–63. A study that does some of what I am proposing here is Lizabeth A. Cohen, "Embellishing a Life of Labor: An Interpretation of the

Material Culture of American Working Class Homes, 1885–1915," *JAC* 3 (Winter 1980): 152–75. In addition, Cary Carson and Lorena Walsh are preparing a major study of the material life of the American housewife along these lines. The lack of detailed field studies is most acute for urban commercial and residential structures. Two conspicuous exceptions are Mary Ellen Hayward, "Urban Vernacular Architecture in Nineteenth-Century Baltimore," *WP* 16 (Spring 1981): 33–63, and Paul Groth's soon-to-be-published research on single-room-occupancy dwellings in early twentieth-century cities.

18. Among the earliest geographers to use American vernacular buildings in this manner was Fred B. Kniffen, whose "Louisiana House Types," *Annals of the Association of American Geographers* (hereafter cited as *AAAG*) 26 (December 1936): 179–93, was a pioneering effort and whose "Folk Housing: Key to Diffusion," *AAAG* 55 (December 1965): 549–77, remains a standard summary of the contribution made by geographers to vernacular architecture studies. See also Fred B. Kniffen and Henry Glassie, "Building in Wood in the Eastern United States: A Time-Place Perspective," *Geographical Review* 56 (January 1966): 40–66, for an important application of geographical techniques to building technologies rather than to built forms.

19. Philadelphia: University of Pennsylvania Press, 1968.

20. Glassie touches on this issue in *Pattern*, pp. 48–55, 64–69, expounds it fully in "Eighteenth-Century Cultural Process in Delaware Valley Folk Building," *WP* 7 (1972): 29–57, and incorporates it into his much more complex argument in *Folk Housing in Middle Virginia: A Structural Analysis of Historic Artifacts* (Knoxville: University of Tennessee Press, 1975), especially pp. 31–32, 86–91. A work that uses the concept fruitfully is James Deetz, *In Small Things Forgotten: The Archaeology of Early American Life* (Garden City, N.Y.: Anchor, 1977). Two efforts to detail the vernacular way of seeing in specific contexts are Upton, "Vernacular Domestic Architecture," and Peterson, "Vernacular Building."

21. John Vlach, "The Shotgun House: An African Architectural Legacy," *Pioneer America* 8 (January–July 1976): 47–70. Vlach has extended his analysis to other aspects of black material culture, including other kinds of houses, in *The Afro-American Tradition in Decorative Arts* (Cleveland: Cleveland Museum of Art, 1978). The Pennsylvania Germans have been the most popular subjects of ethnic material cultural studies. For a sampling of current research that includes architecture, see Scott T. Swank, with Benno M. Forman, Frank H. Sommer, Arlene Palmer Schwind, Frederick S. Weiser, Donald H. Fennimore, and Susan Burrows Swan, *Arts of the Pennsylvania Germans*, ed. Catherine E. Hutchins (New York: Norton, 1983). Edward Chappell employs both the ethnic and the cognitive approaches in an analysis of Germanic architecture in western Virginia, "Acculturation in the Shenandoah Valley: Rhenish Houses of the Massanutten Settlement," *Proceedings of the American Philosophical Society* 124 (February 1980): 55–89. Glassie first noted the Anglicization and Georgianization of Germanic houses in *Pattern*, pp. 48–55.

22. The principal articles in the archaeologists' debate are conveniently collected in James Deetz, ed., *Man's Imprint from the Past* (Boston: Little, Brown, 1971).

23. It is important to note that the central-passage criterion is not one that most scholars would accept (Kniffen, "Folk Housing," p. 555; Glassie, *Pattern*, pp. 66–67). I include it because it seems to me that to include all two-story, two-room houses in the type is to create a category too vague to be useful. Given

that, as I am arguing here, types are heuristic categories created by the scholar, I choose to make the central passage a diagnostic feature of the I-house because I find Glassie's argument about the profound character of the cognitive change it represents convincing (*Folk Housing*, pp. 51, 57, 88–91, 121–22). It is the widespread dissemination of central-passage I-houses in the early nineteenth century, not the introduction of two-story, single-pile houses in the seventeenth century, that seems to me to be the critical change for most American vernacular architecture. The concept of the mental template introduced here was presented by James Deetz in an important study of artifact typology in *Invitation to Archaeology* (Garden City, N.Y.: Natural History Press, 1967), 83–101.

24. Noam Chomsky, *Aspects of the Theory of Syntax* (Cambridge: MIT Press, 1965), 6.

25. Some readers have found that the concepts of structuralism and generative grammar are not explained fully enough in *Folk Housing* to enable them to grasp the argument in all of its subtlety. The gist of the grammar is summarized in Glassie's "Structure and Function, Folklore and the Artifact," *Semiotica* 7 (1973), 313–51, and the carefully arranged and annotated bibliography in *Folk Housing* provides an excellent guide to the theoretical concepts that inform it.

26. Among the best works that employ Glassie's cognitive approach are Tom Carter, "Folk Design in Utah Architecture, 1849–1890," in *Utah Folk Art: A Catalog of Material Culture*, ed. Hal Cannon (Provo: Brigham Young University Press, 1980), 34–59; St. George, " 'Set Thine House in Order' "; and two furniture studies, Robert F. Trent, *Hearts and Crowns: Folk Chairs of the Connecticut Coast, 1720–1840* (New Haven: New Haven Colony Historical Society, 1977), and Robert Blair St. George, "Style and Structure in the Joinery of Dedham and Medfield, Massachusetts, 1635–1685," *WP* 13 (1979): 1–46.

27. For anthropological and linguistic approaches to symbolism, see Edmund Leach, *Culture and Communication: The Logic by which Symbols Are Connected* (Cambridge: Cambridge University Press, 1976); Janet L. Dolgin, David S. Kemnitzer, and David M. Schneider, eds., *Symbolic Anthropology: A Reader in the Study of Symbols and Meanings* (New York: Columbia University Press, 1977); Dan Sperber, *Rethinking Symbolism*, trans. Alice L. Morton (Cambridge: Cambridge University Press, 1975); and Victor Turner, *Dramas, Fields and Metaphors: Symbolic Action in Human Society* (Ithaca: Cornell University Press, 1974).

28. Upton, "Toward a Performance Theory," 173–96. For another consideration of social symbolism, set in the context of economic, ethnic, and art historical investigations, see Alan Gowans, "The Mansions of Alloways Creek," *RACAR: Revue d'art canadien/Canadian Art Review* 3 (1976): 55–71.

29. Michael Owen Jones, "L.A. Add-ons and Re-dos: Renovation in Folk Art and Architectural Design," in *Perspectives on American Folk Art*, ed. Ian M. G. Quimby and Scott T. Swank (New York: Norton, 1980), 325–63; Cromley, "Modernizing," pp. 71–79. A lengthy exploration of Jones's and Cromley's themes that gives more attention to symbolic form is Philippe Boudon's study of the Pessac housing estate in France, *Lived-in Architecture: Le Corbusier's Pessac Revisited*, trans. Gerald Onn (Cambridge: MIT Press, 1979).

30. Charles S. Morris, *Foundations of the Theory of Signs* (Chicago: University of Chicago Press, 1938), has been most helpful to me in understanding semiotics. Two important applications of the theory are Glassie, "Structure and Function," and Charles Jencks and George Baird, eds., *Meaning in Architecture* (New York: George Braziller, 1970).

31. Barbara Rubin, "Aesthetic Ideology and Urban Design," *AAAG* 69 (September 1979): 339–61; see also her "A Chronology of Architecture in Los Angeles," *AAAG* 67 (December 1977): 521–37.

32. Robert Venturi, Denise Scott Brown, and Steven Izenour, *Learning from Las Vegas: The Forgotten Symbolism of Architectural Form* (Cambridge: MIT Press, 1977); Venturi and Rauch, Architects and Planners, *Signs of Life: Symbols in the American City* (Washington: Aperture, 1976); Hirshorn and Izenour, "Learning from Hamburgers"; Paul Hirshorn and Steven Izenour, *White Towers* (Cambridge: MIT Press, 1979). The inclusivist aesthetic that underlies this enthusiasm for commercial architecture is set forth in Robert Venturi, *Complexity and Contradiction in Architecture*, 2nd ed. (New York: Museum of Modern Art, 1977).

33. The description of the two modes of symbolic composition bears an intriguing resemblance to the ideas set forth by Richard Krautheimer in his "Introduction to 'An Iconography of Medieval Architecture,'" *Journal of the Warburg and Courtauld Institutes* 5 (1942), 1–33, which makes useful reading for anyone interested in the character of architectural symbolism.

34. Cummings, ed., *Rural Household Inventories*.

35. George McDaniel, *Hearth and Home: Preserving a People's Culture* (Philadelphia: Temple University Press, 1981), and see above n. 13. Of course, Alan Gowans's *Images of American Living: Four Centuries of Architecture and Furniture as Cultural Expression* (Philadelphia: Lippincott, 1964), though only partly concerned with vernacular architecture, was the too-little-heeded pathfinder here.

36. Venturi and Rauch, *Signs of Life*.

37. Philadelphia: University of Pennsylvania Press, 1982.

38. "What this view requires is a concentration on symbolic *processes*, instead of requiring that the analysis of meaning show only how a particular form represents a more elementary one . . ." (Introduction to *Symbolic Anthropology*, ed. Dolgin, Kemnitzer, and Schneider, p. 44).

4

The Stuff of Everyday Life: American Decorative Arts and Household Furnishings

Kenneth L. Ames

THOMAS SCHLERETH'S impressive historiographic essay in his recent book records and analyzes a century of changing patterns in the methods and purposes of the diverse pursuits that constitute what he calls American material culture studies.[1] This chapter assumes the more limited task of describing a single strand in that web, the study of household furnishings of the past. I have not attempted to provide a thorough history. My emphasis is on literature from about 1970 to the present, a period during which scholarship underwent dramatic transformations in the objects it studied, the ways it studied them, and its reasons for doing so. Once both relatively isolated and narrow, the field has been in transition from studying antiques or artistic objects as ends in themselves to studying those objects in order to understand society and culture. Many of the people mentioned here have left behind a largely avocational study to make a bid to become active participants and peers in the academic investigation of American culture. Those dedicated to reaching outward to other disciplines are known by no single name. Some still refer to themselves as students of the decorative arts, as furnishings are often referred to in the art world. Others have tried to disassociate themselves from what they see as the precious and elitist connotations of that term to become instead students of material culture, of things or objects, of materialism or consumerism, of historic furnishings or historic design. What these scholars share, however, is their field's long-standing belief in the value of studying objects. By focusing on objects, the founders of the field had defined its distinguish-

ing feature and its persisting emphasis. Their major shortcomings, by today's standards, were their failure to sufficiently recognize how central objects are to human life and how useful they can be to historians. If current object historians have anything in common, it may be a belief that things constitute one of the most significant classes of human behavior and accomplishment, and, therefore, one of the most valuable kinds of historical document.

Exactly how far objects of ordinary life, like knives and forks, tables and chairs, or pots and pipkins can be pushed to yield understanding of human life, thought, or society remains unclear and largely untested. Here, however, I can outline some of the recent attempts to find meaning in these and other commonplace things. The following discussion has four unequal parts. The first offers a brief background account of earlier developments in the field. The second identifies what I see as four major orientations currently operative. The third discusses some of the dominant genres of study, while the fourth offers suggestions for future directions.

THE EMERGENCE OF MODERN DECORATIVE ARTS STUDY

The study of decorative arts and antiques, as household furnishings are often called, is not a recent development. The roots of today's study can be traced to mid nineteenth-century continental Europe and Britain and emerging interests there in cultural history, folklore, anthropology, archeology, design reform, and museums as agencies for public instruction. In America, antiquarians had been sporadically gathering up colonial relics since the early years of the nineteenth century. Interest in old American furnishings intensified in the last three decades of the nineteenth century, when collecting antiques became a prominent pastime for a circle of generally affluent and influential Easterners. Responding to the Victorian cult of domesticity, design and social reform movements, notions of environmental determinism, patriotism, localism, nationalism, antimodernism, sometimes nativism, and a variety of other impulses and sentiments, they became participants in that loose cultural coalition known as the colonial revival, furnishing their homes with the handicrafts of preindustrial America, assembling collections, organizing exhibitions, and writing books and articles.[2] These publications laid the foundation for later work, identifying categories of objects considered worthy of study and establishing genres of scholarship that still persist. Important titles from the last quarter of the nineteenth century include *The China Hunters' Club*; John H. Buck's *Old*

Plate, Ecclesiastical, Decorative, and Domestic; Irving Lyon's *The Colonial Furniture of New England;* Alice Morse Earle's *China Collecting in America;* Edwin Atlee Barber's *The Pottery and Porcelain of the United States;* and R. T. H. Halsey's *Pictures of Early New York on Dark Blue Stafford Shire Pottery.*[3]

These volumes document the period's high valuation of furniture, silver, and ceramics, all of which were then at the zenith of their cultural significance. Former luxuries became commonplace, and these goods were being elevated to the status of art through the efforts of the arts-and-crafts movement. These publications also record attitudes about collecting interests, territories, methods, and strategies. In some cases they also reveal the limited if affluent audience their authors addressed: Halsey's *Pictures of Early New York* was printed on handmade paper, illustrated in exquisite color photogravure, and issued in a limited edition of 298 copies. These early books, however, also represent significant documentary scholarship. Halsey, for example, located 220 American scenes and portraits on a class of English ceramics made for the American market; only sixteen or seventeen additional examples have been found since. Barber drew on documents and informants now lost or dead and is continually cited. Lyon was recently reprinted (1977), not as a cultural curiosity but as a model study still rich is useful information.

Over the next thirty years the major contours of the field took shape. Areas of interests were defined, then refined, and the major supporting institutions and media were established. A fuller treatment of the development of the Americana, antiques, and historic preservation movements, all intricately intertwined, can be found in publications by Schlereth, Stillinger, and Hosmer.[4] Here it might be sufficient to recite a litany of the major publications and events that, taken together, gave the field coherence and presence. The first decade of the twentieth century produced Esther Singleton's *Furniture of Our Forefathers*, Luke Vincent Lockwood's *Colonial Furniture in America*, and also the 1909 Hudson-Fulton Exhibition at the Metropolitan Museum of Art, usually considered the earliest major institutional celebration of American decorative arts. The next decade saw E. Alfred Jones's *The Old Silver of American Churches*, Frederick William Hunter's *Stiegel Glass*, Ada Walker Camehl's *The Blue-China Book*, and Francis Hill Bigelow's *Historic Silver of the Colonies and Its Makers*. The crucial decade was the 1920s. A calendar of even a few of the major accomplishments of those years is impressive: in 1921, Ethel Stanwood Bolton and Eva Johnson Coe, in *American Samplers*, introduced the study of a class of objects still considered important for examinations of childhood, education, and women's

domestic work; in 1922, Keyes founded *Antiques Magazine*, for over sixty years the major outlet for brief documentary articles; in 1924, J. B. Kerfoot published *American Pewter*, bringing another mass of early collectible objects into order, and The Metropolitan Museum of Art opened its influential American Wing, a project long nurtured by R. T. H. Halsey; in 1926, Stephen van Rensselear published *Early American Bottles and Flasks* and John D. Rockefeller initiated his metamorphosis of Colonial Williamsburg; 1927 was the year of Rhea Mansfield Knittle's *Early American Glass* and J. Seymour Lindsay's *Iron and Brass Implements of the English and American Home;* 1928 brought Wallace Nutting's encyclopedic *Furniture Treasury* and Albert H. Sonn's *Early American Wrought Iron.* In 1929 another pivotal if oddly named event, The Girl Scouts Loan Exhibition, took place in New York and Henry Ford's Greenfield Village was dedicated. The following year the Henry Francis du Pont Winterthur Museum was incorporated and Francis P. Garvan began to give his extensive collection of American antiques to Yale University.[5]

This list touches only a few of the more prominent publications. Scores of others about collecting antiques or decorating with them could be added, for by the 1920s, antique collecting had become a highly visible feature of American life, complete with its own language, behavior, and seemingly arcane points of controversy. Two hilarious parodies of antique collecting should be added to any bibliography of the movement: *The Collector's Whatnot* (1923), written under pseudonyms by Booth Tarkington, Kenneth Roberts, and Hugh Kahler, and *Antiquamania* (1928), edited under his own name by Kenneth Roberts, ''with further illustrations, elucidations, and wood-cuts done on feather-edged boards by Booth Tarkington.''[6]

Scholarship over the next forty years built on the foundations established by 1930, adjusting details of fact or method and introducing new ranges of materials. A great many people and organizations contributed to the maturation of the field but a few particularly stand out. Charles F. Montgomery provided much of the energy and vision behind the Winterthur Program in Early American Culture, established in 1952, then went on to make the Garvan Collection office at Yale a center for imaginative and experimental research and exhibition. Alan Gowans taught briefly at the University of Delaware and Winterthur but reached a generation of students across the country through his *Images of American Living: Four Centuries of Architecture and Furniture as Cultural Expression* (1964). Swiss historian Siegfried Giedion had few if any formal contacts with students of American decorative arts, but his *Mechanization Takes Command* (1948) offered a sweeping survey of the

impact of technology on American life and thought.[7] Sections on human surroundings, the household, and the bath traced the rationalization of each over the course of the nineteenth and twentieth centuries. Finally, by 1974, there were enough curators and teachers of decorative arts in this country to support a professional organization. The Decorative Arts Society was largely initiated by David A. Hanks, then at the Philadelphia Museum of Art, with the support and assistance of Lynn Springer, then at the St. Louis Art Museum; Dianne Pilgrim, Brooklyn Museum; Henry Hawley, Cleveland Museum of Art; Jonathan Fairbanks, Museum of Fine Arts, Boston; and a number of others.

CURRENT ORIENTATIONS IN DECORATIVE ARTS STUDY

At present the study of historic household furnishings falls into four overlapping orientations: toward collecting, art, history, and theory. This order indicates the relative prominence of each. Publications for collectors dominate the field, with those stressing aesthetic evaluation close behind. In actual practice the two are often inseparable. Studies that deal with history in any broadly conceptionalized way are less common, and statements of theory are rarer still. Chances are good, therefore, that those from other disciplines who dip into this field for the first time will encounter works written for collectors. For some classes of objects they find nothing else.

THE COLLECTING ORIENTATION

In his essay on living history, Jay Anderson put comments on its popular, noninstitutional manifestations near the end.[8] Placing the decorative arts' equivalent, collecting, anywhere but at the beginning of this discussion, however, would seriously misrepresent its central importance to the field. Collecting is neither an afterthought nor a byproduct of studies that focus on objects, but a prerequisite. Students of vernacular architecture or gravestones find their collections more or less intact on the landscape, but those who study portable goods generally rely on more artificial assemblages.

Collecting has usually preceded scholarship and continues to do so today. Typically, someone has started to collect it, whatever it may be, long before scholars become interested in it. The enduring and even growing vitality of the collecting orientation can be seen in the lasting appeal of *The Magazine Antiques*, as an outlet for certain types of

documentary research, and in the popularity of a number of regional antiques tabloids started in the last two decades, including *Maine Antiques Digest, Ohio Antique Review, Antiques and Arts Weekly,* and *The New York-Pennsylvania Collector.*[9]

The range of objects people collect is astonishing. One of my neighbors collects milk bottles and related paraphernalia and displays them in a "moo-seum" in a spare room of his house. A person I visited recently collects shot glasses. Another collects corkscrews. These are all household artifacts or objects of everyday life, and each has its own literature. Often published in small editions and available only through newsletters or at collectors' meetings, or from specialist book dealers, these studies number in the thousands but are nearly unknown outside collecting circles. For hundreds of categories of objects, such publications provide basic documentary histories. Few university or museum scholars know the history of the milk bottle, for example, but the bookshelves of several hundred collectors contain volumes outlining in intricate detail the typology of this evolving artifact and identifying and dating the thousands of dairies recorded on them.

Publications for collectors are much the same, regardless of their subject. Whether they are dealing with milk bottles, art glass, or rare colonial silver, their purpose is fairly consistent: to present facts about the objects. Particularly important are date, place of origin, maker, history of ownership, form or purpose, style, and material. As George Miller notes in a recent overview of ceramics literature, collectors of ceramics, like most other collectors, want to know how old an object is, who made it, and how. These questions created a demand "for research into chronologies, typologies, and the technology of pottery production."[10] The quality of these studies has often been impressive, but collector-oriented publications are history only in the narrow sense. Their relationship to broad historical inquiry is much the same as that of other antiquarian studies. At their best they offer valuable compilations of data for others to interpret or tight narratives of individuals or firms for others to put into larger contexts. Having collectors and collector-oriented institutions generate studies is a beneficial division of labor that may save historians a good deal of effort, but it also means that much is assembled in response to what are essentially hobbyists' interests and needs. Recreational decorative arts studies are important parts of many lives and continually revitalize this field, but hobbyists do not usually ask the same questions as historians or philosophers. It is important to acknowledge that collecting data is a necesary basis for all sound interpretation. Within studies of the decorative arts at the moment, however, there still seems to be disagreement between those who see

documentation as a satisfactory goal in itself and those who see it as only a prerequisite to further inquiry.

THE ART ORIENTATION

The close links between the collecting and art orientations are neatly summarized in the title of a current popular journal, *Art & Antiques*. Although aesthetic judgments often go hand in hand with collecting, I identify art as a separate orientation to dramatize the impact of the discipline of art history.[11] Because so many publications dealing with historic furnishings can be described as art historical, it is worth asking, to paraphrase Svetlana Alpers, whether art history is really history.[12] This is not just a matter of idle musing or cute semantics; history and art history often seem to move in opposite directions. Put in oversimplified terms, historians use art to study the past while art historians use the past to study art. Deeper understanding and experience of objects are goals that art museum curators take seriously. To Wendy Cooper, the curatorial mandate is "to perceive quality in materials, fabrication, and execution of design."[13] For Henry Hawley, the aesthetic experience is paramount "in determining what is to be collected and how objects are to be presented to the public." He argues that the curators job "is to provide works of art and to facilitate the release of emotional energy from a given work of visual art to the person viewing it."[14] Historical considerations are decidedly secondary here, if relevant at all. Those who make such aesthetic judgments may or may not see them as timeless or universal, but to critics they are presentist, ethnocentric, and antithetical to historical inquiry. Today no reflective scholars would claim to write balanced history using only objects or facts they like. Students of American culture should recognize that the art orientation is largely normative and ahistorical. They should also realize that the very expression "decorative arts" is a product of the art orientation and is both pejorative and misleading—pejorative because it subordinates a group of objects to the "real" arts of painting, sculpture, and architecture, and misleading because it indicates that their primary function is decorative.

Both the collecting and art orientations have recently been analyzed. Michael Ettema argues that most scholarship on the decorative arts is unreflective and that today's "curators and museum educators unconsciously perpetuate the traditions of the collectors and antiquarians . . . by assuming that knowledge of old things constitutes knowledge of history." As Ettema sees it, collecting and art orientations

work together "to recreate the past in an image designed for emotional gratification. The effect is to project ourselves on the past rather than to learn from it." An equally critical view comes from Karal Ann Marling, an art historian who is also a student of American culture and society. In her view, "without an analytical framework in which data and artifact intersect," the facts in art-oriented publications "remain mere trivia for the cultured."[15]

One who has worked hard to transcend the limitations of traditional art historical scholarship is Alan Gowans. In *Learning to See: Historical Perspective on Modern Popular/Commercial Arts*, Gowans critiques the three dominant methodologies of art history: aesthetic line-of-progress (an art historical version of Whig history), cultural expression, and social function. The first two are intellectually bankrupt but the last holds great promise:

> With social function, which considers arts and artifacts not only as aesthetic objects or reflections of the spirit of their times, but also as instruments furthering the ideological foundations of society, art history has finally become the effective and prime instrument for historical research that it should always have been, revealing and analyzing those fundamental attitudes and presuppositions by which any age lives, and on which all of the institutions of every society must ultimately rest.[16]

ORIENTATIONS TO HISTORY AND THEORY

I group history and theory together here because many of the "new" historical studies include explicitly theoretical components. Indeed, it is in this area of theoretically informed history that the material culture wing or offshoot of decorative arts scholarship is to be found. While much of that theory is still borrowed from other disciplines, a theoretical core is gradually being hammered out and may continue to be for some time. I will have more to say about this near the end of this chapter.

Although material culture studies and more conventional decorative arts or antiques studies share some of the same ancestors, their relationship is somewhat uneasy these days. If Jules Prown is correct, some people are "suspicious of, even threatened by, material culture."[17] They may have some cause to be, for a number of material culture scholars feel that conventional object studies have been inadequate as history. Material culture studies have sought more sophisticated ideas about historical process and have gained a new sense of

relativity from examinations of popular culture, folklore studies, and anthropology. These ideas run head on into some of the assumptions of the art orientation. As Ettema notes, what differentiate material culture scholars from those with collecting or art orientations are not necessarily the objects they study but their goals and priorities, their modes of inquiry into human actions of the past.

The fullest attempt to define and describe material study by a scholar trained in the art orientation is Jules Prown's "Mind in Matter: An Introduction to Material Culture Theory and Method." Prown groups most household furnishings under the heading of "applied arts" and argues that both their utilitarian purpose and style constitute significant cultural evidence. Exactly how style might be interpreted is the point of an earlier essay, "Style as Evidence." There Prown argues "that objects reflect cultural values in their style, and that these values can therefore by apprehended through stylistic analysis."[18] That Prown's argument and the view set forth by Gowans in *Learning To See* are in significant disagreement indicates how little theoretical cohesion or even interaction currently exists in the field. And although both were trained as art historians, the bibliographies they cite indicate that they are moving away from conventional art history along very different patterns of diverging reading.

This absence of a dominant theoretical paradigm suggests that transformations in historic object study have been much like those in American studies in general. The drama Gene Wise outlined in his 1979 essay has close parallels here, for decorative arts scholars began to redefine themselves as students of material culture shortly after those in American studies began to reject the myth and symbol orientation of their field and go dashing off in all directions.[19] The actual number of people involved in the new orientation is small, but they have had a disproportionate impact within the field and even attracted attention outside, achievements reflecting both new receptivity without and new directions within. Specific comments on the new definitions of history and theory might be more appropriately placed in the following discussion of genres, where departures from traditional efforts stand out in higher relief.

GENRES OF STUDY

Surveys of Periods, Styles, Movements, Regions, and Peoples

The majority of decorative arts literature is quite frankly intended as reference material. Catalogues of museum collections and exhibitions

and indexes of marks, patterns, manufacturers, or artisans all serve as critical collecting and curatorial tools and are still produced today. In the category of expository writing, surveys are a major genre. Typical surveys are organized to illustrate objects related by style, origin, date, material, or some other factor that facilitates assembly of artifactual classes or sequences. Just as typically, surveys take the form of catalogues of museum exhibitions, for most decorative arts study resides in museums of art and history, where producing exhibitions and catalogues are dominant forms of scholarly activity. Small classes and short sequences are more practical and manageable than their opposites; few successful large-scale studies exist. No single survey offers an adequate comprehensive view of American decorative arts or household furnishings, although a book by Edgar Mayhew and Minor Myers, Jr., *A Documentary History of American Interiors,* is probably the best of the type. Arthur Pulos's *American Design Ethic: A History of Industrial Design* (1983) is also valuable, particularly for its treatment of twentieth-century materials. Pulos is an advocate of industrial design as it is understood today and of the American brand of capitalism. Some passages are heavy-handedly ideological, but Pulos also brings a refreshing demystified vision to objects that have sometimes been treated with excessive reverence.[20]

If massive surveys are rare, so are overviews of shorter periods. Least understandable is the lack of a solid volume dealing with the material culture of colonial America, a subject studied for more than a century. The best is probably Wendy Cooper's frankly celebratory volume, *In Praise of America: American Decorative Arts, 1650–1830.* Cooper gestures toward what she calls a " 'total culture' approach," but her book is otherwise a conventional product of the art and collecting orientations. Yale University Art Gallery's earlier bicentennial exhibition, *American Art: 1750–1800, Towards Independence,* examines a more restricted period but yields a subtler and more diversified volume. Brief essays by J. H. Plumb, Neil Harris, Jules Prown, Frank Sommer, and Charles Montgomery on various aspects of cultural and stylistic transfer and change precede discussions of nine categories of objects ranging from paintings and prints to furniture, silver and gold, ceramics, glass, and textiles.[21]

The major survey of the nineteenth century is *19th-Century America: Furniture and Other Decorative Arts,* the catalogue of the Metropolitan Museum of Arts' landmark 1970 exhibition.[22] Although devoted almost entirely to costly objects, this exhibition and its accompanying publication were official endorsements of post-1840 design by one of America's leading institutional arbiters of taste, signaling a formal acceptance of

Victorian objects into the pantheon of art. While sporadic examinations of nineteenth-century furnishings had appeared before, Victorian design was still considered of dubious merit in 1970, and even today some individuals and institutions continue to act as though few noteworthy furnishings have been produced since 1840. Nonetheless, Victoriana has subsequently become very popular. Articles appear regularly in *Nineteenth Century,* the magazine of the Victorian Society in America, founded in 1969, and in *Art & Antiques,* the magazine *Antiques,* and a number of other art and collecting journals.

Stylistic and cultural movements of the last century have been the subjects of several surveys. For *Classical America, 1815–1845,* Berry Tracy and William Gerdts assembled over two hundred objects to show how the international neoclassical taste, known as Empire in this country, was interpreted in high culture American furniture, silver, lamps, clocks, wallpapers, and other furnishings, as well as in painting and sculpture. Houston's Museum of Fine Arts examined the Gothic taste in American furnishings. Princeton University's Art Museum sponsored what remains the most extensive exhibition of the arts-and-crafts movement in America. The catalogue, a collaborative effort of nine authors, edited by R. J. Clark, provided an extensive overview of the movement and its products. Papers from a related symposium, later published in the *Record of the Art Museum,* included short but suggestive pieces by Robert Winter and Carl Schorske on the movement's ideological and social dimensions.[23]

One of the most recent cultural movements examined was the American Renaissance, the subject of a project originated by the Brooklyn Museum. While the term conjures up something different to literary historians, to the originators of the Brooklyn exhibition it meant an episode of self-conscious historicism in the late nineteenth and early twentieth centuries shaped by nationalism, the genteel tradition of ideal beauty, and cosmopolitan eclecticism, all supported by vast industrial fortunes. Biltmore and the palaces at Newport are manifestations of this American Renaissance. Essays by Richard Guy Wilson, Dianne Pilgrim, and Richard Murray examined the cultural roots and phases of this American renaissance and traced its expressions in architecture, landscape design and city planning, painting and sculpture, and domestic luxury industries, like tapestry and stained glass. *The American Renaissance* was innovative in providing an interpretive synthesis of these phenomena but remained within the art museum tradition in its emphasis on elite culture.[24]

A more prevalent type of survey deals with the products of a particular region or group of people, or both. By far the best regional

study is *New England Begins: The Seventeenth Century.*[25] In fact, it is probably not fair to call this multifaceted historical and ethnological inquiry a survey, for it goes far beyond any survey produced by an American museum. A mammoth and impressive achievement, this three-volume catalogue constitutes the most thorough and intellectually sophisticated examination of the material culture of seventeenth-century New England produced so far. Part of its impact derives from its size and part from the meticulous documentation of the objects; an amazing number still survive from that remote period. Yet the greatest cause for the catalogue's immense value is the mix of expertise and approaches contributed by authors and consultants who brought to the product training in history, art history, geography, folklore, and American studies. Generated by a department of decorative arts in a major art museum, *New England Begins* is the quintessential interdisciplinary American studies product, reaching far beyond conventional art museum concerns to provide deep emersion into the artifactual and mental worlds of seventeenth-century New England.

Less aimed at interpretation, the Philadelphia Museum of Art's Bicentennial Exhibition surveyed three centuries of that city's artistic creativity. The catalogue comprehensively recorded and discussed, in entries written by thirty-seven contributors, over five hundred objects made in Philadelphia or by Philadelphians. More limited in time and range of objects, *Long Island Is My Nation: The Decorative Arts and Craftsmen, 1640–1830,* was a documentary and descriptive account of household objects, particularly furniture and silver, known to have been used on Long Island before 1830.[26]

The household furnishings of ethnic, religious, or social groups have also been the focus of many studies. Not at all surprisingly, the emphasis here has usually been on peoples who produced their own distinctive material culture. Pennsylvania Germans and the Shakers have probably attracted more interest and have more extensive bibliographies than any other groups. The Pennsylvania Germans have been studied by themselves and others for a century. Their bibliography is immense and growing. In the last three years alone, three major publications have expanded the documentation and analysis of their material culture. Beatrice Garvan, in *The Pennsylvania German Collection,* records the extensive holdings of the Philadelphia Museum of Art. Garvan and Hummel, in *The Pennsylvania Germans: A Celebration of Their Arts, 1683–1850,* provide an interpretive framework for a large-scale traveling exhibition of Pennsylvania German objects jointly sponsored by the Philadelphia Museum of Art and the Winterthur Museum. *Arts of the Pennsylvania Germans,* edited by Scott T. Swank, presents vigorous

examinations of a variety of Pennsylvania German materials by seven authors. Swank's introductory chapters include studies of German immigration and settlement, architectural forms, and household spaces and the furnishings within them, as well as historiographic essays on the changing perceptions and evaluations of Pennsylvania Germans and their material culture. Swank's final piece chronicles Henry Francis du Pont's activities as a major collector of Pennsylvania German materials, underlining once again the close relationship between collecting and scholarly study of historic objects.[27]

The Shakers, a much smaller group, have still generated a substantial bibliography. Key figures in bringing the Shakers and their artifacts to wider attention were Edward Deming Andrews and Faith Andrews, whose interpretation of Shaker furniture as "religion in wood" still shapes study today.[28]

Both the Pennsylvania Germans and the Shakers have been studied for years, but recent scholarship has reached out to other peoples and their furnishings. Charles Van Ravenswaay's *The Arts and Architecture of German Settlements in Missouri* is an extensive treatment of the artifactual remains of German immigrants who settled along the lower Missouri River Valley in the early nineteenth century. The section on furnishings discusses and illustrates hundreds of household objects, nearly half of them furniture. Van Ravenswaay also includes musical instruments, wood carving, baskets, firearms, objects in tin and copper, textiles, pottery, and a variety of other materials and forms. While primarily descriptive, the book is written with sensitivity and affection and provides a remarkably large body of data from a specific people and place.[29]

Moravian Decorative Arts in North Carolina examines a community distinguished by extraordinary documentation. John Bivens and Paula Welshimer's study is both a catalogue of the collections of Old Salem, Inc., and an attempt to assess the place of artisans and their products in this religiously ordered community. While recording furniture, pottery, textiles, metalwork, prints, paintings, and other objects produced within the settlement between 1775 and 1840, the authors analyzed the ways Moravians met their material needs within their own distinctive framework of religious, economic, and governmental structures.[30]

Nonwhite Americans, on the other hand, have not fared particularly well. Native Americans are still usually relegated to anthropology and are rarely integrated with whites in decorative arts studies, although some institutions have made attempts to do so.[31] The furnishings of black Americans have also been largely ignored with two notable exceptions: John Vlach's *The Afro-American Tradition in Decorative Arts,*

and George McDaniel's *Hearth and Home*. Vlach's study examined nine media in which he claims black artisans produced a distinctive material culture: basketry, musical instruments, wood carving, quilting, pottery, boat building, blacksmithing, building, and grave decoration. While only some of these could be called furnishings, Vlach shows how all exhibited links to African antecedents through iconography, technology, spatial organization, or conceptualization. In the process, Vlach, a folklorist trained in Indiana, brought deep grounding in anthropological theory to a major art museum production, showing how "the traditions and customs which inform the decorative arts are not necessarily the same as those expressed in the fine arts" and contradicting melting-pot assumptions that black Americans lost all vestiges of their own material culture. Vlach's vision of black culture as a living, dynamic, and often subtle fusion of African and European ingredients enriched the decorative arts fields' superficial understanding of tradition and reinforced the views of other scholars of ethnicity who reject static models of culture and tradition.

McDaniel's study examines the lives of black tenant farmers and landowners in southern Maryland after emancipation. Interested in the physical dimensions of life, McDaniel deals with houses and their furnishings in considerable detail. Like Swank, he recreates the spatial arrangements of several interiors, observing how even the smallest spaces were divided into functional zones. And while McDaniel is not a connoisseur of furnishings, he deftly utilizes interviews to convey a sense of the value and meaning specific objects held for their owners.[32]

Books like these by Swank and McDaniel raise questions about the exact nature of material culture. Is it a discipline, a method, or simply another body of data? In these two studies, material culture seems to be interpreted as data, albeit important data, in the service of larger social inquiry. Indeed, in recent years household objects have been discovered or, in many cases, rediscovered as important bodies of data that give a different comprehension and a different focus to historical studies. Two phenomena seem to have moved hand in hand: the diaspora following the dissolution of the myth-and-symbol school of American studies, and the belief that material culture can be a useful adjunct to, or even focus of, many of the newly attractive topics.

Studies of artisans and laborers, childhood, and women's lives have all benefited from intersections with material culture. In women's history this has included explorations of the everyday realities of housework by Susan Strasser, Ruth Schwartz Cowan, and others, and of the "material feminists" who sought alternative lives and work styles by Dolores Hayden. Harvey Green has drawn upon a wide range of

objects—wedding gowns, toys, rolling pins, irons, bustles, pessaries, calling cards, quilts, and many others—to create an artifactual portrait of women's lives in the nineteenth century.[33]

Quilts have become key objects for a number of women's and feminist studies. The earliest literature linked quilts closely to women's work and women's world. In the 1970s quilts became highly visible as art, largely because of their resemblance to the bold abstract patterns of contemporary high-culture painting. For Jonathan Holstein, a major proponent of the art orientation, the history of a quilt was of relatively little importance; what made it worth looking at was its strong visual similarity to abstract and minimalist painting. Patricia Mainardi's feminist manifesto was written partly in response to Holstein's view. For Mainardi, virtually nothing in women's lives from the past is not expressed in quilts. In the hands of other authors, quilts have also served as springboards to inquiries into memory, region, ethnicity, and tradition.[34]

Surveys of Materials and Functions

Despite all of these expanding circles of activity, surveys of materials (silver, pewter, glass) and functions (furniture, lighting, floor coverings) remain major genres. In some cases these studies respond to collecting interests or the needs of historic preservation or restoration, but in others a material or function may constitute a historically defensible approach. Regardless of the rationale, many authors seem intent on pushing this old category in new directions. Charles Carpenter's study of silver made by the Gorham Company goes beyond standard business histories or collectors' guides to survey the company's product line for 150 years. *Silver in American Life,* by Barbara McLean Ward and Gerald W. R. Ward, was intended "to examine silver in all its multi-faceted nature, in as broad a humanistic context as possible." This innovative, wide-ranging exhibition catalogue examines six themes in American silver: its qualities as a metal, its role as currency, the work processes of the traditional silversmith, the industrialization of silver manufacture in the nineteenth century, some of silver's social meanings, and changing styles in silver objects, particularly household furnishings. The catalogue component reinforces the text and includes objects ranging from silver ore, ingots, coins, silversmiths' tools, a fireman's trumpet, trophies, and jewelry to a thorough survey of silver objects for the home. Throughout, *Silver in American Life* maintains a solid foothold in material but builds bridges to other concerns and other scholars.[35]

Occasionally a single book defines and dominates a field. An example is Catherine Lynn's *Wallpaper in America,* one of the major recent works of American design history. Writing in an area with relatively little prior literature, Lynn charted in rich detail over two centuries of changes in wallpaper style, production, and use. While Lynn admits that she originally viewed the topic in rather narrow terms, her final text moves past design, technology, and business into cultural and social history, providing insights into concepts of the home, consumerism, women's roles, and changing aesthetic, moral, religious, and patriotic values in this country.[36]

American Furniture Studies: Preindustrial Period

Commenting on developments in all areas of decorative arts or historic object study is obviously impossible. By looking at furniture studies alone, I can give a sharper sense of recent intellectual orientations and provide entry into the largest and most active area of American scholarship concerned with historic furnishings. Because of pronounced differences between them, I will first discuss studies of early or preindustrial furniture, then move to works dealing with objects of the industrial age.

The literature of early or preindustrial furniture is dominated by the mutually reinforcing concerns of connoisseurship and regionalism. Connoisseurship serves to separate authentic from false, sometimes good (expensive) from bad (cheap), and to determine an object's origins, first by region, then, if possible, by maker. Regionalism is the study of regional variations in different types of furnishings. Its major concerns are to identify and explain these differences.[37] Significant statements about regionalism in early furniture appear in the work of Charles Montgomery and John Kirk.[38] Montgomery's essay in the Yale bicentennial exhibition catalogue argued that regional characteristics were shaped by the interaction of craft specialization and organization and local taste. Kirk's *American Chairs: Queen Anne and Chippendale* analyzed distinctive construction and design elements in chairs from six eighteenth-century "style centers," then offered tentative conclusions about parallels between regional aesthetics and linguistic regionalism. The most extensive and systematic study of regional characteristics is *The Work of Many Hands: Card Tables in Federal America, 1790–1820.* Staff of the Yale University Art Gallery cooperated with Benjamin Hewitt on a project to establish objectively verifiable data about the regional characteristics of one furniture form. In an outstanding example of what Michael Ettema calls "scientific antiquarianism" Hewitt used a com-

puter to track 176 characteristics drawn from 400 card tables. The results not only serve as a guide for making attributions but also reveal "ways in which Federal cabinetmakers utilized specialists and geared their production principally for customers of ready-made tables." Gerald Ward's accompanying essay on card playing may hold more interest to historians. Ward sought to explain not only how card tables were used but why card games were so popular in the early nineteenth century. As part of his answer he offered a functional and symbolic analysis of the once common game of loo.[39]

Nearly all studies of early furniture are structured around region, including the two most important early books in the field, Irving Lyon's *The Colonial Furniture of New England*, already mentioned, and William Hornor's *Blue Book—Philadelphia Furniture*. Lyon's book, initially published in 1891, was the first major study of American colonial furniture; nearly a century later it remains valuable and suggestive. Lyon's contributions were twofold. First, he established chronologies and determined period terminology and use. Secondly, his research identified and drew upon most of the major categories of documents still mined today, including wills, diaries, inventories, newspapers, receipts, and bills. Lyon also visited Britain and Europe in search of precedents and parallels to help him establish what might be called the basic facts of early American furniture history. When Lyon began, nearly all was uncertainty. When he was done, he had drawn the general contours that still shape furniture study.

Hornor's *Blue Book* is an expansive account of furniture produced in Philadelphia. Like Lyon, Hornor examined a vast range and number of documents, including at least 5,000 manuscripts, several hundred account books, and scores of printed volumes, newspapers, and other classes of documents, many of which were in private hands. What differentiates Hornor from Lyon was not only region and time—but emphasis as well. Lyon concentrated almost exclusively on furniture, but Hornor was interested in the social fabric of artisan and patron, producer and purchaser.[40]

The only other study on a par in terms of scale and impact is Charles F. Montgomery's *American Furniture: The Federal Period*. This monumental catalogue of part of the Winterthur Museum collections is prefaced by essays on the business of cabinetmaking and changes in labor that have influenced a number of subsequent artisan and process-centered studies.[41]

New England furniture has been studied more than that of any other region. Perhaps because the process of modernization struck New England before other parts of the country and because the region was

the center of America's intellectual and cultural life, collecting began early and a great many objects were preserved. Yet New England also seems to hold some mythic power in furniture studies, and unverbalized sentiments seem to endow its objects with added significance. Or it may be that the region's uncontestable artifactual richness and its abundant and accessible documentation hold great attraction for furniture scholars. Despite over a century of attention, however, attribution remains a continuing issue. Patricia Kane's *Furniture of New Haven Colony* summarized the colony's history up to the 1660s, but her major thrust was the use of style and motif to isolate four distinctive groups within the surviving body of furniture. *New London County Furniture* was an even more rigorous exercise in identification and attribution. In their attempts to link furniture to names, Minor Myers, Jr., and Edgar Mayhew developed an extensive checklist of makers, with outlines of their careers. They examined forty-six case pieces, dealing with both surface detail and more subtle matters of construction, identifying eighteen types of drawer-front and twenty-six types of drawer-back construction. This information, enhanced by minute examination of joints and even the angles of dovetails, enabled them to link objects to documented craftsmen.[42] *Boston Furniture of the Eighteenth Century* was less an exercise in connoisseurship than a series of essays by eight authors on characteristic objects and their contexts.[43] Brock Jobe's discussion of the Boston furniture industry between 1720 and 1740 drew on surviving account books to explore the structure and dynamics of the trade. Other essays dealt with particular forms or motifs and examined the career of a representative cabinetmaker.

Identification and attribution are the objectives of studies of furniture of most other regions, as well, whether those be Maryland, North Carolina, or Texas.[44] Wallace Gusler's *Furniture of Williamsburg and Eastern Virginia* also had a revisionist purpose, however. Analyzing documents, archeological evidence, and construction, woods, and other aspects of surviving objects, Gusler sought both to document a body of related high-style furniture made in eighteenth-century Williamsburg and to lay to rest the notion that Virginians imported from England all furniture of better quality. Although some shop attributions may be tenuous, this study represents a significant step in the ongoing re-evaluation of the material culture of the South. Two recent publications, *Eastern Shore, Virginia, Raised Panel Furniture, 1730–1830* and *Neat Pieces: The Plain-Style Furniture of 19th Century Georgia*, indicate that the interest in Southern material continues to grow. *Raised Panel Furniture* is clearly preliminary and neither its methodology nor its conclusions are completely developed, but it is noteworthy for demonstrating how long-

ignored areas sometimes turn out to be rich in artifacts of considerable historic and cultural interest. The mere presentation of over a hundred case pieces of distinctive panel construction requires furniture historians to redraw their mental maps of furniture in preindustrial America. *Neat Pieces* is significant for its close attention to thoroughly commonplace objects, documenting the intersection of localist, folkloric, and social history interests.[45]

In matters of attribution, method would seem to be critical, yet furniture historians have not often addressed the topic directly. Schlereth reprinted essays by Montgomery and E. McClung Fleming.[46] Montgomery's essay on connoisseurship was appealing when it first appeared in 1961, but his approach today seems far too subjective. Fleming's more subtle essay raised critical methodological questions and showed how most of them might be answered in the case of a seventeenth-century cupboard. Among the few notable subsequent methodological offerings are two articles by Phillip Zimmerman. In the first, "A Methodological Study in the Identification of Some Important Philadelphia Chippendale Furniture," Zimmerman articulated a system to examine both intrinsic data, like construction and workmanship, and extrinsic data, like histories of ordership and interpretation of style. The uses of extrinsic data are fairly obvious; Zimmerman's contribution lies in explicating ways to exploit intrinsic data. In a second article, "Workmanship as Evidence: A Model for Object Study," Zimmerman amplified his earlier arguments to show how close attention to workmanship could augment understanding of the ways objects were conceived and produced. Drawing from David Pye the idea of the workmanship of certainty and from Benno Forman the notion of workmanship of habit, Zimmerman formulated an examination procedure for objects—in this specific case, Philadelphia chairs in the Chippendale manner. Attention to clues of workmanship of certainty and habit helped him not only to assign seemingly unrelated chairs to the same shops but to posit more general conclusions about the processes of chairmaking in eighteenth-century Philadelphia. Crucial to Zimmerman's analysis was his understanding of eighteenth-century chairs as products of a commercial system and not just works of art.[47]

New Directions in Preindustrial Furniture Studies

The work of three other young scholars of early furniture, Robert F. Trent, Robert St. George, and Edward S. Cooke, Jr., expands the potential of regionally based furniture studies to claim new intellectual territory. Like Zimmerman, these three are graduates of the Winterthur Program in Early American Culture, and all had studied with the late

Benno M. Forman. All three made major statements in catalogues of exhibitions at New England historical societies. With their work, furniture history becomes American Studies.

Robert F. Trent's 1977 *Hearts & Crowns* was a turning point in American furniture study. When it appeared it was the most conceptually aggressive and probing decorative arts exhibition catalogue yet produced. *Hearts & Crowns* was pivotal in expanding and diversifying furniture studies, for it established the validity of studying vernacular furniture while emphatically rejecting three cherished and largely unexamined assumptions of American decorative arts scholarship: "London, via Boston and New York, was the style center for the northern English colonies; masterpieces are the proper object of research; and folk art is a degenerate or at least garbled version of high style forms." Trent traced one specific form of vernacular furniture, the so-called heart-and-crown chair of the Connecticut coast, from its probable introduction by immigrant British artisans to its eventual obsolescence. In recording the life of a single form of a relatively cheap chair over more than a century, Trent outlined the ways makers transformed or adjusted their basic design in response to "challenges" of new design ideas. Both the basic chair form and the shops producing it remained viable until finally run out of business by mass-produced fancy chairs in the early nineteenth century. More important than Trent's history of the form was his imaginative synthesis of ideas drawn from Henri Focillon, George Kubler, and Henry Glassie to generate a system to evaluate objects in terms of the culture that produced them rather than in terms of presentist, high-art analysis or the often condescending concept of folk art. Like *An Anti-Catalogue* of the same year, Trent brought political awareness to furniture study and in so doing both polarized and invigorated the field.[48]

The work of Robert St. George combines interest in culture transfer with what might be called, borrowing from Howard Gardner, the search for mind. St. George's study "Style and Structure in the Joinery of Dedham and Medfield, Massachusetts, 1635–1685" drew on the writings of a diverse group, including Kenneth Lockridge, David Grayson Allen, George Kubler, Benno Forman, Patricia Kane, Henry Glassie, Claude Lévi-Strauss, and others, in an ambitious attempt to reconstruct "the cumulative reality of New England in the seventeenth-century." St. George moved from minute examination of two carved oak panels from the original 1655 pulpit of the first meeting house in Dedham through an analysis of what he termed "artifactual dialect" in over a dozen surviving objects to speculate on those objects' roles in their culture. He attempted to show how "emphasis on maintaining stand-

ards of workmanlike and artificial competence by the joiner's trade" indicated "a need to assert and perpetuate one artifactual language— one order—that was acceptable to the immediate community." In examining specific ways Dedham and Medfield joiners imprinted their "own old England on the New England void," St. George hoped to demonstrate how scholars might "pierce deep into the subjective reality" of another age. In his analysis, the Dedham and Medfield artifacts were "the psychology reality of the seventeenth-century New England yeoman embodied in physical form."[49]

St. George continued his explorations into everyday life in seventeenth-century New England in *The Wrought Covenant*. His introduction to this exhibition catalogue was a richly textured and subtle manifesto calling for a combination of the perspectives of history and anthropology to produce "an historical analysis of expressive behavior." For St. George an essential prerequisite for analyzing expressive behavior in seventeenth-century New England is understanding the English regional subcultures that provided craftsmen with their systems of conceptualizing and making artifacts and furnished their communities with corresponding ideas of appropriateness. Equally important is the concept of artificiality, "the capacity to consistently achieve and display a high degree of control over workmanship" and the craftsman's role of upholding its standards. With these ideas in mind, St. George examined the artifacts "as part of a complex communicative process between makers and users" and as "intellectual and behavioral achievements." Extensive documentary clusters, including objects, a checklist of craftsmen, extracts from inventories, and a bibliography, provide specificity for St. George's arguments and give *The Wrought Covenant* value as both reference tool and statement of theory.[50]

St. George's recent essay in *New England Begins* reaches out beyond the study of single classes of artifacts or clusters of craftsmen to encompass a rich historic ethnography of seventeenth-century New England life. His major themes are the ways "the yeoman ordered the space and time in which he thought and worked." He weaves together an impressive variety of artifactual threads ranging from fields, farmyards, barns, and fences to houses, furnishings, and even clothing, crafting them into a thickly textured interpretative fabric. St. George glides from examinations of details of specific objects to suggestive conceptualizations as he traces changes in "attitudes towards space, time, and the human body" that took place during the seventeenth century.[51]

Cooke's work fits within the rubric of social function. His major publication is *Fiddlebacks and Crooked-backs*, a study that set out to explain

why furniture of the second half of the eighteenth century and the early years of the nineteenth produced in two western Connecticut towns only eighteen miles apart should be so notably different. Cooke found answers in differences in the towns' social and economic structures. Newtown was a conservative farming community that supported the farmer-craftsmen. Woodbury was a growing commercial center that drew independent entrepreneurial craftsmen more responsive to design ideas of larger metropolitan areas. Cooke's methodical examination of documents and objects provides historic illustrations of the now familiar sociological distinction between locals and cosmopolitans.[52]

Although not a concern for Cooke, Trent and St. George dealt with the transfer of culture from Europe, particularly England. Their well-grounded treatments stand in marked contrast to the unsupported and often chauvinistic assumptions about the Americanness of American furniture bandied about over the years. Many claims for the unique qualities of early American furniture reveal more about their authors' ignorance than about furniture and fall flat in the face of John T. Kirk's *American Furniture and the British Tradition to 1830*. Kirk surveyed working methods, forms, decorative motifs, and constructional details of British and American furniture before 1830 to show how American furniture was almost entirely an extension and continuation of British design traditions. As for American invention, Kirk found it limited to very few objects and then usually expressed in "the movement of a dominant line."[53]

Studies of Furniture in the Industrial Age

Studies of furniture made after 1840 or so differ from those of earlier periods in a couple of ways. First, they are much less common. As I noted earlier, the contours of furniture study were already being laid out in the late nineteenth century, when Victorian materials were neither old nor interesting to antiquarians, reformers, or patriots. While occasional books and articles appeared from the 1920s onward, the field only began to coalesce about 1970. Second, and more noteworthy, are the divergences in method, focus, and ultimately, purpose. Nineteenth-century studies generally deal less with connoisseurship, region, or cultural transfer than do studies of earlier periods. And in place of the latter's almost complete absorption with craftsmen and artisans, later studies turn more to customers and consumers. This distinction may reflect a perceived shift in the location of culturally expressive actions or, more likely, it may indicate differences in the political and cultural agendas of those involved.

This is not the place to launch into a full-scale examination of the changing evaluations of the nineteenth century and its products. It should be enough to remember that studies of some nineteenth-century materials have met considerable resistance. In art circles exceptions were usually made for "masterpieces" or for objects like patented furniture or chairs designed by architects that seemed to serve the ideology of modern high art, but products of mass culture were usually spurned.[54] One familiar justification was the claim that they represented the nadir of taste and that somehow mechanization was to blame. Thus, instead of seeing eighteenth- and nineteenth-century materials on a continuum, popular vision saw them in opposition: craft opposed to industry, simplicity opposed to pomp, innocence opposed to degeneracy. The early material fit the need to escape from modernization, was cast as its inverse image, and was therefore good; the later material was indisputably a product of that modernization, was cast as cultural scapegoat, and was therefore bad. This dichotomy may seem overdrawn, but when one author attempted to write objectively about Victorian materials in 1975 he was lauded for looking at the subject "with eyes undimmed by the murk of moral condemnation."[55]

Michael Ettema has specifically addressed the technologically determinist view that mechanization was responsible for the appearance of Victorian furniture. He argues that historians and critics overestimate the transformational power of machinery in the nineteenth century and that industrialization had relatively little impact on furniture design. After carefully studying the actual capabilities of nineteenth-century woodworking machinery, Ettema concluded that machinery least affected high-style, trend-setting furniture because expensive ornament could not be replicated inexpensively; where the machine made its impact was on inexpensive furniture. In other words, mechanization made possible proliferation, not elaboration. Like Zimmerman, Ettema rejected the idea of furniture-making as a "decorative art," preferring to see it as a consumer industry controlled by what he called "the economics of design."[56]

One reason that connoisseurship and attribution are not major issues for those who deal with nineteenth-century materials is because the last century's self-conscious record-keeping and its communications revolution have left today's scholars with vast amounts of documentation, much of it in forms rare or unknown in earlier periods. One study, for instance, drew upon the published catalogues of world's fairs to outline patterns of conflict in international high culture. "The Battle of the Sideboards" demonstrated how sideboards became vehicles for stylistic and cultural values and symbols of cultural hegemony. A visual

analysis of Grand Rapids furniture of the 1870s, on the other hand, relied heavily on photographic images from period trade catalogues rather than on actual furniture. The catalogues constituted a controlled and internally consistent body of data that could not easily be replicated on the same scale with surviving objects and proved entirely adequate for the purpose of examining design conventions. In fact, because they illustrated modes of upholstery now lost, the photographs were superior to extant objects that had been reupholstered and thereby falsified.[57]

As studies examine topics closer to the present, documentation grows richer and more diversified. Cheryl Robertson drew on extensive personal and professional papers in the Prairie Archives at the Milwaukee Art Museum to write *The Domestic Scene*, a monograph on the work of early twentieth-century interior designer George Niedecken. David Hanks's art-oriented study of Frank Lloyd Wright's decorative work and Randall Makinson's examination of the West Coast design team of Greene & Greene were similarly based in substantial collections of designs and documented objects.[58] The logical final step in this movement toward increased documentation and decreased distance between subject and object is Michael Owen Jones's brilliant book, *The Hand Made Object and Its Maker*. This is not history but a behavioral analysis of a contemporary and in some ways traditional rural chairmaker who exhibited archaic and idiosyncratic personal traits but also made extraordinary chairs. In writing this essay in folkloric and artisan theory, Jones dipped deep into the literature of creativity and craft but also spent a good deal of time observing and talking to the chairmaker himself. Only autobiography takes us closer to the creative process.[59]

Another current in later furniture study links objects to social history. *The Rocking Chair Book*, for example, was a fresh and lively survey of that artifact offering not only a general history of the object but comments on the conscious and unconscious meanings of these chairs in three centuries of American life.[60] Other studies have tried to show how household artifacts of Victorian America could be incorporated into discussions of both environments and mentality. Some of my own studies combine sociological orientations drawn from Peter Berger, Erving Goffman, Robert Merton, and Thorstein Veblen, the social function approach of Alan Gowans, and extensive visual analysis to attempt to understand the social meanings and uses of specific objects. In examining nineteenth-century hall stands I tried to demonstrate how those objects met culture-specific utilitarian, social, and psychological needs. A later article by Leslie A. Greene, "The Late Victorian Hall-

stand: A Social History,'' traced the subsequent decline of the hall stand as a status-conferring object in the later years of the last century, as attitudes about the hall and its actual shape and function were changed. Her compact discussion deftly wove together issues of social class, style, and presentation of self.[61]

In an investigation of Victorian parlor organs I took another tack, examining ways those objects were used as nonverbal tools in broad social strategies. Drawing particularly on the evidence of late nineteenth-century advertising images, I tried to argue that Victorians valued parlor organs not only for their manifest function of making music but as props to help them engage in and extend conventionalized social roles, to promote social and cultural continuity over time, to insure social bonding, and to enhance their lives by providing occasions for self-actualization.[62]

Students of this later period have recognized that some objects carry more cultural meaning or weight at a given moment than others. For Diane Douglas, the nineteenth-century sewing machine fit this description. In ''The Machine in the Parlor: A Dialectical Analysis of the Sewing Machine,'' she examined the complex interplay between the sewing machine and nineteenth-century American attitudes and values. She argued that when the sewing machine entered the home it brought into that private, female-dominated, spiritual space part of the outer masculine world of power and industry. Primarily used by women, the sewing machine became a focal point in nineteenth-century debates over women's appropriate role and was preempted for arguments on both sides. Douglas first used contemporary texts and images to show how the machine figured in debates over social issues, then turned to analysis of the physical form of the sewing machine to argue that patterns of reconciliation of social alternatives were echoed in patterns of reconciliation of design alternatives.[63]

For Christopher Monkhouse, the spinning wheel was a critical symbol and reminder of preindustrial America and Puritan New England to the nineteenth-century mind. In his study of Victorian interpretations of that object he traced its unfailingly prominent place in restorations and written and pictorial accounts of colonial America. Although a machine rather than a piece of furniture in the eighteenth century, by the late nineteenth century spinning wheel parts were being recombined to create spinning wheel chairs and rockers. These objects with dual purposes indicate not only the high symbolic value of the spinning wheel but the prominence of chairs and rockers as vehicles for cultural values.[64]

LOOKING TO THE FUTURE

These examinations of rocking chairs, hall stands, parlor organs, and sewing machines go well beyond object identification, connoisseurship, and the accumulation of facts. Along with the studies by Trent, St. George, Cooke, Ettema, the Wards, Lynn, and many others, they are part of a process of broadening the definition of appropriate objects for study, introducing new methods of research, exploring more far-ranging cultural issues, and reaching out to speak a common language with scholars in other fields. Object studies have moved closer to intellectual and academic mainstreams in the late twentieth century. It will be difficult, for example, to speak about everyday life in seventeenth-century New England without some reference to *New England Begins*. Here, and in a half a dozen other instances, the once fusty reference shelf catalogue has been transformed into a major vehicle of interpretation and theory.

The utility of household furnishings for historical studies has been clearly established. These artifacts are not relevant to all historical issues but they do illuminate many, particularly those that relate to values and meaning in everyday life. What we need now are not more manifestos claiming objects are relevant but more people showing how they are. I should make it clear, however, that the study of furnishings is still a very small field. Few within it have addressed the same data, let alone the same questions or assumptions. To have written this essay in terms of issues or controversies would have misrepresented the field and created a false sense of interaction. The study of decorative arts/ household artifacts is still an underpopulated field in need of immigrants and agitators.

Obtaining a critical mass of active scholars would be one step toward creating a field where one person's work overlaps with another's, where concerns are shared and explored by groups and not isolated individuals. More people and more studies can help sharpen the field's focus, identify major issues and build the body of theory every vital field needs. As Robert St. George has reminded me repeatedly, a field that organizes conferences or publications around materials or periods rather than issues or questions still has a lot of maturing to do.

Those who read even the most progressive or ambitious literature in this field will recognize that it, like the larger field of American Studies, is also largely derivative in its theory. What critics see as academic posturings in some scholars' work are efforts to push their minds as far

as possible in searches for new ways to think about and understand objects. Much very basic and exciting documentary work also needs to be done. Scores of categories of objects remain to be studied in depth and examined as they move and change over time, space, and social class.

Because objects are as diverse as the people who make and use them and because these times favor academic pluralism, experimental studies drawing on objects will probably go in many different directions. The publications discussed here have already suggested ways in which furnishings can be used in examinations of technology, business, women's roles, artisans and craftsmen, design values, industrialization, domestic space, patterns of daily life, and a long list of related subjects. More work in all of these will be welcome. Ambitious writers may try to draw upon objects to trace sweeping historical transformations like modernization or the consumer revolution.[65] Regardless of focus, however, many historically oriented studies will probably operate under the assumption that objects are documents that, taking into account their own peculiarities, can be mined more or less like other documents to answer specific historical questions. We will then need to take into fuller consideration suggestions like Bernard Herman's that objects are not the same in their communicative or documentary value. Herman's claim that houses indicate what people hope to be, while smaller objects like ceramics reveal what they actually became, requires qualification but alerts us once again to the recognition that our use of objects as documents urgently needs sophistication and systematization, not to mention some sort of objective verification.[66]

If it is also possible, however, that objects are specific classes of behavior, experience, and reality that are fully comprehended in neither the past nor the present, then the need for entirely different questions and strategies will emerge. These will bring us back full circle to an investigation of the basic and persisting behaviors that lie unexamined at the root of studies on decorative arts and household furnishing.[67] Students of objects still do not really understand collecting, the behavior that is the eternal parent of this field. They still do not have compelling explanations of why museums appeal to people or why exhibitions attract visitors. Nor can those who study objects yet fully explain the undeniable fascination that objects possess and the unreasoned spells they cast. American scholars have not been particularly interested in identifying or understanding the most fundamental relationships between people and objects. Attempts to seek those understandings may completely reshape the field.

NOTES

1. Thomas J. Schlereth, *Material Culture Studies in America* (Nashville, Tenn.: American Association for State and Local History, 1982).

2. Richard H. Saunders, *American Decorative Arts Collecting in New England, 1840–1920* (M.A. thesis, University of Delaware, 1973); Elizabeth Stillinger, *The Antiquers* (New York: Knopf, 1980). Alan Axelrod, ed., *The Colonial Revival in America* (New York: W. W. Norton, 1985).

3. *The China Hunters' Club by the Youngest Member* (New York: Harper and Brothers, 1878); John H. Buck, *Old Plate, Ecclesiastical, Decorative, and Domestic: Its Makers and Marks* (New York: Gorham Manufacturing Co., 1888); Irving W. Lyon, *The Colonial Furniture of New England* (1891; reprint New York: E. P. Dutton, 1977); Alice Morse Earle, *China Collecting in America* (New York: Scribner's Sons, 1892); Edwin Atlee Barber, *The Pottery and Porcelain of the United States* (1893; revised edition New York: G. P. Putnam's Sons, 1901); R. T. Haines Halsey, *Pictures of Early New York on Dark Blue Stafford Shire Pottery* (New York: Dodd and Mead, 1899).

4. Schlereth, *Material Culture Studies*; Stillinger, *The Antiquers*; Charles B. Hosmer, Jr., *Presence of the Past; a History of the Preservation Movement in the United States before Williamsburg* (New York: Putnam, 1965), and *Preservation Comes of Age: From Williamsburg to the National Trust, 1926–1949* (Charlottesville: University Press of Virginia for the National Trust for Historic Preservation, 1980).

5. Esther Singleton, *The Furniture of Our Forefathers* (New York: Doubleday, Page & Co., 1900–1901); Luke Vincent Lockwood, *Colonial Furniture in America* (New York: C. Scribner's Sons, 1901); E. Alfred Jones, *The Old Silver of American Churches* (Letchworth: The Arden Press for the National Society of Colonial Dames of America, 1913); Frederick William Hunter, *Stiegel Glass* (New York: Houghton Mifflin, 1914); Ada Walker Camehl, *The Blue-China Book* (New York: E. P. Dutton, 1916); Francis Hill Bigelow, *Historic Silver of the Colonies and Its Makers* (1917; reprint New York: Tudor Publishing Co., 1948); Ethel Stanwood Bolton and Eva Johnston Coe, *American Samplers* (Boston: Massachusetts Society of the Colonial Dames of America, 1921). J. B. Kerfoot, *American Pewter* (1924; reprint New York: Crown Publishers, 1942); Stephen van Rensselaer, *Early American Bottles and Flasks* (Peterborough: Transcript Printing Co., 1926); Rhea Mansfield Knittle, *Early American Glass* (New York: The Century Co., 1927); J. Seymour Lindsay, *Iron and Brass Implements of the English and American House* (1927; reprint Bass River, Mass.: Carl Jacobs, 1964); Wallace Nutting, *Furniture Treasury* (1928; reprint New York: Macmillan, 1954); Albert H. Sonn, *Early American Wrought Iron* (1928; reprint New York: Hacker Art Books, 1978). The events of the twenties are summarized in Neil Harris, *Winterthur and America's Museum Age* (Winterthur: Winterthur Museum, 1981). For a discussion of Halsey's role in installing the Metropolitan's American Wing, see Wendy Kaplan, "R. T. H. Halsey: An Ideology of Collecting American Decorative Arts," *Winterthur Portfolio* (hereafter cited as *WP*) 17:1 (Spring 1982): 43–53.

6. Examples of collecting and decorating books include: Robert and Elizabeth Shackleton, *The Quest of the Colonial* (New York: The Century Co., 1907); Virginia Robie, *The Quest of the Quaint* (Boston: Little, Brown & Co., 1916); Alice Van Leer Carrick, *Collector's Luck, or a Repository of Pleasant and Profitable Discourses Descriptive of the Household Furniture and Ornaments of Olden Times* (Boston: Atlantic Monthly Press, 1919); Carrick, *The Next-to-Nothing House*

(Boston: Atlantic Monthly Press, 1922); and Helen Koues, *On Decorating the House in the Early American, Colonial, English and Spanish Manner* (New York: Tudor Publishing Co., 1928). Cornelius Obenchain Van Loot, Milton Kilgallen, and Murgatroyd Elphinstone (pseuds.), *The Collector's Whatnot: A Compendium, Manual, and Syllabus of Information and Advice on All Subjects Apertaining to the Collection of Antiques, both Ancient and Not so Ancient* (Boston and New York: Houghton Mifflin, 1923); Kenneth L. Roberts, ed., *Antiquamania* (Garden City: Doubleday, Doran & Co., 1928).

7. Alan Gowans, *Images of American Living: Four Centuries of Architecture and Furniture as Cultural Expression* (Philadelphia & New York: J. B. Lippincott, 1964); Siegfried Giedion, *Mechanization Takes Command: A Contribution to Anonymous History* (New York: Oxford University Press, 1948, 1955).

8. Jay Anderson, "Living History: Simulating Everyday Life in Living Museums," *American Quarterly* 34 (1982): 290-306.

9. *Antiques*, now over sixty years old, has been guided by three editors: Homer Eaton Keyes (1922-1938), Alice Winchester (1938-1972), and Wendell Garrett (1972-).

10. George L. Miller, "Marketing Ceramics in North America: An Introduction," *WP* 19:1 (Spring 1984): 1.

11. Analyses and critiques of art history appear in W. Eugene Kleinbauer, *Modern Perspectives in Western Art History* (New York: Holt, Rinehart and Winston, 1971); James S. Ackerman and Rhys Carpenter, *Art and Archaeology* (Englewood Cliffs: Prentice-Hall, 1963); Theodore K. Rabb, "The Historian and the Art Historian," *Journal of Interdisciplinary History* 4 (1973): 107-117, and Kenneth L. Ames, "Folk Art: The Challenge and the Promise," in Ian M. G. Quimby and Scott T. Swank, eds. *Perspectives on American Folk Art* (New York: W. W. Norton for the Winterthur Museum, 1980), 293-324.

12. Svetlana Alpers, "Is Art History?" *Daedalus* 106:3 (Summer 1977): 1-13.

13. Wendy A. Cooper, in "Forum," *WP* 17 (1982): 261-62.

14. Henry Hawley, in "Forum," *WP* 17 (1982): 262-64.

15. Michael J. Ettema, "History, Nostalgia, and American Furniture," *WP* 17 (1982): 135-44. One attempt to demonstrate the conceptual inferiority of decorative arts draws on Piaget's levels of cognitive development: Suzi Gablik, *Progress in Art* (New York: Rizzoli, 1977). Karal Ann Marling, review of W. I. Homer, *Alfred Stieglitz and the Photo-Secession, WP* 19:1 (Spring 1984): 100.

16. Alan Gowans, *Learning to See: Historical Perspectives on Modern Popular/ Commercial Arts* (Bowling Green: Popular Press, 1981), 4.

17. Jules David Prown, in "Forum," *WP* 17 (1982): 260.

18. Jules David Prown, "Mind in Matter: An Introduction to Material Culture Theory and Method," *WP* 17:1 (Spring 1982): 1-19; Prown, "Style as Evidence," *WP* 15:3 (Autumn 1980): 197-210.

19. Gene Wise, " 'Paradigm Dramas' in American Studies: A Cultural and Institutional History of the Movement," *American Quarterly* 31 (1979): 293-337.

20. Edgar de N. Mayhew and Minor Myers, Jr., *A Documentary History of American Interiors, from the Colonial Era to 1915* (New York: Charles Scribner's Sons, 1980). Arthur J. Pulos, *American Design Ethnic: A History of Industrial Design to 1940* (Cambridge: MIT Press, 1983). Although many surveys of interiors have been published, most are intended as texts for interior designers. Studies more useful to students of American culture include works of basic documentation, like Abbott Lowell Cummings, ed., *Rural Household Inventories* (Boston: The

Society for the Preservation of New England Antiquities, 1964); and architecturally and culturally oriented works, like David P. Handlin, *The American Home* (Boston: Little, Brown, 1979), Dolores Hayden, *The Grand Domestic Revolution* (Cambridge: MIT Press, 1981), George B. Tatum, *Philadelphia Georgian* (Middletown: Wesleyan University Press, 1976), Nicholas B. Wainwright, *Colonial Grandeur in Philadelphia* (Philadelphia: The Historical Society of Pennsylvania, 1964), and Gwendolyn Wright, *Building the Dream* (New York: Pantheon Books, 1981), and *Moralism and the Model Home* (Chicago: University of Chicago Press, 1980).

Photography is an organizing theme in Joseph Byron, *New York Interiors at the Turn of the Century* (New York: Dover, 1976); William Seale, *The Tasteful Interlude* (2nd ed. Nashville: American Association for State and Local History, 1981), and George Talbot, *At Home: Domestic Life in the Post-Centennial Era* (Madison: State Historical Society of Wisconsin, 1976). Museum and historic house considerations dominate Roderic H. Blackburn, *Cherry Hill: The History and Collections of a Van Rensselaer Family* (Albany: Historic Cherry Hill, 1976), Harold L. Peterson, *Americans at Home* (New York: Charles Scribner's Sons, 1971), and William Seale, *Recreating the Historic House Interior* (Nashville: American Association for State and Local History, 1979). For nonelite culture, see Lizabeth A. Cohen, ''Embellishing a Life of Labor: An Interpretation of the Material Culture of American Working-class Homes,'' *Journal of American Culture* 3 (1980): 752–75, and George W. McDaniel, *Hearth and Home* (Philadelphia: Temple University Press, 1982). The best examination of the educational potential of historic houses is Thomas J. Schlereth, *Historic House Museums: Seven Teaching Strategies* (Nashville: American Association for State and Local History, 1978).

21. Wendy A. Cooper, *In Praise of America: American Decorative Arts, 1650–1830/Fifty Years of Discovery Since the 1929 Girl Scouts Loan Exhibition* (New York: Knopf, 1980); Charles F. Montgomery and Patricia E. Kane, eds., *American Art: 1750–1800, Towards Independence* (Boston: New York Graphic Society for Yale University Art Gallery and The Victoria and Albert Museum, 1976).

22. Metropolitan Museum of Art, *19th-Century America: Furniture and Other Decorative Arts* (New York: Metropolitan Museum of Art, 1970).

23. Newark Museum, *Classical America, 1815–1845* (Newark: The Newark Museum Association, 1963); Museum of Fine Arts, Houston, *The Gothic Revival Style in America, 1830–1870* (Houston: The Museum of Fine Arts, 1976); Robert Judson Clark, ed., *The Arts and Crafts Movement in America, 1876–1916* (Princeton: Princeton University Press, 1972); Robert Judson Clark, ed., ''Aspects of the Arts and Crafts Movement in America,'' *Record of the Art Museum, Princeton University* 34 (1975). A good recent examination of one arts-and-crafts community is William Ayres and Ann Barton Brown, eds., *A Poor Sort of Heaven, a Good Sort of Earth: The Rose Valley Arts and Crafts Experiment* (Chadds Ford, Pa.: Brandywine River Museum, 1983).

24. Brooklyn Museum, *The American Renaissance, 1876–1917* (Brooklyn: The Brooklyn Museum, 1979).

25. Department of American Decorative Arts and Sculpture and Jonathan L. Fairbanks, *New England Begins: The Seventeenth Century,* ed. Judy Spear and Margaret Jupe, 3 vols. (Boston: Museum of Fine Arts, 1982).

26. Philadelphia Museum of Art, *Philadelphia: Three Centuries of American Art* (Philadelphia Museum of Art, 1976); Dean F. Failey et al., *Long Island Is My*

Nation: The Decorative Arts and Craftsmen, 1640–1830 (Setauket, N.Y.: Society for the Preservation of Long Island Antiquities, 1976).

27. Beatrice B. Garvan, *The Pennsylvania German Collection* (Philadelphia: Philadelphia Museum of Art, 1982); Beatrice B. Garvan and Charles F. Hummel, *The Pennsylvania Germans: A Celebration of Their Arts, 1683–1850* (Philadelphia: Philadelphia Museum of Art, 1982); Scott T. Swank, ed., *Arts of the Pennsylvania Germans* (New York: W. W. Norton for the Winterthur Museum, 1983).

28. For a summary of their work, see *Shaker: Furniture and Objects from the Faith and Edward Deming Andrews Collections Commemorating the Bicentenary of the American Shakers* (Washington: Smithsonian Institution Press, 1973).

29. Charles van Ravenswaay, *The Arts and Architecture of German Settlements in Missouri* (Columbia: University of Missouri Press, 1977).

30. John Bivens, Jr., and Paula Welshimer, *Moravian Decorative Arts in North Carolina: An Introduction to the Old Salem Collection* (Winston-Salem: Old Salem, Inc., 1981).

31. Museum of Fine Arts, Boston, *Frontier America: The Far West* (Boston: Museum of Fine Arts, 1975); Carolyn Gilman et al., *Where Two Worlds Meet: The Great Lakes Fur Trade* (St. Paul: Minnesota Historical Society, 1982).

32. John Michael Vlach, *The Afro-American Tradition in Decorative Arts* (Cleveland: Cleveland Museum of Art, 1976); McDaniel, *Hearth and Home.*

33. For artisans, see Ralph Rinzler and Robert Sayers, "The Meaders Family: North Georgia Potters," *Smithsonian Folklife Studies* 1 (Washington: Smithsonian Institution Press, 1980), and Ian M. G. Quimby, ed., *The Craftsman in Early America* (New York: W. W. Norton for the Winterthur Museum, 1984). Mary Lynn Stevens Heininger et al., *A Century of Childhood, 1820–1920* (Rochester: The Margaret Woodbury Strong Museum, 1984). Susan Strasser, *Never Done: A History of American Housework* (New York: Pantheon Books, 1982); Ruth Schwartz Cowan, *More Work for Mother: The Ironies of Household Technology from the Open Hearth to the Microwave* (New York: Basic Books, 1983); Dolores Hayden, *The Grand Domestic Revolution: A History of Feminist Designs for American Homes, Neighborhoods, and Cities* (Cambridge: MIT Press, 1981). Harvey Green, *The Light of the Home: An Intimate View of the Lives of Women in Victorian America* (New York: Pantheon Books, 1983).

34. Robert Bishop and Elizabeth Safanda, *A Gallery of Amish Quilts* (New York: E. P. Dutton, 1976); Mary Washington Clark, *Kentucky Quilts and Their Makers* (Lexington: The University Press of Kentucky, 1976); Patricia Cooper and Norma Bradley Buferd, *The Quilters: Women and Domestic Art* (Garden City: Doubleday, 1977); Jonathan Holstein, *The Pieced Quilt: An American Design Tradition* (Greenwich, Conn.: New York Graphic Society, 1973); Jonathan Holstein and John Finley, *Kentucky Quilts 1800–1900* (Louisville: Kentucky Quilt Project, 1982); Stella M. Jones, *Hawaiian Quilts* (Honolulu: Daughters of Hawaii, Honolulu Academy of Arts, and Mission Houses Museum, 1973); Dena S. Katzenberg, *Baltimore Album Quilts* (Baltimore: Baltimore Museum of Art, 1981); Patricia Mainardi, "Quilts: The Great American Art," *The Feminist Art Journal* 2 (Winter 1973): 1, 18–23; Patsy and Myron Orlofsky, *Quilts in America* (New York: McGraw-Hill, 1974); Susan Roach and Lorrie M. Weidlich, "Quilt Making In America: A Selected Bibliography," *Folklore Feminists Communication* 3 (Spring 1974): 5, 17–28; Susan Stewart, "Sociological Aspects of Quilting in Three Brethren Churches in Southeastern Pennsylvania," *Pennsylvania Folklife* 23:3 (Spring 1974): 15–29; John Michael Vlach, "Quilting," *The Afro-American Tradi-*

tion, 44–75; Maude Southwell Wahlman and John Scully, "Aesthetic Principles in Afro-American Quilts," William Ferris, ed., *Afro-American Folk Art and Crafts* (Boston: G. K. Hall & Co., 1983).

35. Charles H. Carpenter, Jr., *Gorham Silver, 1831–1981* (New York: Dodd, Mead, 1982); Barbara McLean Ward and Gerald W. R. Ward, eds., *Silver in American Life: Selections from the Mabel Brady Garven and Other Collections at Yale University* (New York: American Federation of Arts, 1979), xiii.

36. Catherine Lynn, *Wallpaper in America: From the Seventeenth Century to World War I* (New York: A Barra Foundation/Cooper Hewitt Book, W. W. Norton, 1980).

37. Cooper, *In Praise of America,* 156–209.

38. Charles F. Montgomery, "Regional Preferences and Characteristics in American Decorative Arts, 1750–1800," Montgomery and Kane, eds, *American Art: 1750–1800,* 50–65; John T. Kirk, *American Chairs: Queen Anne and Chippendale* (New York: Knopf, 1972).

39. Benjamin A. Hewitt, Patricia E. Kane, and Gerald W. R. Ward, *The Work of Many Hands: Card Tables in Federal America, 1790–1820* (New Haven: Yale University Art Gallery, 1982), 55; Ettema, "History, Nostalgia, and American Furniture," 137; Gerald W. R. Ward, "'Avarice and Conviviality': Card Playing in Federal America," Hewitt, Kane, and Ward, *The Work of Many Hands,* 15–38.

40. William MacPherson Hornor, Jr., *Blue Book—Philadelphia Furniture: William Penn to George Washington* (1935; reprint Washington, D.C.: Highland House, 1977).

41. Charles F. Montgomery, *American Furniture: The Federal Period, in the Henry Francis du Pont Winterthur Museum* (New York: Viking, 1966).

42. Patricia E. Kane, *Furniture of New Haven Colony: The Seventeenth Century Style* (New Haven: The New Haven Colony Historical Society, 1973); The Lyman Allyn Museum, *New London County Furniture, 1640–1840* (New London: The Lyman Allyn Museum, 1974).

43. Walter Muir Whitehill, ed., *Boston Furniture of the Eighteenth Century* (Boston: Colonial Society of Massachusetts, 1974).

44. Baltimore Museum of Art, *Baltimore Painted Furniture, 1800–1840* (Baltimore: Baltimore Museum of Art, 1972); Cecilia Steinfelds and Donald Lewis Stover, *Early Texas Furniture and Decorative Arts* (San Antonio: Trinity University Press, 1974); Lonn Taylor and David B. Warren, *Texas Furniture: The Cabinetmakers and Their Work, 1840–1880* (Austin: University of Texas Press, 1975); Museum of Early Southern Decorative Arts, *The Swisegood School of Cabinetmaking* (Winston-Salem: Museum of Early Southern Decorative Arts, 1973); North Carolina Museum of History, *Thomas Day, Cabinetmaker* (Raleigh: North Carolina Museum of History, 1975).

45. Wallace B. Gusler, *Furniture of Williamsburg and Eastern Virginia, 1710–1790* (Richmond: Virginia Museum, 1979); James R. Melchor, N. Gordon Lohr, and Marilyn M. Melchor, *Eastern Shore, Virginia Raised-Panel Furniture, 1730– 1830* (Norfolk: The Chrysler Museum, 1982); *Neat Pieces: The Plain-Style Furniture of 19th Century Georgia* (Atlanta: Atlanta Historical Society, 1983).

46. Charles F. Montgomery, "Some Remarks on the Practice and Science of Connoisseurship," *American Walpole Society Notebook* (1961), 7–20; E. McClung Fleming, "Artifact Study: A Proposed Model," *WP* 9 (1974): 153–73.

47. Philip D. Zimmerman, "A Methodological Study in the Identification of Some Important Philadelphia Chippendale Furniture," *WP* 13 (1979): 193–208;

Philip D. Zimmerman, "Workmanship as Evidence: A Model for Object Study," *WP* 16 (1981): 283–307.

48. Robert F. Trent, *Hearts and Crowns: Folk Chairs of the Connecticut Coast, 1720–1840, as Viewed in the Light of Henri Focillon's Introduction to "Art Populaire"* (New Haven: New Haven Colony Historical Society, 1977), 91; The Catalog Committee, *An Anti-Catalog* (New York: The Catalog Committee of Artists Meeting for Cultural Change, 1977).

49. Robert Blair St. George, "Style and Structure in the Joinery of Dedham and Medfield, Massachusetts, 1635–1685," *WP* 13 (1979): 1–46.

50. Robert Blair St. George, *The Wrought Covenant: Source Material for the Study of Craftsmen and Community in Southeastern New England, 1620–1700* (Brockton, Mass.: Brockton Art Center/Fuller Memorial, 1979), 13, 14, 16, 17.

51. Robert Blair St. George, " 'Set Thine House in Order': The Domestication of the Yeomanry in Seventeenth-Century New England," in *New England Begins*, 159–88.

52. Edward S. Cooke, Jr., *Fiddlebacks and Crooked-backs: Elijah Booth and Other Joiners in Newtown and Woodbury, 1750–1820* (Waterbury, Conn.: Mattatuck Historical Society, 1982).

53. John T. Kirk, *American Furniture and the British Tradition to 1830* (New York: Knopf, 1982), 159.

54. For example, Herwin Schaefer, *Nineteenth Century Modern* (New York: Praeger, 1970); David A. Hanks, *Innovative Furniture in America, from 1800 to Present* (New York: Horizon Press, 1981); Marvin D. Schwartz, Edward J. Stanek, and Douglas K. True, *The Furniture of John Henry Belter and the Rococo Revival* (New York: E. P. Dutton, 1981).

55. Karal Ann Marling, review of *Winterthur Portfolio* 10, in *Technology and Culture* 17:3 (July 1976): 608.

56. Michael J. Ettema, "Technological Innovation and Design Economics in Furniture Manufacture," *WP* 16 (1981): 197–223.

57. Kenneth L. Ames, "The Battle of the Sideboards," *WP* 9 (1974): 1–27; Kenneth L. Ames, "Grand Rapids Furniture at the Time of the Centennial," *WP* 10 (1975): 23–50. For a survey of trade catalogues in one institution's collections, see E. Richard McKinstry, *Trade Catalogues at Winterthur: A Guide to the Literature of Merchandising, 1750 to 1980* (New York and London: Garland Publishing, 1984).

58. Milwaukee Art Museum, *The Domestic Scene (1897–1927): George M. Niedecken, Interior Architect* (Milwaukee: Milwaukee Art Museum, 1981); David A. Hanks, *The Decorative Designs of Frank Lloyd Wright* (New York: E. P. Dutton, 1979); Randell L. Makinson, *Greene & Greene: Furniture and Related Designs* (Santa Barbara: Peregrine Smith, 1979).

59. Michael Owen Jones, *The Hand Made Object and Its Maker* (Berkeley: University of California Press, 1975).

60. Ellen and Bert Denker, *The Rocking Chair Book* (New York: Main Street Press/Mayflower Books, 1979).

61. Kenneth L. Ames, "Meaning in Artifacts: Hall Furnishings in Victorian America," *Journal of Interdisciplinary History* 9 (1978): 19–46; Leslie A. Greene, "The Late Victorian Hallstand: A Social History," *Nineteenth Century* 6:4 (1980): 51–53.

62. Kenneth L. Ames, "Material Culture as Non-Verbal Communication," *Journal of American Culture* 3 (1980): 619–41.

111

63. Diane M. Douglas, "The Machine in the Parlor: A Dialectical Analysis of the Sewing Machine," *Journal of American Culture* 5 (1982): 20–29.

64. Christopher Monkhouse, "The Spinning Wheel as Artifact, Symbol, and Source of Design," in *Victorian Furniture*, ed. Kenneth L. Ames (Philadelphia: The Victorian Society in America, 1983), 153–75.

65. Cary Carson and Lorena S. Walsh, "The Material Life of the Early American Housewife," paper presented at a conference on women in early America at Colonial Williamsburg, November 5–7, 1981.

66. Bernard L. Herman, "Multiple Materials, Multiple Meanings: The Fortunes of Thomas Mendenhall," *WP* 19:1 (Spring 1984): 85–86.

67. Some recent attempts in other fields include Eugene Linden, *Affluence and Discontent: The Anatomy of Consumer Societies* (New York: Viking, 1979); W. D. Wethersell, *Souvenirs* (New York: Random House, 1981); Mihaly Csikszentmihalyi and Eugene Rochberg-Halton, *The Meaning of Things* (Cambridge: Cambridge University Press, 1981); Mary Douglas, *The World of Goods* (New York: W. W. Norton, 1979).

5

The History of Technology
and the Study of Material Culture

Carroll W. Pursell, Jr.

MATERIAL CULTURE has been described as "the study through artifacts (and other pertinent historical evidence) of the belief systems—the values, ideas, attitudes, and assumptions—of a particular community or society, usually across time," with the history of technology being designated as a subfield of material culture studies.[1] Over the past quarter century a growing cadre of scholars has attempted to describe and account for those things with which Americans do their work and, to a large extent, define themselves as Americans. The history of American technology begins and ends with our material culture.[2]

From one perspective, the linking of the notion of material culture and the history of technology makes obvious sense. Americans impress their culture on the things they make and the ways in which they do things. Technology, therefore, is an expression of our culture, encoded with our dreams, purposes, environment, insights, and limitations. Running strongly against this notion, however, is the perception that technology is neutral, that tools and machines are devoid of meaning, and that meaning flows only from their actual use by real people. According to this notion, the story of America should be written from political biography, not from the history of technology.

Although it is still possible to study technology without ever encountering the physical reality of a three-dimensional machine or tool, such a study is open to two major weaknesses. First, "seeing" devices only through the written word puts one in danger of reproducing old errors of perception, mistaking rhetoric for reality, and misun-

derstanding connections. Generations of writing about the "inter-changeability" of Eli Whitney's muskets, for example, can best be confronted and revised with the empirical fact that, once taken apart, extant museum specimens prove not to be interchangeable at all. Even this needed dose of reality therapy, however, does not exhaust the benefits of a direct study of devices. The discovery that the muskets are not interchangeable tells us nothing of why anyone would want them to be so in the first place, or what kind of people made them, or for what purpose. It is possible to trace the evolution of a series of devices, through actual study of the objects, without enquiring deeply into the culture that shaped the material.[3]

The field of American Studies has always included a number of scholars who were interested in technology, in particular what was American about American technology. Leo Marx's classic *Machine in the Garden* is only the best known of the studies that have emerged from this interest over the years.[4] In more recent times John Kasson's book *Civilizing the Machine* has built upon this foundation, and Anthony F. C. Wallace's brilliant study of *Rockdale* has brought the perspective of cultural anthropology to bear upon the seedtime of American industrialism. James Flink has made major contributions to our understanding of what he calls the car culture in America.[5]

Indeed the list of professional and academic specialists who have contributed to our understanding of American technology would include books by professional writers (for example, David McCullough's *The Great Bridge*) and by recent undergraduates (David Brodsly's *L.A. Freeway*). The architectural historian Dolores Hayden has made a major contribution with her rediscovery of those early "material feminists" who, in her words, "dared to define a 'grand domestic revolution' in women's material conditions," and the writer-illustrator Eric Sloane has illuminated early American life with his numerous and popular short works.[6]

None of these, however, identify themselves primarily as historians of technology. That establishment is firmly rooted in the Society for the History of Technology (founded in 1958) and is most conveniently followed in the society's journal *Technology and Culture* (first published in 1959). This tendency to segregate the history of technology has two adverse effects. First, specialists can too easily overlook the important contributions being made by scholars in other fields, such as women's history, labor history, or the broader field of American Studies (the Society for the History of Technology has often met jointly with the History of Science Society, but never with the American Studies Associ-

ation). Second, the growing body of scholarly literature by historians of technology is often ignored both by specialists in other fields and even by some traditional "internal" historians of technology who come at it from an engineering rather than social perspective.[7]

PROFESSIONAL PARAMETERS

The history of technology as a self-identifying scholarly field is also a house with many rooms, and it is no surprise that several of those most closely associated with other disciplines engaged in the study of material culture have pioneered that study in this specialty. One recent effort has been the study of industrial plants, machines, and processes *in situ*. Following in part the example of the growing interest in industrial archaeology in Great Britain, the (American) Society for Industrial Archaeology was established in 1972 and began to publish its journal in 1975.[8] Introducing the first issue of the journal, Ted Sande asserted that "the study of the industrial site is essentially multidisciplinary in nature," and that "the industrial site must be understood within the larger contexts of social and technological history."[9]

Sande's insistence that the site be interpreted in the context of the history of technology was seen as an attempt to broaden the enthusiasm of those "site-specific" amateurs who continue to dominate the field of industrial archaeology in the United States, but it had the limitation of suggesting a one-way flow of insight. One looked at the history of technology to interpret the site—but was it possible to use the site to better understand the history of technology? In 1981 an issue of the society's journal was given over to the task of, in the words of the editor, focusing "specifically on methodologies for employing historic industrial sites as 'documents' with which to explore . . . questions about the past."[10]

In articles on the development of the leather-belt drive for mill machinery, on an 1861 woolen mill with machinery intact, and on an anthracite blast furnace, three scholars attempted to tease out what information and insight could be gotten from a study of ruins and structures, as well as their furnishings. The first, by Theodore Z. Penn, suggested the use of descriptive models "as conceptual devices which can be used to establish the boundaries of a system or its parts. These descriptive models are qualitative constructs that help to identify materials and textures and to visualize shapes and spatial arrangements." Surprisingly, neither he nor the other two authors—Laurence F.

Gross and Bruce E. Seely—used such models, relying most heavily on traditional published accounts and photographs.[11]

The force of evidence in these articles by three scholars is something less than overwhelming. Assertions that artifacts provide important new data for the historian of technology are seemingly unexceptionable, but the truth of such assertions has yet to be demonstrated with proofs as powerful as logic. When the argument is pushed to its extreme—that the truth can be gotten at *only* through the artifact—it has met both anger and ridicule.[12]

In a recent review of the last decade's literature on the history of American science and technology, Nathan Reingold has observed that "strong pressures from the museum world and from industrial archaeology" are attempting to focus the history of technology on "physical objects," a kind of "thing worship" that he sees as forcing those historians who are more interested in technology as "knowledge" or "systems" to concede the value of things as "evidence of human intentions and their outcomes." He also makes the significant observation that while the history of American science remains very much a subfield of the history of science, most American historians of technology study American technology.[13] It seems reasonable to guess that one reason for this must surely be that tendency in the field to relate technology to things as well as to disembodied "knowledge" and "systems."

A governmental stimulus to the study of technology *in situ* has come through Section 106 of the National Historic Preservation Act of 1966 and similar legislation, at both the state and federal levels. As an analog to the environmental impact statement, this section requires that all federal agencies inquire into the impact of their activities (construction, funding, permits, etc.) on historic resources. This requirement has led to a large amount of historical research on technological sites and structures, but most of it never enters the mainstream of historical literature where it can add to our cumulative knowledge of the built environment.[14]

It is significant that all three of the industrial archaeology articles cited previously were illustrated with drawings done for the Historic American Engineering Record, an agency established in 1969 to aid in the inventory and recording of technological sites and structures in America (like the better known Historic American Buildings Survey). Through both the deposit of drawings, photographs, and narrative histories in the Library of Congress, and a growing list of publications, HAER comes closest to using actual structures to inform the history of technology.[15]

116

MUSEUMS AND METHODS

There is a significant overlap, within the history of technology, between those who read the extant structures and those who work in museums rather than universities. The Society for the History of Technology supports a vigorous Museums Group which has since its founding been a center of interest in artifactual evidence. Gross and Penn both work in museums and belong to this group, as does Brooke Hindle, of the Smithsonian Institution, who has been most closely identified with the movement to use material culture in the field.

Such museums as Henry Ford's Greenfield Village have long sought to collect and display artifacts of our technological past, and it is surely no accident that the Smithsonian Institution's National Museum of History and Technology (recently renamed the Museum of American History) is also one of the two or three centers of scholarship in the history of technology.[16] In 1968 *Technology and Culture* began to carry exhibit reviews, which were intended to do for museum exhibits what book reviews did for the published work of scholars in the field. In part they were to raise the standards of exhibits, but in part they were also needed to give information to scholars who might need to know what was available in museums. As Thomas W. Leavitt wrote in introducing the first review, by Eugene S. Ferguson, "in exhibits devoted to technology there is no substitute for the artifact."[17] A moving quotation from Ferguson drove home the point:

> I think . . . of Teyler's Museum, in Haarlem, The Netherlands. Perhaps a dozen people a day enter this museum; an ancient attendant appears from some far-off room to unlock the door and admit the visitor. Here, in a hall that has changed almost not at all in a hundred years, is the great Van Marum electro-static machine of 1784. A picture would tell me what the machine looked like; a description would tell me what it was for; but the machine itself exhibits the qualities—of scale, workmanship, finish, and the like—that simply are not conveyed indirectly. The noble machine will live in my mind while I live, but Teyler's Museum will have to introduce succeeding generations to the machine, for I cannot transmit in words, with sufficient precision, the qualities that have so impressed me.[18]

Ferguson's first review in *Technology and Culture* covered the Hall of Power Machinery at the Museum of History and Technology, where he

had formerly been curator of mechanical and civil engineering. In his review, he faulted the curator (who, as it happens, was one of the founders of industrial archaeology in the United States) for producing an exhibit that was "essentially dead." While admitting the difficulty of the problem, he insisted that "it is not enough . . . merely to display and identify objects. A great museum should more than perpetuate the idea that machines are neutral because they can do only the bidding of men. Somehow it should be made clear that historically the potential of power has imperceptibly become an imperative." If this larger meaning cannot be demonstrated through artifacts, but only "through books and contemplation," then somehow "the museum hall must push visitors toward the necessary books and contemplation. Otherwise," he warned, "the show becomes promotional rather than interpretive."[19]

It was precisely this promotional aspect that drew the most telling exhibit review yet to appear in *Technology and Culture.*[20] Charging that the new National Air and Space Museum is a sustained provocation for unquestioned technological progress and growth, seen through the lens of the romance of aviation, Michael McMahon traced the ideology imposed on the artifacts back through thirty years of congressional debate over funding the museum. There the goal of the museum was decided upon: "to encourage young people to aspire to great deeds of technological innovation and thus to keep America great." Not all the airplanes in the Smithsonian's collection would do that, however. Congressman Frank Thompson seemed particularly worried in 1970 about the *Enola Gay,* which had dropped the first atomic bomb on Hiroshima. "I don't think we should be very proud of that as a nation," he said. "At least it would offend me to see it exhibited in the museum." Senator Barry Goldwater agreed: "What we are interested in here are the truly historic aircraft. I wouldn't consider the one that dropped the bomb on Japan as belonging in that category."[21] McMahon concluded with the charge that not only the National Air and Space Museum but most science museums misappropriate history to serve the ideology of growth and progress.[22]

If, as Ferguson maintains, machines must have a voice in telling their own story, and yet can easily be appropriated to tell another story imposed upon them, then the role of material culture in the history of technology is at least problematic. When one moves from the typical perspective of museums and historic sites and focuses instead on the scholarly activity of actually writing the history of technology, one finds a strong tradition of explicitly attempting to deal with technology as material culture—that of seeing technology itself as an art form.

ARTIFICE AS ART

The words "artist" and "artisan" have both traditionally been applied to the builder of machines. George Kubler's important book *The Shape of Time: Remarks on the History of Things* defines its object as the study of "all materials worked by human hands under the guidance of connected ideas developed in temporal sequence," warrant enough for the historian of technology.[23] Insisting that "tools and instruments, symbols and expressions all correspond to needs, and all must pass through design into matter," he makes the link explicit by stating that "the artist is an artisan." Historians of technology have not taken up Kubler's insights or attempted to apply his scheme in accounting for the evolution of machines (perhaps because of his structuralist approach), but his observation that "we depend for our extended knowledge of the human past mainly upon the visible products of man's industry" is as clear a statement as we are likely to get as to what the rewards of so doing might be.[24]

The metallurgist and historian Cyril Stanley Smith has been the historian of technology longest associated with the study of connections between technology and art. Starting from the realization that "many of the primary sources I had selected for a study of the history of metallurgy were objects in art museums," he was led to speculate on the relationships between science, art, and technology. He concluded that "it was precisely the artist's search for a continued diversity of materials that gave this branch of technology [materials] its early start and continued liveliness despite an inner complexity which precluded scientific scrutiny until very recently." Indeed, "the attitudes, needs, and achievements of artists have provided a continuing stimulus to technological discovery and, via technology, have served to bring to a reluctant scientific attention many aspects of the complex structure and nature of matter that simplistic science would have liked to ignore."[25]

Eugene S. Ferguson has carried the argument further. While acknowledging that modern technology, at least, is often influenced by science, "carving knives, comfortable chairs, lighting fixtures, and motorcycles are as they are because over the years their designers and makers have established shape, style, and texture." Put another way, while "there may well be only one acceptable arrangement or configuration of a complex technological device, such as a motorcycle . . . , that arrangement is neither self-evident nor scientifically predictable." He traced the development of graphic methods for depicting machines (Leonardo da Vinci's innovation of the "exploded view," for example) and concluded that "much of the creative thought of the designers of our technological world is non-verbal," a kind of visual thinking that is

not only necessary for devices to be pleasing in appearance but practical in use.[26] As Ferguson summed it up in another article, after praising the designer of "elegant inventions," "science will continue to influence technology but it is art that will choose the specific shape of the future."[27]

Noting the "prominence of artists among the projectors" of the steamboat and the telegraph, Brooke Hindle, in his book *Emulation and Invention*, was moved to investigate "the mental manipulation of images and ideas that always precedes the trial and construction and even repair and modification of machines" and "the nature of the American environment that encouraged inventiveness in certain lines of mechanical endeavor and permitted the Americans . . . to pioneer in certain innovations." Hindle attributed both the steamboat and the telegraph to what he calls "the contriving mind," and he concluded that "because early-nineteenth-century mechanical technology rested so much more heavily upon spatial thinking than upon analytical, arithmetic thought, it was more related to the arts and design than to science."[28] Because individual machine components were organized into a machine system, and this had to be fitted into larger social systems, spatial thinking was the critical key.

The work of Smith, Ferguson, and Hindle can all be seen to point in the same direction: toward a notion that particular technologies embody the artistic insights of inventor or engineering designers, and the belief that these can adequately be described only graphically, not through either mathematics or the written word. One implication of this, of central importance to the study of the histories of these technologies, is that the things themselves are critical documents for the understanding of the thought behind them. Unlike intellectual history, which has traditionally dealt with the words of the great thinkers, or the new social history, which often finds truth through aggregate numbers, the historian of technology must deal with the real article.[29]

Yet to point this out is to deal better with the "material" than with the "culture" of material culture. Writing of the "contriving mind" Hindle seized upon an evolutionary analogy: although "natural selection gives a preference to those individuals best adapted to the needs of their environment . . . the genetic change comes first."[30] Too close a concentration on the "genetic change," of course, could lead to the notion that the history of technology is a branch of intellectual history concerned with the origins and evolution of ideas that happen to be communicated in pictures rather than words and in objects other than books. Indeed, it is not surprising that being so closely identified in our own time with science, itself traditionally studied as a history of ideas, technology too is sometimes seen in that light.[31]

Hindle himself has pointed us in the other direction, however. In his influential paper "The Exhilaration of Early American Technology: An Essay," published in 1966, he anticipated John Higham's contention that technology (mechanization and bureaucratization) is the key unifying force in American society, justifying his concern by noting that technology "belongs very close to the center as an expression and a fulfillment of the American experience." If that technology can only be seen and understood through its tangible products, then material culture stands as the necessary study of the American past.[32]

"The physical things of technology," Hindle wrote, "in many ways remain the ultimate source for the history of technology. Preserved products and tools as well as other traces left by these technologists—including railroad cuts and canal segments, razed factories and mine shafts constitute repositories of information poorly understood by the general historian." While denying any necessary conflict between "words and things," he did claim for "artifacts or three-dimensional objects" a "certain primacy" and "central significance." An unelaborated caveat lurks in the argument however. "What can be gained from the visual examination of a technological specimen," he noted, "depends directly upon the knowledge and perceptiveness of the examiner."[33]

Later Hindle returned explicitly to that same point. His own work had never ignored the insight offered by artifacts, and he had served with distinction as director of the Smithsonian's National Museum of History and Technology, but in an article published in 1983 he focused his attention squarely on what he called "Technology through the 3-D Time Warp."[34] After noting that technological artifacts are always "wrenched out of context," he admitted that historical understanding is best communicated through the written word. But what the artifact lacks in the way of ability to communicate historical understanding it makes up for by its unique role in providing that understanding in the first place. For the researcher, the direct experience of the three-dimensionality of technology is a necessary precursor of anything approaching complete understanding of that subject.

Two recent trends in the evolution of technologies—the "black box" and the spread of complex systems—complicate the whole notion of "artifact." These join an even older handicap: the notion that artifacts are often unique examples, entrusted to the care of jealous curators who keep them hidden away and protected from dismantlement and destructive testing. Against these problems, however, Hindle sets the innovative and exciting prospect of computer graphics—to store, manipulate, and reproduce three-dimensional artifacts in a two-dimensional

format that researchers can have readily accessible. If successful, this method could make three-dimensional objects available as data for the study of what Hindle considers the three great purposes of the history of technology: understanding "technological change, the science relationship, and cultural and social meaning."[35]

It may be that, in this search for understanding, the student must try to avoid the very word "technology" itself, as an empty abstraction never to be met with in the real world. We experience various specific tools, machines, and work processes, and understand them through their specific reality. A disaggregation of the term "technology" might allow us to avoid those often pointless debates over whether technology is good or bad, progressive or regressive, whether based on science or something else, whether it should be subsidized or socially controlled. As Langdon Winner has pointed out, specific "artifacts have politics," that is to say, they "can embody specific forms of power and authority."[36] Such a notion lends considerable support to Lewis Mumford's insight that some "technics" are democratic while others are authoritarian and to Thomas Jefferson's more explicit insistence that machines that embody "the valuable properties of simplicity, cheapness and accommodation to the small and numerous calls of life" were more suitable to America than the "greatest which can be used only for great objects."[37]

People are tool-using creatures, and this use is one of the tests used to distinguish us from other creatures. We tend to think of ours as a peculiarly technological age, but in fact all ages have been technological in this sense, and each time and place has had its characteristic tools and techniques. These tools have been used to shape both the nearest and most intimate contours of our lives and also the larger cultural landscape in which they have been used.[38] As a human institution and a form of human behavior concerned with the exercise of prudential judgment, technology has been the thin edge between people and the rest of nature, human and otherwise. We have encoded in this technology, in each time and place, our own sense of organic needs, historic experience, human aptitudes, and ecological complexity and variety, to use Mumford's words.

It is the signal task of the history of technology to decode and explain this culture embedded in material. The historian, with mind prepared by a study of written sources in published or manuscript form, of pictures and recordings, will discover in the site and the artifact its meaning and its "politics." With a notion of intended function, the designer of machines and tools chooses a particular form, and that form in turn limits its possible function. It is a relationship that no evidence less than the thing itself is likely to make clear.

NOTES

1. Thomas J. Schlereth, ed., *Material Culture Studies in America* (Nashville: American Association of State and Local History, 1982), 3, xiii.
2. For the development (and bibliography) of the history of technology, see Carroll W. Pursell, Jr., "History of Technology," in *A Guide to the Culture of Science, Technology, and Medicine*, ed. Paul T. Durbin (New York: The Free Press, 1980), 70–120. Two helpful historiographic essays are Eugene S. Ferguson, "The American-ness of American Technology," *Technology and Culture* 20 (January 1979): 3–24, and Thomas P. Hughes, "Emerging Themes in the History of Technology," *Technology and Culture* 20 (October 1979): 697–711. Two excellent recent bibliographic articles on neglected aspects of the history of technology are Judith A. McGaw, "Women and the History of American Technology," *Signs* 7 (Summer 1982): 798–828, and Eugene S. Ferguson, "Historical Roots of the Energy Crisis: A Basic Bibliography of Energy History," *Science, Technology & Society*, Curriculum Newsletter of the Lehigh University STS Program, no. 33 (December 1982): 1–21.
3. This approach is often stigmatized as "internalist." See, for example, Robert S. Woodbury, *History of the Lathe to 1850: A Study in the Growth of a Technical Element of an Industrial Economy* (Cleveland: Society for the History of Technology, 1961).
4. Leo Marx, *The Machine in the Garden: Technology and the Pastoral Ideal in America* (New York: Oxford University Press, 1964). See also Marvin Fisher, *Workshops in the Wilderness: The European Response to American Industrialization, 1830–1860* (New York: Oxford University Press, 1967), Alan Trachtenberg, *Brooklyn Bridge: Fact and Symbol* (New York: Oxford University Press, 1965), Morrell Heald, "Technology in American Culture," *Stetson University Bulletin* 62 (October 1962): 1–18, and Hugo A. Meier, "American Technology and the Nineteenth-Century World," *American Quarterly* 10 (Summer 1958): 116–130.
5. John F. Kasson, *Civilizing the Machine: Technology and Republican Values in America, 1776–1900* (New York: Grossman Publishers, 1976); Anthony F. C. Wallace, *Rockdale: The Growth of an American Village in the Early Industrial Revolution* (New York: Alfred A. Knopf, 1978); James J. Flink, *The Car Culture* (Cambridge: MIT Press, 1975). Other recent contributions include John F. Kasson, *Amusing the Million: Coney Island at the Turn of the Century* (New York: Hill & Wang, 1978); Robert E. Snow and David E. Wright, "Coney Island: A Case Study in Popular Culture and Technical Change," *Journal of Popular Culture* (Spring 1976): 960–75; William D. and Deborah C. Andrews, "Technology and the Housewife in Nineteenth-Century America," *Women's Studies* 2 (1974): 309–28; Howard P. Segal, "American Visions of Technological Utopia, 1883–1933," *The Markham Review* 7 (Summer 1978): 65–76; John B. Rae, *The Road and Car in American Life* (Cambridge: MIT Press, 1971); Warren James Belasco, *Americans on the Road: From Autocamp to Motel, 1910–1945* (Cambridge: MIT Press, 1979); Joseph Interrante, "You Can't Go to Town in a Bathtub: Automobile Movement and the Reorganization of Rural American Space, 1900–1930," *Radical History Review* 21 (Fall 1979): 151–68; and Jeffrey K. Stine, *Nelson P. Lewis and the City Efficient: The Municipal Engineer in City Planning during the Progressive Era*, Essays in Public Works History, no. 11 (Chicago: Public Works Historical Society, 1981).
6. David McCullough, *The Great Bridge* (New York: Simon and Schuster, 1972); David Brodsly, *L.A. Freeway: An Appreciative Essay* (Berkeley: University of

California Press, 1981); Dolores Hayden, *The Grand Domestic Revolution: A History of Feminist Designs for American Homes, Neighborhoods, and Cities* (Cambridge: MIT Press, 1981); Eric Sloane, *A Reverence for Wood* (New York: Funk and Wagnalls, 1965). See also Emma Rothschild, *Paradise Lost: The Decline of the Auto-Industrial Age* (New York: Random House, 1973); Tamara K. Hareven and Randolph Langenbach, *Amoskeag: Life and Work in an American Factory-City* (New York: Pantheon Books, 1978); and Jim Hightower, *Hard Tomatoes, Hard Times: A Report of the Agribusiness Accountability Project on the Failure of America's Land Grant College Complex* (Cambridge: Schenkman Publishing Co., 1973).

7. David A. Hounshell, "On the Discipline of the History of American Technology," *Journal of American History* 67 (March 1981): 854–65, and the follow-up, Darwin H. Stapleton and David A. Hounshell, "The Discipline of the History of Technology: An Exchange," *Journal of American History* 68 (March 1982): 897–902. An important critique is contained in A. Hunter Dupree, "Does the History of Technology Exist?" *Journal of Interdisciplinary History* 11 (Spring 1981): 685–94.

8. Kenneth Hudson, "The Growing Pains of Industrial Archaeology," *Technology and Culture* 6 (Fall 1961): 621–26; Ted Sande, "A New Adventure," *IA: The Journal of the Society for Industrial Archaeology* (hereafter referred to as *IA*) 1 (Summer 1975): v. See also T. E. Leary, "Industrial Archaeology and Industrial Ecology," *Radical History Review* 21 (Fall 1979): 171–82. It should be noted that the National Association for Industrial Archaeology, in Britain, was not founded until 1973 after two decades of growing interest at the local and regional level.

9. Sande, "A New Adventure," vi. See also David Weitzman, *Traces of the Past: A Field Guide to Industrial Archaeology* (New York: Charles Scribner's Sons, 1980).

10. Dianne Newell, "Editorial," *IA* 7 (1981): iii.

11. Theodore Z. Penn, "The Development of the Leather Belt Main Drive," *IA* 7 (1981): 1–14; Laurence F. Gross, "The Importance of Research Outside the Library: Watkins Mill, A Case Study," *IA* 7 (1981): 15–26; Bruce E. Seely, "Blast Furnace Technology in the Mid-19th Century: A Case Study of the Adirondack Iron and Steel Company," *IA* 7 (1981): 27–54.

12. I am thinking of a session at an annual meeting of the Society for the History of Technology in which advocates of material evidence were openly charged with being anti-intellectual.

13. Nathan Reingold, "Clio as Physicist and Machinist," *Reviews in American History* 10 (December 1982): 275.

14. A particularly interesting example is given in Darlene Roth, "Feminine Marks on the Landscape: An Atlanta Inventory," *Journal of American Culture* 3 (Winter 1980): 673–85.

15. See for example Matthew Roth, *Connecticut: An Inventory of Historic Engineering and Industrial Sites* (N.P., Society for Industrial Archaeology, 1981), and Patrick M. Malone, *The Lowell Canal System* (Lowell: The Lowell Museum, 1976). For an example of recent HAER attempts to use surviving sites and structures to project the past into the future, see U.S. Department of the Interior, *Rehabilitation: Fairmount Waterworks 1978. Conservation and Recreation in a National Historic Landmark* (Washington: Government Printing Office, 1979). Bridge inventories have been made for several states. One such is Fredric L. Quivik, *Historic Bridges of Montana* (Washington: GPO, 1982).

16. On the role of the Smithsonian as a "graduate school" in the history of technology, see Svante Lindqvist, *The Teaching of History of Technology in USA—A Critical Survey in 1978* (Stockholm: Royal Institute of Technology Library, 1981), 35.

17. Thomas W. Leavitt, "Exhibit Reviews: Toward a Standard of Excellence: The Nature and Purpose of Exhibit Reviews," *Technology and Culture* 9 (January 1968), 70–75.

18. Quoted in *Technology and Culture*, 9: 72.

19. Eugene S. Ferguson, "Exhibit Reviews: Hall of Power Machinery, Museum of History and Technology, U.S. National Museum (Smithsonian Institution)," *Technology and Culture* 9 (January 1968): 75–85.

20. Michal McMahon, "Exhibit Review: The Romance of Technological Progress: A Critical Review of the National Air and Space Museum," *Technology and Culture* 22 (April 1981): 281–96.

21. Quoted in *Technology and Culture*, 22: 294.

22. Other exhibit reviews in *Technology and Culture* include W. David Lewis, "The Smithsonian Institution's '1876' Exhibit," vol. 18 (October 1977): 670–84; Theodore Z. Penn, "The Slater Mill Historic Site and the Wilkinson Mill Machine Shop Exhibit," vol. 21 (January 1980): 56–66; and Larry Lankton, "Something Old, Something New: The Reexhibition of the Henry Ford Museum's Hall of Technology," vol. 21 (October 1980): 594–613. So-called Living History Farms represent another type of museum, not yet reported on to the history of technology community. See G. Terry Sharrer, "Hitching History to the Plow," *Historic Preservation* 32 (November–December 1980): 42–49, and Jay A. Anderson, "Immaterial Material Culture: The Implications of Experimental Research for Folklife Museums," *Keystone Folklore* 21 (1976–1977): 1–13.

23. George Kubler, *The Shape of Time: Remarks on the History of Things* (New Haven: Yale University Press, paperbound ed., 1962), 9.

24. Kubler's *Shape of Time*, 10, 11.

25. Cyril Stanley Smith, "Art, Technology, and Science: Notes on Their Historical Interaction," *Technology and Culture* 11 (October 1970): 493–549.

26. Eugene S. Ferguson, "The Mind's Eye: Nonverbal Thought in Technology," *Science* 197 (26 August 1977): 827–36.

27. Eugene S. Ferguson, "Elegant Inventions: The Artistic Component of Technology," *Technology and Culture* 19 (July 1978): 450–60. In his address Ferguson refers to Kubler's book and credits Brooke Hindle with helping him understand it. John A. Kouwenhoven made much of elegant design in his classic *Made in America* (New York: Doubleday and Co., 1948). "Industrial Design" removes the process another step away from the engineer and gives it over to people more concerned with ideology and corporate image than elegant invention. See Jeffrey L. Meikle, *Twentieth-Century Limited: Industrial Design in America, 1925–1939* (Philadelphia: Temple University Press, 1979).

28. Brooke Hindle, *Emulation and Invention* (New York: New York University Press, 1981). See also his "The Underside of the Learned Society in New York, 1754–1854," in *The Pursuit of Knowledge in the Early American Republic*, ed. Alexandra Oleson and Sanborn C. Brown (Baltimore: Johns Hopkins University Press, 1976), 84–116. However, see Patricia Cline Cohen, *A Calculating People: The Spread of Numeracy in Early America* (Chicago: University of Chicago Press, 1982).

29. Ferguson cites the observations of Francis Galton to the effect that the scientists he interviewed seldom thought visually but rather in words ("The

Mind's Eye, in *Science*, vol. 197: 833–34). For a contrary view see Hindle, "Technology through the 3-D Time Warp," delivered as his presidential address before the Society for the History of Technology in 1982 and published in *Technology and Culture* 24:3 (July 1983).

30. Hindle, *Emulation and Invention*, 128.

31. See, for example, three articles in *Technology and Culture:* Otto Mayr, "The Science-Technology Relationship as a Historiographic Problem," vol. 17 (October 1976): 663–73, Edwin T. Layton, Jr., "American Ideologies of Science and Engineering," also in vol. 17, and Eda Fowlks Kranakis, "The French Connection: Giffard's Injector and the Nature of Heat," in vol. 23 (January 1982): 3–28.

32. John Higham, "Hanging Together: Divergent Unities in American History," *Journal of American History* 61 (June 1974): 5–28; Brooke Hindle, *Technology in Early America: Needs and Opportunities for Study* (Chapel Hill: University of North Carolina Press, 1966), 28.

33. Hindle, *Technology in Early America*, 10, 31, 11. This same publication contains the still useful "A Directory of Artifact Collections," compiled by Lucius F. Ellsworth, 95–126.

34. Hindle, "Technology through the 3-D Time Warp." For two of his earlier works, see Brooke Hindle, ed., *Material Culture of the Wooden Age* (Tarrytown: Sleepy Hollow Press, 1981) and *Emulation and Invention*.

35. Hindle, "Technology through the 3-D Time Warp."

36. Langdon Winner, "Do Artifacts Have Politics?" *Daedalus* 109 (Winter 1980): 121–36. An excellent example is David F. Noble, "Social Choice in Machine Design: The Case of Automatically Controlled Machine Tools," in *Case Studies On the Labor Process*, ed. Andrew Zimbalist (New York: Monthly Review Press, 1979), 18–50. See also Susan Strasser, *Never Done: A History of American Housework* (New York: Pantheon Books, 1982), and William H. Friedland, Amy E. Barton, and Robert J. Thomas, *Manufacturing Green Gold: Capital, Labor, and Technology in the Lettuce Industry* (Cambridge: Cambridge University Press, 1981).

37. Lewis Mumford, "Authoritarian and Democratic Technics," *Technology and Culture* 5 (Winter 1964): 1–8; Thomas Jefferson to George Fleming, 29 December 1815, quoted in Carroll Pursell, "The American Ideal of a Democratic Technology," *The Technological Imagination: Theories and Fictions*, ed. Teresa de Lauretis et al. (Madison: Coda Press, 1980), 11. See also Carroll Pursell, "The History of Technology as a Source of Appropriate Technology," *The Public Historian* 1 (Winter 1979): 15–22. The relationship of "style" to place is discussed in Thomas Parke Hughes, "Regional Technological Style," in Tekniska Museet Symposia, *Technology and Its Impact on Society*, Symposium No. 1, 1977 (Stockholm: Tekniska Museet, 1979), 211–34. For a discussion of neighborhood variations in technology, see Susan J. Kleinberg, "Technology and Women's Work: The Lives of Working Class Women in Pittsburgh, 1870–1900," *Labor History* 17 (Winter 1976): 58–72. For an interesting new model, see David E. Wright and Robert E. Snow, "The Battle of Technological Styles of America: A Brief History and Analysis," *Journal of American Culture* 3 (Fall 1980): 456–69.

38. Historians of technology have been nearly unanimous in ignoring structuralism, but James Deetz has shown something of what this approach might produce. See also his use of Lewis Binford's distinctions between the technomic, sociotechnic, and ideotechnic functions of technology. *In Small Things Forgotten: The Archaeology of Early American Life* (Garden City: Anchor Books, 1977), 51.

6

Visible Proofs:
Material Culture Study
in American Folkloristics

Simon J. Bronner

PREPARING for the Third International Folk-Lore Congress of the 1893 World's Columbian Exposition in Chicago, organizer Fletcher S. Bassett wrote *The Folk-Lore Manual*. Taking a cue from British folklorists who organized the first congress in 1891, Bassett proclaimed, "No science dealing with man is quite perfect without the aid of Folk-Lore." His manual outlined for users the materials of folklore often neglected by historians, sociologists, literary scholars, and natural scientists—items like customs, songs, tales, and other oral traditions. Bassett added a special note on the need for physical evidence: "tangible objects—visible proofs of the traditional customs, superstitions, and ceremonies."[1] At the exposition, folklorist Stewart Culin, curator of the American Folklore Society, set up a major display of objects to illustrate the material realm of folklore. For these early American folklorists, organizing and defining their discipline in front of the world, objects signified vividly the beliefs, practices, and aesthetics found among common people.

When the term "folklore" was originally coined by Britisher William Thoms in 1846, he intended the word to cover what was previously called popular antiquities or literature. The materials he sought to recover—"manners, customs, observances, superstitions, ballads, proverbs"—made up the romantic "Lore of the People." Often overlooked is the fact that the antiquarians of the period also had a strong interest in the physical relics representing British tradition— Roman ruins, medieval peasant implements, and pagan fetishes. Indeed, many of their early folklore collections included physical as well as verbal evidence.

American folklorists retained the British emphasis on oral evidence, but after the American Folklore Society was formed in 1888 by anthropologically minded folklorists, many of its early presidents, including Daniel Brinton, Otis Mason, Frederic Ward Putnam, Stewart Culin, and Franz Boas recognized objects as part of the folklorist's concern. The first volume of the *Journal of American Folklore* had a survey of Pennsylvania-German folklore, which covered architecture, foodways, and crafts.[2] Books such as *The Origin of Invention* (1889) by Otis Mason and *Objects Used in Religious Ceremonies* (1982) by Stewart Culin gave tangible evidence of the primitive roots of "civilized" culture. The objects were lore, because they revealed the rituals, beliefs, and uses surrounding them; the lore was surviving bits of the knowledge of the folk.

To the early society folklorists, the folk were usually isolated or racially distinct, lower class or illiterate. The society folklorists were interested in relics of old English folklore (ballads, tales, and superstitions) and in the lore of southern blacks and American Indians.[3] Influenced by the scientific and social allure of evolution popularized by Charles Darwin, Herbert Spencer, and Edward Taylor, the society folklorists typically invoked an evolutionary scheme with primitive folk at the bottom and civilized Victorians at the top.

As the Victorian era ended and the twentieth century arrived, folklorists became dissatisfied with the primitivistic notion of folk. They examined patterns of lateral diffusion more than vertical evolution. They realized that people of all classes have traditions; all people have lore. One can collect folklore from boys in Brooklyn and workers in Detroit. "Folk" came to be used less as a noun for a class of people and more as an adjective describing informal learning. Folklore was more than surviving bits of knowledge; it was a multiform process of learned tradition—gained from word of mouth, repeated imitation and demonstration, and participation in customs. Not bound by the standardization of formal or mass culture, the products of folklore repeat and vary. Such products represent learning and relating that occur when people meet face to face and share things in common.

The term "folklore" is commonly used to mean the materials of tradition, as well as their study. To make a distinction between the two, folklorists in the 1960s began using "folklore" for the traditions themselves and "folkloristics" for their study. The use of "folkloristics" represents modern folklorists' push to present behavioral theories and methods of interpreting folk products in their social settings. It sets folklore between the social and behavioral sciences and the humanities.

"Folklife" and "folk culture" are terms with more ethnological connotations and continental European roots. In their original use of

"folk culture" and "folklife," proponents meant an enclosed traditional society and its practices. By emphasizing folklife or folk culture, the researcher stressed the cultural integration of the whole community, especially of ethnic, peasant, occupational, and sectarian groups. Some of that emphasis is still found in American Studies, but the use of "folklife" by American folklorists today refers less to an alternative approach than an underscoring that customs and objects are included in one's study. Folklife also draws attention to traditions that cannot be as easily collected and classified as tales or houses, such as worldview, style, and attitude. Nonetheless, "folklore" remains the predominant umbrella term for the traditions, and "folkloristics" for their study.

Folk objects as part of folklore study signify informal learning and traditional ideas. Material culture study in folkloristics today is much more than the collection of relict artifacts it was in the last century. Material culture study today scours the city as well as the country; it looks for the current and everyday in addition to the past and exotic. Today's folklorists assess modern and past contexts for the conception, creation, use, alteration, and apprehension of the physical world.

The diversity of material culture study in folkloristics is revealed in the field's basic textbook, *American Material Culture and Folklife* (1985), which I edited. In the chapter on the idea of the folk artifact, I defined material culture this way:

> A craft, a house, a food, that comes from one's hands or heart, one's shared experience with other people in a community, one's learned ideas and symbols, visibly connects persons and groups to society and to the material reality around them. That interconnection is material culture. Material culture is made up of tangible things crafted, shaped, altered, and used across time and across space. It is inherently personal and social, mental and physical. It is art, architecture, food, clothing, and furnishing. But more so, it is the weave of these objects in the everyday lives of individuals and communities. It is the migration and settlement, custom and practice, production and consumption that is American history and culture. It is the gestures and processes that extend ideas and feelings into three-dimensional form.[4]

Hence material culture research is not merely the study of things. It is the interrelation of objects and technics in social life. It is, at bottom, a study of people.

Folklorists generally stand together when asked why the folk object commands their attention. Folk things offer a straightforward, intimate picture of the traditional attitudes and beliefs of makers and users.

Typically not mass-produced, but rather handmade and distributed locally, the personal folk object gives tangible clues to immediate human experience and communication. Those things that enter folk tradition tend to endure over time and vary across space. Of particular interest to American Studies, the tendency to vary across space allows for examinations of objects as symbols of cultural place and identity, and the basic human demands, needs, and functions which objects serve. Folk things map out the immediate cultural worlds in which people operate.

The cultural worlds people live in are both socially and personally defined. People learn about their environments through social contacts, but they also discover and comprehend the surroundings by themselves. Objects are tangible references people use to outline the worlds they know, the ones they try to cope with, and those they aspire to or imagine. Art, craft, architecture, clothing, and food become markers for the physical and intellectual surroundings with which people identify. Such objects reify intangible, abstract human and spiritual relations in those surroundings. Indeed, folk objects and actions are especially striking evidence of the hidden experiences, values, and mores of people. The significance humans attach to their objects can be traced to the artifact's ability to be touched and seen, and its three-dimensional, alterable quality. When people manipulate forms they create expressions. When students of material culture study the varied expressions generated by informal learning, they reveal a telling and influential segment of cultural communication and conduct.

This essay organizes material culture studies in American folkloristics by spotlighting core concerns of various researchers. This scheme should not suggest "schools" of theory, since analysts often employ various approaches depending on the questions asked and type of "visible proofs" desired. But an agenda arranged according to researchers' prevalent concerns gives some structure to the span of folkloristic research.[5] Generally moving from older, conventional standpoints to newer perspectives in the discipline, the list includes object and text, setting and region, group and network, individual and personality, event and action, and idea and thought. The headings provide signposts to the assumptions and concepts used by folklorists. They suggest directions folklorists take and some of the views they hold.

OBJECT AND TEXT

Because of their primary concern with the origin and diffusion of cultural forms, folklorists in the late nineteenth and early twentieth

century treated the object as a completed text. They read the object much as they read their folktales for clues to provenance and purpose. They reduced the artifact to its basic themes and compared them. In his magnum opus of 1907, *Games of the North American Indians,* Stewart Culin divided all gaming objects into morphological classes.[6] By noting the particular density of some forms in certain areas, he hoped to show the origin and distribution of Indian games. Finding gaming objects similar to those used in earlier religious rites, Culin proposed that playful games arose from serious divinatory contests. Culin treated artifacts as survivals from lower rungs of the cultural ladder. Comparisons were often made to similar rites and objects in other periods and places, despite differences in context. Although folklorists still rely on making comparisons of objects to show relations of cultural forms, they insist that the historical and social context of the objects needs to be similar to make the comparison valid.

A second way of considering the object as text has persisted more vigorously. The researcher imagines the artifact as a mirror of culture, a code from which the researcher can infer beliefs, attitudes, and values. Instead of saying, "in literature as in life," the analyst implies, "with the artifact as with culture." Louis C. Jones, a strong voice for material culture study and associated since 1947 with the folk museums at Cooperstown, used this approach often in his writings. Speaking of folk art, for example, he asserted, "The importance of a folk genre piece may be greater as a document than as a work of art, and it should be recognized as a supplement to the written word, as a historical source." In his *Outward Signs of Inner Beliefs,* Jones discussed the emotional values Americans revealed in material expressions of patriotism from the nineteenth and twentieth centuries. Carvings, banners, and butter molds were hailed as symbols of the rising nation.[7] The changing appearance of American patriotic symbols from the early Indian queen to the later use of the neoclassical goddess and to Uncle Sam showed a line from America's pristine self-image to its construction of a new civilization, and finally to its populist façade.

Jones and others using folk artifacts to provide documentation not readily available in books and illustrations often appeared preoccupied with reconstructing the life of the unlettered, lower classes. These folklorists used folk objects as the building blocks of a folk history, often a social history of everyday rural life apart from popular culture.

Folklorists like Alan Dundes have used artifacts to document modern middle-class and urban life. In *Work Hard and You Shall Be Rewarded,* Dundes showed how photocopied letters and cartoons, a new tangible, hangable folklore common in business offices, reflect the

131

workaday tensions of the educated and occasionally well-paid in American society.[8] Loudell F. Snow demonstrated the reinforcement that popular media give folklore, in "Mail Order Magic: The Commercial Exploitation of Folk Belief." She described folk amulets, charms, and candles common in modern advertising, and used them as mirrors of an alternative belief system coexisting with scientific medicine in urban America.[9]

A pronounced textual feature of objects is that they typically have form and content. Folk artifacts, like other folk expressions, are said to contain texts that repeat and vary. Using this characteristic as a premise, many folklorists have read meaning into sets of objects having similar form and content. Based on similarities of African and American shotgun housing forms, John Vlach buttressed the argument for African retentions in America.[10] In *The Afro-American Tradition in the Decorative Arts*, Vlach interpreted similarities in form and content among a range of African and Black-American artifacts to find common aesthetic preferences distinguishing Black American creators.[11]

The decorative features of folk artifacts have attracted some folklorists to decipher the symbolic codes that exist within designs and adornments. John Joseph Stoudt, who wrote from the 1930s to the 1970s on folk art, did provocative studies of Pennsylvania German folk iconography. He reported the presence of Jungian archetypes representing anticapitalist religious values.[12] In "The Cemetery as a Cultural Text," Ricardas Vidutis and Virginia A. P. Lowe read designs as an index to religious expression and attitude toward death.[13] They additionally analyzed the location of gravemarkers in relation to one another, in this instance from a small town in southern Indiana. Placed in a historical chronology, changes in the stones' form and content over time suggested a movement in the community from ethnic pietism to the "garden-like ideal of American romanticism."[14]

Although the text is treated differently in such material culture studies, the object is consistently considered the study's center from which inferences are made. The object as text is usually completed and historical, and it lacks clues to its maker or creative context. Using the object as a stable text allows the analyst to classify and compare isolated examples, with the goal of making statements of meaning about the culture or the practice the object represents.

SETTING AND REGION

Henry Glassie's landmark work, published in 1968, *Pattern in the Material Folk Culture of the Eastern United States,* used folk objects to

describe regions that emanate from several cultural hearths on the Eastern Seaboard.[15] Glassie argued for folk objects as evidence of regional cultures. Folk objects tend to vary across space, remain stable over time, and display local connections. Thus he could document the folk-built landscape and reasonably infer the historical integrity of regional cultures. By observing house and barn form across space, he mapped the fuzzy borders of America's regions and movement of ideas. Whereas previous folk material culture studies stressed crafts and foods, Glassie made a case for architecture as the most desirable cultural fact because architecture is readily visible and countable, it is a direct utilitarian response to the environment, and it tenaciously holds its ground over time.

While Glassie's *Pattern* combined folklore and cultural geography, several other folklorists had pushed for an even wider interdisciplinary approach to American material culture. Don Yoder, Louis C. Jones, Norbert Riedl, Warren Roberts, and Bruce Buckley, for example, brought to the attention of younger folklorists German and Scandinavian models of regional ethnology upon which they based their "folklife study."[16] They proposed a "total-culture" study of a community or region. Rather than separating narratives, customs, and objects for identification and interpretation, they called for a holistic approach that reconstructs the fabric of the whole from the weave of the various cultural threads. Combining anthropology, geography, and history, folklife study drew support from those studying regional and sectarian groups like the Pennsylvania Germans and Utah Mormons. Although not intended to overstate material culture, folklife proponents stressed physical and customary evidence in reaction to the prevalent verbal orientation of American literary folklorists.

A new generation of students trained in folklife eventually arose in the 1970s. Showing the regional integration of language and architecture, Howard Wight Marshall and John Michael Vlach collaborated on what would become an influential article, "Toward a Folklife Approach to American Dialects."[17] Marshall later completed a major regional study, *Folk Architecture in Little Dixie,* based on Glassie's geographic method.[18] Also using Glassie's work as a foundation, John Moe in "Concepts of Shelter" charted through folk architecture the migration of ideas into the Midwest and Great Plains.[19]

The label "folklife" has caught on more than its method. Critics complain of the assumption of folk culture as passive and conservative, primarily rural or isolated, and superorganic. Even Glassie has questioned his earlier studies.[20] The major anthology of the movement published in 1976, *American Folklife,* presented studies of material cul-

ture, but stopped short of the type of community study set up as the goal of folklife study in its strictest sense.[21]

While region remains important to many folkloristic studies, other works survey the folk arts of a state to demonstrate its cultural distinctiveness. Occasionally the surveys highlight cultural regions existing within the state. Noteworthy books can be found for Oregon, Utah, Michigan, Mississippi, and Vermont.[22] The setting can also be a county, as in the exemplary *Barn Building in Otsego County, New York* by Henry Glassie and *The Traditional Arts and Crafts of Warren County, Kentucky* by Annie Archbold.[23]

Often using oral history to aid folk material culture research, some studies uncover the traditional life of a town, neighborhood, or village. In *Hollybush* for example, Charles E. Martin reconstructed the housing and activities of an extinct eastern Kentucky farming community.[24] C. Kurt Dewhurst and Marsha MacDowell meanwhile showed how the pottery industry of Grand Ledge, Michigan, created a local culture revolving around the main occupation.[25]

For such studies the researchers chose rooted, stable communities. Describing mobile Americans—suburban dwellers, army brats, students, and truck drivers, to name a few—moving in and out of various settings across the landscape remains a challenge for the American folklorist to interpret. Folklorists want to describe how such people derive their sense of place, their sense of rootedness, in a changing society and environment.

GROUP AND NETWORK

Folklore is often attached to groups. Researchers refer to ethnic, occupational, or religious folklore as traditions shared and learned by members of groups. Alan Dundes based his influential 1965 definition of "folk" on groupness. "The term 'folk' can refer to *any group of people whatsoever* who share at least one common factor. It does not matter what the linking factor is—it could be a common occupation, language, or religion—but what is important is that a group formed for whatever reason will have some traditions that it calls its own. In theory a group must consist of at least two persons, but generally most groups consist of many individuals. A member of the group may not know all other members, but he will probably know the common core of traditions belonging to the group, traditions which help the group have a sense of group identity."[26] With this idea in mind, the researcher examines the persistence and vitality of group identity and boundary by collecting

and interpreting folk products peculiar to the group. With the leeway allowed in the notion of group given by Dundes, the researcher can collect a family's folklore, the folk arts of the deaf or a group of friends, in addition to the conventional ethnic and regional groups.

Although much of the nineteenth-century folkloristic collection was devoted to American Indians, the most extensive recent work in folk material culture concentrated on American ethnic and racial groups. The indefatigable collectors Harry Hyatt and Newbell Niles Puckett amassed volumes of field-collected data on Afro-American folk objects, especially charms and amulets.[27] More recently, William Ferris's anthology *Afro-American Folk Art and Crafts* presented the substantial contemporary scholarship on black material culture.[28] Setting the tone for the field, John Vlach's many publications use black folk art to "tell the tale of survival in a creolized culture."[29]

German-American material culture has attracted a major portion of attention in the literature. Having the advantage of an academic power base, especially in Pennsylvania, and the backing of a well-organized folklore society devoted to Pennsylvania-German studies founded in 1891, folklorists working with German-American folklore had ready outlets and encouragement for their research. These folklorists inherited a continental European tradition of scholarship that stressed objects and customs in addition to tales. When the Pennsylvania folklorists looked to show the distinctive German culture in their region, they naturally included the striking arts of fraktur and *scherenschnitte* (paper cutting), and the architecture of the forebay barn. The Pennsylvania German Society and the Pennsylvania German Folklore Society have published several impressive monographs, including Amos Long's *The Pennsylvania German Family Farm* and Preston Barba's *Pennsylvania German Tombstones.*[30]

The United States has no series of folkloristic publications on ethnic and religious groups to match the series published by the Canadian National Museum of Man, but the list of articles and books on folk material culture of ethnic groups is growing.[31] A monumental early work that included folk artifacts is Phyllis Williams's *South Italian Folkways in Europe and America.*[32] Exemplary of modern scholarship is Charles Briggs's *The Wood Carvers of Cordova, New Mexico* on Hispanic-American folk art. Don Yoder's seminal essays on folk costume and cookery from the 1970s had suggested the later directions in ethnic and religious studies realized in sweeping books such as *Religious Folk Art in America* by C. Kurt Dewhurst, Betty MacDowell, and Marsha Mac-Dowell, and *Ethnic and Regional Foodways in the United States* edited by Linda Keller Brown and Kay Mussell.[33]

135

Groups linked to a person's job, age, and sex have been given less than their due. Bruce Nickerson had to ask in the title of an article published in 1974, "Is There a Folk in the Factory?"[34] Yes, he answered. Based on techniques informally passed down to them, factory workers construct tools and animal figures from scrap materials. Robert McCarl added in "The Production Welder" that under certain conditions industrial work takes on folk processes.[35] If not *in* work, *from* work, workers have their folk crafts that make statements about the work they do. Coal miners have a tradition of decorative anthracite carving, lumberjacks have their carved wooden fans and chains, and as Bruce Jackson has shown, prisoners, an institutional group, have their own folk implements and beverages.[36]

That different age groups show preferences for particular styles of folk artifacts has only recently been studied. Children's folk material culture, unlike adult things, is often hidden, ephemeral, and temporary, thus making documentation difficult, yet none the less valuable. Folk objects made by children can be important to American Studies, for example, because American Studies researchers commonly overstate the importance of factory or adult-made objects and toys in interpreting children's culture. Recent articles by Mac E. Barrick and Mark West surveying American folk toys signal a movement toward interpreting the objects children make and know.[37]

Unlike "public" skills and performances common in middle age, the arts of the elderly tend to be esoteric, or are made in seclusion. A thought-provoking essay on this subject is Alan Jabbour's "Some Thoughts from a Folk Culture Perspective" in *Perspectives on Aging*.[38] Studies are now appearing that include assessments of the folk art particular to the aged, including my own *Chain Carvers: Old Men Crafting Meaning*.[39] Are there also designs and genres to which people during adolescence and middle age are attracted? What roles do objects play in the rites of passage between ages?

The rise of women's studies has inspired folkloristic studies of the different spheres of material culture characteristic of men and women. C. Kurt Dewhurst, Betty MacDowell, and Marsha MacDowell made a significant contribution to the scholarship with *Artists in Aprons: Folk Art by American Women*.[40] The issue of whether women's genres can be identified and explained pervades several recent publications, including *Women's Folklore, Women's Culture*, edited by Rosan A. Jordan and Susan J. Kalcik.[41]

Although many material culture studies are classified according to the group they cover, many folklorists have moved away from the idea that a group has a culture that members accept. Looking more at the

individual or the event in which group interaction takes place, these folklorists ask in what networks does the individual operate.[42] What identities does the individual have and how are they expressed in particular settings? The old term "group" has turned into "social context" to show that members actively choose their associations and traditions. Thus the identities people relate to America's constituent groups and the traditions arising from the connection of persons sharing something in common remain a frequent organizing principle of folkloristic studies.

INDIVIDUAL AND PERSONALITY

Michael Owen Jones's *The Hand Made Object and Its Maker* ranks among the most influential folkloristic works of the last decade.[43] Jones's book revealed the life and work of a Kentucky chairmaker. Instead of surveying isolated elements of many craftsworkers' products, as was common previously, Jones concentrated on a single craftsman's surrounding, personality, and creative process. Conceptually, his approach allowed for sociopsychological assessments of motivation for, and meanings of, expressing creativity and perpetuating tradition. Pragmatically, one could no longer do the kind of sweeping comparative survey of many "old" living craftspeople romantic folklorists wanted; the coopers, basketmakers, and chairmakers just weren't around as much as they used to be. So a logical move to place folk art study in the modern world was to look in depth at those genuine folk practitioners that remained and those that were emerging. Of course folklorists realized that despite the disappearance of many "old" crafts, new modern technics arose that were worthy of folkloristic study. Yet folklorists were predominantly drawn to the older crafts, especially out in the country. Their previous training and general temperament stressed the romantic lure of the countryside. As the urban field opened to folklorists, they slowly discovered new opportunities for research. Degree-granting programs in folklore in urban universities such as the University of Pennsylvania and the University of California at Los Angeles began to encourage local collections. The oldest folkloristic Ph.D. program, at Indiana University, sponsored a field project in Gary, Indiana, and the program at Cooperstown, usually stressing rural material culture, sent a team of researchers to Utica, New York.[44]

Michael Owen Jones strongly influenced many of the changes occurring during the late seventies in folk material culture study and folkloristics. He called for new methods of collecting, including gathering life histories and making psychological analyses. Objects were used

137

to find symbolic projections of self, and clues to a maker's relationships with others. The analyst examined the whole creative process, including all the intervening procedures and conditions between the conception and completion of the product. In these steps, the maker subtly reveals his values and attitudes to the analyst. Because of the emphasis on process and personality in the new studies, personal products like art, craft, and foodways came more to the fore than static, completive architecture.

Citing Jones's influence, John Vlach published *Charleston Blacksmith: The Work of Philip Simmons* in 1981.[45] Vlach broke new ground by discussing how the urban environment fostered, not necessarily discouraged, as many would have it, the retention of "old" crafts. Vlach gave a thorough description of Simmons's view of his environment and community, his clients and friends. Thus one of the core questions asked is about the role of community in shaping the aesthetic and change of Simmons's creative tradition. This inquiry differs somewhat from that of Jones, who was more concerned with the chairmaker's psyche and actions than his surroundings and ethnic influences.

Another important interpretation of a life history was given by William Ferris in 1975. In "Vision in Afro-American Folk Art: The Sculpture of James Thomas," Ferris uncovered the motivations for, and meanings of, strange skulls and faces Thomas molded in clay.[46] Drawing continuities of Thomas's sculptural repertoire with his verbal and musical repertoire, indeed with Thomas's dreams and visions, Ferris inferred from Thomas's memories and creations a fatalistic cultural attitude toward death and an affirmation of Afro-American identity.

The techniques of collecting life histories and making sociopsychological analyses in material culture study are now being refined as new folk biographies appear. American folklorists are examining, for instance, the precedents of such research among East European and Russian folklorists.[47] The life histories that folklorists are increasingly using resemble oral autobiographies that interpret the informant's experience. They can supplement the personal history American Studies scholars are unfolding through the study of written autobiographies.[48] The renewed interest in the creative individual promises new insights into the relations of style and personality, expression and experience.

EVENT AND ACTION

When the creative process became more of a research concern as a result of substantial discussion during the 1970s on folklore as "perfor-

mance in context'' and ''events as a social experience and communicative act,'' vigorous new studies surfaced that considered material culture not just as a product of behavior, but behavior itself.[49] People confront objects in daily encounters. Some of the encounters appear as events or rituals—eating meals, dressing in the morning, taking out the trash, and decorating the house. Although a folk thing is not being *made* in the old sense, creativity takes place because forms are manipulated, actions are consummated, roles are enacted. Aesthetic and behavioral principles derived from folk processes dictate people's conduct and communication in such events.

In a major statement on artifactual events, *Foodways and Eating Habits*, several authors explored what people eat and how and why they eat those things in particular situations.[50] Such incidental events as eating an Oreo cookie, Elizabeth Mosby Adler showed, became profound rituals of separating combined foods. The rituals are part of the need persons have to involve risk and creativity in their daily lives, and to define working categories of food combination. Amy Shuman contended that how you ask for a portion of food—''Just a tiny slice, please!'' or ''Pile it on!''—constitutes a rhetoric of behavior that expresses social relations and attitudes toward food apportionment in various situations. In another essay, Thomas Adler reported the widespread American tradition of men cooking or barbecuing on Sundays. Considering the cooking processes involved, Adler noted society's usual association of roasting outdoors with masculinity and boiling done indoors with femininity. Making men's cooking a ritual event reduced the tension of an awkward masculine role. Indeed, the event indicates how encounters persons have with technical processes express changing role relations, in this case within the American nuclear family, and guiding codes of behavior.

Michael Owen Jones, expanding on his own contributions to folk art study, published in 1981 a provocative urban study, ''L.A. Add-ons and Re-dos: Renovation in Folk Art and Architectural Design.'' Calling for a behavior-centered study of folklore, he contended that ''the folklorist focusing on 'human behavior' could, say, study the activities of welders in a factory without having to be concerned directly with the products that tumble off an assembly line, or examine a writer's familiarity with and incorporation of characterizations of behavior in fiction without having to be committed to the other kinds of questions that intrigue a literary scholar or research his or her own behavior such as that of singing and hypothesizing and ritualizing and constructing things.''[51] Jones demonstrated his idea with a description of behavioral similarities based on informally learned models when people fix-up, redo, or add-on to their modern urban houses.

In this view, action becomes central. Although ritual or custom might surround creativity, the behavior signifies the human apprehension and alteration of the physical world. In effect, our bodies become objects unto themselves and to the inanimate surroundings. Gestures and movements give shape and expression to our bodies and to other objects.[52] Arrangements of hair, covers of cosmetics or paint, applications of jewelry and tattoos make our bodies tell something about ourselves. Indeed, actions become forms that are meditated, arranged, and manipulated. Because of the fundamental need people have to objectify human feelings and ideas, the actions often, but not necessarily, result in material creations, but they are still part of material culture.

IDEA AND THOUGHT

Having accepted behavior as a jumping-off point for their study, some folklorists looked still deeper for mind. Henry Glassie, in an important theoretical study, *Folk Housing in Middle Virginia,* justified his structural analysis of a region's architectural rigor mortis by asserting, "Artifacts are worth studying because they yield information about the ideas in the minds of people long dead. Culture is pattern in mind, the ability to make things like sentences or houses. These things are all that the analyst has to work with in his struggle to get back to the ideas that are culture."[53] Based on Noam Chomsky and Claude Lévi-Strauss's linguistic theories, Glassie presented a structure of rules, a "grammar" representing base mental concepts that underlie and order architectural form and designing competence. The mental operations that influence the house designer's repertoire of form and competence are based on binary oppositions of symbolic ideas such as artificial and natural, private and public. Glassie's description of such mental operations becomes rather extended and complex, but ultimately he used his structural analysis to help explain the base concepts upon which a people in middle Virginia at one time shaped their dwellings and world.

Michael Owen Jones also sought to uncover cognitive processes, but he was more concerned with the present than the past. To get at mind, he stressed the observable behavior of people dealing with objects, not the structure of past artifacts. In a perspective on working as art, inspired by anthropologist Franz Boas, Jones identified a fundamental "feeling for form" and an ability to achieve "formal excellence" underlying workers' capacity to cope with the day-to-day repetition of their tasks.[54] Rather than project an image of the abstract mind, Jones

emphasized the sensory relations of thought to action. Work, like eating, is a physiological and intellectual experience.[55] "What is required for an activity to have esthetic value," he argued, "is that an individual be aware of and manipulate qualities appealing to the senses in a rhythmical and structured way so as to create a form ultimately serving as a standard by which its perfection (or beauty) is measured. Sometimes these forms elevate the mind above the indifferent emotional states of daily life because of meanings conveyed or past experiences associated with them, but they need not do so to be appreciated."[56] In his 1980 article, "A Feeling for Form, As Illustrated by People at Work," Jones examined the alterations to the assembly-line system that workers informally devised at a Vega plant in Lordstown, Ohio. Stressing teamwork, play, and creativity, the new work system succeeded in increasing production and worker satisfaction, although it was opposed by management and union. Once this type of knowledge is acquired from folkloristic study, Jones urged, one should seek opportunities to apply a psychological feeling for form to managerial and labor practices. Folkloristic study in context can thus supply interpretations of face-to-face interaction and creative expression to expand the analysis of organizational behavior and labor history.

In keeping with this concern for identifying basic human sensory and mental processes that underlie and order material culture, I proposed in *Grasping Things* that the sense of touch holds an integral cultural role in the reasoning and problem solving of people.[57] Show a puzzle to someone, and they want to handle it, touch it, and "work it out." Faced with an apparition, people try to touch it, to see if it is real. Shoppers ask to "see" a sweater, but what they mean is that they want to feel it and consequently know it. After all, "Seeing's believing, *but feeling's the truth*." People use objects significantly to more than reflect ideas; they work through ideas through touch and other senses.

The consumption of turtle soup and turtle butchering in southern Indiana are customs that demand strong sensory reactions. Although part of the area is well known for the practice, many residents have mixed feelings about the hunting and consumption of turtles. Why then does such a practice persist? Among other reasons is the human capacity to hold conflicting views. Yet the American Studies and anthropological literature abounds with the assumption of a homogeneous, like-minded community. Consequently the individual is sketched as a passive, single-minded cultural carrier. Rather, to make decisions people often actively establish cognitive polarities of conflicting attitudes. For example, individuals in southern Indiana confront both the pride and loathing they simultaneously feel for turtle butchering. Altering the

texture and appearance of the soup to hide the turtles, and participating communally and ritually at church picnics in the physical preparation and consumption, compensated for some of the loathing. Although not countenanced by all residents, this folk practice continues under certain conditions that allow the pride to carry weight.[58]

Besides describing the mental operations of individuals, folklorists also locate the collective predominant aesthetic and philosophical assumptions of people. Alan Dundes and Barre Toelken have shown these assumptions to be the building blocks of cultural worldview—"cognitive, existential aspects of the way the world is structured."[59] European-Americans, for example, show a preference for straight lines in space and time. Dwellings, sentences, and boundaries are typically rectilinear, and time displays a forward-moving, linear orientation.[60] What influence has literacy had on this pattern? Jack Goody discusses the effects of "tabular thinking" on material culture.[61] When people began writing, he argues, they made lists and then tables. They projected this organizational scheme onto their objects and ideas, which became symmetrical and linear.

The numerical concept of threes also pervades American language and material culture. Americans customarily eat three meals a day; divide sizes into small, medium, and large; observe red, yellow, and green traffic signals, and so on. Henry Glassie showed an instance of three as a special case of binary pairs in the predominance of bilateral symmetry—two units designed to evenly flank a central one—in Western folk art. This pattern reflected a natural, bodily design and a striving for order in the rapid change of modern civilization.[62]

Many American Indian groups provide a contrast to European-American worldview. In narratives they rely on fours—four scenes, tasks, and so on. Working time and dwelling space are conceived circularly. Such folk ideas are often unconscious, unstated premises supplying, according to Dundes, "the raw materials for the study of human thought."[63] By comprehending thought, the folklorist grasps underlying roots of the ways the tangible and intangible products of a people are perceived, shaped, and ordered.

NEW OBJECTS, REMAINING CONCERNS

The material culture seedling planted by Fletcher Bassett almost a century ago has grown to show many folkloristic branches and its share of offshoots. For all its promise, however, material culture study in folkloristics cannot stand exclusively on physical evidence. Having re-

dressed much of the evidential imbalance of years past that concentrated largely on verbal sources, many folklorists are anxious to reintegrate the material facts with customary, gestural, oral, and written evidence. As the last two categories of event and action, and idea and thought demonstrate, folklorists are beginning to explore the shadowy areas at the outer borders of the tangible and intangible. Work, play, and movement become forms to which the methods of material culture study can be applied. Such subjects force researchers to add communication, process, behavior, and cognition to the working research lexicon. In fact, I am in favor of carrying over concerns of the event and individual, thought and action, to American Studies. Such concerns in material culture study raise the possibility of bridges between the work of American and European folklorists studying objects. A special issue in 1978 of *Ethnologia Scandinavica* cited American work in important articles on "Dwellings as Communication," "Symbolic Values in Clothing," and "The Concept of Identity."[64] American Studies in turn benefits from European regional and national studies of cultural communication.

Many folklorists are simultaneously snapping up the philosophical bait of aesthetic and worldview. While implying retention of the humanistic foundation of folkloristics, material culture study demands its own rigor based on the recent contributions of the social and behavioral sciences to folk artifactual research. More than collection, this requires method. Mind and behavior beg for the theories, past and future, to explain them. My study of the rise of manner books and its relation to the aesthetics of suburban houses, for example, relates the social and environmental change brought by urbanization and industrialization in American history, and the growth of the middle class, to changes in American folk design and behavior. I examined the influence of the shape of our objects on the ways Americans perceive their made world and the ways they act toward one another.[65] I offer this example as an attempt to apply and develop cognitive and behavioral theories in material culture study, folkloristics, and American Studies.

Folklorists generally have moved beyond identification to interpretation; and they are slowly moving toward the extensive testing and generating of hypotheses. This is not meant to belittle the vitality of older, conventional humanistic concerns. To be sure, different folklorists have different priorities and purposes. In many instances, a folklorist, Henry Glassie for example, has addressed several questions with different approaches. To contribute to American Studies, however, the folkloristic uncovering of the specific acts, scenes, settings, actors, roles, and props—ones often outside of historical verbal inquiry—in the drama

that is the American experience may indeed be the folklorist's major task at hand.

Few folklorists today choose to describe a unique and holistic American folk culture. For American Studies, artifactual study in folkloristics has been used rather to aver America's cultural pluralism, or to reveal the fundamental behavioral and cognitive similarities among people that transcend national boundaries. Increasingly, the diverse, specific situations (meeting strangers, living on the road, setting up cooperative households, growing up ethnic), settings (the impersonal business office, the backyard barbecue, the boy scout camp, the retirement community), and events (the "booster" festival, the family celebration, the sports spectacle, the club initiation rite) loosely framed by America compose the frequent backdrop of folklorists working in American Studies.

Of special concern are the conditions under which people choose to express their many identities, one of which may be "American."[66] Material culture study, which interprets the meaning of products of informal interaction and learning, can significantly contribute to the role of folkloristics in American Studies. That role entails describing the cultural equipment and expectations of Americans, and thus encompasses both the unity and diversity of American expressive behavior as it is enacted in social life.[67] The American folklorist's bookshelf steadily expands to accommodate the varied, complex identities of age, sex, family, and occupation—to name a few identities increasingly attracting attention in print. In the newer studies, folklorists argue that group identity does not control the individual. Rather, a person selects and expresses identities strategically. How individuals negotiate between those varied identities and how they impart their personalities through folk objects will undoubtedly continue to command folkloristic research.

A lesson the literature of American folkloristics teaches is that the death bells that some scholars like to sound for folklore ring falsely. To be sure, a need exists to document for posterity old landscapes, old ways of doing things, and to preserve historic objects, but our eyes should be ever open for the presently new and young. Despite constant calls for "getting it before it's lost," new folk processes arise and grow. Although material folk culture sometimes appears as a nostalgic relic of the preindustrial era in museums and in the popular press, researchers should realize that folk technics regularly adapt to new surroundings and conditions in the modern world. Children string chains of gum-wrappers; woodcarvers make figures with chain saws; urban dwellers build sidewalk sheds for their trash cans. People still learn skills informally and put their folk imprint on the built environment. Material

folk culture changes and new folk forms emerge, but this characteristic makes it even more significant to American Studies, for folklore often reacts to, and acts on, the events of the day. Through symbol and story, folklore can tell what people can't talk about. As a historical fixture, folklore can also relate the past and influence the future.

Despite the commercialization and standardization of society, people still primarily rely on informal learning. People demand tradition. They still venerate the handmade, and they still depend on folklore for their sense of place, past, and being. Folklore and its folk artifacts are not restricted to some isolated caste or class of society, or even some remote corner of the landscape. Come exam time, I can collect as many lucky beliefs from my "mainstream" students as I ever did among isolated mountain folk. As technology marches on, at the same time people retain control over their lives by realizing the workings of tradition. The last decade has witnessed simultaneously a revolution in standardized food processing and a rise in home gardening, a revolution in prefabricated building and a rise in self-built log homes (over one million in 1984). People can be found adapting the shape of technology to prevalent folk ideas of appropriate aesthetic and use. The automobile and modern house have become personalized and altered objects that connect their owners to others with similar styles or traditions. Take a look at repeated patterns of lawn ornaments, van decorations, and interior arrangements. When seats in my classroom are spread randomly, students insist on rearranging them into symmetrical rows. Folk design?

Folklorists' humanistic orientation has drawn them to technical processes over which people have personal control. Henry Glassie feels, for example, "when manufacture is broken into separate jobs done by separate people, the maker's control is abandoned to the design, and the product, the latest Ford automobile, is more the designer's than the maker's; it seems more the product of circumstance than of culture."[68] But even when physical objects are not "made" or adorned, actions and thoughts signify artistic and technical processes. Today's folklorists keep notebooks open and cameras clicking when they encounter behavior involving such processes. Although an important part of material culture study in folkloristics seeks to identify America's folk-built past, a modern development has been to record the observable behaviors of workers making things, persons receiving folk objects, and participants in events making use of objects. Folklorists are trying to understand how symbols are created and changed, how objects function for people, and how designs are conceived and executed. Objects and actions commonly "speak" louder than words, and folklorists are actively looking at material culture as communication and learning.

Folk material culture is capable of providing evidence of the everyday past and of supplying the "visible proofs" of the changing beliefs and customs people hold. Students can study individuals to analyze the creative impulse and to interpret how personality is conveyed through objects and technical activities. The influence of social movements, historical trends, and geographical changes on folk material culture, too, needs attention from students. In the backs of their minds scholars hope that with the patterns uncovered from objects and technical processes used in social life, they can predict future attitudes, manners, and problems of our materialistic society. Joining verbal and other types of evidence, material culture helps to give a broader, more vivid picture of human endeavor. Folk material culture valuably fills out the range of expression considered by the student and critic of culture. The goal is that material culture study and folkloristics let students see the past in a new light, and more fully grasp the present world around them. For American Studies, the study of folk material culture can especially be a major resource for understanding relations between social identity and expression, between personal conduct and communication, and significantly, between human idea and design.

NOTES

1. Fletcher Bassett, *The Folk-Lore Manual* (Chicago: Chicago Folk-Lore Society, 1892), 8, 12.
2. Walter James Hoffman, "Folklore of the Pennsylvania Germans," *Journal of American Folklore* 1 (1888): 125–35.
3. William Wells Newell, "On the Field and Work of a Journal of American Folklore," *Journal of American Folklore* 1 (1888): 3.
4. In *American Material Culture and Folklife*, ed. Simon J. Bronner (Ann Arbor, Mich.: UMI Research Press, 1985), 3.
5. For further discussion of the concepts and assumptions beyond this essay, see Simon J. Bronner, "Concepts in the Study of Material Aspects of American Folk Culture," *Folklore Forum* 12 (1979): 133–72; Michael Owen Jones, "The Study of Folk Art Study: Reflections on Images," in *Folklore Today*, ed. Linda Dégh, Henry Glassie, Felix J. Oinas (Bloomington: Indiana University, 1976), 291–304. Some of the more extensive bibliographic surveys of the range of material folk culture studies are: Simon J. Bronner, ed., *American Folk Art: A Guide to Sources* (New York: Garland Publishing, 1984); Howard Wight Marshall, *American Folk Architecture: A Selected Bibliography* (Washington, D.C.: American Folklife Center, 1981); Ormond Loomis, *Sources on Folk Museums and Living Historical Farms* (Bloomington, Indiana: Folklore Forum Bibliographic and Special Series, No. 16, 1977). See also Susan Sink, *Traditional Crafts and Craftsmanship in America* (Washington, D.C.: American Folklife Center, 1983); Simon J. Bronner, "Researching Material Culture: A Selected Bibliography," *Middle*

Atlantic Folklife Association Newsletter 5 (October 1981): 5–12; Simon J. Bronner and Christopher Lornell, "Folklore and Art History," in *Afro-American Folk Arts and Crafts,* ed. William Ferris (Boston: G. K. Hall, 1983), 353–93; Simon J. Bronner, "The Hidden Past of Material Culture Studies in American Folkloristics," *New York Folklore* 8 (Summer 1982): 1–10.

6. *Games of the North American Indians* (1907; reprint New York: Dover, 1975).

7. *Three Eyes on the Past: Exploring New York Folklife* (Syracuse: Syracuse University Press, 1982), 167; *Outward Signs of Inner Beliefs: Symbols of American Patriotism* (Cooperstown: New York State Historical Association, 1975).

8. Alan Dundes and Carl R. Pagter, *Work Hard and You Shall Be Rewarded: Urban Folklore from the Paperwork Empire* (1975; reprint Bloomington: Indiana University Press, 1978). For more on urban material folk culture, see Simon J. Bronner's "Researching Material Folk Culture in the Modern American City," in his *American Material;* Bronner's "Folklore in the Bureaucracy," in *Tools for Management,* ed. Frederick Richmond and Kathy Nazar (Harrisburg, Pa.: PEN Publications, 1984); and Barbara Kirshenblatt-Gimblett's "The Future of Folklore Studies in America: The Urban Frontier," in *Folklore Forum* 16 (1983): 175–234.

9. "Mail Order Magic," *Journal of the Folklore Institute* 16 (January–August 1979): 44–74.

10. "Sources of the Shotgun House: African and Caribbean Antecedents for Afro-American Architecture" (Ph.D. diss., Indiana University, 1975); "The Shotgun House: An African Architectural Legacy," *Pioneer America* 8 (1976): 47–70.

11. *The Afro-American Tradition in Decorative Arts* (Cleveland: Cleveland Museum of Art, 1978).

12. *Pennsylvania German Folk Art: An Interpretation* (Allentown: Schlecter's, for the Pennsylvania German Folklore Society, 1966).

13. "The Cemetery as a Cultural Text," *Kentucky Folklore Record* 26 (July–December 1980): 103–13.

14. Vidutis and Lowe's "Cemetery as a Cultural Text," 12. This conclusion came as a result of semiotic analysis. For other semiotic analyses of material culture, see Danielle M. Roemer, "In the Eye of the Beholder: A Semiotic Analysis of the Visual Descriptive Riddle," *Journal of American Folklore* 95 (April–June 1982): 173–99; Henry Glassie, "Structure and Function, Folklore and the Artifact," *Semiotica* 7 (1973): 313–51.

15. *Pattern* (Philadelphia: University of Pennsylvania Press, 1968).

16. Don Yoder, "The Folklife Studies Movement," *Pennsylvania Folklife* 13 (July 1963): 43–56; Louis C. Jones, "Three Eyes on the Past: A New Triangulation for Local Studies," *New York Folklore Quarterly* 12 (1956): 3–13; Warren Roberts, "Folk Architecture," *Folklore and Folklife,* ed. Richard M. Dorson (Chicago: University of Chicago Press, 1972), 281–93; Bruce Buckley, "A Folklorist Looks at the Traditional Craftsman," in *Country Cabinetwork and Simple City Furniture,* ed. John D. Morse (Charlottesville: University of Virginia Press, 1968), 265–76; Riedl, "Folklore and the Study of Material Aspects of Folk Culture," *Journal of American Folklore* 79 (1966): 557–63.

17. "Toward a Folklife Approach," *American Speech* 48 (1973): 163–91.

18. Howard W. Marshall, *Folk Architecture in Little Dixie: A Regional Culture in Missouri* (Columbia: University of Missouri Press, 1981).

19. "Concepts of Shelter," *Journal of Popular Culture* 11 (1977): 219–53. Other geographic and folkloristic statements of midwestern and Great Plains architecture are found in Roger Welsch, *Sod Walls: The Story of the Nebraska Sodhouse* (Broken Bow, Nebr.: Purcells, 1968); Warren E. Roberts, *Log Buildings of Southern Indiana* (Bloomington, Ind.: Trickster Press, 1984); Robert W. Bastian, "Indiana Folk Architecture: A Lower Midwestern Index," *Pioneer America* 9 (December 1977): 113–36; Jan Harold Brunvand, "The Architecture of Zion," *The American West* 13 (1976): 28–35; Terry Jordan, *Texas Log Buildings* (Austin: University of Texas Press, 1978); Austin and James Fife, "Hay Derricks of the Great Basin and Upper Snake River Valley," *Western Folklore* 7 (1948): 225–39.

20. See his appended note to "The Types of the Southern Mountain Cabin," in Jan H. Brunvand, *The Study of American Folklore: An Introduction,* 2nd ed. (New York: W. W. Norton, 1978), 391–420. See also the criticisms in Trefor M. Owen, "Folk Life Studies: Some Problems and Perspectives," *Folk Life* 19 (1981): 5–16; Bronner, "Concepts," 136–53; M. O. Jones, "The Study of Folk Art Study," 297–99.

21. Typical of the volume are studies that concentrate on a practice or object. See Warren E. Roberts's "The Whitaker-Waggoner Log House from Morgan County, Indiana," Gerald Davis's "Afro-American Coil Basketry in Charleston County, South Carolina: Affective Characteristics of an Artistic Craft in a Social Context," and Walter L. Robbins's "Wishing In and Shooting In the New Year among the Germans in the Carolinas," *American Folklife,* ed. Don Yoder (Austin: University of Texas Press, 1976), 185–208, 151–84, 257–79.

22. Suzi Jones, ed., *Folk Art of the Oregon Country* (Eugene: Oregon Arts Commission, 1980); Suzi Jones, *Oregon Folklore* (Eugene: Oregon Arts Commission, 1977); Hal Cannon, ed., *Utah Folk Art* (Provo, Utah: Brigham Young University Press, 1980); C. Kurt Dewhurst and Marsha MacDowell, *Rainbows in the Sky: The Folk Art of Michigan in the Twentieth Century* (East Lansing: Michigan State University, 1978); Patti Carr Black, ed., *Made by Hand: Mississippi Folk Art* (Jackson: Mississippi Department of Archives and History, 1980); Jane C. Beck, ed., *Always in Season: Folk Art and Traditional Culture in Vermont* (Montpelier: Vermont Council on the Arts, 1982). A substate historical survey is John H. Braunlein's *Colonial Long Island Folklife* (Stony Brook, N.Y.: The Museums at Stony Brook, 1976).

23. Henry Glassie, *Barn Building in Otsego County* (1974; reprint Cooperstown: New York State Historical Association, 1976); Annie Archbold, *The Traditional Arts and Crafts of Warren County* (Bowling Green, Ky.: Bowling Green–Warren County Arts Commission, 1980).

24. *Hollybush: Folk Building and Social Change in an Appalachian Community* (Knoxville: University of Tennessee Press, 1984).

25. *Cast in Clay: The Folk Pottery of Grand Ledge, Michigan* (East Lansing: Michigan State University, 1980).

26. Alan Dundes, "What Is Folklore?" *The Study of Folklore,* ed. Alan Dundes (Englewood Cliffs, N.J.: Prentice-Hall, 1965), 2. The "community" as group is discussed in John Vlach's "The Concept of Community and Folklife Study," in *American Material Culture and Folklife,* ed. Bronner, 63–76.

27. Hyatt, *Hoodoo, Conjuration, Witchcraft, and Rootwork,* 5 vols. (Hannibal, Mo.: Alma Egan Hyatt Foundation, 1970–78); Puckett, *Folk Beliefs of the Southern Negro* (1926; reprint New York: Dover, 1969); Michael Edward Bell, "Harry Middleton Hyatt's Quest for the Essence of Human Spirit," *Journal of the Folklore*

Institute 16 (January–August 1979): 1–27; William H. Wiggins, Jr., "The Field Photography of Newbell Niles Puckett," *Made by Hand,* ed. Patti Carr Black (Jackson: Mississippi Department of Archives and History, 1980), 33–37.

28. *Afro-American Folk Art and Crafts* (Boston: G. K. Hall, 1983).

29. John Vlach, "Arrival and Survival: The Maintenance of an Afro-American Tradition in Folk Art and Craft," *Perspectives on American Folk Art,* ed. Ian M. G. Quimby and Scott T. Swank (New York: W. W. Norton, 1980), 216.

30. Long, *The Pennsylvania German Family Farm* (Breinigsville: The Pennsylvania German Society, 1972); Barba, *Pennsylvania German Tombstones* (Allentown: Schlecter's, for the Pennsylvania German Folklore Society, 1954). Germans in other states are covered in G. M. Ludwig, *The Influence of the Pennsylvania Dutch in the Middle West,* vol. 10 (Allentown: Publications of the Pennsylvania German Folklore Society, 1945); Institute of Texan Cultures, *The Texan Germans* (San Antonio: Institute of Texan Cultures, 1970); Charles Van Ravenswaay, *The Arts and Architecture of German Settlements in Missouri* (Columbia: University of Missouri Press, 1977); Margaret Hobbie, comp., *Museums, Sites, and Collections of Germanic Culture in North America* (Westport, Conn.: Greenwood, 1980).

31. Two of the ethnic-religious material culture titles in the Canadian series are: Nancy-Lou Gellermann Patterson, *Swiss-German and Dutch-German Mennonite Traditional Art in the Waterloo Region, Ontario* (Ottawa: National Museum of Man, 1979); Charles M. Sutyla, *The Finnish Sauna in Manitoba* (Ottawa: National Museum of Man, 1977). Recent examples of United States studies are Neil Grobman, *Wycinanki and Pysanky: Forms of Religious and Ethnic Folk Art from the Delaware Valley* (Pittsburgh: Pennsylvania Ethnic Heritage Studies Center, 1981); Yvonne Lockwood, "The Sauna: An Expression of Finnish-American Identity," *Western Folklore* 36 (January 1977): 71–84; Janet Langlois, "Mooncake in Chinatown, New York City: Continuity and Change," *New York Folklore Quarterly* 28 (1972): 83–117; Robert Thomas Teske, "Living Room Furnishings, Ethnic Identity, and Acculturation Among Greek Philadelphians," *New York Folklore* 5 (Summer 1979): 21–32; David R. Lee and Hector H. Lee, "Thatched Cowsheds of the Mormon Country," *Western Folklore* 40 (April 1981): 171–87.

32. *South Italian Folkways* (1938; reprint New York: Russell and Russell, 1969).

33. Briggs, *The Wood Carvers of Cordova, New Mexico: Social Dimensions of an Artistic Revival* (Knoxville: University of Tennessee Press, 1980); Yoder, "Folk Costume," "Folk Cookery," in *Folklore and Folklife,* ed. Richard M. Dorson (Chicago: University of Chicago Press, 1972), 295–324, 325–50; *Religious Folk Art in America* (New York: E. P. Dutton, 1983); *Ethnic and Regional Foodways in the United States* (Knoxville: University of Tennessee Press, 1984).

34. "Is There a Folk in the Factory?" *Journal of American Folklore* 87 (April–June 1974), 133–39. Further discussion is provided in Bruce Nickerson, "Factory Folklore," *Handbook of American Folklore,* ed. Richard M. Dorson (Bloomington: Indiana University Press, 1983), 121–27, and in Nickerson's "Ron Thiesse: Industrial Folk Sculptor," *Western Folklore* 37 (April 1978): 128–33.

35. "The Production Welder: Product, Process and the Industrial Craftsman," *New York Folklore Quarterly* 30 (December 1974): 243–53.

36. Angus Gillespie, "Traditional Anthracite Coal Carving in Northeastern Pennsylvania" (Paper read at the American Folklore Society meeting, Detroit, 1977); Marsha MacDowell and C. Kurt Dewhurst, "Expanding Frontiers: The

Michigan Folk Art Project," in *Perspectives on American Folk Art*, 54–78 (lumbering); Bruce Jackson, "Folk Ingenuity Behind Bars," *New York Folklore Quarterly* 22 (December 1966): 243–50.

37. Mac E. Barrick, "Folk Toys," *Pennsylvania Folklife* 29 (Autumn 1979): 27–34; Mark I. West, "Meaning in the Making: The Toys of Young Folk," *Tennessee Folklore Society Bulletin* 48 (Winter 1982): 105–10. See also Mary Knapp and Herbert Knapp, *One Potato, Two Potato: Folklore of American Children* (New York: W. W. Norton, 1976). Although Stewart Culin's publications remain the most encyclopedic coverage of folk toys and games, he rarely noted the ages of players and construction of the objects. See his *Games of the North American Indians; Chess and Playing Cards* (1898; reprint New York: Dover, 1976); *Chinese Games with Dice and Dominoes* (Washington: Smithsonian Institution, 1893).

38. "Some Thoughts," *Perspectives on Aging*, ed. Priscilla W. Johnston (Cambridge, Mass.: Ballinger, 1982), 139–49.

39. Simon J. Bronner, *Chain Carvers: Old Man Crafting Meaning* (Lexington: University Press of Kentucky, 1984); William Ferris, "Local Color: Memory and Sense of Place in Folk Art," in *Made by Hand*, 11–22; Kenneth L. Ames, "Folk Art: The Challenge and the Promise," in *Perspectives on American Folk Art*, 316–20; Amy Brook Snider, "The Education of the Elderly Artist," *Images of Experience: Untutored Older Artists*, ed. Ellen Schwartz, Amy Snider, Don Sunseri (New York: Pratt Institute, 1981), 1–5.

40. *Artists in Aprons* (New York: W. W. Norton, 1979).

41. *Women's Folklore, Women's Culture* (Philadelphia: University of Pennsylvania Press, 1985). See also, Claire Farrer, "Women and Folklore," *Journal of American Folklore* 88 (January–March 1975): v–xv; Andrea Greenberg, "American Quilting," *Indiana Folklore* 5 (1972): 264–79.

42. See Beth Blumenreich and Bari Lynn Polansky, "Re-evaluating the Concept of Group: ICEN as an Alternative," in *Conceptual Problems in Contemporary Folklore Study*, ed. Gerald Cashion (Bloomington, Indiana: Folklore Forum Bibliographic and Special Series No. 12, 1975), 12–17; Richard Bauman, "Differential Identity and the Social Base of Folklore," in *Toward New Perspectives in Folklore*, ed. Américo Paredes and Richard Bauman (Austin: University of Texas Press, 1972), 31–41; William A. Wilson, *On Being Human: Folklore of Mormon Missionaries* (Logan: Utah State University Press, 1981); Simon J. Bronner, " 'Learning of the People': Folkloristics in the Study of Behavior and Thought," *New York Folklore* 9 (Summer 1983): 75–88.

43. *Hand Made Object* (Berkeley and Los Angeles: University of California Press, 1975).

44. Inta Gale Carpenter, ed., *Folklore of the Calumet Region* (1977; reprint New York: Arno Press, 1980); Richard M. Dorson, *Land of the Millrats* (Cambridge: Harvard University Press, 1981); Susan G. Davis, ed., *Utica Project Issue* (Special issue of *New York Folklore*, No. 4, 1978).

45. *Charleston Blacksmith* (Athens: University of Georgia Press, 1981).

46. "Vision in Afro-American Folk Art: The Sculpture of James Thomas," *Journal of American Folklore* 88 (April–June 1975): 115–31.

47. Examples of studies drawing interest are Mark Azadovski, *A Siberian Tale Teller* (Austin: University of Texas Monograph Series No. 2, 1974); Gyula Ortutay, *Hungarian Folklore* (Budapest: Adadémiai Kiadó, 1972); A. M. Astaxova, "Improvisation in Russian Folklore," *The Study of Russian Folklore*, ed. Felix J. Oinas and Stephen Soudakoff (The Hague: Mouton, 1975), 91–110. I discuss

their ideas further in "Investigating Identity and Expression in Folk Art," *Winterthur Portfolio* 16 (Spring 1981): 65–83.

48. See Robert F. Sayre, "The Proper Study—Autobiographies in American Studies," *American Quarterly* 29 (1977): 241–62. Examples of autobiographical work in folk material culture are Leonard St. Clair and Alan Govenar, *Stoney Knows How: Life as a Tattoo Artist* (Lexington: University Press of Kentucky, 1981); Gerald Alvey, *Dulcimer Marker* (Lexington: University Press of Kentucky, 1984); Ferris, *Local Color*; Bronner, *Chain Carvers*; Vlach, *Charleston Blacksmith*.

49. Quoted terms come from, respectively, Dell Hymes, "The Contribution of Folklore to Sociolinguistic Research," *Toward New Perspectives in Folklore*, ed. Américo Paredes and Richard Bauman (Austin: University of Texas Press, 1972); Robert Georges, "Toward an Understanding of Storytelling Events," *Journal of American Folklore* 82 (October–December 1969): 313–27. See also, Dan Ben-Amos and Kenneth Goldstein, eds., *Folklore: Performance and Communication* (The Hague: Mouton, 1975).

50. "Creative Eating. The Oreo Syndrome"; "The Rhetoric of Portions"; "Making Pancakes on Sunday: The Male Cook in Family Tradition," *Foodways and Eating Habits: Directions for Research*, ed. Michael Owen Jones, Bruce Giuliano, Roberta Krell (Los Angeles: California Folklore Society, 1981), 4–10, 72–80, 45–54.

51. "L.A. Add-ons and Re-dos," in *Perspectives on American Folk Art*, 325–63. The quote is on p. 355.

52. For examples, see Jay Anderson, "Immaterial Material Culture: The Implications of Experimental Research for Folklife Museums," in *Material Culture Studies in America*, ed. Thomas J. Schlereth (Nashville: American Association for State and Local History, 1982), 306–15; John A. Rickford and Angela E. Rickford, "Cut-Eye and Suck-Teeth: African Words and Gestures in New World Guise," in *Readings in American Folklore*, ed. Jan Harold Brunvand (New York: W. W. Norton, 1979), 355–73; Michael J. Bell, *The World from Brown's Lounge: An Ethnography of Black Middle-Class Play* (Urbana: University of Illinois Press, 1983); Susan D. Rutherford, "Funny in Deaf—Not in Hearing," *Journal of American Folklore* 96 (July–September 1983): 310–22.

53. *Folk Housing in Middle Virginia: A Structural Analysis of Historic Artifacts* (Knoxville: University of Tennessee Press, 1975), 17.

54. "A Feeling for Form, as Illustrated by People at Work," in *Folklore on Two Continents*, ed. Nikolai Burlakoff and Carl Lindahl (Bloomington, Ind.: Trickster Press, 1980), 260–69.

55. See Michael Owen Jones, "The Sensory Domain," in *Foodways and Eating Habits*, ed. Michael Owen Jones, Bruce Giuliano, Roberta Krell (Los Angeles: California Folklore Society, 1981), 1–3.

56. "A Feeling for Form," 261.

57. Simon J. Bronner, "The Haptic Experience of Culture," *Anthropos* 77 (1982): 351–62; and Bronner, *Grasping Things: Folk Material Culture and the Body Politic in America* (Lexington: University Press of Kentucky, 1986).

58. Simon J. Bronner, "The Paradox of Pride and Loathing, and Other Problems," in *Foodways and Eating Habits*, ed. Jones, Giuliano, Krell, 115–24. The discussion begun there is expanded in *Grasping Things*.

59. Alan Dundes, "Folk Ideas as Units of World View," in *Toward New Perspectives*, 93–103; Barre Toelken, "Folklore, Worldview, and Communication," *Folklore: Performance and Communication*, ed. Dan Ben-Amos and Kenneth Goldstein (The Hague: Mouton, 1975), 265–86.

60. See Barre Toelken, *The Dynamics of Folklore* (Boston: Houghton Mifflin, 1979), 225–36 (straight lines); Dorothy Lee, "Codifications of Reality: Lineal and Nonlineal," *Every Man His Way,* ed. Alan Dundes (Englewood Cliffs, N.J.: Prentice-Hall, 1968), 329–43 (linearity); Simon J. Bronner, "The Anglo-American Aesthetic," *Encyclopedia of Southern Culture,* ed. William Ferris and Charles Wilson (Chapel Hill: University of North Carolina Press, 1985) (rectangular bias); Alan Dundes, "Thinking Ahead: A Folkloristic Reflection of the Future Orientation in American Worldview"; "The Number Three in American Culture," in *Interpreting Folklore* (Bloomington: Indiana University Press, 1980), 69–85, 134–59.

61. See Jack Goody, *The Domestication of the Savage Mind* (Cambridge: Cambridge University Press, 1977); Michael P. Carroll, "The Logic of Anglo-American Meals," *Journal of American Culture* 5 (Fall 1982): 36–45.

62. See Henry Glassie, "Folk Art," *Folklore and Folklife,* ed. Richard M. Dorson (Chicago: University of Chicago Press, 1972), 253–80.

63. Alan Dundes, "Folk Ideas as Units of World View," 103. Although this type of interpretation stresses a broad description of cultural attitudes that is reminiscent of the holistic studies of Don Yoder and Louis C. Jones, the study of worldview applies much more of a psychological understanding of symbolic folk products than the earlier holistic studies that emphasized sociohistorical description. Worldview study uncovers shared ideas and ways of thinking cutting across communities. Mental assumptions are studied more than social functions. Studies of worldview commonly reach beyond national borders to the shared assumptions of a continent, or even the world, although research commonly is taken from local community observation and comparison. See Bronner, "The Idea of the Folk Artifact," *American Material Culture and Folklife,* 3–46.

64. Anne Louise Gjesdal Christensen, "Dwellings as Communication"; Bo Lönnqvist, "Symbolic Values in Clothing"; Wigdis J. Espeland, "The Concept of Identity in Connection with Out-Groups and Minorities," *Ethnologia Scandinavica* 9 (1979): 68–88, 92–105, 139–47. See also, Ants Viires, "On the Methods of Studying the Material Culture of European Peoples," *Ethnologia Europaea* 9 (1976): 35–42; Sergeij A. Tokarev, "Toward a Methodology for the Ethnographic Study of Material Culture," in *American Material Culture and Folklife,* ed. Bronner, 77–96.

65. Simon J. Bronner, "Manner Books and Suburban Houses: The Structure of Tradition and Aesthetics," *Winterthur Portfolio* 18 (Spring 1983): 61–68. For background on the theory and method described, see Simon J. Bronner, "Toward a Philosophy of Folk Objects: A Praxic Perspective," in *Personal Places: Perspectives on Informal Art Environments,* ed. Daniel Franklin Ward (Bowling Green, Ohio: Popular Press, 1984).

66. Arguing for the holistic study of American culture was Richard M. Dorson, whose *American Folklore* (Chicago: University of Chicago Press, 1959) well represented his stand. For the folkloristic reaction to this view, see Simon J. Bronner and Stephen Stern, "American Folklore vs. Folklore in America: A Fixed Fight?" *Journal of the Folklore Institute* 17 (January–April 1980): 76–84; Simon J. Bronner, "Malaise or Revelation? Observations on the 'American Folklore' Polemic," *Western Folklore* 41 (January 1982): 52–61; Michael Owen Jones, "Another America: Toward a Behavioral History Based on Folkloristics," *Western Folklore* 41 (January 1982): 43–51.

67. This role is described by Richard Bauman and Roger D. Abrahams with Susan Kalčik, "American Folklore and American Studies," *American Quarterly* 28 (1976): 360–77.

68. Henry Glassie, "Folkloristic Study of the American Artifact: Objects and Objectives," in *Handbook of American Folklore*, ed. Richard M. Dorson (Bloomington: Indiana University Press, 1983), 376–83. See also his "Artifact and Culture, Architecture and Society," in *American Material Culture and Folklife*, ed. Bronner, 47–62.

7

Social History Scholarship
and Material Culture Research

Thomas J. Schlereth

A GENERATION AGO only a few American historians would have recognized or have been interested in either social history or material culture as an important research strategy in historical studies. As has been amply documented, however, social history has had a historiography stretching far beyond the emergence of its so-called new practitioners of the 1960s; the history of scholars working with artifactual evidence likewise extends well into the late nineteenth century.[1] Yet, thirty years ago, only mavericks in the historical profession—a Dixon Ryan Fox or a Thomas Wertenbaker—showed any significant interest in either of these approaches to the past.

Social history presently commands widespread attention among American historians, with one interpreter going so far as to propose that it "may very well qualify as the main cynosure of historical scholarship in the United States in the 1970s."[2] But material culture scholarship has also risen to a higher level of professional regard in the past decade. For example, two American scholarly journals, *Material Culture* and the *Winterthur Portfolio,* now carry the term "material culture" as part of their mastheads; both now emphasize the historical research of several disciplines that seek to integrate artifacts into their cultural context.[3] In the United States the label "material culture" now frequently appears as the disciplinary specialty of scholars,[4] in the titles of monographs, scholarly papers, fellowships, and conferences,[5] and as the subject of undergraduate and graduate courses.[6]

To what do we attribute scholarly interest in the study of American things? What is the basis of material culture studies? What might be its

import for American social history? How might social history contribute to material culture research? A few years ago Laurence Veysey undertook to assess the parallels and disagreements between intellectual history and the new social history.[7] Here, I would like to attempt a similar analysis, but focus on the relations, past and present, between students of material culture and social historians. In this chapter I have, however, imposed a number of limitations on my topic. First, I propose only to deal with scholarship done on American material culture and social history, recognizing that this restriction does an obvious injustice to the considerable internationality of both these approaches to historical study. Second, I acknowledge that what I propose here is only a digest of the current material culture work that I anticipate would be of interest to social historians. I have, therefore, divided my analysis into two parts—(1) a summary of the common affinities and major differences between material culture research and social history; and (2) a review of six topical areas (residential spaces, domestic life, women and children, working and workers, life experiences, community landscapes)—where the interests of material culture research and social history coincide.

MATERIAL CULTURE STUDIES AND SOCIAL HISTORY: PARALLELS AND PROBLEMS

The rubric "material culture studies" is increasingly being used as the most appropriate generic name describing the research, writing, teaching, and publishing done by individuals who interpret past human activity largely, although not exclusively, through extant physical evidence. I prefer the term "material culture studies" over a label such as "artifact studies" or "physical history" because, given its origins in archaeology and anthropology, the name brings to mind the strong interest of its practitioners in studying human behavior. To quote Eugene Ferguson, most material culture researchers have "a firm conviction that material data has a potential to contribute fundamentally to the understanding of human behavior" because "material culture is not merely a reflection of human behavior; material culture is a part of human behavior."[8]

In light of such a methodological assumption, social historians committed to formulating "fundamental conceptualizations about the main springs of social behavior in the past" might, understandably, see common goals in their interpretive objectives and in those of contemporary material culturists.[9] Social historians and many material culture

researchers also share other common ground in addition to a mutual concern for historical explanations of human behavior over time and place. For example, both social history and material culture studies challenge the older view of history as past politics, both have sought to demonstrate the great diversity of the American people and their life-styles, and both have been anxious to expand (some would say, explode) the traditional boundaries of American historical scholarship and thereby actually to redefine what constitutes American history.[10]

Each of these approaches to the past made its debut into the academy in the early twentieth century, and each came of age in the post-World War II era. Moreover, neither resembles a formal school but rather each consists of diverse congeries—cliometricians, interdisciplinary social theorists, critically minded social democrats in the case of social history, structuralists, functionalists, environmentalists, behavioralists in material culture research—with often complementary and sometimes contradictory approaches to historical scholarship. This ideological diversity results, in part, because modern material culture studies and the new social history both have strong interdisciplinary roots, the former in a coalition of the arts and humanities, the latter in the social sciences.

Each has been frequently considered by other historians as a maverick, overly specialized approach to the past. Yet each has claimed to hold a key to a more democratic, populist, even proletarian history. Social history has meant a concern for achieving a historical perspective on the everyday lives of ordinary people. Similarly, argues one material culture scholar, "a close recording and interpretation of the material culture can provide insights into the life of the "'common man.'" It is this man, argued Harold Skramstad, who, "while dominant numerically, leaves little or no written record of his existence and whose activities do not produce a self-conscious literary record."[11]

Students of material culture and social historians tend to agree that most individuals in the past left few literate records. For the majority of people, the primary historical record of their lives is not written but survives as data gathered about them or, as happens even more frequently, as objects made and used and finally discarded by them. Material culture, claim its advocates, is more democratic than literary or statistical documents, as well as less sensitve to the subjectivity that every person brought, however unconsciously, to his or her written or oral accounts of peoples and events. Such an assertion concurs with social history's concern for a higher degree of representativeness in the evidential basis of all historical explanation.[12]

The common interest in the careful questioning of meaning in historical evidence has prompted a self-conscious awareness of meth-

odological issues among both social historians and students of material culture. Perhaps, to date, social history has been more innovative and productive in methodological experimentation, but the crucial issues currently debated among the most creative material culture scholars are largely those of methodology: What constitutes a defensible historical explanation? What type of data produces the highest degree of causal precision? How does the historian measure change and depict it intelligibly? What are the important questions that are worth asking about past human behavior?[13]

Among historians working with objects and among some social historians, there is also a mutual commitment as to formats of communicating historical information and insight other than the history establishment's venerable rhetorical mode of presentation. As James Henretta has pointed out, social historians have proposed various new presentation techniques (e.g., quantification, conceptual models, phenomenological analyses) as alternatives to the traditional linear narrative approach;[14] material culturists in their work with extant three-dimensional evidence have likewise sought innovative formats (e.g., participatory exhibitions, experimental archaeology, outdoor living history museums) where new historical data and information might be most accurately and meaningfully conveyed to a wide sector of the American public.

Despite these several convergent interests, a number of issues separate social historians and historians who have sought to use artifacts as a primary data base. One difference has been their respective publics. Academic social historians have tended to write only for other fellow specialists, showing little interest in disseminating their data, methods, and conclusions outside the academic compounds of the universities. By a curious irony, an elite that has sought to study the history of the masses has been reluctant to translate its research to a wider professional audience, much less the general populace. Material culturists, on the other hand, have usually worked in a more diverse and decentralized institutional structure composed of museums, government agencies (e.g., the National Park Service, the American Folklife Center, the Smithsonian Institution), and state historical societies as well as in colleges and universities. Research and publication (i.e., in exhibits as well as articles) in these institutional settings has required many students of artifactual evidence to be much more aware of the public face of their historical interpretations.

With a few exceptions, most material culturists have not shared the enthusiasm of those in social history who see quantification as a principal salvation of historical studies. The recognition of the necessity

of a quantitative sense regarding evidence, of the importance of every historian being acutely sensitive to the representativeness of sources, has developed only very recently among those working with artifactual data. As will be suggested below, quantification has been a research tool for a few scholars working with probate inventories, wills, and other statistical collections of objects, but there is still considerable hesitancy on the part of scholars initially trained to study single objects (i.e., especially as art objects) to embrace techniques for monitoring and manipulating large aggregates of physical data.

Finally, it must be acknowledged that material culture studies, despite all the methodological creativity demonstrated by some of its most pioneering proponents, are still only beginning to explore the conceptual and analytical potential of this approach to historical study. Traditionally content to collect and to describe objects, many material culturists still resist the methodological necessity of extracting and synthesizing social behavior from such three-dimensional data. Or, to put it another way, many resist the imperative to deduce, wherever possible, the culture behind the material.

In several topical areas, however, scholars in material culture research have made both methodological advances and substantive contributions to contemporary knowledge about American history. A brief survey of these selected research areas may prove useful to social historians in their similar quest for a broader, more diversified, more human understanding of the past. As noted earlier, I have chosen to review selected work in a number of specific subject areas (or subfields) of social history in which material culturists have also done research. I have also interjected, where relevant, a brief description and assessment of what I see as some of the predominant intellectual frameworks behind various modes of material culture research. I have termed these various paradigms as follows: structuralist, cultural historical, functionalist, behavioralistic, and environmentalist. I hope this dual effort— to assess recent material culture scholarship both by topical orientation and by conceptual framework—helps to characterize recent scholarly trends without caricaturing them. I fully recognize that my paradigmatic frameworks may tend to homogenize the work of various individuals, placing them as I do in certain categories. I am also well aware that in any comprehensive historiographical analysis, the work of the individuals evaluated should be more thoroughly differentiated one from another than I have been able to do within the confines of this review essay. Finally, I am cognizant that scholars in material culture research, as in all other research fields, have held different intellectual positions at various stages of their scholarly careers.[15]

RESIDENTIAL SPACES

When John Demos devoted part one ("The Physical Setting") of his *Little Commonwealth: Family Life in the Plymouth Colony* to the domestic shelter and artifacts of the seventeenth-century Pilgrim community, he was recognizing a fact crucial to much material culture research: as the elementary unit of humankind is the individual, the elementary artifact on the landscape is the dwelling. Housing, argues J. B. Jackson, represents "the most reliable indication of man's essential identity, a microcosm of his most intimate world" and a form of material culture evidence that "satisfies not only his biological but also his social and spiritual needs." Demos, of course, went on to explore these societal implications of architectural evidence (e.g., status, privacy, social segreagation, repression of familial anger and aggression, child-rearing practices) in his pioneering application of social and behavioral science concepts to the houses of seventeenth-century Massachusetts.[16]

Although Demos's analysis of the material culture of a single seventeenth-century New England colony was brief, inferential, and only a case study, it does represent one type of social history that has employed housing as significant evidence. Here one also thinks of Gwendolyn Wright's *Moralism and the Model Home, Domestic Architecture and Cultural Conflict in Chicago, 1873–1913*, George McDaniel's *Hearth and Home: Preserving a People's Culture*, and David Handlin, *The American Home, Architecture and Society, 1815–1915*. Such research eschews the usual approach of the traditional architectural historian in that it avoids mere "façadism" (e.g., interpreting a house primarily through its front elevation and aesthetic style) as well as elitism (e.g., researching only structures designed by professional architects).[17]

This is not to say that contemporary material culturists are totally disinterested in architecture as style or in style as historical evidence. Useful studies have been done by Alan Gowans, Clifford E. Clark, Jr., Robert C. Twombly, and Jules D. Prown.[18] Current interest, however, is more with typology than with style, with vernacular forms rather than academic idioms. The quest for the meaning of vernacular housing has received part of its inspiration from a coterie of British labor historians, folklife researchers, and landscape historians and, in part, from a rebellious movement within the ranks of the American architectural history establishment known as the Vernacular Architecture Forum. Social historians will find the *VAF Newsletter*, edited by Dell Upton, an invaluable resource. It includes extremely current bibliographical data on both popular and folk structures—the two main subdivisions of vernacular building.[19]

Popular housing is now being studied from numerous perspectives. For example, ever since Herbert Gans's work on *The Levittowners,* an interest in the material culture of Anglo-American suburbia has steadily increased due to the work of individuals such as architect Robert Venturi, geographer Peirce Lewis, and architectural historian Gwendolyn Wright.[20] Now the history of urban middle- and lower-class neighborhoods has also been examined through their extant housing stock. Tenement districts, slums, and even alleys are receiving attention, as are issues such as the social meaning of home ownership, housing and property controls, and residential class segregation.[21] As will be noted below, research on workers' housing has greatly expanded since Roy Lubove first used such physical evidence in his investigation of New York City's tenements. Coupled with this concern for the social history of low-cost housing, an interest has evolved in subsidized public housing.[22]

Folklorists have long been taken with the historical and cultural dimensions of traditional American houses. Their recent work, now catalogued in several bibliographies, has import for social historians.[23] Often exploring the American experience from a regional perspective, these studies range in time from the seventeenth-century Chesapeake Bay area (Cary Carson et al., "Impermanent Architecture in the Southern American Colonies," *Winterthur Portfolio* 16 [Summer–August 1981]: 135–96) to the nineteenth-century Texas frontier (Terry G. Jordan, *Texas Log Buildings, A Folk Architecture* [Austin: University of Texas Press, 1978]), and in space from *Carolina Dwelling,* edited by Doug Swain et al. (Raleigh: North Carolina State University School of Design, 1978) to Donald Brown's "Social Structure as Reflected in Architectural Units at Picuris Pueblo, New Mexico," in *The Human Mirror,* ed. Miles Richardson (Baton Rouge: Louisiana State University Press, 1974).

Students of the construction techniques involved in erecting folk structures have begun to explore changes in a community's economic and social organization of work through such building practices.[24] In two pioneering books—*Patterns in the Material Folk Culture of the Eastern United States* and *Folk Housing in Middle Virginia: A Structural Analysis of Historic Artifacts*—Henry Glassie has researched such historical processes in order to understand the person who used them and the products that resulted from them. As the subtitle of his *Folk Housing* book indicates, Glassie has also approached material culture via the paradigm of twentieth-century structuralism, particularly as articulated by Noam Chomsky and Claude Lévi-Strauss.

From the linguist Chomsky, Glassie borrowed the concept that "culture is pattern in mind, the ability to make things like sentences or

161

houses."[25] Rejecting the concept that objects are the simple products of passive minds, Glassie attempted to develop a systematic model that would account for and help analyze the design abilities of an idealized maker of artifacts. As a case study, he investigated the builders of 156 houses constructed between the middle of the eighteenth century and World War I in a seventy square-mile area of Middle Virginia. His research objective, using almost exclusively material culture data left behind by anonymous builders, was to discover the unwritten boundaries or "artifactual grammar" of the creative process as it was exercised in a particular region's vernacular architecture.

Glassie began his "structural analysis of historic artifacts" (his subtitle) with a geometric base structure—the square. Instead of arguing that houses evolve, however, he proposed that it was the ability to design houses that did. He had found such a competency illustrated in some seventeen structural types and subtypes of Middle Virginia houses. These he noted were all generated by the base concept and the square reflecting numerous conscious and unconscious individual decisions among the builders of such houses. Combining the basic structuralistic techniques with thorough fieldwork examining housing plans, decorative motifs, and building hardware, he sought to articulate "rule sets" for forming the collective reasoning behind the construction of the anonymous housing he was investigating. Replete with elaborate tables and charts that seek to plot the "paradigmatic structure of the mind of the middle Virginia architect," Glassie used his artifactual grammar to classify an assortment of material culture (e.g., bricks, hinges, woodwork, window placement) in order to understand the behavioral rationale for the creation of house types.[26]

American material culture structuralism, as personified by Glassie's *Folk Housing in Middle Virginia,* understandably has drawn fire from various camps. Some historians claim that despite its token gestures toward tracing a change in minds, the approach, by definition, tends only to work in areas of relative cultural stasis. Fellow folklorists have complained that Glassie's subjective system of binary mental opposites (e.g., intellect-emotion, internal-external, complex-simple, and twelve others), borrowed from Gaston Bachelard, Christian Norberg-Schultz, and, of course, Lévi-Strauss, merely substitutes one kind of ideological arbitrariness for another in interpreting human behavior patterns. Still others remark that the results from such structural analysis are not adequately comparative.[27] Application of the structuralist paradigm to American artifactual data such as housing is still in its methodological infancy; it remains to be seen if this approach will yield what its advocates claim: "the basic and universal patterns that structure— however, unconsciously—human consciousness."[28]

A final group of material culturists who work with housing do so in more piecemeal fashion. They are interested in house parts and how such artifacts may have shaped human behavior and attitudes over time. For example, they have studied the domestication of the garage, the historical role of residential gardens and landscaping, the rise and fall of the porch and its evolution into the patio, as well as the significance of a home's front and back entrances as social spaces.[29] Works in contemporary environmental psychology—Erving Goffman's *The Presentation of Self in Everyday Life* (1959), Edward T. Hall, *The Hidden Dimension* (1969), and Robert Sommer, *Personal Space: The Behavioral Basis of Design* (1969)—have frequently informed these analyses.

DOMESTIC ARTIFACTS

In keeping with the folk proverb that claims a house is not a home, a few historians have begun to research the material life of Americans as revealed in patterns of home furnishings, foodways, clothing, and organization of domestic space as ways of gaining insight into the social past of middle-class and working-class cultures. For instance, Carole Shammus's survey of "The Domestic Environment in Early Modern England and America" and Lizabeth Cohen's useful case study ("Embellishing a Life of Labor: An Interpretation of the Material Culture of American Working Class Homes, 1885–1915") are excellent examples of the feasibility of using domestic settings for historical evidence of the values of social identities of ordinary people. Shamus and Cohen contend that the material culture of the domestic environment has much to contribute to our historical understanding of the average familial, feminine, and vocational experience of Americans, an understanding that goes beyond the outlines sketched by social historians who have merely quantified occupations and family events such as births, marriages, and deaths.[30]

Material culturists in the decorative arts have been at work to rectify this oversight as well. In addition to the standard cultural history surveys of American domestic life,[31] we now have work being done on a whole range of common household items—parlor furniture, mourning pictures, hallway stands, eating utensils, cleaning devices, family photo albums, kitchen appliances—that are seen as indices of a society's values as important as its elite artifacts or its literary remains. The material culture of nineteenth-century hallways (hat and clothing stands, mirrors, hallchairs, and card receivers), parlors (especially the ubiquitous home parlor organ), and dining rooms (table settings and eating

163

accouterments) have been imaginatively analyzed by Kenneth Ames, while Edward O. Laumann and James S. House have studied the patterning of material artifacts in the living rooms of twentieth-century, working-class families.[32] Still others have attempted to write American social history using wallpaper, silver, ceramics, chairs, and other commonplace domestic artifacts as important evidential bases in their research.[33]

Several of these studies have also employed quantification techniques in their comparative analyses of statistical collections of past material culture. Such collections are found in the form of probate inventories, craftsmen's ledgers, auction lists, wills, deeds, and sales records. Colonial historians were first to turn to inventories to study social and economic behavior, and they have subsequently contributed a substantial corpus of research based upon this form of material culture. Abbott Lowell Cummings's *Rural Household Inventories Establishing the Names, Uses and Furnishings of Rooms in the Colonial New England Home, 1675–1775* (1964), although dealing primarily with the property of wealthy families, contains an excellent discussion of how to interpret the probate inventory as a historical resource for the study of lower- and middle-class households as well. In addition to their vogue among American colonialists, inventories are also now being integrated into nineteenth-century family and housing history.[34]

The photograph, an artifact first created in the nineteenth century, has also been of immense use to historians interested in American domestic life. Several works deserve special mention: George Talbot's *At Home: Domestic Life in the Post-Centennial Era, 1876–1920* (1976); Catherine Noren, *The Camera of My Family* (1973); and William Seale, *The Tasteful Interlude: American Interiors through the Camera's Eye, 1850–1917* (1975). Historical photography, when examined closely and in sufficient quantity to insure a representative evidential sample, often provides valuable inferences as to how occupants organized and used space as well as interacted with one another. Through photography we know more about family life as lived in residential spaces such as kitchens, bedrooms, hall passages, pantries, inglenooks, nurseries, and servants' quarters, as well as in parlors, living rooms, front porches, and dining rooms.[35]

Social historians, whether interested in material culture as evidence or not, have paid scant attention to eating, assuredly one of humankind's most common necessities. Despite the enormous material culture that surrounds this essential experience, it has also been similarly ignored by most serious material culturists, with the exception of foodways scholars such as Jay Anderson, Charles Champ, Don Yoder,

and the contributors to the January 1981 special issue of *Western Folkore.*[36] The geographical and chronological focus of most of this research, however, has been primarily on rural and preindustrial communities.[37] Only recently has some attention been given to the artifacts of twentieth-century food preparation, service, and disposal. In the latter instance, William Rathje has applied the long established archaeological techniques of midden analysis to the household trash cans of Tucson, Arizona, in order to determine food consumption and food waste and the correlation of such factors to food price level and social behavior.[38]

In calling for the integration of foodways (and all other appropriate material, statistical, and documentary data) into his cultural historical anthropological approach, James Deetz has argued for a research paradigm that seeks "the detection and explication of apparently unrelated changes in *all* [my emphasis] aspects of a people's culture, material and otherwise."[39] Although not directly influenced by the devotees of a collective mentalité approach to the past, he shares this school's interest in the study of popular beliefs, customs, and modes of behavior as well as its commitment to "thick description"—the technique of subjecting to intense scrutiny a mass of facts of every kind so as to elicit every possible cultural meaning from them. Like the mentalité history model, Deetz's cultural history approach is based more on humanistic anthropology than on the social sciences.

Yet the Deetz cultural history paradigm does not disregard social science research methods such as quantification or model-building. In its attempt at as total a reconstruction of past lifeways as possible, its practitioners seek (from material and documentary data alike) information about how cultural change occurs in topics such as sexual divisions of labor, demographic and paleonutritional issues, the impact of technology on social behavior, and kinship patterns.[40] Deetz, a historical archaeologist long associated with the historical reconstruction of Plimoth Plantation (Massachusetts) and with research on artifacts excavated and collected there and in various areas of New England, developed his theory from a combination of documentary and artifactual evidence. This data suggested to Deetz that New England evolved through three phases: a Stuart yeoman phase (1620–1660), a localized Anglo-American era (1660–1760), and a Georgian period (1760–1830).[41]

In some ways, Deetz's *In Small Things Forgotten* can be viewed as an American counterpart to Fernand Braudel's *Capitalism and Material Life.* For example, although much briefer and lacking Braudel's extensive documentation, the Deetz interpretation, like Braudel's, sticks close to home for its data. The changing domestic technologies of house build-

ing, heating, lighting, plumbing, food preparation, and garbage removal are resources in both histories. Extant artifacts are often the only data by which such past behavior can be reconstructed. In a similar spirit, Albert E. Parr has used lighting and heating fixtures to speculate on how innovations in such domestic technology drastically interrupted the traditional evening orientation of the pre–nineteenth-century family toward a single hearth (a shared communal space), thereby prompting major changes in parent-child and sibling relationships.[42] Others have documented the significance for domestic history of the advent of indoor plumbing (especially the appearance of the bathroom in the nineteenth century) and the installation of central heating.[43]

WOMEN AND CHILDREN

Understandably, the material culture of the American home has figured in the work of historians of women who, while not always adherents of a social history approach to their topic, are frequently included in that field's ranks. A special interest among some such scholars in the decorative arts and in the history of technology has focused on kitchen tools and appliances and on their roles in defining, confining, or undermining "woman's place" in society. While various researchers have contributed to this scholarly enterprise, the work of Ruth Schwartz Cowan and Delores Hayden is representative of their general concerns.[44] Cowan's research has moved from the study of a single artifact genre ("A Case of Technology and Social Change: The Washing Machine and the Working Wife") to kitchen appliances in general ("The 'Industrial Revolution' in the Home: Household Technology and Social Change in the 20th Century") to women's interaction with technological material culture throughout American history ("From Virginia Dare to Virginia Slims: Women and Technology in American Life").[45] Hayden's interests have been more spatial and environmental than technological. Her *Seven American Utopias: The Architecture of Communitarian Socialism, 1790–1975* (1976) details the social and cultural history of several counter-culture societies through their extant structures and sites, as well as through their furniture, household technology, and photography. Hayden's *The Grand Domestic Revolution: A History of Feminist Designs for American Homes, Neighborhoods, and Cities* (1981) provides the social historian with a useful review of the interaction of domestic feminism, cooperative housekeeping, the community kitchen movement, and projects for social reform.[46]

Mary Johnson's bibliographical essays and Martha Moore Trescott's anthology *Dynamos and Virgins Revisited* (1979) are two other valuable introductions to scholarship using artifacts to explain the social history of American women.[47] Johnson points out, for instance, how public documents and private correspondence rarely make mention of the tasks of housewifery, tasks which consumed so much of the time, energy, and creativity of women in the past. Her bibliography surveys the literature that, through the interpretation of common household utensils, furnishings, and interior decor, has sought answers to a series of questions concerning women's private lives: What were the tasks of housewives? How did they adapt to changing economic patterns? What were their responses to technological innovations? How did the more functional divisions of various rooms affect women's relations with others in the family? What impact did household chores have on women's self-perceptions? Such questions have led to historical studies of women's roles in household production and processing,[48] servant management and social control,[49] and the design, manufacture, and social role of clothing.

In the triptych of human necessities—food, clothing, and shelter—clothing has received almost as little attention as has food from professional historians. Despite the insights drawn by Phillipe Aries and John Demos from early modern costume styles and materials,[50] clothing—an artifact frequently made by women—has figured as an important historical resource in only a few innovative studies. As with foodways, much of the most useful current scholarship is being pursued by folklife scholars.[51] The valuable research that has been done by others, however, has tended to use clothing as historical evidence to plot configurations of social status (e.g., Jeanette C. Lauer and Robert H. Lauer, "The Language of Dress: A Sociohistorical Study of the Meaning of Clothing in America"), gender identification (e.g., Deborah Jean Warner, "Fashion, Emancipation, Reform, and the Undergarment"), or democratization (e.g., Margaret Walsh, "The Democratization of the Women's Dress Pattern Industry").[52]

The theme of how democratic culture impinged upon material culture permeates Claudia Kidwell and Margaret Christman's *Suiting Everyone: The Democratization of Clothing in America* (1974), a volume that also acted as the catalog to a Smithsonian museum exhibition of the same name. Kidwell, who has done pioneering social history studies of vernacular clothing such as eighteenth-century short gowns and nineteenth-century bathing attire,[53] uses artifacts to explore two principal themes in *Suiting Everyone*. She examines the economic transformation resulting from the shift from dressing in homemade clothing to ready-

to-wear clothing, and the social shift in customs from dressing according to one's class to a new "democratic dress" whereby everyone strives to dress alike. As Thorstein Veblen noted in *The Theory of the Leisure Class,* this style of democratic uniformity in dress created a tension in American society between the ideals of equality and individuality. Kidwell explores the social dimensions of this tension as well as other paradoxes, such as the oppressive nature of the sweated industries that produced cheaper and better clothing for an ever-widening segment of the populace.

If the production of clothing was traditionally considered women's work,[54] even more generic female functions have been the bearing and raising of children. Women menstruate, parturate, and lactate; men do not. Yet written history takes little note of these obvious facts and their possible impact upon life as lived in the past. These uniquely female experiences have prompted a wide range of material culture: pessaries, sanitary napkins, tampons, various intrauterine devices, artificial nipples, bottle sterilizers, and pasteurized and evaporated milks are only a few. The social history based upon this unique female material culture evidence has only begun to be explored. With the possible exception of tracers of the technology of contraception,[55] scholars are only now becoming aware of how neglected this topic has been. Virginia Drachman's analysis of gynecological instruments and surgical decisions in hospitals in late nineteenth-century America is a helpful work-in-progress report but much more needs to be done.[56] As Ruth Cowan points out, none of the standard histories or bibliographies of American technology contains a single reference to such a significant cultural artifact as the baby bottle. Here is a simple implement that, along with its attendant delivery systems, has revolutionized a basic biological process, transformed a fundamental human experience for vast numbers of infants and mothers, and served as one of the more controversial exports of western technology to underdeveloped countries—yet it finds no place in our histories of technology or social histories.

As Cowan points out, there are a host of questions which scholars might reasonably ask about the baby bottle. For how long has it been part of western culture? When a mother's milk could not be provided, which classes of people used the bottle and which the wet nurse, and for what reasons? Which was a more crucial determinant for widespread use of the bottle, changes in milk technology or changes in bottle technology? Who marketed the bottles, at what prices, to whom? How did mothers of different social classes and ethnic groups react to them? Can the phenomenon of "not enough milk," which was widely reported by pediatricians and obstetricians in the 1920s and 1930s, be

connected with the advent of the safe baby bottle? Which was cause and which effect?[57]

Historians need to ask similar questions about the technologies of child-rearing. Most material culture students have, however, usually focused their research more specifically on child play rather than on child nurture.[58] Playthings, for instance, are studied as factors significant in shaping individual personalities and cultural traits. Acknowledging the fact that most toys are made by adults to appeal and to sell to other adults, these researchers still see great potential in such artifacts for writing a more comprehensive history of childhood.[59] Taking a clue from Johan Huizinga's classic cultural history, *Homo Ludens* (1949), American Studies scholar Bernard Mergen has provided would-be researchers with a survey of the topic's potential, a bibliographical guide to past work and resource data, as well as a review of research theories and conclusions resulting from using "toys as hypotheses" in material culture study.[60] Students of the toys available for children in the twentieth century, for example, are struck by two particular facts: in selection of toys, children have been encouraged to follow the scientific and technological fads of their elders; these toys were often advertised as being more appropriate for one sex than the other.[61]

WORK, WORKING, WORKERS

Products for one individual's play are, of course, the products of another individual's work. Historians have also begun to study the material culture of American working places as well as their products.[62] Some of this research has taken the form of town or community studies, some has focused primarily on working conditions within mills, mines, shops, and factories, and some has primarily investigated workers' housing.[63] Two fields of material culture studies—the history of technology and industrial archaeology—have contributed (along with the work of scholars like Herbert Gutman and Gary Nash) to this new brand of labor history.

To date, most historians of technology have been primarily absorbed in a time-period up to and including industrialization in the nineteenth century.[64] The industrial archaeologists, working in concert with historical archaeologists in recovering the buried history of the working-class poor, have done some promising research in cities such as Detroit, Birmingham, Paterson, N.J., Atlanta, Brooklyn, N.Y., and Alexandria, Va.[65]

In an attempt to move beyond the traditional subjects of labor history (e.g., unionization, strikes, the personalities of labor leaders), these scholars have probed both the specialized work processes of American laborers and the total historical experience of such workers as persons in the wider society. Whereas much previous material culture study, especially in art and decorative arts history, tended to concentrate its research efforts solely on the objects produced by an individual (e.g., a Paul Revere silver tankard, or a Duncan Phyfe chair), now there is more scholarship that considers the artifacts in a wider social and economic context. A worker's creations are seen as the results of mental and manual activity often called craftsmanship as well as being manifestations of the economic and social status of the producers and users. Whereas formerly only the works were of interest, now the working and the worker are receiving attention. Examples of this orientation would be several essays on artisans by Benno Foreman; Darrett Rutmann's *Husbandmen of Plymouth: Farms and Villages in the Old Colony, 1620–1692* (1967); Charles Hummel's *With Hammer in Hand: The Dominy Craftsmen of East Hampton, New York* (1968); Robert Trent's *Hearts and Crowns* (based upon the theories of Henri Focillon's *Art Populaire*); and George Kubler's *The Shape of Time: Remarks on the History of Things* (1962).[66]

Many students of work processes and attendant technologies have been labeled functionalists in their approach to material culture evidence. The functionalist paradigm holds that culture is primarily a means of adapting to environment, with technology as the primary adaptive mechanism. The utility of artifacts within the context of a technological system, whether it be a kitchen appliance, a Corliss steam engine, or an interstate highway system, provides the key to understanding transmission and adaptation in this approach to material culture research. With only a secondary concern for the origins of artifacts, the functionalists are primarily interested in the ramifications of material culture; they are intrigued with process, change, adaptation, and the cultural impact of objects. Bronislaw Malinowski's and A. R. Radcliffe Brown's approaches to anthropological research provide part of the theoretical base for the functionalist approach to material culture; Lewis H. Morgan, Franz Boas, Ruth Benedict, and especially William Bascom are also cited as methodological progenitors. Within the history of technology the work of Siegfried Giedeon, Lynn White, and Carl Condit bear the stamp of a functional interpretation.[67]

Methodological arguments, in support of the functionalist approach in American material culture studies, have been put forth in several publications by Warren Roberts, a contemporary folklife researcher. Citing the criteria of "practicality" in a "local context" as the vital de-

terminants in the manufacture and use of many artifacts, Roberts and other functionalists tend to sound much like environmentalists (to be discussed below) when they enumerate specific factors such as available materials, weather conditions, technical competencies, support services, family structures, and economic systems which affect the selection, use, and transmission of material culture.[68] While recognizing the many facets that make up an object's milieu, of equal concern to the functionalist is the maker of an object. Material culture functionalists try to explain both how an object was "worked" (i.e., how its maker functioned in order to make it), as well as how the object itself "works" (i.e., how it actually functions in a sociocultural context).

Those who espouse the functionalist approach are anxious to demonstrate that material culture is, at its core, a reflection of the rationality and practicality of the participants in a culture.[69] They argue, therefore, that description of the worker's (maker's) motives best supports the analyst's functional explanation. Oral history fieldwork, not surprisingly, is a frequently employed research tool when dealing with the material culture of still-living memory. But often informant data are not available for cultural activity of the past, leaving the researcher to surmise the functional sequence originally used in the manufacture and use of an artifact. Such a fascination with the "mind of the maker" often allies the functionalist with the structuralists, previously mentioned, and the behavioralists, to be discussed momentarily.

Interest in the cognitive processes involved in the production of past material culture likewise intrigues a group of scholars who now call themselves "experimental archaeologists." The history of their approach has been summarized by Jay Anderson and Robert Asher, and elaborated on by John Coles in his primer *Archaeology by Experiment*. In Anderson's words, "experimental archaeology was developed as a means of (1) practically testing theories of past cultural behavior, especially technological processes involving the use of tools, and (2) obtaining data not readily available from more traditional artifact analysis and historical sources." Since experimental archaeology seeks to "imitate or replicate" the original functions or processes involved in using certain artifacts, the technique has also been called "imitative archaeology."[70]

Perhaps the most spectacular and most publicized application of the experimental approach has been the Kon Tiki expedition on which Thor Heyerdahl sought to test his hypothesis that people, with certain available technologies, could have sailed the four thousand miles between South America and the Polynesian Islands, transplanting themselves and their culture before 1100 A.D. Other instances of

experimental archaeology research include work on tool manufacture, house-building, and especially on foodways. In each case, a key research objective was to discover how artifacts originally functioned in the society that made and used them.[71]

Perhaps this assumption of the "primacy of production in everyday life" may help account, as one social historian has argued, for much "present-day interest in *mentalité*, in material culture, and in the ethnohistory of ordinary people."[72] In order to extract historical evidence of the values and social identities of workers, other historians have investigated artifactual data for its possibly distinctive racial, ethnic, or folk content. In the reconstruction of the social history of the American Indian, of course, material culture data have been paramount. Research based on the black material culture evidenced in architecture, arts, crafts, tools, and funerary markers has been catalogued in several bibliographies.[73] Such data acts as the primary evidential base in works such as John Vlach, *The Afro-American Tradition in the Decorative Arts* (1977); George McDaniel's *Hearth and Home: Preserving a People's Culture* (1981); and the current work ("Black Settlements in America, 1965–Present") of Entourage, Inc., a public history organization at the University of Texas.[74] Historical archaeologists have contributed a considerable quantity of new information to further our understanding of slave habitations, northern free black communities, and black material culture as produced in segregated enclaves of Jim Crow America.[75]

Ethnicity, long considered an important factor in the study of various artifacts, is now seen by material culturists as a significant theme in understanding working-class culture. For example, there has been research on the interrelations between living room furnishings, ethnic identity, and acculturation among Greek-Philadelphians; studies of ethnic differentiation among the West Coast Chinese through their specialized foodways and cultural practices; and work on social stratification patterns of Eastern and Southern Europeans through family photograph albums.[76] The bulk of this research—by folklife scholars, architectural historians, and decorative arts specialists—has been done on mainstream immigrant groups such as the Germans, Scandinavians, and the Dutch. More recent ethnic communities, such as those of Pacific Islanders, Laotians, and Puerto Ricans, are only beginning to be examined.[77]

LIFE EXPERIENCES

Several useful ethnographic investigations of ethnicity through artifacts can be found in Simon Bronner's *American Material Culture and*

Folklife: A Symposium (1982). The contributors to this volume are also much taken with the possibility of inferring individual human behavior from material culture evidence.[78] Although several of these interpreters begin their historical analyses with artifacts such as country furniture, musical instruments, vernacular houses or common tools, these things are but a means to an end: the objective is to understand specific behavior—defined, for example, by folklorist Michael Owen Jones, as "those activities and expressive structures manifested principally in situations of first-hand interaction."[79] This paradigm, which I call behavioralistic, tends, therefore, to focus on the individual creator of objects; it proceeds on the assumption that each individual is largely unique in his or her beliefs, values, skills, and motivations. In the study of such an individual's material culture, the researcher aspires to understand and explain personal creativity, cognitive processes, and aesthetic individuality. The behavioralistic approach to material culture thus emphasizes the diversity of human creative expression and motivation. Although much in debt to the social and behavioral sciences, this perspective also shares a degree of kinship with the traditional art history perspective in its concentration on an object's creator and how his individual beliefs, values, and aspirations shape his creations.

Folk art has been the material culture genre most thoroughly studied by behavioralists as they have turned most of their attention toward understanding the modern context of material evidence rather than attempting to reconstruct past societies from artifactual remains. Michael Owen Jones has been a major proponent and practitioner of this orientation in material culture studies. Limiting himself largely to contemporary material culture (e.g., furniture made in the Cumberland Mountains of southeastern Kentucky, the vernacular housing of "L.A. Add-ons and Re-dos" in southern California), Jones has defined his task as an effort to "understand more fully human behavior." Furthermore, Jones maintains that "research into human behavior must begin as well as end with human beings and should focus on the individual."[80] In fact, in his major book, The Handmade Object and Its Maker, Jones concentrated his research primarily on one man, an Upland South chairmaker who went by simply the name of "Charley." Jones did this for two reasons. First, he insists that "an object cannot be fully understood or appreciated without knowledge of the man who made it, and the traits of one object cannot be explained by reference only to antecedent works of an earlier period from which later qualities allegedly evolved." Second, argued Jones, "much of what has been called art, especially what has been labeled folk and primitive art, is useful in some way, which means that the object produced is as much an instrument to

achieve some practical result as it is an end in itself (including not only drums and chairs but also masks, bis poles and divination tapers). As a consequence the researcher cannot divorce what he calls artistic or creative processes from technological ones; the outputs of production serve not only what some people refer to as aesthetic ends but also practical purposes; and the evaluations of products admit considerations of both appearance and fitness for use."[81]

In Jones's behavioralistic analysis, each individual maker of objects personifies a novel complex of skills that defy precise categorization into environmental, regional, or historical divisions. His approach tends to stress the diversity of human creativity rather than its uniformity as sought, say, by most of the behavioralists as well as by the structuralists in their quest for the universal patterns that undergird human consciousness. While both perspectives hope to enter the mind of an object's maker in order to get at the "mental template" of *homo faber*, the structuralists have tended to investigate large aggregates of data (e.g., Glassie's 156 Middle Virginia houses) whereas "Jonesian behavioralists" such as William Ferris, John Vlach, and Simon Bronner have concentrated their attention on a few craftsmen and the products they have made.[82]

By no means do all behavioralistic studies follow the Jones model. Most do share, however, his belief that certain forms of behavior are pervasive, constituting much of the oral, kinesic, and symbolic communication among people in face-to-face interaction. Frequently such behavior is encapsulated in objects, but the study of it has often been neglected in traditional American history interpretations.

In a recent manifesto, "Toward a Behavioral History," Jones singled out Allan Ludwig's *Graven Images, New England Stonecarving and Its Symbols, 1650–1815* as a model application of the behavioralistic perspective to material culture evidence. Ludwig's research into the symbolism, rituals, and forms of funerary art in colonial Massachusetts and Connecticut reveals a story different from conventional histories of New England Puritanism based solely on written sources. The strictly verbal evidence depicted the Puritans as an iconophobic, nonmystical people whose piety, while once pronounced, declined dramatically near the end of the seventeenth century. Not so, suggests the cross section of New England gravestones that Ludwig documented, analyzed, and interpreted. The material culture evidence examined appears to lead to at least three novel conclusions: (1) that a very strong religious sentiment flourished among inhabitants of New England until well into the nineteenth century, as evidenced by the symbols on their gravestones; (2) that these gravestones also show that America has had an art

tradition emphasizing abstraction, simplicity, and purity of line that warrants serious attention for its excellence as well as its relationship to modern aesthetics; and (3) that the Puritans in America created much figural as well as religious art, despite the inference that has usually been drawn from official written sources that they were a highly iconophobic culture. Ludwig's careful examination of the visual imagery of funerary artifacts (the creation of which was not officially controlled by church authorities) reveals to the behavioralist Jones an iconographic tradition that evolved in the day-to-day interactions of the common people. Hence Jones concluded: "This iconography in stone was understood by, and was meaningful to, many individuals regardless of educational level, social status, or personal achievement. For the forms created by New England stonecarvers were largely universal patterns, continuous through time and thus basic to human expression regardless of national or religious identity, the principal 'Americanism in style' being 'the eccentricities of individual hands' discernable in particular local areas." Since Ludwig's pioneering study first appeared in 1966, the material culture of death and dying has been the basis for an expanding area of behavioralistic research.[83]

Using material culture data from the distant American past remains the exception rather than the rule among advocates of the behavioralistic model. Most research deals with contemporary persons, processes, and products, and in order to conduct such research, fieldwork is essential. The fieldwork component espoused by Jones and other behavioralists in order, for example, to identify the impact of a craftsman's beliefs, values, and aspirations upon the manufacture, use, and sale of his products has a certain affinity with scholarly trends now variously labeled "the new ethnography," "ethnosemantics," or "cognitive anthropology." The behavioralistic approach to artifact study also parallels current social history research on many of life's common occurrences—birthing, growing, marrying, aging, and, as mentioned, dying.[84]

The behavioralistic research orientation also finds like-minded investigators pursuing a corollary approach to material culture study frequently called performance theory. Advocates of this approach, who are found in the structuralist and functionalist camps as well, are intrigued by the many unexplored interconnections between material and mind, and they apply a "performance" or "phenomenological" mode of analysis to artifactual matter.[85] For example, researchers such as Dell Upton and Thomas Adler argue that the human processes involved in conceiving, making, perceiving, using, adapting, decorat-

ing, exalting, loathing, and discarding objects are intrinsic elements of human experience. Such experiences, not just the objects involved in them, are what the material culture student should strive to comprehend. To performance theorists, the human processes of creation, communication, and conduct are the important features of material culture research.

In his attempt to get into the minds of the makers of artifacts, Dell Upton has tested the validity of performance theory in his investigation of vernacular architecture of early Tidewater Virginia. By studying the "performance" extant in traditional houses, he has attempted to recreate the shapes of patterned behavior within such buildings. In the enterprise, he sought answers to questions such as: From whom does a builder of a house get his ideas? What does he do with such ideas between the time he learns them and the time that he produces a structure?[86] Material culture scholars, using the performance concept, share affinity with the experimental archaeologists described earlier as practitioners of the functionalist perspective, and with the process reconstructionists discussed in the cultural history approach.

Thomas Adler has proposed that performance theory should apply to the contemporary material culture researcher as well as to the topics he researches. Making specific reference to bluegrass banjos and traditional woodworking tools, Adler suggests the necessity of personal experience with the artifacts that the researcher studies in order to understand more fully how earlier people actually experienced such objects. Thus, in addition to the usual referential knowledge (e.g., seeing a banjo in a mail-order catalogue or reading a description of it in a nineteenth-century diary) and mediated knowledge (e.g., hearing banjo music played over a radio or by a person at a folk music concert), a material culture student must also, whenever possible, acquire experiential knowledge (e.g., by playing the banjo). One can understand performers of the past only by becoming performers in the present. In summary, Adler argues that "a scholarly interpreter who would speak of bluegrass banjos or traditional woodworking tools or any other traditional instruments is on the strongest possible ground if he can bolster his referential and mediated knowledge with the knowledge gained from actually trying to engage instruments in expressive acts. He needs to do not only fieldwork, but artifactually involved fieldwork. It is certainly not necessary that we all become great performers, but it is essential that we pay attention to the importance of experience as a force operating on tradition. That can best be accomplished by recognizing our inevitable personal involvement with our objects of study."[87]

COMMUNITY LANDSCAPES

Social and environmental psychologists have often claimed a correlation between environments and behavior. The material culture of public buildings, spaces, institutions, landscapes, and transportation networks has been seen as revelatory of certain cultural patterns. Urban historians, folklife researchers, architectural historians, and cultural geographers have sought to explain change through the shifts (e.g., in location and in form) of such artifactual data through time and across space. These interpreters have worked at both macro- and microlevels of inquiry, seeking to explain past American life via interpretations that range in scope from the built environment of entire cities to detailed investigations of urban street-lighting systems. They have been likewise interested in rural, suburban, and urban spaces. In general, they have believed ''any sign of human action in the landscape implies a culture, recalls a history, and demands an ecological interpretation; the history of any people evokes its setting in a landscape, its ecological problems and its cultural commitments, and the recognition of a culture calls for the discovery of traces it has left on the earth.''[88]

Social historians will undoubtedly be familiar with the research of urbanists such as Sam Bass Warner, Blaine Brownell, and Richard Wade, who have used material culture (e.g., public transportation patterns, housing, public works, cartography, urban photography, landscape architecture) in their historical interpretations of American cities; some may not, however, know the valuable work of geographers and landscape historians such as Peirce Lewis, David Ward, John Stilgoe, J. B. Jackson, and Grady Clay.[89]

These material culturists have concentrated their efforts largely on artifacts of urban complexes. Others have narrowed their focus to study the spatial and architectural significance of public institutions such as settlement houses, prisons, asylums, hospitals, and communitarian compounds.[90] For many, transportation networks have been a key to explaining residential clustering, racial segregation, and occupation patterns; for instance, the hypothesis of Warner's now famous *Street-Car Suburbs* has spawned many sequels, among them Oliver Zunz's ''Technology and Society in the Urban Environment: The Case of the Third Avenue Elevated Railway.''[91] Investigations of early transportation arteries and artifacts—horse-car barns, railroad stations, ferry slips, interurban lines—have all yielded additional information about the passengers who used them.

Public structures comprise the most obvious element for probing the city as a historical site. Yet the topographical and geographical

features of the city (particularly its parks, public squares, recreational facilities, water fronts, alleys, and open spaces) have also provided historians with indices for measuring social change.[92] In a review essay, "Social History and the History of Landscape Architecture," Roy Lubove notes several reasons for examining such data. He argues that the use of landscape artifacts can expand our knowledge of the urbanization process, demonstrate the interconnections between politics and design as well as between social theory and social reform, help trace the development of professionalization in urban institutions, and, in general, dramatize the role of proxemic analysis in historical study.[93] In a similar spirit, the editors of the *Radical History Review* devoted an entire issue to the spatial dimension of history, featuring research on nineteenth-century middle-class parks and working-class recreation, industrial archaeology, housing and property relations, the evolution of charity hospitals, and the development of the American department store.[94] Several of the *RHR* essays focus on public works and urban plans as the data by which the politics of spatial design, especially as a vehicle for social control, can be studied.

Historians of town and city planning, with a similar sensitivity to space as an artifact wherein a changing set of social relations takes place, also offer perspective on this approach in basic texts by John Reps, Norman T. Newton, and Mellier Scott. Individual case studies of American city-planners, such as Daniel Burnham of Chicago and Robert Moses of New York, have also revealed much about the impact of spatial design on the economic, racial, and social past of a city. For example, the two hundred or so low-hanging overpasses on Long Island were deliberately designed by Robert Moses to discourage the presence of buses on his parkways. Automobile-owning whites of "upper" and "comfortable middle" classes (as Moses called them) would be free to use the parkways for recreation and commuting. Poor people and blacks, who normally used public transit, were kept off such roads because the twelve-foot tall buses they normally rode could not get through Moses's overpasses.[95]

In his latest book, *Cities of the American West: A History of Frontier Urban Planning* (1979), John Reps has extended his research on civic design from traditional urban complexes to more rural communities. It is important to note that—unlike most mainline social history research to date—a great deal of work by geographers and folklorists has appeared on the artifacts of rural American space and how country people have used such terrain. For example, many current practitioners, preoccupied with the migration and diffusion of objects such as fence types, barns, field patterns, and houses, identify with the early work of Carl O. Sauer

who, in turn, had been highly influenced by the cultural anthropologist A. L. Kroeber, a fellow faculty member at University of California in the 1930s. In addition to the work of Sauer and Kroeber, the interpretations of *The Great Plains* (1936) by a metahistorian like Walter Prescott Webb or of *The Grasslands of North America* (1947) by a geographer such as James Malin are other examples of what might be called an environmentalist approach to material culture. Perhaps the greatest influence on the current generation of material culturists with this perspective has been the teaching and publishing career of Fred B. Kniffen at Louisiana State University. Numerous contemporary advocates of the environmentalist paradigm—geographers, folklorists, anthropologists—were trained by Kniffen and espouse his interests and his methods.[96]

To study material culture, Kniffen has proposed five methodological procedures: identification, classification, arrangement, interpretation, and presentation. The identification of cultural features in the form of artifacts on a particular landscape and, where possible, limited to a specific historical time framework constitutes the first step toward deriving what he terms a "cultural taxonomy."[97] Classification follows and entails division of the objects into types. Arrangement of the types into complexes enables the analyst to plot the diffusion of a culture through time and space. The interpretation step requires examination of the diffusion process to determine origin, dissemination route(s), and the distribution of culture. These conclusions are then presented via some appropriate communication medium. Among folklife scholars and cultural geographers, the Kniffen model of reconstituted diffusion routes of material culture data has been enormously influential; there is hardly an article or monograph in American landscape studies that does not cite his now classic methodological essay, "Folk Housing: A Key To Diffusion" (1965) or his practical applications of this theory.[98]

The environmentalist approach to material culture research rests on several assumptions. To begin with, it accepts as axiomatic that culture diffuses across space and acquires and loses elements through the effects of the environment. Advocates of this approach have a particular penchant for vernacular or folk material culture (especially housing) because, as Henry Glassie has claimed, folk artifacts supposedly remain stable over time but variable over space. Belief in such stability, however, tends to attribute to artifacts a super-organic existence, often minimizing the individual's role in their creation. Such a belief also frequently ascribes an "innate cultural conservatism" to groups that produce such objects. A more doctrinaire diffusionist in his first major publication (i.e., *Pattern in the Material Folk Culture of the Eastern United States,* 1969), Henry Glassie has recognized the implicit determinism in

179

this perspective in his more recent work (i.e., *Folk Housing in Middle Virginia*, 1976). He, like several other contemporary environmentalists, now seeks to avoid interpretations of material culture evidence strictly in terms of ecological forces to which individuals must conform or explanations in which the individual's singular creativity and personal cognition play no significant role.

Environmental material culturists work under at least three other presuppositions related to the concept of diffusion: (1) that rural, preindustrial landscapes presumedly best preserve artifactual survivals of culture; (2) that such a landscape provides the material culturist with superior data for ascertaining a succession of regional cultures across time; and (3) that a region's diverse material culture is, at its core, integrative. That is to say, all the culture manifested in a region's material culture can be considered to be an integrated whole. Thus, if one artifact such as a dog-trot house type spreads (i.e., diffuses) across a region, it is assumed other artifacts (e.g., smokehouses, fences) related to the house type will also move or diffuse. In order to monitor and to interpret such movement, contemporary scholars working with material folk culture have resorted to various techniques. John Moe, for example, has employed the work of the cognitive anthropologists in an oral-history approach to informant fieldwork. Others have turned to quantification, particularly when attempting to deal with the classification and arrangement procedures in the Kniffen model. Still others have applied the methodology to high-style artifacts such as Frank Lloyd Wright's Prairie houses and their diffusion among the midwestern middle-class.[99]

No matter what their individual techniques, these students of material culture are widely interested in the interpretation of ordinary landscapes. As Peirce Lewis recognizes, they are researching the history of "mobile homes, motels, gas stations, shopping centers, billboards, suburban tract housing, the look of fundamentalist churches, water-towers, city dumps, garages and carports" because "such things are found nearly everywhere that Americans have set foot, and they obviously reflect the way ordinary Americans behave most of the time."[100]

Such a position, common to the other artifact orientations and material culture paradigms surveyed in this essay, shares many affinities with contemporary social history practice. Perhaps the strongest bonds of common cause between current material culture studies and social history research are a mutual interest in the vernacular, the typical, the commonplace of the past; a desire to make history, as William Makepeace Thackeray once hoped, "more familiar than heroic"; a sense of

the potential to expand the traditional discourse of American history; and perhaps, most importantly, a common concern to bring a wider sociohistorical understanding, as Lewis put it, to "the way ordinary Americans behave most of the time."

NOTES

1. Laurence Veysey, "The 'New' Social History in the Context of American History," *Reviews in American History* 7:1 (March 1979): 1–12; Thomas J. Schlereth, "Material Culture Studies in America, 1876–1976: Notes Toward A Historical Perspective," *Material History Bulletin* 8 (1979): 89–98.

2. Michael Kammen, "The Historian's Vocation and the State of the Discipline in the United States," in his *The Past before Us: Contemporary Historical Writing in the United States* (Ithaca: Cornell University Press, 1980), 34.

3. A review of the Board of Editors on these two journals also reveals the diversity of disciplines and subdisciplines frequently identified with material culture studies in the United States: folklore and folklife, cultural geography, architectural history, historical geography, American Studies, history, decorative arts, history of technology, and historical archaeology.

4. For example, in the 1979 graduate/undergraduate description of Boston University's American and New England Studies Program, Jane C. Nylander, a curator of textiles and ceramics of Old Sturbridge Village and an adjunct professor of American Studies at the University is specifically designated as a specialist in eighteenth- and nineteenth-century American material culture. In the *Society for Historical Archaeology Newsletter* 12:1 (March 1979): 12–13, the University of Pennsylvania's Department of American Civilization also advertised a new teaching position for an assistant professor of American Material Culture. The Colorado Historical Society now employs a curator of material culture who administers the "material culture department of the Colorado Historical Society with the responsibility for planning, developing, implementing and supervising programs to aid in the understanding of the cultural and historical heritage of Colorado." *History News* 35:5 (May 1980): 19.

5. Thomas J. Schlereth, *Material Culture Studies in America* (Nashville, Tenn.: American Association for State and Local History, 1982); Brooke Hindle, *Material Culture of the Wooden Age* (Tarrytown, N.Y.: Sleepy Hollow Press: 1981); Lucius Ellsworth and Maureen O'Brien, eds., *Material Culture: Historical Agencies and the Historian* (Philadelphia: Book Reprint Service, 1969); Ian M. G. Quimby, ed., *Material Culture and the Study of American Life* (New York: W. W. Norton, 1978); Henry Glassie, *Pattern in the Material Folk Culture of the Eastern United States* (Philadelphia: University of Pennsylvania Press, 1968); Simon J. Bronner, ed., *American Material Culture and Folklife: A Symposium* (Cooperstown Graduate Associate Proceedings: 1981); "Material Culture: A Conference" sponsored by the Bay State Historical League, Bradford, Mass., 20–22 June 1980; North Carolina Department of Cultural Resources, "The Material Culture of Black History: Problems and Methods," Durham, N.C., 13 December 1980. The Smithsonian Institution now awards specific fellowships in "American History and Material Culture" through its Office of Fellowships and Grants.

6. As early as the 1950s, Anthony N. B. Garvan offered a seminar in the University of Pennsylvania's American Civilization Program listed as "The Material Aspects of American Culture." E. M. Fleming notes that he developed his course ("The Artifact in American History") in the Winterthur Museum–University of Delaware program with Garvan's model in mind. See E. M. Fleming, "The Study and Interpretation of the Historical Artifacts: A New Profession" (unpublished essay, 1965), 16. A sample of typical graduate and undergraduate material culture courses currently offered would include those at institutions such as Yale, George Washington University, State University of New York at Oneonta, Boston University, Indiana University, University of Notre Dame, University of California at Berkeley, and the College of William and Mary. The University of Delaware presently offers the Ph.D. in American Material Culture Studies.

7. Laurence Veysey, "Intellectual History and The New Social History," in *New Directions in American Intellectual History*, ed. John Higham and Paul K. Conklin (Baltimore: Johns Hopkins University Press, 1979), 3–26.

8. Eugene Ferguson, *Historical Archaeology, and the Importance of Material Things* (Columbia, S.C.: Society for Historical Archaeology, 1977), p. 8, 37.

9. On the historian's quest for an understanding of social behavior in the past, see Peter Stearns, "Toward a Wider Vision: Trends in Social History," in Kammen, *The Past before Us*, 212–218.

10. On this realignment, see Carl N. Degler, "Remaking American History," *The Journal of American History* 67:1 (June 1980): 7, 16–17, and Cary Carson, "Doing History with Material Culture," in *Material Culture and the Study of American Life*, 41–49.

11. Stearns, "Trends in Social History," 212–18; Harold Skramstad, "American Things: Neglected Material Culture," *American Studies International*, 10:3 (Spring 1972): 13.

12. James Deetz, "Scientific Humanism and Humanistic Service: A Plea For Paradigmatic Pluralism in Historical Archaeology" (unpublished paper, University of California at Berkeley, 1981), 3; Veysey, "The 'New' Social History," 4–7. Carson, "Doing History with Material Culture," 48–61.

13. Typical examples of the current debate over material culture methodology can be found in Jules David Prown, "Style As Evidence" and "Mind in Matter: An Introduction To Material Culture Theory and Method," *Winterthur Portfolio* (hereafter referred to as *WP*), 15:3 and 17:1 (Autumn 1980 and Spring 1982); Simon Bronner, "Concepts in the Study of Material Aspects of American Folk Culture," *Folklore Forum* 12:213 (1979): 133–72; Thomas J. Schlereth, "Material Culture Studies in America, 1876–1976," in *Material Culture Studies in America* (Nashville: American Association For State and Local History, 1982), chapter 1.

14. James A. Henretta, "Social History as Lived and Written," *American Historical Review* 84:5 (December 1979): 1314–1321.

15. For instance, I have characterized the work of Michael Owen Jones as exemplifying the behavioralistic approach to modern material culture studies. Although Jones himself uses the term "behavioralist" frequently in his recent work, he is not particularly comfortable with it because of certain associations it evokes, particularly with the strict behaviorism of B. F. Skinner or of the less deterministic behavioral approaches of anthropologist Edward Hall or sociologist Edward O. Laumann. Since Jones is presently interested primarily in

human cognition and behavioral interaction as prompted by the manufacture or use of artifacts (and not in the objects *per se*), his behavioralistic (my term, not his) perspective differs substantially from that of fellow folklorists such as John Vlach or Henry Glassie, who are also interested in the behavior resulting from the manufacture and use of material culture.

Mention of Glassie's prolific work prompts me to suggest that he could be included in several of my paradigmatic categories (e.g., environmentalist, functionalist, behavioralist) in addition to the one I have assigned him— structuralist. Similarly, the informed reader will quickly recognize many other scholars included in my cast of characters who could and do play several parts in the *dramatis personae* of contemporary American material culture research. In fact, almost all of the truly innovative thinkers in each of my heuristic categories have frequently borrowed methods and concepts from several other perspectives.

A more complete account of the paradigms discussed in this essay and their implications in material culture historiography can be found in chapter 1 of my *Material Culture Studies in America,* pages 1–75.

16. J. B. Jackson's manifesto for the primacy of the house in the social history of the American landscape can be found in an editorial in his influential journal *Landscape* (1952): 2. Examples of Demos's application of behavioral concepts to extant material culture are in *A Little Commonwealth: Family Life in Plymouth Colony* (New York: Oxford University Press, 1970), 46–51, 56–58.

17. On the methodological dilemmas of façadism, see John Maass, "Where Architects Fear To Tread," *Journal of Society of Architectural Historians* 28 (March 1969): 3–8.

18. Alan Gowans, *Images of American Living: Four Centuries of Architecture and Furniture as Cultural Expression* (Philadelphia: Lippincott, 1964; revised ed., Harper, 1979); Clark E. Clifford, Jr., "Domestic Architecture as an Index to Social History: The Romantic Revival and the Cult of Domesticity in America, 1840–1870," *Journal of Interdisciplinary History* 7 (Summer 1976): 33–56; Robert C. Twombly, "Saving the Family: Middle-Class Attraction to Wright's Prairie House, 1901–1909," *American Quarterly* 27:1 (March 1975): 57–72; Prown, "Style as Evidence," 197–200.

19. Upton's quarterly bibliography is found in the *Vernacular Architecture Forum Newsletter* (406 Second Street, Annapolis, Maryland, 21403). Summary bibliographic statements can also be found in his essay "Ordinary Buildings: A Bibliographical Essay on American Vernacular Architecture," *American Studies International* 19:2 (Winter 1981): 57–75. For an extended treatment of "popular architecture," with attention to methodology, see Richard Guy Wilson, "Popular Architecture," in *Handbook of Popular Culture,* vol. 2, ed. Thomas Inge (Westport, Conn.: Greenwood Press, 1980), 265–85.

20. Robert Venturi, *Signs of Life: Symbols in the American City* (New York: Aperture, 1976); Peirce Lewis, "The Unprecedent City," in *The American Land* (Washington: Smithsonian Press, 1981); Saim Nalkaya, "The Personalization of a Housing Environment: A Study of Levittown, Pennsylvania" (Ph.D. dissertation, University of Pennsylvania, 1980); Gwendolyn Wright, *Building the Dream: A Social History of Housing in America* (New York: Pantheon, 1981).

21. Mary Ellen Hayward, "Urban Vernacular Architecture in Nineteenth-Century Baltimore," *WP* 16:1 (Spring 1981): 33–63; Betsy Blackman, "Re-Walking the 'Walking City': Housing and Property Relations in New York City,

1780–1840," *Radical History Review* 21 (Fall 1979): 131–50; James Borchert, *Alley Life in Washington, D.C.: Family, Community, Religion and Folklore in the City, 1850–1970* (Urbana: University of Illinois Press, 1980); Robert W. Bastian, "Architecture and Class Segregation in Late Nineteenth-Century Terre Haute, Indiana," *The Geographical Review* 65:2 (April 1975): 166–79; Daniel D. Luria, "Wealth, Capital, and Power: The Social Meaning of Home Ownership," *Journal of Interdisciplinary History* 7 (Autumn 1976): 261–82.

22. Roy Lubove, *The Progressives and the Slums: Tenement House Reform in New York City, 1890–1917* (Pittsburgh: University of Pittsburgh Press, 1962). On recent literature, see the review article by John F. Bauman, "Housing the Urban Poor," *Journal of Urban History* 6:2 (1980): 211–20, where the following new works are evaluated: Roger D. Simon, *The City-building Process: Housing and Services in New Milwaukee Neighborhoods, 1880–1910*; Anthony Jackson, *A Place Called Home: A History of Low-Cost Housing in Manhattan*; Thomas Lee Philpott, *The Slum and the Ghetto: Neighborhood Deterioration and Middle-Class Reform, Chicago, 1880–1930*; and Devereux Bowly, Jr., *The Poorhouse: Subsidized Housing in Chicago, 1895–1976*. See also, Amy K. Epstein, "Multifamily Dwellings and the Search for Respectability: Origins of the New York Apartment House," *Urbanism Past and Present* 5:2 (1980): 29–39.

23. See, for example, Howard Wight Marshall, *American Folk Architecture: A Selected Bibliography* (Washington: American Folklife Center, 1981); Simon J. Bronner, *Bibliography of American Folk and Vernacular Art* (Bloomington, Ind.: Folklore Publications Group-Monograph Series No. 3, 1980).

24. Dell Upton, "Traditional Timber Framing," in *The Material Culture of the Wooden Age*, ed. Brooke Hindle (Tarrytown, N.Y.: Sleepy Hollow Restorations Press, 1981), 35–93; Abbott L. Cummings, *The Framed Houses of Massachusetts Bay, 1625–1725* (Cambridge: Harvard University Press, 1979); Peter Marzio, "Carpentry in the Southern Colonies During the Eighteenth Century," *WP* 7 (1972): 229–50; Peter Moogk, *Building a House in New France: An Account of the Perplexities of Client and Craftsmen in Early Canada* (Toronto: McClelland and Stewart, 1977); Fred W. Peterson, "Vernacular Building and Victorian Architecture: Midwestern American Farm Houses," *Journal of Interdisciplinary History* 12:3 (Winter 1982): 409–427.

25. Henry Glassie, *Folk Housing in Middle Virginia: A Structural Analysis of Historic Artifacts* (Knoxville: University of Tennessee Press, 1975), 17.

26. Glassie, *Folk Housing*, see chapter 7, "Reason in Architecture," 114–74.

27. See reviews of Glassie's *Folk Housing* by Harvey Green in *American Quarterly* 32 (Summer 1980): 222–28, and by George McDaniel in *Journal of American Folklore* 91 (1978): 51–53.

28. Other examples of the structuralist analysis to shelter can be found in James Deetz, *In Small Things Forgotten: The Archaeology of Early American Life* (Garden City: Doubleday, 1977); Robert B. Saint George, "Style and Structure in the Joinery of Dedham and Medfield, Massachusetts, 1635–1685," *WP* 13 (1979): 1–29; Bruce Lohof, "The American Service Station: The Evolution of a Vernacular Form," *Industrial Archaeology* 11:2 (Spring 1974): 1–13.

29. J. B. Jackson, "The Domestication of the Garage," *Landscape* 20:2 (Winter 1976): 10–19; Pamela West, "The Rise and Fall of the American Porch," *Landscape* 20:3 (Spring 1976): 42–47; Roger L. Welsh, "Front Door, Back Door," *Natural History* 88:6 (June–July 1979): 76–82; Stephen Constantine, "Amateur Gardening and Popular Recreation in the 19th and 20th Centuries," *Journal of*

Social History 14 (1981): 387–406; Shirley Ardener, ed., *Woman and Space, Ground Rules and Social Maps* (New York: St. Martins, 1981).

30. Carole Shammus, "The Domestic Environment in Early Modern England and America," *Journal of Social History* 14 (Fall 1980): 4–24, contains her entire argument; Lizabeth A. Cohen, "Embellishing a Life of Labor: An Interpretation of the Material Culture of American Working-Class Homes, 1885–1915," *Journal of American Culture* 3:4 (Winter 1980): 752–75. Also see Cary Carson and Lorena S. Walsh, "The Material Life of the Early American Housewife," a paper presented at the Williamsburg Conference on Women in Early America (5–7 November 1981), 1–54.

31. For example, see Russell Lynes, *The Domesticated Americans* (New York: Harper & Brothers, 1977), and his *The Tastemakers* (New York: Harper & Brothers, 1949); J. C. Furnas, *The Americans: A Social History, 1587–1914* (New York: G. P. Putnam, 1969).

32. Kenneth Ames, "Meaning in Artifacts: Hall Furnishings in Victorian America," *Journal of Interdisciplinary History* 9:1 (Summer 1978): 19–46; "Murderous Propensities: Notes on Dining Iconography of the Mid-Nineteenth Century," in *Three Centuries–Two Continents*, ed. Nancy H. Schless and Kenneth L. Ames (Watkins Glen, N.Y.: American Life Foundation, 1983); "Material Culture as Non-Verbal Communication: A Historical Case Study," *Journal of American Culture* 3:4 (Winter 1980): 619–41. Edward O. Laumann and James S. House, "Living Room Styles and Social Attributes: The Patterning of Material Artifacts in a Modern Urban Community," *Sociology and Social Research* 54 (1970): 321–42; Shelia Leurant de Bretteville, "The 'Parlorization' of our Homes and Ourselves," *Chrysalis: A Magazine of Woman's Culture* 8 (Summer 1979).

33. Catherine Lynn, *Wallpaper in America: From the Seventeenth Century to World War I* (New York: W. W. Norton, 1980); Barbara Ward, *Silver in American Life* (Boston: David R. Godine, 1979); Ian M. G. Quimby, ed. *Ceramics In America* (Charlottesville: The University Press of Virginia, 1975); Dean F. Failey et al., *Long Island Is My Nation: The Decorative Arts and Craftsmen, 1640–1830* (Setauket, N.Y.: Society for the Preservation of Long Island Antiquities, 1976).

34. On the use of inventory and other material culture statistical data, see Gloria L. Main, "Probate Records as a Source for Early American History," *William and Mary Quarterly*, 3rd series, 32:1 (1975): 89–99; Mary C. Beaudry, "Worth Its Weight in Iron: Categories of Material Culture in Early Virginia Probate Inventories," *Quarterly Bulletin of the Archaeological Society of Virginia* 33 (1978); Bettye Pruitt, *Massachusetts Tax Valuation List of 1771* (New York: Garland, 1979); Carson, "Doing History with Material Culture," 47–64; Cary Carson, "From the Bottom Up: Zero Base Research for Social History at Williamsburg," *History News* 35 (January 1980): 7–9; Joanne Bowen, "Probate Inventories: An Evaluation from the Perspective of Zooarchaeology and Agricultural History at the Mott Farm," *Historical Archaeology* 9 (1975): 11–25; Jack Michel, "In a Manner and Fashion Suitable to Their Degree: A Preliminary Investigation of the Material Culture of Early Rural Pennsylvania," *Working Papers from the Regional Economic History Research Center* 5:1 (1981): 1–88.

35. A survey of the research potential of photography as historical evidence can be found in chapter 1, "Mirrors of the Past: Historical Photography and American History," of my *Artifacts and the American Past* (Nashville: AASLH, 1980), 11–49. Also see the special issue "Focus on Photography," *Journal of American Culture* 4 (Spring 1981), particularly Ralph Bogardus, "Their 'Carte de Visite to Posterity:' A Family's Snapshots as Autobiography and Art": 114–22.

36. Jay Anderson, "Food and Folklore: A Special Issue," *Keystone Folklore Quarterly* 16 (1971): 153–214; Charles Champ, "Food in American Culture: A Bibliographic Essay," *Journal of American Culture* 2 (1979): 559–70; Don Yoder, "Food Cookery," in *Folklore and Folklife: An Introduction,* ed. Richard M. Dorson (Chicago: University of Chicago Press: 1972), 325–50. Michael Owen Jones, Bruce Giuliano, and Robert Krell, eds., "Foodways and Eating Habits: Directions for Research [Special Issue]," *Western Folklore* 40 (1980). A useful bibliography is G. Terry Sharrer, *1001 References for the History of American Food Technology* (Davis, Calif.: United States Department of Agriculture, 1978). Also see Charles Camp "Foodways," in *Handbook of Popular Culture,* vol. 2, ed. Thomas Inge (Westport, Conn.: Greenwood Press, 1981), 141–62.

37. For example, see Sarah F. McMahon, "Provisions Laid Up for the Family: Towards a History of Diet in New England, 1650–1850," *Historical Methods* 14 (Winter 1981): 4–21; William L. Langer, "American Foods and Europe's Population Growth, 1750–1850," *Journal of Social History* 8 (Winter 1974–1975): 51–66; Rodris Roth, "Tea Drinking in Eighteenth-Century America," *Contributions from the Museum of History and Technology,* bulletin 228 (1961): 61–91; James Deetz and Jay Anderson, "The Ethnogastronomy of Thanksgiving," *Saturday Review of Science* (25 November 1927): 29–39.

38. William R. Rathje, "In Praise of Archaeology, Le Projet du Garbage," in Ferguson, *Historical Archaeology,* 36–42. Also see George R. Stewart, *Not So Rich As You Think* (Boston: Houghton Mifflin Co., 1968). Also see Judith Walzer Leavitt, "The Wasteland: Garbage and Sanitary Reform in the Nineteenth-Century American City," *Journal of the History of Medicine and Allied Sciences* 35 (October 1980), and Martin V. Melosi, *Garbage in the Cities: Refuse, Reform, and the Environment, 1880–1980* (College Station: Texas A & M Press, 1981).

39. James Deetz, "Scientific Humanism and Humanistic Science" (unpublished paper, March 1981), 8.

40. American archaeologist Mark Leone and others see the emphasis of this approach centered around the issue of cultural change rather than cultural homogeneity. Process reconstructionists, as Leone sees the followers of Deetz, hope "to contribute general knowledge about how culture, not specific cultures, changes." In this endeavor, process theorists turn to history, for they admit it is only in the unfolding of long sequences of time that some cultural processes become visible. They are, however, anxious to discredit the assumption that the total reconstruction of past lifeways can be accomplished. Instead, they advocate, through the use of the contemporary conceptual models of evolutionism, cultural ecology, and systems theory, the comprehensive study of how culture changes. In this brand of cultural history, material culture plays a significant role. Addressing fellow archaeologists in 1972, Leone argued: "Were archaeology to become the science of material culture or material objects, past and present, the entire field would be revolutionized. At the moment, material culture as a category of phenomena is unaccounted for. It is scattered between interior decorators, advertising firms, and historians of technology. But when one considers how little we know about how material culture articulates with other cultural subsystems, one begins to see the potential. There exists a completely empty niche, and it is neither small nor irrelevant." Mark P. Leone, "Issues in Anthropological Archaeology," in his anthology, *Contemporary Archaeology,* 19.

41. The Deetz macro-explanation of colonial American history is presented in detail above in chapter 1.

42. Albert E. Parr, "Heating, Lighting, and Human Relations," *Landscape* 19:1 (Winter 1970): 28–29; also see Loris S. Russell, "Early Nineteenth Century Lighting," in *Building in Early America*, ed. Charles Petersen (Radnor, Pa.: Chilton Books, 1976), 186–201.

43. On the history of the American bathroom, one should start with Siegfried Giedeon's fascinating essay, "The Mechanization of the Bath," in his *Mechanization Takes Command: A Contribution to Anonymous History* (1948; reprint New York: W. W. Norton, 1969); also consult Eugene S. Ferguson, "An Historical Sketch of Central Heating," in Petersen's *Building in Early America*, 165–85; Reyner Banham, *The Architecture of the Well-Tempered Environment* (Chicago: University of Chicago Press, 1969); Mary N. Stone, "The Plumbing Paradox: American Attitudes Toward Late 19th-Century Domestic Sanitary Arrangements," *WP* 14 (1979).

44. In addition to the scholarship of Cowan and Hayden cited below, see Deborah C. Andrews and William C. Andrews, "Technology and the Housewife in Nineteenth-Century America," *Women Studies* 2:3 (1974): 309–28; Dorothy E. Smith, "Household Space and Family Organization," *Pacific Sociological Review* 14:1 (January 1971): 53–78; Gwendolyn Wright, "Sweet and Clean: The Domestic Landscape in the Progressive Era," *Landscape* 20:1 (October 1975): 38–43; David P. Handlin, "Efficiency and the American Home," *Architectural Association Quarterly* 5:4 (October 1973): 50–54; Kimberly W. Carrell, "The Industrial Revolution Comes to the Home: Kitchen Design Reform and Middle-Class Women," *Journal of American Culture* (Fall 1979): 488–99; as well as Melvin Rotsch, "The Home Environment," and Anthony Garvan, "Effects of Technology on Domestic Life, 1830–1880," in *Technology in Western Civilization*, ed. Melvin Kranzberg and Carroll Pursell (New York: Oxford University Press, 1967), 217–36, 546–52.

45. Ruth Schwartz Cowan, "A Case of Technology and Social Change: The Washing Machine and the Working Wife," in *Clio's Consciousness Raised: New Perspectives on the History of Women*, ed. Mary Hartman and Lois Banner (New York: Harper Torchbooks, 1974), 245–53; "The 'Industrial Revolution' in the Home: Household Technology and Social Change in the 20th Century," *Technology and Culture* 17 (January 1976): 1–23; "From Virginia Dare to Virginia Slims: Women and Technology in American Life," *Technology and Culture* 20:1 (January 1979): 51–63.

46. Hayden's work has also appeared in serial literature; see, for example, "Collectivizing the Domestic Workplace," *Lotus: Rivista Internazionale Di Architetura Contemporanea* 12 (Summer 1976): 73–90; "Catherine Beecher and the Politics of Housework" and "Challenging the American Domestic Ideal," in *Women in American Architecture: A Historic and Contemporary Perspective*, ed. Susana Torre (New York: Whitney Library of Design, 1977); "Melusina Fay Peirce and Cooperative Housekeeping," *International Journal of Urban and Regional Research* 2 (1978); "Charlotte Perkins Gilman and the Kitchenless House," *Radical History Review* 21 (Winter 1979–1980); "Two Utopian Feminists and Their Campaigns for Kitchenless Houses," *Signs: A Journal of Women in Culture and Society* 4:2 (Winter 1978): 274–90.

47. Mary Johnson, "Women and Their Material Universe: A Bibliographical Essay," paper presented at Regional Economic History Research Center, Hagley Museum, Wilmington, Del., August 1981, 1–37; Mary Johnson, "What's in a Butterchurn or a Sad Iron? Some Thoughts on Using Artifacts in Social

History," paper presented at Organization of American Historians Meeting, Philadelphia (April 1982), 1–28; Martha More Trescott, ed., *Dynamos and Virgins Revisited: Women and Technological Change in History* (Metuchen, N.J.: The Scarecrow Press, Inc., 1979).

48. Joan M. Jensen, "Cloth, Butter and Boarders: Women's Household Production for the Market," *The Review of Radical Political Economics* 12:2 (Summer 1980): 14–24; Renata Bridenthal, "Loom, Broom and Womb: Producers, Maintainers and Reproducers," *Frontiers* 1 (Fall 1975), 1–41; Patricia Branca, "A New Perspective on Woman's Work: A Comparative Typology," *Journal of Social History* 9 (Winter 1975): 129–53; and Mary Johnson, "Madame E. I. duPont and Madame Victorine du Pont Baudny, The First Mistresses of Eleutherian Mills: Models of Domesticity in the Brandywine Valley during the Antebellum Era," paper presented in Regional Economic History Conference, "Industrious Woman: Home and Work in the 19th Century Mid-Atlantic Region," Wilmington, Del., September 1981.

49. On the material culture of domestic service, see Susan M. Strasser, "Mistress and Maid, Employer and Employee: Domestic Service Reform in the United States, 1897–1920," *Marxist Perspective* 1:4 (Winter 1978): 52–67; Helen Callahan, "Upstairs-Downstairs in Chicago, 1870–1907: The Glessner Household," *Chicago History* 6:4 (Winter 1977–78): 195–209; David M. Katzman, *Seven Days A Week: Women and Domestic Service in Industrial America* (New York: Oxford University Press, 1978).

50. Philippe Aries, *Centuries of Childhood: A Social History of Family Life,* trans. Robert Baldrick (New York: Knopf, 1969), 50–61, and Demos, *Little Commonwealth,* 52–58.

51. Useful overviews can be found in Don Yoder, "Folk Costume," in *Folklore and Folklife: An Introduction,* ed. Dorson (Chicago: University of Chicago Press, 1969), 295–324, and Don Yoder, "Sectarian Costume Research in the United States," in *Forms Upon the Frontier: Folklife and Folk Arts in the United States,* ed. Austin Fife and Alta Fife (Logan: Utah State University Press, 1969), 41–67.

52. Jeanette C. Lauer and Robert H. Lauer, "The Language of Dress: A Sociohistorical Study of the Meaning of Clothing in America," *Canadian Review of American Studies* 10 (Winter 1979): 305–23; Deborah Warner, "Fashion, Emancipation, Reform, and the Rational Undergarment," *Dress: Journal of the American Costume Society* 14:4 (1978): 24–29; Margaret Walsh, "The Democratization of Fashion: The Emergence of the Woman's Dress Pattern Industry," *Journal of American History* 66:2 (September 1979): 299–313.

53. Claudia Kidwell, "Short Gowns," *Dress: Journal of the Costume Society of America* 4 (1979): 30–65; Claudia Kidwell, *Women's Bathing and Swimming Costume in the United States* (Washington: U.S. National Museum, 1964); Claudia Kidwell, "Riches, Rags and Inbetween," *Historic Preservation* 28:3 (July–September 1976): 1–6.

54. Susan Swan's *Plain and Fancy: American Women and Their Needlework, 1799–1850* (New York: Holt, 1977), is an excellent example of a perceptive analysis of needlecraft in relation to woman's culture. Swan addresses issues prominent in women's history literature and offers insights into the ways that needlework both reflected and encouraged socialization patterns and sex-role stereotypes in eighteenth- and nineteenth-century America. Similar themes are explored in Patricia Mainardi, "Quilts: The Great American Art," *Radical America* 7:1 (1973): 36–68.

55. Linda Gordon, *Woman's Body, Woman's Right: A Social History of Birth Control in America* (New York: Grossman, 1976), focuses on the ideas about birth control, but not on the devices themselves. For beginning study, see Vern L. Bullough, "A Brief Note on Rubber Technology and Contraception: The Diaphragm and the Condom," *Technology and Culture* 22:1 (1981): 104–11.

56. Virginia G. Drachman, "Gynecological Instruments and Surgical Decisions at a Hospital in Late Nineteenth-Century America," *Journal of American Culture* 3:4 (Winter: 1980): 660–72; also see Vern L. Bullough, "Female Physiology, Technology, and Women's Liberation," in *Dynamos and Virgins Revisited*, ed. Trescott, 236–51; and Vern Bullough and Martha Voight, "Women, Menstruation, and Nineteenth-Century Medicine," *Bulletin of the History of Medicine* 47 (1973): 66–82.

57. Cowan, "Virginia Dare to Virginia Slims," 52.

58. For example, although psychohistorians recognize the importance of toilet training in personality formation, few have sought to investigate whether toilet training practices have been affected by the various technologies that impinge upon them: inexpensive absorbent fabrics, upholstered furniture, diaper services, wall-to-wall carpeting, paper diapers, and the like. The crib, the playpen, the teething ring, and the cradle are as much a part of our culture as houses and factories, yet we know almost nothing of their history.

59. Jac Remise, *The Golden Age of Toys* (Greenwich, Conn.: New York Graphic Society, 1967), 11, argues the case for the strong "adult" bias to toys as material culture evidence.

60. Bernard Mergen, "The Discovery of Children's Play," *American Quarterly* 27 (October 1975): 399–420; and Bernard Mergen, "Games and Toys," in *Handbook of American Popular Culture*, vol. 2, ed. M. Thomas Inge (Westport, Conn.: Greenwood Press, 1980), 163–90; Bernard Mergen, "Toys and American Culture: Objects as Hypotheses," *Journal of American Culture* 3:4 (Winter 1980): 743–51.

61. Carroll W. Pursell, Jr., "Toys, Technology, and Sex Roles in America, 1920–1940," in *Dynamos and Virgins Revisited*, ed. Trescott, 252–67; Donald W. Ball, "Toward a Sociology of Toys: Inanimate Objects, Socialization, and the Demography of the Doll World," *Sociological Quarterly* 8 (1967): 447–58. For a discussion of the historical development of the Barbie Doll and its role in socializing children to certain sex-roles, see Ronald Marchese, "Material Culture and Artifact Classification," *Journal of American Culture* 3:4 (Winter 1980): 605–19.

62. See, for example, the Merrimack Valley Textile Museum, *Homespun to Factory Made: Woolen Textiles in America, 1776–1876* (North Andover, Mass., 1977); Anthony F. C. Wallace, "Extended Family and the Role of Women in Early Industrial Societies" (unpublished paper presented at the Regional Economic History Conference, "Industrious Women: Home and Work in the 19th Century Mid-Atlantic Region," Wilmington, Del., September 1981); Deborah J. Warner, *Perfect in Her Place: Women at Work in Industrial America* (Washington: Smithsonian Institution Press, 1981); Daniel Walkowitz, "Working-Class Women in the Gilded Age: Factory, Community and Family Life Among Cohoes, New York Cotton Workers," *Journal of Social History* 5:4 (Summer 1972): 464–90.

63. To date, New England towns have been the most thoroughly studied, with Lowell, Mass., receiving the most attention. There have also been interesting studies on Amoskeag by W. Langebach and T. Haraven; on Cohoes,

New York, by D. Walkowitz; Rockdale, Pa., by A. Wallace; and Maine, by R. Horwitz. Two uses of architecture in labor history are James E. Vance, Jr., "Housing the Worker: The Employment Linkage as a Force in Urban Structure," *Economic Geography* 42 (1966): 294–325; and Richard Pommer, "The Architecture of Urban Housing in the United States During the Early 1930s," *Journal of Society of Architectural Historians* 37:4 (December 1978): 234–64.

64. See, for example, Brooke Hindle, ed., *The Material Culture of the Wooden Age* (Tarrytown, N.Y.: Sleepy Hollow Press, 1981); Robert Howard, "Interchangeable Parts Re-Examined: The Private Sector of the American Arms Industry on the Eve of the Civil War," *Technology and Culture* 19:4 (1978): 633–49; and Brooke Hindle, *Technology in Early America* (Chapel Hill: University of North Carolina Press, 1966).

65. For a survey of urban archaeology research around the United States and its social history implications, see Claudia Lorber, "Digging Up Our Urban Past," *New York Times Magazine* (12 April 1981), 52–55, 68, 72, 87–88, 120–124.

66. Benno Foreman's essays include "Urban Aspects of Massachusetts Furniture in the Late Seventeenth Century," in *Country Cabinet Work and Simple City Furniture*, ed. John Morse, 1–34, and "Delaware Valley 'Crookt Foot' and Seat-Back Chairs: The Fussell-Slavery Connections," *WP* 15:1 (1981): 41–64. On Trent's imaginative use of Focillon and Kubler, see *Hearts and Crowns: Folk Chairs of the Connecticut Coast, 1720–1840, as Viewed in Light of Henri Focillon's Introduction to Art Populaire* (New Haven: New Haven Historical Society, 1977).

67. Dorson, "Concepts of Folklore and Folklife Studies," in *Folklore and Folklife*, ed. R. Dorson, 20–21. Bronner, "Concepts," 145–46. Sigfried Giedeon, *Mechanization Takes Command* (New York: Oxford University Press, 1964); Lynn White, *Medieval Technology and Social Change* (New York: Oxford University Press, 1964); Carl Condit, *The Chicago School of Architecture* (Chicago: University of Chicago Press: 1964). Of course, not all historians of technology follow the functionalist model; see Cowan's revision of its tenets in "Industrial Revolution in the Home," 1–23.

68. See, for example, his essay on "Folk Architecture in Context: The Folk Museum," *Pioneer America Society Proceedings* 1 (1973): 34–50.

69. Richard S. Latham, "The Artifacts as Cultural Cipher," in *Who Designs America?* ed. Laurence B. Holland (New York: Anchor, 1966), 257–80.

70. Jay Anderson, "Immaterial Material Culture: The Implications of Experimental Research for Folklife Museums," *Keystone Folklore* 21:2 (1976–77): 1–13; Robert Asher, "Experimental Archaeology," *American Anthropology* 63 (1961): 793–816; John Coles, *Archaeology by Experiment* (New York: Charles Scribners, 1973).

71. Thor Heyerdahl, *Kon-Tiki*, trans. F. H. Lyon (New York: Rand McNally, 1950); also see Errett Callahan, *The Old Rag Report: A Practical Guide to Living Archaeology* (Richmond: Department of Sociology/Anthropology, Virginia Commonwealth University, 1973), and Donald W. Callender, "Reliving the Past: Experimental Archaeology in Pennsylvania," *Archaeology* 29 (1976): 173–78.

72. James Henretta, "Social History as Lived and Written," *American Historical Review* 84:5 (December 1979): 1293–1322; also see Billy G. Smith, "The Material Lives of Laboring Philadelphians, 1750–1800," *William and Mary Quarterly* 38 (April 1981); Jean-Pierre Hardy, "Un Projet de Recherche sur les Artisans du Quebec," *CMA Gazette* 11:3 (1978): 26–34; Bruce Laurie et al., "Immigrants and Industry: The Philadelphia Experience, 1850–1880," *Journal of Social History* 9 (1975): 219–48.

73. Rodney Barfield, "North Carolina Black Material Culture: A Research Opportunity," *North Carolina Folklore Journal* 27:2 (November 1979): 61–66; Kip Lornell, "Black Material Folk Culture," *Southern Folklore Quarterly* 42 (1978): 287–94; William Ferris, ed., *Afro-American Folk Art and Crafts* (Boston: G. K. Hall, 1981).

74. Entourage, Inc., a team of landscape architects, planners, and historians based in Austin, Texas, is presently embarked on a national study of the role of blacks in the development of the American built-environment. To date, more than eight hundred settlements in forty states have been identified and documented. An excellent case study of the black worker and his working life is Phil Peek, "Afro-American Material Culture and the Afro-American Craftsman," *Southern Folklore Quarterly* 42 (1978): 109–34.

75. See, for example, Deetz's chapter 7, "Parting Ways," in *In Small Things Forgotten*, 138–54; Robert Asher and Charles H. Fairbanks, "Excavation of a Slave Cabin: Georgia, U.S.A.," *Historical Archaeology* 5 (1971): 3–17; Robert L. Schuyler, "Sandy Ground: Archaeological Sampling in a Black Community in Metropolitan New York," *Conference on Historic Sites Archaeology Papers* 7 (1972): 13–52; Bert Salwen, *An Annotated Bibliography: Archaeology of Black American Culture* (Washington: Interagency Archaeological Services, 1978).

76. Robert T. Teske, "Living Room Furnishings, Ethnic Identity, and Acculturation Among Greek-Philadelphians," *New York Folklore* 5 (1979): 21–31; William S. Evans, Jr., "Food and Fantasy: Material Culture of the Chinese in California and the West, Circa 1850–1900," and Patricia Etter, "The West Coast Chinese and Opium Smoking" in *Archaeological Perspectives on Ethnicity in America*, ed. Robert L. Schuyler (Farmingdale, N.Y.: Baywood, 1980), 89–96 and 97–101; Mary Ann Jacobsen and Ruth E. Gates, "Norwegian American Ethnicity and Ethnic Clothing, Textiles, and Household Objects," *Ethnicity* 6 (1979): 215–21; Victor Greene, "Old Ethnic Stereotypes and the New Ethnic Studies," *Ethnicity* 5 (1978): 298–350; Richard Oestreicher, "From Artisan to Consumer: Images of Workers, 1840–1920," *Journal of American Culture* 4:1 (Spring 1981): 47–64.

77. Charles van Ravenswaay, *The Arts and Architecture of German Settlements in Missouri: A Survey of a Vanishing Culture* (Columbia: University of Missouri Press, 1977); *Museums, Sites, and Collections of Germanic Culture in North America*, comp. Margaret Hobbie (Westport, Conn.: Greenwood Publishing Company, 1980); Roberta S. Greenwood, *3500 Years on One City Block* (1975) and *The Changing Faces of Main Street* (1976), vols. 1 and 2 of the San Buenaventura Mission Plaza Archaeological Report, published by the City of San Buenaventura's Redevelopment Agency, Ventura, Calif. Peter O. Wacker, "Dutch Material Culture in New Jersey," *Journal of Popular Culture* 11:4 (1978): 948–58; C. Fred Blake, "Graffiti and Racial Insults: The Archaeology of Ethnic Relations in Hawaii," in *Modern Material Culture: The Archaeology of Us*, ed. Richard A. Gould and Michael B. Schiffer (New York: Academic Press: 1981), 87–100; Yvonne R. Lockwood, "The Sauna: An Expression of Finnish-American Identity," *Western Folklore* 36 (1977): 71–84; Cotton Mather and Matti Kaups, "The Finnish Sauna: A Cultural Index to Settlement," *Annals of the Association of American Geographers* 53 (1963): 497–504.

78. See, for example, Bernard Herman, "The Whole Cloth of Ethnography: Time and The Folk Artifact," Michael O. Jones, "Folkloristics and Fieldwork," and Thomas A. Adler, "Personal Experience and the Artifact: Musical Instru-

ments, Tools, and the Experience of Control," all in *American Material Culture and Folklife: A Prologue and a Dialogue*, ed. S. J. Bronner (Ann Arbor: UMT Research Press, 1985).

79. Michael Owen Jones, "Ask the Chairmaker" (unpublished paper presented at American Studies Association National Meeting, Boston, October 1977).

80. Michael O. Jones, "Two Directions for Folkloristics in the Study of American Art," *Southern Folklore Quarterly* 32 (1968): 249–59; Michael Owen Jones, *The Hand-Made Object and Its Maker* (Berkeley: University of California Press: 1975), vii; Michael Owen Jones, "L.A. Add-ons and Re-dos: Renovation in Folk Art and Architecture Design," in *Perspectives on American Folk Art*, ed. Ian M. G. Quimby and Scott Swank (New York: W. W. Norton, 1980), 325–63.

81. Jones, *Hand-Made Object and Its Maker*, vii–viii. To demonstrate the "hand-made" quality of his own book manuscript, Jones had the entire text hand-lettered by David Comstock.

82. See William Ferris, "Vision in Afro-American Art: The Sculpture of James Thomas," *Journal of American Folklore* 88 (1975): 115–31; John M. Vlach, "The Craftsman and the Communal Image: Philip Simmons, Charleston Blacksmith," *Family Heritage* 2:1 (February 1979): 14–19; Simon J. Bronner, "We Live What I Paint and I Paint What I See: A Mennonite Artist in Northern Indiana," *Indiana Folklore* 12 (1979): 5–17.

83. Michael Owen Jones, "Bibliographic and Reference Tools: Toward A Behavioral History" (unpublished paper presented at AASLH Folklore and Local History Conference, New Orleans, 4–6 September 1980), 7–9. On gravestones as evidence for social history, see Peter Benes, *The Masks of Orthodoxy: Folk Gravestone Carving in Plymouth, Massachusetts, 1689–1805* (Amherst: University of Massachusetts Press, 1977); Richard V. Francaviglia, "The Cemetery as an Evolving Cultural Landscape," *Annals of the Association of American Geographers* 61:2 (1971): 501–509; Kenneth Ames, "Ideologies in Stone: Meanings in Victorian Gravestones," *Journal of Popular Culture* 14:4 (Spring 1981): 641–50; and Martha V. Pike and Janice Gray Armstrong, eds., *A Time To Mourn: Expressions of Grief in Nineteenth-Century America* (Stony Brook, N.Y.: The Museums at Stony Brook, 1980).

84. For example, see Francis Tally, "American Folk Customs of Courtship and Marriage: The Bedroom," in *Forms Upon the Frontier*, ed. Fife and Fife, 138–58; David Hackett Fischer, *Growing Old in America* (New York: Oxford University Press, 1977); Martha Pike, " 'In Memory of': Artifacts Related to Mourning in Nineteenth-Century America," *Journal of American Culture* 3:4 (Winter 1980): 642–59; Charles O. Jackson, ed., *Passing: The Vision of Death in America* (Westport, Conn.: Greenwood, 1977). An important European influence on such work with the artifacts of rites of passage has been Phillipe Aries's *Centuries of Childhood* and, more recently, his *The Hour of Our Death* (New York: Knopf, 1981).

85. Thomas Adler, following Edmund Husserl, summarized the phenomenological position as applied to folk artifacts as follows: "We are beginning to get a pretty good idea of the distribution of folk houses on the land, and we can all mostly agree how baskets were made, how bread was baked, and how quilts are put together. We are now in need of some perspectives that can help us to elicit and to generalize about the traditional meanings that underlie and are embedded in traditional artifacts. The hardest core of meanings to get at may be

those that arise directly from the phenomenal stream, from the actual experiences a person has with an object.

"The study of such experiences necessarily involves the taking of an internalized view. In conducting a phenomenological investigation, an analyst sets aside the referential knowledge he already has and momentarily divests himself of his memories of an object, recognizing crucial distinctions to be made between direct experiential knowledge, the memories of experience, and referred knowledge to others. Whether or not historical and personal knowledge can actually be set aside is a moot point; phenomenologists make the attempt, because experiences are by their very nature things of the here-and-now. All we have, experientially speaking, is the present, and each moment of our experience is filled, in part, by material presences that are loci of denotational and connotational meaning. If we can create an appropriate language in which to speak of the ways we all experience artifacts, we may be able to commence an unambiguous discussion of the significance of objects, as well as of their distribution and construction." Thomas Adler, "Personal Experience and the Artifact: Musical Instruments, Tools, and the Experience of Control," in *American Material Culture and Folklore* 103, ed. Bronner.

86. Dell Upton, "Toward a Performance Theory of Vernacular Architecture: Early Tidewater Virginia as A Case Study," *Folklore Forum* 12 (1979): 173–95.

87. Adler, "Personal Experience and the Artifact," 110.

88. Philip L. Wagner and Marvin W. Mikesell, eds., *Readings in Cultural Geography* (Chicago: University of Chicago Press, 1962), 23. The scope and size of material culture evidence used in such studies of public spaces can be gauged by comparing Reyner Banham, *Los Angeles: The Architecture of Four Ecologies* (New York, 1972); Sally Noreen, *Public Illumination in Washington, D.C.* (Washington: George Washington University, 1975); Deborah S. Gardner, "American Urban History: Power, Society, Artifact," *Trends in History* 2:1 (1981): 49–78.

89. Sam Bass Warner, *The Urban Wilderness: A History of the American City* (New York: Harper and Row, 1972); Sam Bass Warner, *The Private City: Philadelphia in Three Periods of Its Growth* (Philadelphia: University of Pennsylvania Press, 1968); Blaine Brownell and David Goldfield, *Urban America: From Downtown to No Town* (Boston: Houghton Mifflin, 1979); Richard Wade and Harold Meyer, *Chicago: Growth of a Metropolis* (Chicago: University of Chicago Press, 1968); Peirce Lewis, *New Orleans: The Making of an Urban Landscape* (Cambridge, Mass.: Ballinger, 1976); David Ward, *Cities and Immigrants: A Geography of Change in Nineteenth-Century America* (New York: Oxford: 1971); John Stilgoe, *Common Landscape* (New Haven: Yale University Press, 1982); J. B. Jackson, *American Space: The Centennial Years, 1865–1876* (New York: Norton, 1972); Grady Clay, *Close-Up: How to Read the American City* (Chicago: University of Chicago Press, 1979).

90. Guy Szuberla, "Three Chicago Settlements: Their Architectural Form and Social Meaning," *Journal of The Illinois State Historical Society* 70 (May 1977): 114–29; Norman Johnson, *Human Cage: A Brief History of Prison Architecture* (New York: Walker & Co., 1973); John D. Thompson and Grace Goldin, *The Hospital: A Social and Architectural History* (New Haven: Yale University Press, 1976); Dolores Hayden, *Seven American Utopias: The Architecture of Communication Socialism, 1790–1975* (Cambridge, Mass.: MIT Press, 1976); Robert Sommer, *Tight Spaces: Hard Architecture and How To Humanize It* (Englewood Cliffs, N.J.: Prentice-Hall, 1974).

91. Sam Bass Warner, *Street-Car Suburbs: The Process of Growth in Boston, 1870–1900* (Cambridge: Harvard University Press, 1962); Olivier Zunz, "Technology and Society in the Urban Environment: The Case of the Third Avenue Elevated Railway," *Journal of Interdisciplinary History* 4:1 (Summer 1972): 89–102; Robert J. Jucha, "The Anatomy of a Streetcar Suburb: A Development History of Shadyside, 1752–1816," *The Western Pennsylvania Historical Magazine* 62:4 (October 1979): 301–319; Timothy J. Sehr, "Three Gilded Age Suburbs of Indianapolis: Irvington, Brightwood, and Woodruff Place," *Indiana Magazine of History* 77:4 (December 1981): 305–332; Robert M. Fogelson, *Fragmented Metropolis, Los Angeles, 1850–1930* (Cambridge: Harvard University Press, 1967); Anne Bloomfield, "The Real Estate Associates: A Land and Housing Developer of the 1870s in San Francisco," *JSAH* 37 (1978); Glen Holt, "Urban Mass Transit History," in *The National Archives and Urban Research*, ed. Jerome Fincter (Athens, Ohio: Ohio University Press, 1974), 81–105.

92. Galen Cranz, "Changing Roles of Urban Parks: From Pleasure Garden to Open Space," *Landscape* 22:3 (Summer 1978): 9–18; Ronald L. Fleming and Lauri A. Haldman, eds. *Common Ground* (Cambridge, Mass.: The Harvard Common Press, 1982); Jere S. French, *A Brief History of the City Square* (Dubuque, Ia.: Kendall/Hunt, 1978); James Borchert, *Alley Life in Washington*; David Brodeur, "Evolution of the New England Town Common, 1630–1966," *The Professional Geographer* 19 (1967): 313–18; Harvard University–Department of Landscape Architecture, *Public Space: Environmental Awareness in America During the Late Nineteenth-Century* (Cambridge: Harvard University Press, 1975).

93. Roy Lubove, "Social History and the History of Landscape Architecture," *Journal of Social History* 9 (1975): 268–75, wherein the following books are reviewed: Elizabeth Barlow (text) and William Alex (illustrative portfolio), *Frederick Law Olmsted's New York* (New York: Praeger Publishers, 1972); Leonard K. Eaton, *Landscape Artist in America: The Life and Work of Jens Jensen* (Chicago: University of Chicago, 1964); Albert Fein, *Frederick Law Olmsted and The American Environmental Tradition* (New York: George Braziller, 1972); *Landscape into Cityscape: Frederick Law Olmsted's Plans for a Greater New York City*, ed. Albert Fein (Ithaca, N.Y.: Cornell University Press, 1968); Norman T. Newton, *Design on the Land: The Development of Landscape Architecture* (Cambridge: Harvard University Press, 1971); Laura Wood Roper, *FLO: A Biography of Frederick Law Olmsted* (Baltimore: John Hopkins University Press, 1973); *Civilizing American Cities: A Selection of Frederick Law Olmsted's Writings on City Landscapes*, ed. S. B. Sutton (Cambridge: MIT Press, 1971).

94. In the Fall 1979 issue (Volume 21) of *Radical History Review*, American social historians will find several articles of interest: "Historians and the Spatial Imagination" by Jon Amsden; "Middle-Class Parks and Working-Class Play: The Struggle over Recreational Space in Worcester, Massachusetts, 1870–1910," by Roy Rosenzweig; "Out of the Ashes: The Great Fire and the Transformation of London's Public Markets," by Susan Henderson; "Rewalking the 'Walking City': Housing and Property Relations in New York City, 1780–1840," by Betsy Blackmar; "You Can't Go to Town in a Bathtub: Automobile Movement and the Reorganization of Rural American Space, 1900–1930," by Joseph Interrante; "Industrial Archaeology and Industrial Ecology," by T. E. Leary; "Social Control and Social Service: The Changing Use of Space in Charity Hospitals," by David Rosner; "Palace of Consumption and Machine for Selling: The American Department Store, 1880–1940," by Susan Porter Benson.

95. John Reps, *Town Planning in America* (Princeton: Princeton University Press, 1965); John Reps, *The Making of Urban America* (Princeton: Princeton University Press, 1965); Mellier Scott, *American City Planning Since 1890* (Berkeley: University of California Press, 1969); Giorgio Ciucci et al., *The American City: From the Civil War to the New Deal* (Cambridge, Mass.: MIT Press, 1979). On individual planners see Thomas Hines, *Burnham of Chicago, Architect and Planner* (New York: Oxford University Press, 1974); Robert Caro, *The Power Broker: Robert Moses and the Fall of New York* (New York: Random House, 1974); Thomas J. Schlereth, "Burnham's *Plan* and Moody's *Manual:* City Planning as Progressive Reform," *APA Journal* 47:3 (January 1981): 70–82; on the general relation of planning, urban technologies, and politics, see Landon Winner, "Do Artifacts Have Politics?" *Daedalus* (1981): 121–36.

96. The influence of Kniffen's theory and practice can be easily seen in H. J. Walker and W. G. Haag, eds., *Man and Cultural Heritage: Papers in Honor of Fred B. Kniffen* (Baton Rouge: Louisiana State University, 1974).

97. Fred Kniffen, "American Cultural Geography and Folklife," in *American Folklife,* ed. Don Yoder (Austin: University of Texas Press, 1976), 51–59.

98. For example, Kniffen's "Louisiana House Types," *Annals, Association of American Geographers* 26 (1936): 179–93.

99. Kniffen, "American Cultural Geography," 60, 63. A survey of other environmentalist positions can be found in Simon J. Bronner, "Modern Anthropological Trends and Their Folkloristic Relationships," *Folk Life* 19 (1981): 66–83; John F. Moe, "Concepts of Shelter: The Folk Poetics of Space, Change, and Continuity," *Journal of Popular Culture* 11 (1977): 219–53; Robert W. Bastian, "The Prairie Style House: Spatial Diffusion of a Minor Design," *Journal of Cultural Geography* 1 (Fall–Winter 1980): 50–65.

100. Peirce Lewis, "Axioms for Reading the Landscape: Some Guides to the American Scene," in *The Interpretation of Ordinary Landscapes: Geographical Essays,* ed. D. W. Meinig (New York: Oxford University Press, 1979), 19. Here also see Schlereth *Artifacts and the American Past,* 184–203.

8

A Guide to General
Research Resources

Thomas J. Schlereth

SINCE THIS BOOK'S chief concern is to assess the major material culture scholarship of the past two decades as well as various new directions of promising work-in-progress, this bibliography is deliberately brief and general. Its entries are of two types: (1) bibliographies of bibliographies that either provide an overview of the entire range of material culture studies or offer a selection of entries describing a specific material culture discipline and (2) serial publications that publish material culture research, regularly or occasionally, and constitute the periodical literature most frequently consulted by researchers in the field. Because the majority of the titles in both the bibliographies and in the serial listing are self-evident, no additional annotation has been included. Although the majority of the entries in both sections deal with research in the United States, a North American perspective has been sought in resource selection wherever possible. For additional bibliographic research tools such as guides to general and specialized anthologies, dissertations, exhibit catalogues, and classic material culture scholarship prior to 1950, see Thomas J. Schlereth, *Material Culture Studies in America* (Nashville, Tenn.: American Association for State and Local History, 1982), 342–52.

A SELECTED BIBLIOGRAPHY OF BIBLIOGRAPHIES

Alexandrin, Barbara, and Robert Bothwell. *Bibliography of the Material Culture of New France.* History Series 4, Ottawa, National Museum, 1970.

Anderson, Jay. "Sources and Resources: Of Each Kind, a Baker's Dozen." *Time Machines: The World of Living History.* Nashville, Tenn.: AASLH, 1984, 195–211.

Barfield, Rodney, "North Carolina Black Material Culture: A Research Opportunity." *North Carolina Folklore Journal* 27:2 (November 1979): 61–65.

Blanchette, Jean-Francois, Rene Bouchard, and Gerald Pocius. "A Bibliography of Material Culture in Canada, 1965–1982." *Canadian Folklore Canadien* 4 (1982): 107–46.

Bronner, Simon J. *Bibliography of American Folk and Vernacular Art.* Bloomington, Ind.: Folklore Publications Group Monograph Series, 1980.

————. "Researching Material Culture: A Selected Bibliography." *Middle Atlantic Folklife Association Newsletter* 5:1 (October 1981): 5–12.

Butler, Patrick H. "Material Culture as a Resource in Local History: A Bibliography." *The Newberry Papers in Family and Community History* 77:2 (1977): 1–24.

Ehresmann, Donald. *Applied and Decorative Arts: A Bibliographic Guide to Basic Reference Works, Histories and Handbooks.* Littleton, Colo.: Libraries Unlimited, 1977.

Eubanks, Sharon Y. *A Bibliography of Books, Pamphlets, and Films Listed in the Living Historical Farms Bulletin from December 1970 through May 1976.* Washington: Association for Living Historical Farms and Agricultural Museums, 1976.

Ferguson, Eugene. *Bibliography of the History of Technology.* Cambridge, Mass.: MIT Press, 1968.

Gritzner, Janet, and Charles F. Gritzner. "Selected Bibliography of Studies Relating to Rural Settlement and American Material Folk Culture." *Forgotten Places and Things: Archaeological Perspectives on American History,* comp. and ed. Albert E. Ward. Albuquerque, N.M.: Center for Anthropological Studies, 1984.

Hamp, Steven K. "Special Bibliography / Meaning in Material Culture: Bibliographic References Towards an Analytical Approach to Artifacts." *Living Historical Farms Bulletin* 4 (May 1980): 9–13.

Hindle, Brooke. *Technology in Early America: Needs and Opportunities for Study.* Chapel Hill: University of North Carolina Press, 1966.

Jakle, John A. *Past Landscapes: A Bibliography for Historical Preservationists Selected from the Literatures of Historical Geography.* Monticello, Ill.: Council of Planning Libraries, 1974.

Johnson, Mary. "Material Culture Studies and Social History: Recent Trends." *Choice* (December 1982): 535–45.

Karpel, Bernard, ed. *The Arts in America: A Bibliography,* 4 vols. Washington: Smithsonian Institution Press, 1979.

Kniffen, Fred B. "Material Culture in the Geographic Interpretation of the Landscape." *The Human Mirror,* ed. Miles Richardson. Baton Rouge: Louisiana State University Press, 1974.

Loomis, Ormand. *Sources on Folk Museums and Living History Farms.* Bloomington, Ind.: Folklore Forum Bibliographic and Special Series, 1977.

Marshall, Howard Wight. *American Folk Architecture: A Selected Bibliography.* Washington: American Folklife Center Publications, 1981.

McIntyre, W. John. "Artifacts as Sources for Material History Research." *Material History Bulletin* 8 (1979): 21–35.

Mergen, Bernard. *Play and Playthings: A Reference Guide.* Westport, Conn.: Greenwood Press, 1982.

Peek, Phil. "Afro-American Material Culture and the Afro-American Craftsman." *Southern Folklore Quarterly* 42:2–3 (1978): 109–34.

Place, Linda, Joanna Zagrando, James Lee, and John Lovell. "The Object as Subject: The Role of Museums and Material Culture Collections in American Studies." *American Quarterly* 26 (1974): 281–94.

Pocius, Gerald L. "Material Folk Culture Research in English Canada: Antiques, Aficionados, and Beyond." *Canadian Folklore Canadien* 4 (1982): 27–41.

Quimby, Ian M. G. "Trends in American Material Culture." *East-Central Newsletter* 6:1 (February 1983): 1–3. Morgantown, W. Va.: American Society for Eighteenth-Century Studies, West Virginia University.

Rath, Frederick L., (Jr.), and Merrilyn Rodgers O'Connell. *Guide to Historic Preservation, Historical Agencies, and Museum Practices: A Selective Bibliography.* Cooperstown: New York State Historical Association, 1966.

Schlereth, Thomas J. *Artifacts and the American Past.* Nashville: American Association for State and Local History, 1980.

Sink, Susan. *Traditional Crafts and Craftsmanship in America: A Selected Bibliography.* Washington: American Folklife Center, 1983.

Skramstad, Harold. "American Things: Neglected American Material Culture." *American Studies International* 10 (Spring 1972): 11–22.

Sokol, David. *American Architecture and Art: A Guide to Information Sources.* Detroit: Gale Research Company, 1976.

Upton, Dell. "Vernacular Architecture Bibliography." *VAF Newsletter.* Bibliography in each issue.

Vance, Mary. *John Brinckerhoff Jackson: A Bibliography.* Vance Bibliographies, Architecture Series: Bibliography #A 641. Monticello, Ill.: Vance Bibliographies, 1984.

Wasserman, Paul, and Esther Herman, eds. *Catalog of Museum Publications and Media,* 2nd ed. Detroit: Gale Research Company, 1980.

Watts, Linda, and Ann C. Ratliff. *Visual History: An Introduction and Selected Bibliography.* Newark: Department of History, University of Delaware, n.d.

Watt, Robert D. "Toward a Three-Dimensional View of the Canadian Past: Can Material History Take Us There?" *Material History Bulletin* 8 (1979): 27–31.

Whitehall, Walter Muir. *The Arts in Early American History.* Chapel Hill: University of North Carolina Press, 1965.

Wildhaber, Robert. "Folklife Bibliography." *New York Folklife Quarterly* 21 (1965): 259–302.

A SELECTED LISTING OF SERIAL LITERATURE
IN MATERIAL CULTURE RESEARCH

Agricultural History. University of California Press, Berkeley, California.
 1927. Quarterly.
AIA Journal. American Institute of Architects, Washington, D.C.
 1944. Monthly.
American Anthropologist. American Anthropological Association, Washington, D.C.
 1898. Quarterly.
American Antiquity. Society for American Archaeology, Washington, D.C.
 1935. Quarterly.
American Ceramics. Harry Dennis Publishers, New York.
 1984. Quarterly.
American Neptune. Peabody Museum of Salem, Salem, Massachusetts.
 1941. Quarterly.
American Quarterly. American Studies Association, Philadelphia.
 1949. Quarterly.
American Walpole Society Notebook. American Walpole Society.
 1910. Randomly.
American West. Western History Association, Cupertino, California.
 1964. Bimonthly.
Antiques (The Magazine of Antiques). New York.
 1922. Monthly.
Aperture: The Quarterly of Fine Photography. Millerton, New York.
 1952. Quarterly.
APT Bulletin. Association for Preservation Technology, Ottawa, Canada.
 1969. Quarterly.
Archeology. Archaeological Institute of America, New York.
 1948. Bimonthly.
Architectural Forum. Whitney Publications, New York.
 1917–1973. Ten issues annually.
Archives of American Art Journal (previously *Archives Quarterly Bulletin*). Archives of American Art.
 1960. Quarterly.
Art in America. Marion, Ohio.
 1913. Bimonthly.

Art Index. H. W. Wilson Co., Bronx, New York.
 1929. Quarterly.
Art Journal. College Art Association of America.
 1917. Quarterly.
Association of American Geographers Annals. Association of American Geographers, Washington, D.C.
 1911. Quarterly.
Association of Historians of American Art Newsletter. City University of New York.
 1979. Three issues annually.
Burlington Magazine. London, England.
 1903. Monthly.
Canadian Historical Sites. Canadian Government Publishing Centre, Quebec, Canada.
 1970. Irregular.
Clarion, America's Folk Magazine. Museum of American Folk Art, New York.
 1971. Quarterly.
Classical America. Boston.
 1974. Randomly.
Connoisseur. London, England.
 1901. Nine issues annually.
Cooperstown Graduate Association Proceedings. Cooperstown, New York.
 1978. Randomly.
Decorative Arts Newsletter. Decorative Arts Society of the Society of Architectural Historians.
 1975. Quarterly.
Dress: Journal of the Costume Society of America. The Costume Institute, New York.
 1975. Annually.
Early American Industries Association Chronicle. Albany, New York.
 1933. Quarterly.
Engineering News-Record. McGraw-Hill Publications Co., New York.
 1874. Weekly.
Environmental Review. Society for Environmental History, Duquesne University, Pittsburgh, Pennsylvania.
 1973. Semi-annually.
Ethnologia Scandinavia: A Journal for Nordic Ethnology. Royal Gustav Adolf Academy, Lund, Sweden.
 1971. Quarterly.
Folklife Center News. U.S. Library of Congress, Washington, D.C.
 1978. Quarterly.
Folklore Forum. Bloomington, Indiana.
 1968. Three issues annually.
Folklore Institute. Indiana University, Bloomington.
 1964. Three issues annually.

Furniture History. London, England.
 1970. Annually.
Geographical Review. American Geographical Society, New York.
 1916. Quarterly.
Historical Archaeology. Society for Historical Archaeology.
 1967. Annually.
Historical Preservation. National Trust for Historic Preservation, Washington, D.C.
 1949. Quarterly.
Historical Methods. Heldref Publications, Washington, D.C.
 1967. Quarterly.
Historical Technology. Historic Technology, Inc., Marblehead, Massachusetts.
 1970. Irregular.
History and Archaeology. Canadian Government Publishing Centre, Quebec, Canada.
 1975. Occasional.
History News. American Association for State and Local History.
 1954. Monthly.
History of Technology. Mansell Publishing, London, England.
 1976. Annually.
IA: The Journal of the Society for Industrial Archaeology. Boston.
 1976. Annually.
Industrial Archaeology. Devon, England.
 1964. Quarterly.
Isis. History of Science Society, Philadelphia.
 1912. Five issues annually.
Journal of American Culture. Popular Culture Association, Bowling Green, Ohio.
 1978. Quarterly.
Journal of American Folklore. American Folklore Society, Washington, D.C.
 1888. Quarterly.
Journal of American History. Indiana University, Bloomington.
 1914. Quarterly.
Journal of American Institute of Architects. American Folklore Society, Washington, D.C.
 1913. Thirteen issues annually.
Journal of Cultural Geography. Bowling Green, Ohio.
 1980. Quarterly.
Journal of Early Southern Decorative Arts. Museum of Early Southern Decorative Arts, Winston-Salem, North Carolina.
 1975. Quarterly.
The Journal of Economic History. Economic History Association, Wilmington, Delaware.
 1941. Quarterly.

Journal of Field Archaeology. Boston University, Boston, Massachusetts.
1974. Quarterly.
Journal of Glass Studies. Corning Museum of Glass, Corning, New York.
1959. Annually.
Journal of Interdisciplinary History. Cambridge, Massachusetts.
1970. Quarterly.
Journal of Popular Culture. Popular Culture Association, Bowling Green,
Ohio.
1967. Quarterly.
Journal of Social History. Carnegie-Mellon University Press, Pittsburgh,
Pennsylvania.
1967. Quarterly.
Journal of the Society of Architectural Historians. Philadelphia, Pennsylvania.
1941. Quarterly.
Journal of Transport History. Manchester University Press, Manchester,
England.
1953. Semi-annually.
Journal of Urban History. Sage Publications, Inc., Beverly Hills, California.
1974. Quarterly.
Keystone Folklore. Pennsylvania Folklore Society, Philadelphia.
1956. Quarterly.
The Kiva. Arizona Archaeological and Historical Society, Tucson.
1935. Quarterly.
Landscape. Berkeley, California.
1952. Three issues annually.
Landscape Architecture. American Society of Landscape Architects, Louisville, Kentucky.
1910. Bi-monthly.
Landscape History. Society for Landscape Studies.
1979. Quarterly.
Living History Farms Bulletin. Association of Living History Farms and
Agricultural Museums, Washington, D.C.
1975. Bi-monthly.
Living History Magazine. Reston, Virginia.
1983. Quarterly.
Material Culture: The Journal of the Pioneer America Society (formerly *Pioneer
America: The Journal of Historic American Material Culture,* 1968–1984). The
Pennsylvania State University, Middletown.
1984. Semi-annually.
Material History Bulletin. National Museum of Man, Ottawa, Canada.
1971. Semi-annually.
Mentalities/Mentalites. Outrigger Publishers, Hamilton, New Zealand.
1984. Quarterly.
Museum News. American Association of Museums, Washington, D.C.
1924. Bi-monthly.

New York Folklore Quarterly. New York Folklore Society, Buffalo, New York.
1975. Semi-annually.
Nineteenth Century. Victorian Society of America, Philadelphia, Pennsylvania.
1975. Quarterly.
North American Archaeologist. Baywood Publishing Inc., Farmingdale, New York.
1979. Quarterly.
North American Culture. Society for the North American Cultural Survey, University of Florida, Gainesville.
1984. Annually.
Northeast Historical Archaeology. University of Pennsylvania, Philadelphia.
1971. Semi-annually.
Old-Time New England. Society for the Preservation of New England Antiquities, Boston.
1910. Quarterly.
Pennsylvania Folklife. Pennsylvania Folklife Society, Lancaster.
1949. Quarterly.
Places: A Quarterly Journal of Environmental Design. MIT Press, Cambridge.
1984. Quarterly.
Prospects: An Annual of American Cultural Studies. New York.
1975. Annually.
The Public Historian. University of California Press, Berkeley.
1979. Quarterly.
Railroad History. Smithsonian Institution, Washington, D.C.
1921. Semi-annually.
Review in American History. Johns Hopkins University Press, Baltimore, Maryland.
1973. Quarterly.
Smithsonian. Smithsonian Associates, Washington, D.C.
1970. Monthly.
Smithsonian Studies in History and Technology (replaced *Contributions to the Museum of History and Technology,* 1959–1968). Washington, D.C.
1969. Randomly.
Studies in the Anthropology of Visual Communications. Temple University, Philadelphia.
1973. Three issues annually.
Southern Exposure. Institute for Southern Studies, Chapel Hill, North Carolina.
1973. Quarterly.
Studies in Traditional American Crafts. Madison County Historical Society, Madison County, New York.
1979. Annually.

Technology and Culture. Society for History of Technology, University of Chicago Press.

 1960. Quarterly.

Textile History. Butterword Scientific Ltd., Guildford, Surrey, England.

 1968. Two issues per year.

Vernacular Architecture Newsletter. Vernacular Architecture Forum, University of California, Berkeley.

 1979. Quarterly.

Visual Resources: An International Journal of Documentation. Iconographic Publications.

 1980. Tri-quarterly.

Winterthur Portfolio: A Journal of American Material Culture.

 1964–1978. Annually; Winterthur Museum, Winterthur, Delaware.

 1979. Three issues annually; University of Chicago Press.

Contributors

KENNETH L. AMES currently is director of the Office of Advanced Studies at the Henry Francis duPont Winterthur Museum in Delaware. He is also an adjunct associate professor of art history at the University of Delaware. His teaching and research interests focus on nineteenth-century decorative arts, particularly furniture.

Ames began his art history training at Carleton College and took his advanced degrees in the field at the University of Pennsylvania. A founding member of the Decorative Arts Society, he has also served as the book review editor of the *Winterthur Portfolio* and as a member of the editorial board of *Material Culture*. For seven years (1975–1982), he directed the influential Winterthur Summer Institute.

The author of a highly provocative analysis of American folk art (*Beyond Necessity: Art in the Folk Tradition,* 1977) and the editor of a pioneering anthology of research on nineteenth-century furniture scholarship (*Victorian Furniture,* 1982), Kenneth Ames is also well-known for his important contributions to the serial literature of material culture studies. A representative sample of his major articles would include "The Battle of the Sideboards," *Winterthur Portfolio* 9 (1974); "What Is the Neo-Grec?" and "Sitting in (Neo-Grec) Style," *Nineteenth Century* 2:2 and 2:3–4 (Summer and Fall 1976); "Meaning in Artifacts: Hall Furniture in Victorian America," *Journal of Interdisciplinary History* 9:1 (Summer 1978); "Material Culture as Nonverbal Communication: A Historical Case Study," *Journal of American Culture* 3:4 (Winter 1980); and "Ideologies in Stone: Meanings in Victorian Gravestones," *Journal of Popular Culture* 14:4 (Spring 1981).

SIMON J. BRONNER is associate professor of folklore and American studies at the Capitol Campus of the Pennsylvania State University at Middletown. There he teaches courses in American folklore, material culture, regionalism, and ethnography.

207

Bronner began his folklore career as an undergraduate at the State University of New York at Binghamton. He took his master's degree in the Cooperstown Graduate Program of the State of New York and his Ph.D. in folklore and American studies at Indiana University. He edits *The Folklore Historian* and *Material Culture*, as well as acting as general editor for a new publication series of the UMI Press titled *American Material Culture and Folklife*.

Many of Bronner's publications have been major historiographical contributions to both folk art research (for example, *American Folk Art: A Guide to the Sources*, 1984) and to material culture studies (for example, *Approaches to the Study of Material Aspects of American Folk Culture*, 1979). Recently he edited a valuable anthology of writings on *American Material Culture and Folklife* (1984). Other material culture essays that also share this perspective are Bronner's "Hidden Past of Material Culture Studies in American Folkloristics," *New York Folklore* 8 (Summer 1982); "Investigating Identity and Expression in Folk Art," *Winterthur Portfolio* 16:1 (Spring 1981); and his most recent book, *Chain Carvers: Old Men Crafting Meaning* (1984).

PEIRCE F. LEWIS currently teaches American geography at the Pennsylvania State University at University Park, where he has been a faculty member since 1958. A winner of several outstanding teaching awards, his primary professional interest has been the American landscape—its origins, morphology, and symbolism.

A double major (philosophy and history) at Albion College, Lewis took his graduate degrees in geography at the University of Michigan. A past president of the Association of American Geographers, he has been extremely active on its Committee on the Teaching of Local Geography Project. He has been a contributing editor to *Material Culture: The Journal of the Pioneer American Society* and presently is a member of the editorial board of the *Journal of Historical Geography*.

In addition to his succinct urban geography, *New Orleans: The Making of an Urban Landscape* (1976), Peirce Lewis has written several classic articles that are frequently anthologized. For example, "Small Town in Pennsylvania," *Annals of the Association of American Geographers* 62:2 (1972); "Common Houses, Cultural Spoor," *Landscape* 19:2 (1975); "Axioms of the Landscape: Some Guides to the American Scene," in *The Interpretation of Ordinary Landscapes*, ed. Donald W. Meinig (1979); and "The Unprecedented City," in *The American Land*, ed. A. Doster et al. (1979).

CARROLL W. PURSELL, JR., is professor of history at the University of California, Santa Barbara. He has also taught at the Case Institute of Technology, the University of Wisconsin at Milwaukee, and at Lehigh University. His research interests focus on the interrelations of United States history, science, and technology as well as the historical dimensions of science policy.

A graduate of the University of Delaware's Hagley Program, Pursell took his bachelor of arts degree and Ph.D. in history from the University of California at Berkeley. He has been active in the Society for the History of Technology (serving as the organization's secretary in 1975), the Organization of American Historians, and the American Historical Association.

In 1968 Pursell co-edited, with Melvin Kranzberg, a two-volume selection of readings on *Technology in Western Civilization*. He has also assembled *Readings in Technology and American Life* (1969) and a recent collection of biographical studies entitled *Technology in America: A History of Ideas and Individuals* (1981).

Carroll Pursell has also contributed several specialized studies to the history of American technology. These include *Early Stationary Steam Engines in America* (1969), *The Military-Industrial Complex* (1972), and *From Conservation to Ecology* (1980).

THOMAS J. SCHLERETH directs the Graduate Program in the department of American studies at the University of Notre Dame where he teaches American cultural, urban, and architectural history as well as material culture studies. His present research interests center on nineteenth-century social history and material culture theory.

Schlereth was trained as a historian in three midwestern institutions: University of Notre Dame, University of Wisconsin, and University of Iowa. He serves as a member of the editorial board of the *Winterthur Portfolio, Material Culture, Museum Studies Journal,* and *North American Culture* and is an associate editor of *The Old Northwest.*

The author of a biography, *Geronimo: The Last of the Apache Chiefs* (1974); a monograph on eighteenth-century European-American intellectual history, *The Cosmopolitan Ideal in Enlightenment Thought* (1977); and a university history, *The University of Notre Dame: A Portrait of Its History and Campus* (1976), he has also contributed to the publication series of both the American Association of Museums (*It Wasn't That Simple,* 1978, 1984) and the American Association for State and Local History (*Historic House Museums,* 1978).

Schlereth's recent books focus directly on material culture as historical evidence. These include *Artifacts and the American Past* (1980); *Material Culture Studies in America* (1982); and *U.S. 40: A Roadscape of the American Experience* (1985).

DELL UPTON is presently an assistant professor in the department of architecture at the University of California, Berkeley, where he teaches world, American, and vernacular architecture. Previously he taught at George Washington, Boston University, University of Virginia, and Case-Western Reserve. A specialist in the built-environment of Chesapeake Tidewater, he also acts as a historiographer and bibliographer of the American vernacular architecture movement.

Taking an undergraduate history/English degree at Colgate University, Upton pursued his graduate studies in American civilization at Brown University. The major force beyond the formation of the Vernacular Architecture Forum, he has been editor of its serial publication, *Vernacular Architecture Newsletter,* since its founding in 1979. He is also on the editorial boards of the *American Quarterly, Winterthur Portfolio,* and *Material Culture.*

In 1985–86 Dell Upton will publish two new books: *Common Places: Readings in American Vernacular Architecture,* co-edited with John Vlach (University of Georgia Press, 1985), and *Holy Things and Profane: Anglican Parish Churches in Colonial Virginia* (Architectural History Foundation / MIT Press, 1986). His important research articles include "Toward a Performance Theory of Vernacular Architecture in Tidewater Virginia," *Folklore Forum* 12:2/3 (1979); "Traditional Timber Framing," in *Material Culture of the Wooden Age,* ed. Brooke Hindle (1981); "Pattern Books and Professionalism: Aspects of the Transformation of American Domestic Architecture, 1800–1860," *Winterthur Portfolio* 19:2/3 (Summer–Autumn 1984).

Index

Adler, Elizabeth Mosby, 139
Adler, Thomas, 139, 175–76
advertising, 20
affective understanding
—and material culture, 8, 12–13
Afro-American Folk Art and Crafts (Ferris), 135
Afro-American Tradition in the Decorative Arts, The (Vlach), 91, 132, 172
Alpers, Svetlana, 85
American Art: 1750–1800, Towards Independence (Plumb, Harris, Prown, Sommer, Montgomery), 88
American Chairs: Queen Anne and Chippendale (Kirk), 94
American Design Ethic: A History of Industrial Design (Pulos), 88
American Furniture: The Federal Period (Montgomery), 95
American Furniture and the British Tradition to 1830 (Kirk), 100
American Home, Architecture and Society, 1815–1915, The (Handlin), 160
American Material Culture and Folklife (Bronner), 129, 172–73
"American-ness" of artifacts, xi, 17, 100
American Renaissance, The (Wilson, Pilgrim, Murray), 89
"American Scene, The" (Lowenthal), 42
American Skyline (Tunnard and Reed), 48
American Small Town, The (Jakle), 48
Americans on the Road (Belasco), 46

American Space: The Centennial Years, 1865–1876 (Jackson), 49
American Studies
—and material culture, ix, x, xii, 104, 114, 129, 130, 136, 138, 141–42
—myth-and-symbol school of, xiii, 92
"American Way of History, The" (Lowenthal), 44
Amerindian material culture, 1, 2, 19, 128, 131, 135, 172
Ames, Kenneth, x, xi, xii, 22, 27, 102, 164, 207
Anderson, Jay, 19, 83, 164, 171
Andrews, Edward Deming, 91
Andrews, Faith, 91
archaeology
—above-ground, 6
Archaeology by Experiment (Coles), 171
Archbold, Annie
—*The Traditional Arts and Crafts of Warren County, Kentucky,* 134
architectural history, ix, 6, 7, 58
Aries, Phillipe, 167
Armstrong, Robert Plant, 67
art history, ix, x, xiv, 3, 6, 7, 58, 85–86, 170
artifacts. *See* material culture
Artifacts and the American Past (Schlereth), 73
Artists in Aprons: Folk Art by American Women (Dewhurst, MacDowell, and MacDowell), 136

Art Populaire (Focillon), 170
Arts and Architecture of German Settlements in Missouri, The (Van Ravenswaay), 91
arts-and-crafts movement, 80, 81, 89
Arts of the Pennsylvania Germans (Swank), 90
Asher, Robert, 171
At Home: Domestic Life in the Post-Centennial Era, 1876–1920 (Talbot), 164
Atlanta Historical Society
—*Neat Pieces: The Plain-Style Furniture of 19th Century Georgia,* 96
attribution, 97, 101

Bachelard, Gaston, 162
Baerwald, Thomas
—"The Emergence of a New Downtown," 48
Bailyn, Bernard
—*Education in the Forming of American Society,* 16
Barba, Preston
—*Pennsylvania German Tombstones,* 135
Barber, Edwin Atlee
—*The Pottery and Porcelain of the United States,* 81
Barn Building in Otsego County, New York (Glassie), 134
Basalla, George, 17
Bascom, William, 170
Bassett, Fletcher S., 127, 142
behavioralistic approach to material culture, 157, 173–76
"Beholding Eye: Ten Versions of the Same Scene, The" (Meinig), 42
Belasco, Warren James
—*Americans on the Road,* 46
Benedict, Ruth, 170
Bivens, John
—*Moravian Decorative Arts in North Carolina,* 91
black (Afro-American) material culture, 65, 66, 91–92, 128, 132, 135, 138, 172
Blue Book—Philadelphia Furniture (Hornor), 95
Boaz, Franz, 128, 140, 170
Boorstin, Daniel, xiii, 17
Boston Furniture of the Eighteenth Century (Whitehill, ed.), 96
Boston Museum of Fine Arts
—*New England Begins: The Seventeenth Century,* 16, 90, 104
Bowden, Martyn, ed.
—*Geographies of the Mind,* 42
Braudel, Fernand, 6, 21

—*Capitalism and Material Life,* 165
Briggs, Charles
—*Wood Carvers of Cordova, New Mexico,* 135
British material culture, xi, 21, 62, 71, 80, 115
Brodsly, David
—*L.A. Freeway,* 114
Bronner, Simon, x, xi, xii, xiii, 174, 207–8
—*American Material Culture and Folklife,* 129, 172–73
—*Chain Carvers: Old Men Crafting Meaning,* 136
—*Grasping Things,* 141
Brown, Albert F., 59, 60
Brown, Donald
—"Social Structure as Reflected in Architectural Units at Picuris Pueblo, New Mexico," 161
Brown, Linda Keller, ed.
—*Ethnic and Regional Foodways in the United States,* 135
Brown, Scott, 70
Brownell, Blaine, 177
Buckley, Bruce, 133
Burlingame, Roger, xii
By the Beautiful Sea: The Rise and High Times of That Great American Resort, Atlantic City (Funnell), 46

Capitalism and Material Life (Braudel), 165
Carlson, Alvar, 46
Caro, Robert, 45, 178
Carolina Dwelling (Swain et al., eds.), 58, 161
Carson, Cary, 21, 161
"Case of Technology and Social Change: The Washing Machine and the Working Wife, A" (Cowan), 166
"Cemetery as a Cultural Text, The" (Vidutis and Lowe), 132
ceramics, 81, 164
Chain Carvers: Old Men Crafting Meaning (Bronner), 136
Charleston Blacksmith: The Work of Philip Simmons (Vlach), 138
Chestang, Ennis
—"Rural Revolution in East Carolina," 46
"Chihuahua, as We Might Have Been" (Jackson), 45
China Collecting in America (Earle), 81
Chomsky, Noam, 66, 67, 140, 161
Christman, Margaret
—*Suiting Everyone: The Democratization of Clothing in America,* 167–68
chronology. *See* material culture: eras of

Cities of the American West: A History of Urban Planning (Reps), 178
Civilizing the Machine (Kasson), 114
Clark, Clifford, 160
Classical America, 1815–1845 (Tracy and Gerdts), 89
Clay, Grady, 177
—*Close-up: How to Read the American City*, 48
Climatic Atlas of the United States (U.S. Dept. of Commerce), 42
Close-up: How to Read the American City (Clay), 48
clothing (costume), 167–68
Cohen, Lizabeth
—"Embellishing a Life of Labor: An Interpretation of the Material Culture of American Working Class Homes, 1885–1915," 163
Coles, John
—*Archaeology by Experiment*, 171
collecting orientation in decorative arts, 83–85
Colonial Furniture in America (Lockwood), 81
Colonial Furniture of New England, The (Lyon), 81, 95
Common Landscapes of America, 1598–1845 (Stilgoe), 11
computer graphics, x, 15, 121–22
"Concepts of Shelter" (Moe), 133
Condit, Carl, 170
connoisseurship, 94, 101
—defined, 61, 104
consumerism, 20, 21, 101, 105, 132
Conzen, Michael
—"Fashioning the American Landscape," 42
Cooke, Edward S., 97, 104
—*Fiddlebacks and Crooked-backs*, 99–100
Cooper, Wendy, 85
—*In Praise of America: American Decorative Arts, 1650–1830*, 88
Cotter, John, 6
Cowan, Ruth Schwartz, 22, 92, 166, 168
—"A Case of Technology and Social Change: The Washing Machine and the Working Wife," 166
—"From Virginia Dare to Virginia Slims: Women and Technology in American Life," 166
—"Industrial Revolution in the Home," 166
craftsmanship
—defined, 170

creativity, xii, xiii, 20, 22, 66, 67, 102, 136–37, 173–74
Cromley, Elizabeth Collins, 69
Cronquist, Arthur
—*The Natural Geography of Plants*, 42
Culin, Stewart, 127, 128
—*Games of the North American Indians*, 131
cultural anthropology, ix, xiv, 3, 6, 26, 58, 62
cultural geography, ix, xi, 2, 3, 6, 35–56, 58, 62, 64, 133
Cultural Geography of the United States, The (Zelinsky), 42
cultural hearths, 64, 113
cultural-history approach to material culture, 165–66
cultural landscape, 35, 39, 40–50
cultural materialism, 4–5
cultural transfer, 61, 100
culture
—defined, 140
—elite, 5, 65, 160
—folk, 37
—mass, 100
—popular, 5, 25, 87, 180
—vernacular, 5, 25, 30 n.31
culture concept, xii, xiii, 4, 7, 29 n.20, 64
Cummings, Abbott Lowell, 71
—*The Framed Houses of Massachusetts Bay, 1625–1725*, 61
—*Rural Household Inventories Establishing the Names, Uses and Furnishing of Rooms in the Colonial New England Home, 1675–1775*, 164

Darwin, Charles, 128
Datel, Robin E.
—"Historic Preservation and Urban Change," 44
decorative arts, ix, 6, 17, 79–112, 163, 166, 170
Deetz, James, 5, 7, 21, 23, 27
—*In Small Things Forgotten: The Archaeology of North American History*, 22, 165
definitions
—material culture, xii, 1, 2–6, 27, 28 n.2, 113, 129
—material culture studies, 156
"Democratization of the Women's Dress Pattern Industry, The" (Walsh), 167
Demos, John, 16, 167
—*Little Commonwealth: Family Life in the Plymouth Colony*, 160
Denker, Ellen and Bert

—*The Rocking Chair Book,* 102
Dewhurst, C. Kurt, 134
—*Artists in Aprons: Folk Art by American Women,* 136
—*Religious Folk Art in America,* 135
diachronic analysis, 17–18
Dickens, Charles
—*American Notes,* 49
diffusion, 38, 130, 178, 179–80
Dingemans, Dennis J.
—"Historic Preservation and Urban Change," 44
Documentary History of American Interiors, A (Mayhew and Myers), 88
"Domestic Environment in Early Modern England and America, The" (Shammus), 163
domesticity (domestic life), 20, 64, 80, 156, 163–66
Domestic Scene, The (Robertson), 102
Dorson, Richard, 6
Douglas, Diane
—"The Machine in the Parlor: A Dialectical Analysis of the Sewing Machine," 103
Dunbar, Gary
—"Illustrations of the American Earth: A Bibliographic Essay on the Cultural Geography of the United States," 47
Duncan, James
—"Landscape Taste as a Symbol of Group Identity [in] a Westchester County Village," 43
Dundes, Alan, 134, 135, 142
—*Work Hard and You Shall Be Rewarded,* 131
Durand, Loyal
—"Mountain Moonshining in East Tennessee," 46
Dwyer, Jane, 26
Dynamos and Virgins Revisited (Trescott), 167

Earle, Alice Morse
—*China Collecting in America,* 81
Eastern Shore, Virginia, Raised Panel Furniture, 1730–1830 (Melchor, Melchor, and Lohr), 96
Education in the Forming of American Society (Bailyn), 16
"Education of a Geographer, The" (Sauer), 36
Eliade, Mircea, xi, 43
"Embellishing a Life of Labor: An Interpretation of the Material Culture of American Working Class Homes, 1885–1915" (Cohen), 163

"Emergence of a New Downtown, The" (Baerwald), 48
Emulation and Invention (Hindle), 120
environmental perception, 38–39, 41, 42
"Environmental Perception" (Saarinen and Sell), 39
Erixon, Signurd, xiv
Ethnic and Regional Foodways in the United States (Brown and Mussell, eds.), 135
ethnicity, 65, 68, 90–91, 93, 172
ethnic material culture, 19, 43, 65, 66, 90–91, 133, 134, 172
Ettema, Michael, 17, 85, 94, 101, 104
—and "scientific antiquarianism," 94
European material culture studies, xi, 21, 80, 133, 135
Evans, E. Estyn, 38
evidence, material culture. *See* material culture: evidence for
"Exhilaration of Early American Technology: An Essay, The" (Hindle), 121
experimental archaeology, 19–20, 171–72
—defined, 171
explanatory theory. *See* material culture: explanations of

facadism
—defined, 160
"Fashion, Emancipation, Reform, and the Undergarment" (Warner), 167
"Fashioning the American Landscape" (Conzen), 42
"Feeling for Form, As Illustrated by People at Work, A" (Jones), 141
Fenton, Andrew, 6
Ferguson, Eugene, 11, 117, 118, 119, 120, 156
Ferguson, Leland, 12
Ferris, William, 174
—*Afro-American Folk Art and Crafts,* 135
—"Vision in Afro-American Folk Art: The Sculpture of James Thomas," 138
Fiddlebacks and Crooked-backs (Cooke), 99–100
"Field Patterns in Indiana" (Hart), 45
fieldwork, x, 2, 7, 162, 171, 175, 176
Fitchen, John
—*The New World Dutch Barn: A Study of Its Characteristics, Its Structural System, and Its Probable Erectional Procedures,* 19
Fleming, E. McClung, 6, 25, 97
Focillon, Henri, 97
—*Art Populaire,* 170
folk
—defined, 128, 134

Folk Architecture in Little Dixie (Marshall), 133
folk art, 98, 138, 141, 173–74
folk culture
—defined, 128–29
"Folk Housing: A Key to Diffusion" (Kniffen), 179
Folk Housing in Middle Virginia: A Structural Analysis of Historic Artifacts (Glassie), 38, 67–68, 140, 161, 162, 180
folklife, ix, xi, 14, 128, 133
folklore, 2, 58, 87, 128
—defined, 127
folkloristics, 3, 6, 127, 130, 142–43, 144
—defined, 129
foodways, 135, 141, 164–65
Ford, Larry
—"Urban Preservation and the Geography of the City in the USA," 44
Foreman, Beno, 97, 98, 170
Foucault, Michel, 18
Fox, Dixon Ryan, 155
Framed Houses of Massachusetts Bay, 1625–1725, The (Cummings), 61
Francaviglia, Richard, 43
"From Virginia Dare to Virginia Slims: Women and Technology in American Life" (Cowan), 166
Frye, Northrop, 18
functionalism, xi, 61, 95, 157, 170–71
Funnell, Charles
—*By the Beautiful Sea: The Rise and High Times of That Great American Resort, Atlantic City*, 46
Furnas, J. C., 17
furniture, 81, 88, 94–103, 163–64
Furniture of New Haven Colony (Kane), 96
Furniture of Our Forefathers (Singleton), 81
Furniture of Williamsburg and Eastern Virginia (Gusler), 96

Games of the North American Indians (Culin), 131
Gans, Herbert
—*The Levittowners*, 161
Garvan, Beatrice
—*The Pennsylvania German Collection*, 90
—*The Pennsylvania Germans: A Celebration of Their Arts, 1683–1850*, 90
Geographies of the Mind (Lowenthal and Bowden, eds.), 42
geography. See cultural geography
"Geography, Experience, and Imagination: Toward a Geographical Epistemology" (Lowenthal), 39
geomorphology (landforms), 37, 41, 42

Georgianization
—defined, 65
Gerdts, William
—*Classical America, 1815–1845*, 89
Germans, 172
—in Missouri, 91
—in Pennsylvania, 90, 128, 132, 133, 135
Giedion, Siegfried, 6, 170
—*Mechanization Takes Command*, 82
Glassie, Henry, xi, xii, 13, 14, 19, 46, 63, 98, 133, 142, 143, 145, 174
—*Barn Building in Otsego County, New York*, 134
—*Folk Housing in Middle Virginia: A Structural Analysis of Historic Artifacts*, 38, 67–68, 140, 161, 162, 180
—*Passing the Time in Ballymenone: Culture and History of an Ulster Community*, 30, 71
—*Pattern in the Material Folk Culture of the Eastern United States*, 47, 64, 132, 161, 179
Gleason, H. A.
—*The Natural Geography of Plants*, 42
Goffman, Erving, 102
—*The Presentation of Self in Everyday Life*, 163
Goody, Jack, 142
Gowans, Alan, xiii, 17, 22, 102, 160
—*Images of American Living: Four Centuries of Architecture and Furniture as Cultural Expression*, 82
—*Learning to See: Historical Perspective on Modern Popular/Commercial Arts*, 86
Grand Domestic Revolution: A History of Feminist Designs for American Homes, Neighborhoods, and Cities, The (Hayden), 166
Grasping Things (Bronner), 141
Graven Images, New England Stonecarving and Its Symbols, 1650–1815 (Ludwig), 174–75
Great Bridge, The (McCullough), 49, 114
Great Plains, The (Webb), 45, 46, 49, 179
Green, Harvey, 92
Greene, Leslie A.
—"The Late Victorian Hallstand: A Social History," 102–3
Greenough, Horatio, 9
Gross, Laurence G., 115–16
Groth, Paul
—"Street Grids as Frameworks for Urban Variety," 45
Gusler, Wallace
—*Furniture of Williamsburg and Eastern Virginia*, 96
Gutman, Herbert, 169

Hale, John, 11
Hall, Edward T.
—*The Hidden Dimension*, 163
Halsey, R. T. H.
—*Pictures of Early New York on Dark Blue Stafford Shire Pottery*, 81
Handlin, David
—*The American Home, Architecture and Society, 1815–1915*, 160
Handlin, Oscar
—"The Significance of the Seventeenth Century," 16
Hand Made Object, The (Jones), 102, 137, 173
Hanks, David, 102
Harris, Marvin, 5
Harris, Neil
—in *American Art: 1750–1800, Towards Independence*, 88
Hart, John Fraser, 46, 49
—"Field Patterns in Indiana," 45
—*The Look of the Land*, 48
Hawley, Henry, 85
Hayden, Dolores, 92, 114
—*The Grand Domestic Revolution: A History of Feminist Designs for American Homes, Neighborhoods, and Cities*, 166
—*Seven American Utopias: The Architecture of Communitarian Socialism, 1790–1975*, 166
Hearth and Home (McDaniel), 92, 160, 172
Hearts and Crowns (Trent), 98, 170
Hecht, Melvin, 43
Henretta, James, 158
Heyerdahl, Thor, 171
Hidden Dimension, The (Hall), 163
Hilliard, Sam B.
—"An Introduction to Land Survey Systems in the Southeast," 45
Hindle, Brooke, xi, xiii, 6, 11, 12, 15, 23, 27
—*Emulation and Invention*, 120
—"The Exhilaration of Early American Technology: An Essay," 121
—"Technology through the 3-D Time Warp," 121
Hirshorn, Paul, 70
historical archaeology, ix, xiv, 2, 6, 7, 165
Historical Geography of the United States: A Bibliography (McManis), 47
Historic American Engineering Record (HAER), 116
"Historic Houses as Learning Laboratories: Seven Teaching Strategies" (Schlereth), 73
historic preservation, 25, 44, 93, 116

"Historic Preservation and Urban Change" (Datel and Dingemans), 44
History of Technology (Singer), 47
"History Outside the History Museum: The Past on the American Landscape" (Schlereth), 47
Hollybush (Martin), 134
Homo Ludens (Huizinga), 169
Hornor, William
—*Blue Book—Philadelphia Furniture*, 95
Hoskins, William, 38, 39
household furnishings, 79–112, 163–64
Howard, Robert, 22
Hubka, Thomas, 63
Hudson-Fulton Exhibition, 81
Huizinga, John
—*Homo Ludens*, 169
Human Mirror, The (Richardson), 26
Human Nature in Geography (Wright), 39
Hume, Ivor Noel
—*Martin's Hundred*, 22
Hummel, Charles
—*With Hammer in Hand: The Dominy Craftsmen of East Hampton, New York*, 170
Husbandmen of Plymouth: Farms and Villages in the Old Colony, 1620–1692 (Rutmann), 170

iconography, 92, 175
"Illustrations of the American Earth: A Bibliographic Essay on the Cultural Geography of the United States" (Dunbar), 47
Images of American Living: Four Centuries of Architecture and Furniture as Cultural Expression (Gowans), 82
"Impress of Effective Central Authority upon the Landscape" (Whittlesey), 44
industrial archaeology, 115, 116, 169
industrialization, 104
"Industrial Revolution in the Home" (Cowan), 166
In Praise of America: American Decorative Arts, 1650–1830 (Cooper), 88
In Small Things Forgotten: The Archaeology of North American History (Deetz), 22, 165
"Introduction to Land Survey Systems in the Southeast, An" (Hilliard), 45
invention, xiii, 119–20
Isaac, Rhys
—*Transformation of Virginia, 1740–1790*, 11, 20
Isham, Norman Morrison, 59, 60

"Is There a Folk in the Factory?" (Nickerson), 136
Izenour, Steven, 70

Jabbour, Alan
—"Some Thoughts from a Folk Culture Perspective," 136
Jackson, J. B., xi, 36, 39–40, 43, 44, 160, 177
—*American Space: The Centennial Years, 1865–1876,* 49
—"Chihuahua, as We Might Have Been," 45
Jakle, John, 44
—*The American Small Town,* 48
—*Past Landscapes: A Bibliography for Historic Preservation,* 47
Jefferson, Thomas, 122
Johnson, Hildegard Binder
—*Order Upon the Land,* 45
Jones, Louis C., 133
—*Outward Signs of Inner Beliefs,* 131
Jones, Michael Owen, 140
—"A Feeling for Form, As Illustrated by People at Work," 141
—*The Hand Made Object and Its Maker,* 102, 137, 173
—"L.A. Add-ons and Re-dos," 69, 139, 173
—"Toward a Behavioral History," 174
Jordan, Rosan A., ed.
—*Women's Folklore, Women's Culture,* 136
Jordan, Terry, 48
—*Texas Graveyards, A Cultural Legacy,* 43
—*Texas Log Buildings, A Folk Architecture,* 161

Kalcik, Susan J., ed.
—*Women's Folklore, Women's Culture,* 136
Kalm, Peter
—*Travels in North America,* 49
Kane, Patricia, 98
—*Furniture of New Haven Colony,* 96
Kasson, John
—*Civilizing the Machine,* 114
Kelly, J. Frederick, 60
Kidwell, Claudia
—*Suiting Everyone: The Democratization of Clothing in America,* 167–68
kinesics, 5
Kirk, John
—*American Chairs: Queen Anne and Chippendale,* 94
—*American Furniture and the British Tradition to 1830,* 100
Kluckhohn, Clyde, xiv, 2, 13

Kniffen, Fred B., xi, 25, 36, 40, 46, 47
—"Folk Housing: A Key to Diffusion," 179
—"Louisiana House Types," 37
Kouwenhoven, John, 13, 17
Kroeber, Alfred, xii, xiv, 179
Kubler, George, xi, 3, 98
—*The Shape of Time: Remarks on the History of Things,* 119, 170

"L.A. Add-ons and Re-dos" (Jones), 69, 139, 173
L.A. Freeway (Brodsly), 114
Land and Life: A Selection from the Writings of Carl Ortwin Sauer (Leighly, ed.), 36
Landscape (magazine), 39–40
"Landscape Taste as a Symbol of Group Identity [in] a Westchester County Village" (Duncan), 43
"Language of Dress: A Sociohistorical Study of the Meaning of Clothing in America, The" (J. C. Lauer and R. H. Lauer), 167
Lankton, Larry, 6
"Late Victorian Hallstand: A Social History, The" (Greene), 102–3
Lauer, Jeanette C. and Robert H.
—"The Language of Dress: A Sociohistorical Study of the Meaning of Clothing in America," 167
Learning to See: Historical Perspective on Modern Popular/Commercial Arts (Gowans), 86
Leavitt, Thomas W., 117
Leone, Mark, 27
Levi-Strauss, Claude, xi, 18, 67, 98, 140, 161, 162
Levittowners, The (Gans), 161
Lewis, Peirce, xi, xii, xiii, 161, 177, 180, 181, 208
—and "the galactic city," 48
life experience
—and object study, 137–38, 156
linguistics
—generative or transformational grammar, 67, 140, 162
—structural, 66
Little Commonwealth: Family Life in the Plymouth Colony, The (Demos), 160
Lockwood, Luke Vincent
—*Colonial Furniture in America,* 81
"Log Houses as Public Occasions: A Historical Theory" (Newton and Pulliam), 48
Lohr, N. Gordon

—*Eastern Shore, Virginia, Raised Panel Furniture, 1730–1830,* 96
Long, Amos
—*The Pennsylvania German Family Farm,* 135
Look of the Land, The (Hart), 48
Louder, Dean
—*This Remarkable Continent: An Atlas of the United States and Canadian Societies and Culture,* 50
"Louisiana House Types" (Kniffen), 37
Lowe, Virginia A. P.
—"The Cemetery as a Cultural Text," 132
Lowenthal, David, 43
—"The American Scene," 42
—"The American Way of History," 44
—*Geographies of the Mind,* 42
—"Geography, Experience, and Imagination: Toward a Geographical Epistemology," 44
—"Past Time, Present Place," 44
Lubove, Roy, 161
—"Social History and the History of Landscape Architecture," 178
Ludwig, Alan, 21
—*Graven Images, New England Stonecarving and Its Symbols, 1650–1815,* 174–75
Lynes, Russell
—"Upperbrow, Middlebrow, and Lowbrow," 43
Lynn, Catherine, 104
—*Wallpaper in America,* 94
Lyon, Irving W., 49, 60
—*The Colonial Furniture of New England,* 81, 95

McCarl, Robert
—"The Production Welder," 136
McCracken, Grant, 27
McCullough, David, 46–47
—*The Great Bridge,* 49, 114
McDaniel, George, 71
—*Hearth and Home,* 92, 160, 172
MacDowell, Betty
—*Artists in Aprons: Folk Art by American Women,* 136
—*Religious Folk Art in America,* 135
MacDowell, Marsha, 134
—*Artists in Aprons: Folk Art by American Women,* 136
—*Religious Folk Art in America,* 135
Machine in the Garden (Marx), 114
"Machine in the Parlor: A Dialectical Analysis of the Sewing Machine, The" (Douglas), 103
McKendrick, Neil, 20, 21

McMahon, Michael, 118
McManis, Douglas
—*Historical Geography of the United States: A Bibliography,* 47
McPhee, John, 49
"Mail Order Magic: The Commercial Exploitation of Folk Belief" (Snow), 132
Malinowski, Bronislaw, 170
Mannion, John, 6
Map of the Landforms of the United States (Raisz), 41
Marling, Karal Ann, 86
Marshall, Howard Wight, 133
—*Folk Architecture in Little Dixie,* 133
Martin, Charles E.
—*Hollybush,* 134
Martin's Hundred (Hume), 22
Marx, Leo
—*Machine in the Garden,* 114
Mason, Otis T., 1, 128
material civilization, 6
material culture
—approaches to
—behavioralistic, 157, 173–76
—cultural history, 165–66
—environmentalist, 157, 179–80
—formal-and-technological, 60
—functionalist, 157, 170–71, 175
—structuralist, 157, 161–63, 175
—areas in Europe
—Britain, xi, 21, 62, 71, 80, 115
—Europe, 80, 135
—France, 21
—Scandinavia, xi, 133
—areas in the United States
—midwestern, 91, 101–2, 133, 134
—northeastern, xii, 16–17, 21, 22–23, 61, 64, 95, 98–99
—Pacific Coast, 19, 69, 102, 178
—rural, 45, 47, 72
—southern, 10, 19, 20, 58, 62, 91, 92, 96–97
—southwestern, 2, 135, 161, 178
—urban, 48, 92–93, 136, 161, 177–78
—definitions of, xii, 1, 2–6, 27, 28 n.2, 113, 129
—eras of
—seventeenth-century (colonial), 21, 22–23
—eighteenth-century (colonial), 22–23, 88
—nineteenth-century (Victorian), 20, 21, 88, 100–103
—twentieth-century (modern), 24–25, 27

—evidence for
 —affective understanding of, 8, 12–13
 —distinctive features of, 8–13
 —temporal tenacity of, 9–10
 —three-dimensionality of, 8, 11, 121–22
 —wider representativeness of, 8, 11–12, 157
—explanations of
 —singularity of, 19–20
 —superiority of, 21–23
 —support for, 20–21
—groups of
 —Amerindian, 1, 2, 19, 128, 131, 135, 142, 172
 —black (Afro-American), 65, 66, 91–92, 128, 132, 135, 138, 172
 —ethnic, 19, 43, 65, 66, 90–91, 133, 134, 172
 —women, 81, 136, 163, 166–69
—in museums, xi, 7, 11, 16, 20, 21, 25, 27, 117–18, 158
—nomenclature of, xii, 1–2, 29 n.17
—in teaching, ix, xiv, 21
material culture studies, 6–8, 86, 113, 129, 136, 143
—common errors in research on, 14–18
—defined, 156
—difficulty of access and verification of, 15, 27
—exaggeration of human efficacy in, 15–16
—fecklessness of data survival in, 14
—and penchant toward progressive determinism, 16, 17, 72, 86
—proclivity of, for synchronic interpretation, 18, 85
Material Culture Studies in America (Schlereth), 79
material history, 6
material life, 6
Mayhew, Edgar
—*A Documentary History of American Interiors*, 88
—*New London County Furniture*, 96
mechanization, 101
Mechanization Takes Command (Giedion), 82
Meinig, Donald, 39
—"The Beholding Eye: Ten Versions of the Same Scene," 42
Melchor, James R. and Marilyn M.
—*Eastern Shore, Virginia, Raised Panel Furniture, 1730–1830*, 96
mentalité, 165, 172
mental template, 66, 140, 174
Mercer, Henry Chapman, 59
Mergen, Bernard, 169

"Methodological Study in the Identification of Some Important Philadelphia Chippendale Furniture, A" (Zimmerman), 97
methodology, x, 7, 24, 27, 72, 97, 115, 158, 162
Metropolitan Museum of Art
—*19th-Century America: Furniture and Other Decorative Arts*, 88
Michel, Jack, 63
midden analysis, 165
midwestern material culture, 91, 101–2, 133, 134
"Mind in Matter: An Introduction to Material Culture Theory and Method" (Prown), 87
modernization, xi, 24, 95, 101, 104
Moe, John
—"Concepts of Shelter," 133
Monkhouse, Christopher
—"Spinning Wheel as Artifact," 103
Montgomery, Charles F., 82, 88, 94
—in *American Art: 1750–1800, Towards Independence*, 88
—*American Furniture: The Federal Period*, 95
Moralism and the Model Home, Domestic Architecture and Cultural Conflict in Chicago, 1873–1913 (Wright), 160
Moravian Decorative Arts in North Carolina (Bivens and Welshimer), 91
Morgan, Lewis H., 170
Morison, Elting, 17
morphology, 43, 45
"Morphology of Landscape, The" (Sauer), 36
Moses, Robert, 178
Mumford, Lewis, 122
museums
—exhibitions in, 88, 104, 117, 158
—and material culture collections, xi, 7, 11, 16, 20, 21, 25, 27, 117–18, 158
Mussell, Kay, ed.
—*Ethnic and Regional Foodways in the United States*, 135
Myers, Minor, Jr.
—*A Documentary History of American Interiors*, 88
—*New London County Furniture*, 96

Nash, Gary, 169
Nash, Roderick
—*Wilderness and the American Mind*, 42–43, 45
National Historic Preservation Act of 1966, 116

Natural Geography of Plants, The (Gleason and Cronquist), 42
Neat Pieces: The Plain-Style Furniture of 19th Century Georgia (Atlanta Historical Society), 96
New England Begins: The Seventeenth Century (Boston Museum of Fine Arts), 16, 90, 104
New London County Furniture (Myers and Mayhew), 96
Newton, Milton B., 38
—"Log Houses as Public Occasions: A Historical Theory," 48
—"Settlement Patterns as Artifacts of Social Structure," 38
New World Dutch Barn: A Study of Its Characteristics, Its Structural System, and Its Probable Erectional Procedures, The (Fitchen), 19
Nickerson, Bruce
—"Is There a Folk in the Factory?" 136
19th-Century America: Furniture and Other Decorative Arts (Metropolitan Museum of Art), 88
nomenclature
—of material culture, xii, 1–2, 29 n.17
Norberg-Schultz, Christian, 162
northeastern material culture, xii, 16–17, 21, 22–23, 61, 64, 95, 98–99

object-oriented studies, 59–62
oral history, 171, 175
Order Upon the Land (Johnson), 45
Outward Signs of Inner Beliefs (Jones), 131

Pacific Coast material culture, 19, 69, 102, 178
Parr, Albert E., 166
Parsons, James
—quoted on C. Sauer, 37
Passing the Time in Ballymenone: Culture and History of an Ulster Community (Glassie), 38
Past Landscapes: A Bibliography for Historic Preservation (Jakle), 47
"Past Time, Present Place" (Lowenthal), 44
Pattern in the Material Folk Culture of the Eastern United States (Glassie), 47, 64, 132, 161, 179
Penn, Theodore Z., 115–16
Pennsylvania German Collection, The (Garvan), 90
Pennsylvania German Farm Family, The (Long), 135

Pennsylvania Germans: A Celebration of Their Arts, 1683–1850, The (Garvan), 90
Pennsylvania German Tombstones (Barba), 135
performance theory, 175–77
Personal Space: The Behavioral Basis of Design (Sommer), 163
photographs, 164
Pictures of Early New York on Dark Blue Stafford Shire Pottery (Halsey), 81
Pitt-Rivers, A. Lane, 1, 28
Plowden, David, 46
Plumb, J. H.
—in *American Art: 1750–1800, Towards Independence*, 88
politics
—and artifacts, 122–23
popular culture. *See* culture: popular
post construction (earthfast), 10, 19
Pottery and Porcelain of the United States, The (Barber), 81
Poulsen, Richard
—*The Pure Experience of Order*, 18
Prentice, Helaine Kaplan, 39, 40
Presentation of Self in Everyday Life, The (Goffman), 163
probate inventories, 60, 64, 71, 164
"Production Welder, The" (McCarl), 136
Prown, Jules David, 12, 13, 86, 160
—in *American Art: 1750–1800, Towards Independence*, 88
—"Mind in Matter: An Introduction to Material Culture Theory and Method," 87
—"Style as Evidence," 87
proxemics, 5, 63, 163, 178
Pulliam, Linda
—"Log Houses as Public Occasions: A Historical Theory," 48
Pulos, Arthur
—*American Design Ethic: A History of Industrial Design*, 88
Pure Experience of Order, The (Poulsen), 18
Pursell, Carroll, x, xi, xiii, 22, 208–9
Pye, David, 97

quantification, 158–59, 164, 165
Quimby, Ian, 27

Radcliffe Brown, A. R., 170
Rainey, Ruben, 43
Raisz, Erwin
—*Map of the Landforms of the United States*, 41
Rathje, William, 165
recreation

—and artifacts, 20
Reed, H. H.
—*American Skyline*, 48
Regional Geomorphology of the United States (Thornbury), 41
regionalism, xi, xiii, 17, 41, 89–90, 93, 94, 134, 161, 180
Reingold, Nathan, 165
Religious Folk Art in America (Dewhurst, MacDowell, and MacDowell), 135
Reps, John
—*Cities of the American West: A History of Frontier Urban Planning*, 178
residential spaces, 156, 160–63
Richardson, Miles
—*The Human Mirror*, 26
Roberts, Warren, 7, 133, 170–71
Robertson, Cheryl
—*The Domestic Scene*, 102
Rockdale (Wallace), 114
Rocking Chair Book, The (Denker), 102
Rooney, John
—*This Remarkable Continent: An Atlas of United States and Canadian Societies and Culture*, 50
Rubin, Barbara, 69
Rural Household Inventories Establishing the Names, Uses and Furnishings of Rooms in the Colonial New England Home, 1675–1775 (Cummings), 164
"Rural Revolution in East Carolina" (Chestang), 46
Rutmann, Darrett
—*Husbandmen of Plymouth: Farms and Villages in the Old Colony, 1620–1692*, 170

Saarinen, Thomas
—"Environmental Perception," 39
St. George, Robert, xii, 6, 22, 97, 104
—"Style and Structure in the Joinery of Dedham and Medfield, Massachusetts, 1635–1685," 98–99
—*The Wrought Covenant*, 99
Sande, Theodore, 115
Sauer, Carl Ortwin, xi, 37, 40, 47, 178, 179
—"The Education of a Geographer," 36
—*Land and Life: A Selection from the Writings of Carl Ortwin Sauer*, 36
—"The Morphology of Landscape," 36
Schiffer, Michael, 27
Schlereth, Thomas, xi, xii, xiii, xiv, 72, 81, 209
—*Artifacts and the American Past*, 73
—"Historic Houses as Learning Laboratories: Seven Teaching Strategies," 73

—"History Outside the History Museum: The Past on the American Landscape," 47
—*Material Culture Studies in America*, 79
"scientific antiquarianism," 94
Seale, William
—*The Tasteful Interlude: American Interiors through the Camera's Eye, 1850-1917*, 164
Seeley, Bruce F., 116
Sell, James L.
—"Environmental Perception," 39
semiotics, 69
"Settlement Patterns as Artifacts of Social Structure" (Newton), 38
Seven American Utopias: The Architecture of Communitarian Socialism, 1790-1975 (Hayden), 166
Shakers, 90, 91
Shammus, Carole
—"The Domestic Environment in Early Modern England and America," 163
Shape of Time: Remarks on the History of Things, The (Kubler), 119, 170
"Significance of the Seventeenth Century, The" (Handlin), 16
silver, 81, 93, 164
Silver in American Life (Ward and Ward), 93, 104
Singer, Charles, et al., eds.
—*History of Technology*, 47
Singleton, Esther
—*Furniture of Our Forefathers*, 81
Skramstad, Harold, 157
Smith, Cyril Stanley, 13, 119, 120
Smith, Merritt Roe, 22
Smith-Rosenberg, Carroll, 25
Snow, Loudell F.
—"Mail Order Magic: The Commercial Exploitation of Folk Belief," 132
social history, x, 14, 19, 26, 58, 155–95
—its common ground with material culture studies, 157–58
"Social History and the History of Landscape Architecture" (Lubove), 178
"Social Structure as Reflected in Architectural Units at Picuris Pueblo, New Mexico" (Brown), 161
Society for History of Technology (SHOT), 114
sociology, 58
"Some Thoughts from a Folk Culture Perspective" (Jabbour), 136
Sommer, Frank
—in *American Art: 1750-1800, Towards Independence*, 88

Sommer, Robert
—*Personal Space: The Behavioral Basis of Design,* 163
southern material culture, 10, 19, 20, 58, 62, 91–92, 96
South Italian Folkways in Europe and America (Williams), 135
southwestern material culture, 2, 135, 161, 178
Spencer, Herbert, 128
"Spinning Wheel as Artifact" (Monkhouse), 103
Stewart, George
—*U.S. 40,* 49
Stilgoe, John, 47, 177
—*Common Landscapes of America, 1598–1845,* 11
Stoudt, John Joseph, 132
Street-Car Suburbs (Warner), 177
"Street Grids a Frameworks for Urban Variety" (Groth), 45
structuralism, 157, 161–62
style, 103, 160
"Style and Structure in the Joinery of Dedham and Medfield, Massachusetts, 1635–1685" (St. George), 98–99
"Style as Evidence" (Prown), 87
Suiting Everyone: The Democratization of Clothing in America (Kidwell and Christman), 167–68
Swain, Doug, et al., eds.
—*Carolina Dwelling,* 58, 161
Swank, Scott T.
—*Arts of the Pennsylvania Germans,* 90
symbolically oriented object studies, 69–70
symbolism, 44, 45, 68, 70, 71, 95
synchronic analysis, 17–18
Szabo, Mario, 20

Talbot, George
—*At Home: Domestic Life in the Post-Centennial Era, 1876–1920,* 164
Tasteful Interlude: American Interiors through the Camera's Eye, 1850–1917, The (Seale), 164
Taylor, Edward, 128
teaching with material culture, ix, xiv, 21
technology
—history of, ix, xi, 3, 6, 7, 12–13, 17, 22, 46, 47, 113–26, 166, 169
"Technology and Society in the Urban Environment: The Case of the Third Avenue Elevated Railway" (Zunz), 177
"Technology through the 3-D Time Warp" (Hindle), 121

temporal tenacity
—of material culture evidence, 9–10
"*Terrae Incognitae:* The Place of Imagination in Geography" (Wright), 39
Texas Graveyards, A Cultural Legacy (Jordan), 43
Texas Log Buildings, A Folk Architecture (Jordan), 161
Thackeray, William Makepeace, 180
Theory of the Leisure Class, The (Veblen), 168
This Remarkable Continent: An Atlas of United States and Canadian Societies and Culture (Rooney, Zelinsky, and Louder), 50
This Scene of Man: The Role and Structure of the City in the Geography of Western Civilization (Vance), 48
Thomas, William, 127
Thompson, Robert Faris, 65
Thornbury, William
—*Regional Geomorphology of the United States,* 41
three-dimensionality
—of material culture evidence, 8, 11, 121–22
Toelken, Barre, 142
Topophilia: A Study of Environmental Perception, Attitudes, and Values (Tuan), 39
tourism, 46
"Toward a Behavioral History" (Jones), 174
toys, 136, 169
Tracy, Barry
—*Classical America, 1815–1845,* 89
tradition, 93, 128, 130, 137, 145
—defined, 67
Traditional Arts and Crafts of Warren County, Kentucky, The (Archbold), 134
transfer of culture (cultural transfer), 61–100
Transformation of Virginia, 1740–1790 (Isaac), 11, 20
Travels in North America (Kalm), 49
Trent, Robert F., 22, 97, 104
—*Hearts and Crowns,* 98, 170
Trescott, Martha Moore
—*Dynamos and Virgins Revisited,* 167
Tuan Yi-Fu, 43
—*Topophilia: A Study of Environmental Perception, Attitudes, and Values,* 39
Tunnard, Christopher
—*American Skyline,* 48
typology, x, 66, 67, 84, 160

United States, Department of Commerce
—*Climatic Atlas of the United States,* 42

"Upperbrow, Middlebrow, and
Lowbrow" (Lynes), 43
Upton, Dell, x, xi, 10, 160, 175, 176, 209
urbanization, x, xi. *See also* urban material
culture
urban material culture, 48, 92–93, 136,
161, 177–78
"Urban Preservation and the Geography
of the City in the USA" (Ford), 44
U.S. 40 (Stewart), 49

Vance, James
—*This Scene of Man: The Role and Structure
of the City in the Geography of Western
Civilization,* 48
Van Ravenswaay, Charles
—*The Arts and Architecture of German
Settlements in Missouri,* 91
Veblen, Thorstein, 102
—*The Theory of the Leisure Class,* 168
Venturi, Robert, 70, 161
vernacular architecture, ix, xi, 17, 57–78,
133, 160–61, 179–80
Veysey, Laurence, 156
Vidutis, Ricardas
—"The Cemetery as a Cultural Text," 132
"Vision in Afro-American Folk Art: The
Sculpture of James Thomas" (Ferris),
138
Vlach, John Michael, 65, 66, 92, 133, 135,
174
—*The Afro-American Tradition in the Deco-
rative Arts,* 91, 132, 172
—*Charleston Blacksmith: The Work of Philip
Simmons,* 138
volkskunde, 6

Wade, Richard, 177
Wallace, Anthony F. C.
—*Rockdale,* 114
Wallpaper in America (Lynn), 94
Walsh, Margaret
—"The Democratization of the Women's
Dress Pattern Industry," 167
Ward, Barbara McLean
—*Silver in American Life,* 93, 104
Ward, David, 177
Ward, Gerald W. R.
—*Silver in American Life,* 93, 104
Warner, Deborah Jean
—"Fashion, Emancipation, Reform, and
the Undergarment," 167
Warner, Sam Bass
—*Street-Car Suburbs,* 177
Washburn, Wilcomb, 10, 15
Watts, May Thielgaard, 43
Webb, Walter Prescott, xiii

—*The Great Plains,* 45, 46, 49, 179
Welshimer, Paula
—*Moravian Decorative Arts in North Car-
olina,* 91
Wertenbaker, Thomas, 155
White, Lynn, 170
Whitehill, Walter Muir, ed.
—*Boston Furniture of the Eighteenth Century,*
96
Whitney, Eli, 22, 46, 114
Whittlesey, Derwent
—"The Impress of Effective Central Au-
thority upon the Landscape," 44
wider representatives of material culture
evidence, 11–12, 157
Wilderness and the American Mind (Nash),
42–43, 45
Williams, Phyllis
—*South Italian Folkways in Europe and
America,* 135
Winner, Langdon, 122
Wissler, Clark, 1
*With Hammer in Hand: The Dominy Crafts-
men of East Hampton, New York* (Hum-
mel), 170
women, 94, 105, 114, 156, 166–69. *See also*
material culture: groups—women
Women's Folklore, Women's Culture (Jordan
and Kalcik, eds.), 136
Wood, Elizabeth, 6
Wood Carvers of Cordova, New Mexico
(Briggs), 135
workers, 92, 163, 169–72
Work Hard and You Shall Be Rewarded
(Dundes), 131
workmanship, 99
—of certainty, 97
—of habit, 97
"Workmanship as Evidence: A Model for
Object Study" (Zimmerman), 97
*Work of Many Hands: Card Tables in Federal
America, 1790–1820, The* (staff of Yale
University Art Gallery), 94
Wright, Frank Lloyd, 102
Wright, Gwendolyn, 161
—*Moralism and the Model Home, Domestic
Architecture and Cultural Conflict in
Chicago, 1873–1913,* 160
Wright, John Kirkland, 36, 38, 40, 42
—*Human Nature in Geography,* 39
—"*Terrae Incognitae:* The Place of Imagina-
tion in Geography," 39
Wrought Covenant, The (St. George), 99

Yale University Art Gallery
—*The Work of Many Hands: Card Tables in
Federal America, 1790–1820,* 94
Yoder, Don, xi, xiv, 133, 135, 164

Zelinsky, Wilbur, 40, 43
—*The Cultural Geography of the United States*, 42
—*This Remarkable Continent: An Atlas of United States and Canadian Societies and Culture*, 50
Zimmerman, Phillip
—"A Methodological Study in the Identification of Some Important Philadelphia Chippendale Furniture," 97

—"Workmanship as Evidence: A Model for Object Study," 97
Zunz, Oliver
—"Technology and Society in the Urban Environment: The Case of the Third Avenue Elevated Railway," 177